VIRGINIA
BARBECUE

JOSEPH R. HAYNES

VIRGINIA
BARBECUE

A HISTORY

AMERICAN PALATE

Published by American Palate
A Division of The History Press
Charleston, SC
www.historypress.net

Cover: Upper-left photo on front is Van Jackson of the Barbecue Exchange in Gordonsville, Virginia. *Author's collection.*

First published 2016

Manufactured in the United States

ISBN 978.1.46713.673.0

Library of Congress Control Number: 2016939301

Notice: The information in this book is true and complete to the best of our knowledge. It is offered without guarantee on the part of the author or The History Press. The author and The History Press disclaim all liability in connection with the use of this book.

For all the old-time Virginia barbecue cooks who have passed on.

To all who still proudly cook delicious and authentic Virginia barbecue today.

CONTENTS

ACKNOWLEDGEMENTS

I wish to thank all of the people who assisted, encouraged and supported me in my efforts to research and write this book. First, I thank my wife, who rode with me for hours as we made numerous long road trips on weekends while I conducted "research" meeting great Virginia barbecue cooks and enjoying their delicious Virginia-style barbecue. Second, I thank my family, who tolerated my many dinner conversations about Virginia barbecue history.

I also thank the good people at the University of Virginia Library, the Virginia Tech Libraries, the Library of Virginia, the Boatwright Memorial Library at the University of Richmond, the Boston Public Library and too many historical societies in Virginia to name. I also want to thank Lorraine I. Quillon, who pulled no punches when offering valuable and sometimes painful advice. Dr. Matthew B. Reeves, Ashley Runyon and Jane Friedman went beyond the call of duty in their assistance in making this book a reality. Thanks to Lake E. High Jr. for his advice and his contagious love and passion for authentic southern barbecue. Thanks to Robert F. Moss for the inspiration and encouragement to write this book. My friend Al McNeill has my gratitude for his valuable advice. I also extend my thanks to the good folks at The History Press for their assistance in helping turn my manuscript into a book.

INTRODUCTION

You can find barbecue in Virginia. You can also find Virginia barbecue in Virginia. There is a difference. This book is about authentic Virginia-style barbecue and its history. When I was a youngster, my father often took me to a local barbecue restaurant that served delicious Virginia-style barbecued beef sandwiches. The cooks there would chop the tender meat before adding a hint of slightly sweet and tangy sauce and serving it on hamburger buns. I liked to top mine with coleslaw. The restaurant closed many years ago when the owner retired. Local residents still miss those barbecued beef sandwiches. For several decades, a local politician hosted beef barbecues on his farm, and all were invited. Roadside vendors sold pork and chicken barbecue basted with a thin, vinegary sauce. The barbecue was tender, and the sauce was spiced and tangy. The barbecue served by the local restaurants and vendors are some of my earliest memories of real Virginia-style barbecue.

In 1978, the owner of a local barbecue restaurant hired me to bus the counter and take to-go orders. I worked there on nights and weekends while in high school. It was my first "real" job. The memories of the people, the aroma of the barbecue and the tangy flavor of the central Virginia–style barbecue sauce are still vivid in my mind. Long lines and big crowds were the norm. On many evenings, the owner would give me a look and nod—that was his way of telling me to hang up the "sold out" sign. I kept a close watch for that look and nod because it meant that I would be getting off early that night.

INTRODUCTION

After graduating high school, I resigned from the barbecue restaurant to attend college. Since those days, I have eaten barbecue at some of the finest barbecue restaurants in the United States. I have also enjoyed barbecue prepared by world champion barbecue cooks. Although the barbecue from places like Texas, North Carolina, Georgia, South Carolina and Alabama is delicious, the Virginia barbecue that I grew up eating is as good as the best that I have enjoyed anywhere else in the country.

Over the years, I have cooked my share of barbecue. I have competed in sanctioned contests with good success. I have been the student of some of the finest barbecue cooks in the world today. The largest organization of barbecue and grilling enthusiasts in the world has certified me as a master barbecue judge. Although I have experimented with many styles of barbecue through the years, the style that I have always found myself spending the most time trying to replicate is the Virginia barbecue that I have enjoyed since my youth. Some of it was tangy. Some of it was sweet. All of it was delicious, and I have never tasted anything exactly like it outside the state of Virginia.

Several authors today, such as Robert F. Moss and Bob Garner, have recognized that southern barbecue was born in Virginia while, at the same time, declaring that Virginia-style barbecue has all but disappeared because almost no Virginia barbecue practices still exist. The truth is, Virginia barbecue is alive and well, and I've never had a problem finding delicious versions of the real thing.

The widespread lack of knowledge about Virginia's barbecue and barbecue traditions is what prompted this book. Herein, I write about the "how" and the "why" of barbecue in Virginia in addition to the "what." The questions explored in this book include:

- How did southern barbecue develop in Virginia?
- How did the word *barbecue* come to Virginia?
- What are the details of Virginia's barbecue traditions?
- How has barbecue in Virginia changed over the centuries?
- How did barbecue spread from Virginia to the rest of the South?
- Where can authentic Virginia barbecue be found today?
- What are some authentic and delicious Virginia-style barbecue recipes that I can make at home?

I realize that some may disagree with my conclusions. I am writing about barbecue, after all. I could have taken the approach of simply stating that on

such and such a date, so and so held a barbecue, where someone barbecued a lamb or a hog. I could have stopped after writing about the buckets full of vinegar, salt, butter and pepper used to baste barbecue as it cooked. I could have simply mentioned that Native Americans in Virginia cooked on wooden hurdles and in earthen pots without drawing any conclusions as to how such things influenced Virginia's settlers. That would have been the safe route. However, at the end of the day, all I would have is a list of "X" number of barbecues held in "X" number of years by some people in Virginia. I would certainly know something about the history of barbecue in Virginia. However, the safe route isn't the most interesting or meaningful route. Therefore, I dug deeper into the subject. I read, observed, listened, debated, analyzed, smelled, tasted, experimented and learned. The result of those activities is this book.

CHAPTER 1
"REAL" AMERICAN BARBECUE

The idea was evidently conceived by a rural population, and in a district where villages and the ordinary public buildings of the present time were few and far between. For purposes of business or pleasure, the people found it necessary, or advisable, to meet together in masses, at stated periods; and as these meetings were a kind of rural festival, and as the animals served up on these occasions were commonly roasted entire, it was not unnatural that the feast should eventually have become known as a barbecue.
–Charles Lanman, from Haw-Ho-Noo: Or, Records of a Tourist *(1850)*

Americans didn't invent the ancient art of barbecuing. However, they can make the argument that they perfected it. When Noah Webster defined what barbecue is in the United States, he expanded it from just the West Indies barbecued hog to the American definition that includes any animal. In the 1828 edition of his dictionary, he wrote:

> B'ARBECUE, *n. In the West Indies, a hog roasted whole. It is, with us* [Americans], *used for an ox or perhaps any other animal dressed in like manner.* B'ARBECUE, *v.t. To dress and roast a hog whole, which is done by splitting the hog to the back bone, and roasting it on a gridiron; to roast any animal whole.*[1]

Webster contrasted American southern barbecue with Caribbean barbecue. Of course, the only large animals in the West Indies were the

ones Europeans carried there, such as hogs. In North America, there are numerous indigenous large animals, such as deer and bison, from which to make delicious American barbecue.

Few Americans argue against the fact that southern barbecue is the most purely American food that exists. By some definitions of the word *cuisine*, the American passion for barbecue actually qualifies it as an authentic American cuisine. However, that's the only thing about it on which many Americans agree.[2] In fact, ask 100 Americans what barbecue is, and there is a probability that you will get at least 101 different answers. Besides arguing over what barbecue is, Americans also argue over the spelling of the word *barbecue*. Is it "barbecue" or "barbeque" or "bar-b-q" or "BBQ"? The disagreement about the spelling of the word goes back centuries. In 1815, a newspaper writer commented on an advertisement for a barbecue in Kentucky, writing, "[A] word which they barbarously spell 'barbacue.'"[3]

Disagreements aside, some technical details are indisputable. Because this book examines American barbecue over the last four hundred years, it is important to understand how people cooked foods hundreds of years ago and the terminology associated with those cooking methods. Barbecuing is just one dry-heat cooking technique. Three others are roasting, broiling and hot smoking.

ROASTING

Roasting is a cooking method typically using temperatures in the range of 300° Fahrenheit (F) to 500°F.[4] Today, the method for roasting meat can be as simple as placing it on a rack in the oven. However, that was more of a baking technique in the days of open-hearth cooking. When using an outside fire or an open-hearth kitchen (like those used in colonial times), roasting involves building a flaming fire and placing meat on a spit or a stake in front of it, not over it. An 1824 cookbook explained, "No meat can be well roasted except on a spit turned by a jack, and before a steady fire—other methods are no better than baking."[5] Another cookbook stated, "Roast it before a clear, steady fire, avoiding a smoke or blaze near the roaster."[6]

Years ago, it wasn't unusual for people in the United States to call barbecuing "roasting." In 1898, an encyclopedia of cookery explained, "In America a kind of open-air festival, where animals are roasted whole, is styled a Barbecue."[7] The practice of referring to barbecuing meats as being

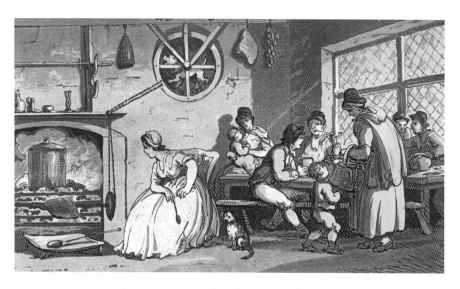

Dog power turns the spit as meat roasts before the fire. *From* Remarks on a Tour to North and South Wales, in the Year 1797 *by Henry Wigstead.*

roasted was commonplace. Today, we are more precise and are careful to draw a distinction between barbecuing and roasting. However, old-school barbecue parlance allows for "roasting" a whole hog on a barbecue grill.

BROILING

Broiling involves placing meat directly under or over a high-temperature heat source.[8] Therefore, grilling meat hot and fast on our backyard grills

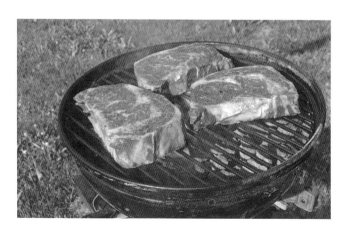

Steaks "broiling" on the grill. *Author's collection.*

is a form of broiling.[9] Grilling (i.e., broiling) typically calls for a cooking temperature at or above 350°F and is best suited for smaller, thinner cuts of meat. This is how southerners cook steaks, hamburgers, hot dogs and sausages at cookouts, not barbecue at barbecues. However, in California, what southerners call grilling is a barbecuing technique, and people in Texas claim that they can barbecue sausages.

Smoking

Smoking is an ancient food preservation technique.[10] Although it is no longer required in our world with ubiquitous refrigeration and canning techniques, people still enjoy the flavor of smoked foods. Professional cooks cold-smoke meat at temperatures of 100°F or less. Hot-smoking temperatures range between 150°F and 200°F.[11] Hot-smoked meat, such as Canadian bacon, is ready to eat when the process is complete. Cold-smoked meat, such as Virginia ham, remains uncooked.[12] The process of smoking meat dehydrates it, kills bacteria and hinders its future growth. It also enhances flavor. Cold-smoking fish and meat nowadays can be risky. Therefore, experts do not recommend that people smoke foods at home because cold-smoked foods can be dangerous, especially for children, pregnant women, people with compromised immune systems and the elderly.[13] The same can be true of hot-smoked meats. Therefore, leave the preparation of smoked foods to professionals.

Referring to southern-style barbecued meat as "smoked meat" is a twentieth-century practice. For example, newspaper advertisements from around the turn of the twentieth century for "smoked brisket" were referring to bacon made of brisket rather than barbecued brisket as we think of it today. However, by 1935, the portable barbecue "smoker" had made its debut.[14]

Barbecuing

Traditional barbecuing in the South is similar to a combination of broiling and smoking. Like smoking, barbecuing imparts a smoky flavor to meat. However, barbecuing requires higher temperatures than smoking and lower temperatures than broiling or roasting, typically in the 250°F to 325°F range. Hence the "low and slow" mantra of southern barbecue cooks. The

Virginia barbecue on a reverse-flow smoker. *Doug Anderson of Anderson BBQ Company, Lancaster, Virginia.*

lower temperatures used for barbecuing ensure that the center portions of the large cuts of meat reach the proper level of doneness before the outside surface is scorched.[15]

Today, southern barbecuing techniques include what is more like a roast-smoking process than a broil-smoking process, and I know of few southerners who complain about the change. Because of convenience and health department requirements, some cook southern barbecue today with indirect heat in a chamber that concentrates smoke from the fire around the meat while it cooks. When barbecuing in a Texas-style horizontal offset smoker, the meat sits beside the fire in a way that is similar to how meat is positioned when roasting it. However, the original method of barbecuing in the South calls for using a grill over hardwood coals burning at relatively low temperatures directly under the meat.

As western states joined the Union, the American definition of barbecue expanded to include the western barbecuing technique.

SOUTHERN BARBECUE

Among the most defining traditions of the South is its down-home southern barbecue. To southerners, barbecue comes in number four on the sacred scale just behind the Bible, love for Mom and Old Glory. Moreover, any tampering with the traditions of southern barbecue is not just sacrilege but also an insult.

Southern barbecue must be cooked using hardwood for a long time. If that's not how it's cooked, it isn't "real" barbecue. If it isn't pull tender, it isn't

"real" barbecue. If it doesn't have a smoky flavor from the real wood fire, it's not "real" barbecue. In the South, it's impossible to barbecue hamburgers, hot dogs and steaks. Southerners grill those foods and serve them at cookouts, not barbecues.[16] In the South, calling grilled meats barbecue is a lot like calling margarine butter. Non-southerners just have to face the fact that grilled hot dogs and hamburgers are not what made American barbecue famous. Southern barbecue did that.

Wesley Jones, born enslaved in 1840, was a South Carolina barbecue cook. In 1937, at the age of ninety-seven, he shared his old southern barbecuing technique and recipe:

> *Night befo' dem barbecues, I used to stay up all night a-cooking and basting de meats wid barbecue sass* [sauce]. *It made of vinegar, black and red pepper, salt, butter, a little sage, coriander, basil, onion, and garlic. Some folks drop a little sugar in it. On a long pronged stick I wraps a soft rag or cotton fer a swap, and all de night long I swabe dat meat 'till it drip into de fire. Dem drippings change de smoke into seasoned fumes dat smoke de meat. We turn de meat over and swab it dat way all night long 'till it ooze seasoning and bake all through.*

Speaking of spectators, Jones continued, "Dey looked at my 'karpets' [pit stakes]. On dem I had whole goats, whole hogs, sheep and de side of a cow. Dem lawyers liked to watch me 'nint' dat meat. Dey lowed I had a turn fer ninting it [anointing it]."[17]

In 1938, Wilbur Kurtz, historian for the movie *Gone with the Wind*, interviewed an African American barbecue cook from Georgia named Will Hill. In his seventies at the time, Hill described how he barbecued hogs, sheep and beef after the end of the Civil War. Hill barbecued on iron grills over coals in a pit. The grills were five-feet-long and two-feet-wide units, and each individual animal carcass had its own grill unit. This made it easier to turn the carcasses as they barbecued.

Turning the meat, according to Hill, was a "continuous performance" that was required to prevent the meat from scorching. The hickory or oak coals in the pit were replenished by a fire that was kept burning beside it. Part of Hill's "continuous performance" was also the basting of the meat. Like Jones, he attached clean rags to the end of sticks and used them to baste the meat with a mixture of "vinegar, mustard, pepper and sugar—with butter added for mutton basting."[18]

From southern barbecue's earliest beginnings in seventeenth-century Virginia, barbecue cooks all over the South have been basting meat as it

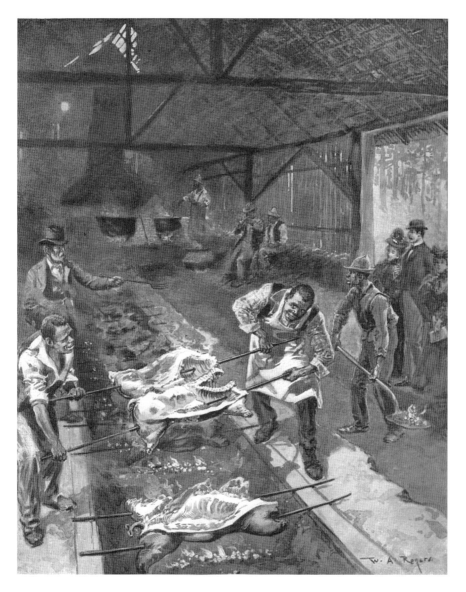

Turning the barbecuing meat at a southern barbecue, circa 1896. From *Harper's Weekly*, November 2, 1896. *Author's collection.*

barbecues with colonial Virginia's basic vinegar, salt, pepper and oil "sauce." Unlike today, only a few old recipes called for seasoning meat with a barbecue rub before barbecuing it.[19] A firsthand account of barbecue in the 1870s tells us, "Barbecue in those days was seasoned in the cooking."[20] In Virginia, the barbecue baste was even known as "the seasoning."[21]

It is traditional to eat southern barbecue with your fingers. This tradition goes back hundreds of years. In one account of a nineteenth-century Texas barbecue, we are told that there were "no knives, no forks, no napkins, nothing but bread and meat."[22] An attendee at an 1840 Kentucky barbecue wrote, "There was neither cloth, dishes, plates, or knives and forks; and abundance of bread but no vegetables. The meats were spread along the rough boards, and every man helped himself with his own jack-knife, or borrowed a neighbor's."[23] At an 1860 political barbecue in New York City, the host did not furnish forks, knives or even plates, as it was expected that "nature's gifts of teeth and fingers" along with "the artificial aid of the flat biscuit" would serve as substitutes.[24] In 1917, journalist Irvin S. Cobb wrote of barbecues, "A Jeffersonian simplicity likewise governs the serving out of the barbecued meats…You eat with the tools Nature has given you, and the back of your hand is your napkin."[25] The organizers of a 1922 barbecue held in Kansas expected so many attendees that they advertised, "Knives, forks, spoons, plates and cups are to be furnished by guests who partake of the barbecue."[26]

By 1909, southern-style barbecue had changed, and those changes were evident, even in Texas. The people of Bryan and Brazos Counties held a barbecue that year where the hosts served "all kinds of barbecue sauces" on the side with the barbecue.[27] The modern central Texas practice of not serving sauce with barbecue only goes back to around the turn of the twentieth century. It started when meat markets began selling barbecued meats as way of reducing waste. Of course, butcher shops don't usually provide knives, forks, plates or sauce.[28]

The almost universal modern practice of serving barbecue sauce on the side started to gain popularity in the late nineteenth century and was pretty much a standard offering at least by the early 1900s. Nevertheless, there are accounts of hosts who served sauce on the side with barbecue as far back as at least the early 1800s. For example, at the 1806 wedding of the Virginian parents of Abraham Lincoln, the hosts served honey and peach syrup in gourds to go with barbecued sheep.[29] In 1825, people in Schuylkill, Pennsylvania, enjoyed "a fine barbacue [sic] with spiced sauce."[30] By 1871, a Dr. J.H. Larwill of Georgia was selling barbecue sauce with the tagline, "For fresh meats of all kinds it cannot be excelled."[31] By 1872, *Mrs. Hill's Southern Practical Cookery and Receipt Book* included a "Sauce for Barbecues" recipe.[32] By 1913, a cookbook author included the exhortation in her barbecued pig recipe, "Have plenty of sauce to serve with [the] meat."[33] Not everyone heeded the advice. As late as 1952, a newspaper columnist commented on the modern practice of serving barbecue "with a seasoned sauce" that there were days in the

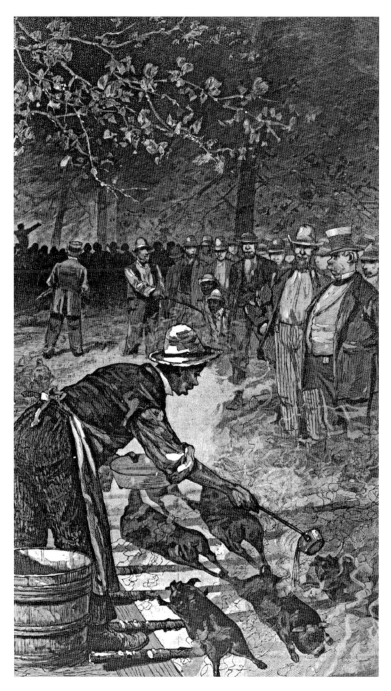

Southern barbecue in antebellum times cooked directly over the coals. *From Frank Leslie's Popular Monthly 40, no. 3 (September 1895). Courtesy Boatwright Memorial Library, University of Richmond Library.*

past "when a barbecue was something other than a drug store sandwich" made of chopped-up meat smothered in sauce.[34]

Tomato has been an ingredient in barbecue sauces for longer than most people realize. In 1860, a writer for a South Carolina newspaper wrote about the "dishes of tomato sauce" served on plantations alongside barbecued meats.[35] An article originally published in 1859 tells us how some antebellum barbecue baste recipes, called "seasoning gravy," included tomato ketchup along with the red pepper and vinegar.[36]

Tomato in barbecue sauce is popular today. However, as late as the early twentieth century, barbecue sauce with tomato in it wasn't universally accepted. An author in 1927 commented, "Both these recipes include catsup or tomato paste, whereas the genuine barbecue should be made preferably without this addition."[37]

South Carolina is famous for its mustard-based barbecue sauces. In our times, Alabama has made white barbecue sauce famous. There are also versions of white barbecue sauces served in Tennessee. Although Alabama claims it, white barbecue sauce has been around since at least the early 1800s. Mary Randolph's 1828 edition of her cookbook *The Virginia Housewife* contains a recipe that she called "White Sauce for Fowl" that was meant to be served with roasted or barbecued birds.[38] Cookbook author Lettice Bryan's 1839 barbecued pork recipe calls for a white sauce served on the side made with sweet cream.[39] A barbecue cook in 1890s New York, of all places, was famous for his white barbecue sauce. His name is J. Lee Teller of Richfield Springs, New York. His white barbecue sauce was "much like mayonnaise to look at." The recipe included eggs, tarragon vinegar and paprika.[40] In the early 1970s, a backyard barbecue cook named Emerson (Slim) Betterly of Honeoye, New York, often served what he claimed was an original white barbecue sauce made of vinegar, cooking oil, poultry seasoning, pepper and egg.[41] In 1958, a newspaper shared a white barbecue sauce recipe made with cottage cheese, bleu cheese dressing and olive oil among its ingredients.[42]

Barbecuing whole carcasses is the original and oldest way to cook southern barbecue, but all that changed when barbecue stands started popping up in towns and cities around the turn of the twentieth century. City butcher shops and, later, refrigeration enabled entrepreneurial cooks to serve just the cheapest cuts of meat, which increased profits due to reduced direct costs.[43]

When it comes to barbecue in the United States, southern barbecue is the gold standard. In 1919, columnist Jefferson Bell wrote, "Present day cookery has not yet invented any method of cooking meats that can compare with the primitive barbecue." She continued, "If you are lucky enough to secure a part of the left-over meat [to take home], you are one of fortune's favorites, for there is no known viand equal to it."[44]

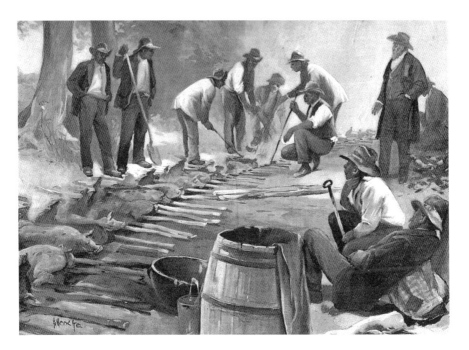

A typical southern barbecue, circa 1896. Sketch by A. Hencke from *Harper's Weekly*, October 24, 1896. *Author's collection.*

> *The distinguishing feature of a barbecue is the dressing used to baste the meats while roasting. It is customary to excavate a fire trench in the ground and across it place iron bars on which the meat rests. Pigs, lambs, calves and even oxen are thus roasted whole or in halves. At first they are seared as quickly as possible over a bed of live coals and afterwards roasted more slowly to avoid scorching and frequently basted with a mixture of salt, pepper, vinegar and butter. The process is a slow one, owing to the size of the meats and the exposure to the free circulation of air, but for the same reasons the results are fine. The meats are juicy and well flavored, a peculiar zest being imparted by the vinegar, which also serves to soften the fiber of the meat.*
>
> Everyday Housekeeping: A Magazine for Practical
> Housekeepers and Mothers (1897)

VIRGINIA BARBECUE

WESTERN BARBECUE

As the borders of the United States spread farther west in the nineteenth century, new customs and food traditions entered the country's culture. Once California became a part of the Union, the South was no longer the only region in the country with a long-held barbecue tradition, but don't expect southerners to agree on that point. As far back as 1884, southerners claimed that there was only "imitation barbecue north of the Ohio."[45] When the Persian consul general hosted a Persian barbecue in Washington, D.C., in 1911, a writer for the *Washington Times* commented, "It puts a crimp in one of our most cherished traditions that there could be any real barbecue outside of the South."[46] Like Persian barbecue, western barbecue is also a crimp in that tradition.

Western barbecue in the United States goes all the way back to the days of the Spanish colonists who settled in what is now the western and southwestern United States. Unlike southern barbecue, western barbecue includes several different cooking techniques such as grilling at high temperatures directly over coals or by baking, or steaming, in an earthen oven. It goes back to when Spanish conquistadors learned how to cook meat by burying it in the ground with hot rocks from Native Americans.[47] Several authors in the nineteenth and twentieth centuries call this cooking technique barbecuing.[48]

In 1950, Clay Potts, known in those days as Oklahoma's barbecue king, explained how to cook western barbecue. Potts instructed us to start out by digging a pit three and a half feet deep and wide enough to hold all of the meat. He recommended blackjack oak or hickory for the fire, cut to size and placed in the pit. He instructed us to burn the wood down to coals. There should be enough wood to create an eighteen-inch-deep bed of hot embers. Cut the meat into eight-pound chunks and wrap it in cheesecloth, then burlap, and tie it up tight with twine. Dip the wrapped meat in water and place it in the pit with the coals. The pit must be covered first with boards, then a tarp and, finally, with dirt. After cooking for ten hours, the meat is ready to eat.[49]

By the year 1769, George Washington was regularly attending old Virginia barbecues, and by the year 1821, Virginia's barbecue tradition was about two hundred years old. On the other hand, the Spanish didn't settle in California until around 1769, and by 1821, California was transitioning from being a Spanish colony to a province of Mexico.[50] By the time thirty thousand people attended a southern-style barbecue in Ohio held in honor of Henry Clay in 1842, California was still a foreign land that wouldn't

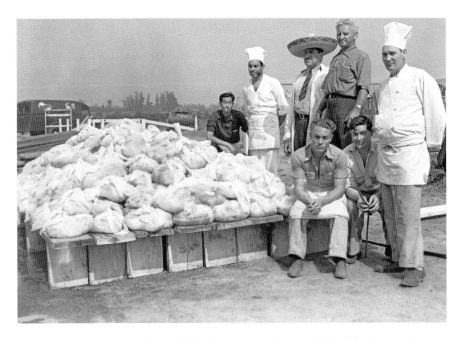

Beef wrapped and ready to be buried in the barbecue pit at a California barbecue, circa 1930s. *Library of Congress, Prints and Photographs Division, LC-DIG-ds-01517.*

gain American statehood for eight more years.[51] Therefore, it should be no surprise that the headline for a barbecue held on Santa Catalina Island in 1909 included not Brunswick stew or burgoo but "chili con carne," as well as "frijoles and other Spanish dishes" in addition to "ten thousand pounds of choice beef, pork and mutton."[52]

In California and parts of the Southwest, barbecue recipes originally comprised a mix of Spanish, African, Mexican and Native American cookery.[53] By the late nineteenth century, Californians were holding "Spanish barbecues" where meats were "barbecued in true Spanish style."[54] One such barbecue, advertised as a "whole ox barbecued a la Mexicana," was held in Whittier, California, in 1909 at El Ranchito, the former home of the first Mexican governor of California, Pío Pico.[55] It was a Spanish barbecue held "especially for eastern visitors."[56] Joe Romero did the work of barbecuing the 550-pound ox. The bill of fare included Spanish beans, chili, enchiladas and tamales. An orchestra and dancers entertained diners.[57]

In 1905, some people in San Juan Capistrano hosted a Spanish barbecue. Pedro Rivera was one of the pit masters. The cooks dug a pit eight feet long, eight feet deep and four feet wide and lined it with stones. They built a huge fire in order to heat the stones until they were red hot. They cut a two-ton ox

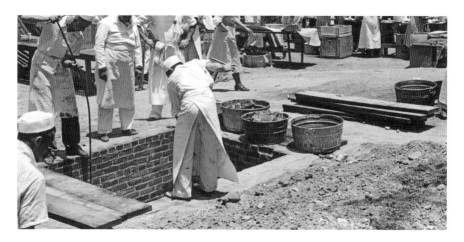

Removing beef from the pit at a western barbecue in California, circa 1930s. *Library of Congress, Prints and Photographs Division, LC-DIG-ppmsca-08753.*

Wrapping being removed from western-style barbecued beef, circa 1940. *Library of Congress, Prints and Photographs Division, LC-USF33-012919-M1.*

into chunks and wrapped the meat in cheesecloth. They swept the embers out of the pit and buried the wrapped meat in it. Twelve hours later, Rivera pronounced the barbecue "ver' good," and it was time to eat! The hosts

served three fifty-gallon kettles of frijoles, a half ton of potatoes, six barrels of olives and forty gallons of chili with the barbecued meat.[58]

In Compton, California, in 1898, people held "a genuine old-style California barbecue and bull's head breakfast." Under the shade of apple and olive trees was a barbecue pit where "aged Mexican cooks" prepared the feast, which included thirteen bulls' heads. [59] In 1907, people in San Gabriel, California, hosted a bull's head barbecue for breakfast. They served "fearful and fiery sauces."[60] A reporter described it as a "feast beside which an old Virginia barbecue seems a mere light lunch."[61] People all over the Southwest cook this style of barbecue.[62]

In the 1800s, places in California like Santa Maria where large ranches existed would hold Spanish-style (western-style) barbecues for the ranch hands. Each nationality contributed to the festivities. According to one account, "Indians dance, Germans sing, and the Italians play stringed instruments."[63] Today, cooks prepare delicious Santa Maria–style barbecue over red oak wood seasoned with a mixture that includes salt, pepper and garlic.[64]

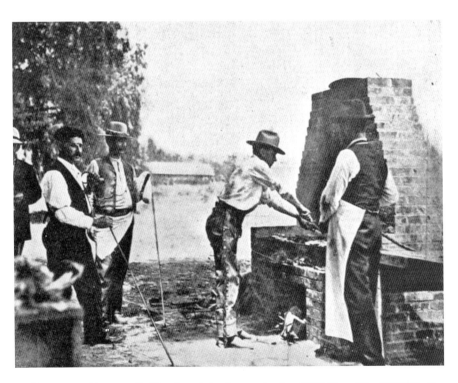

Joe Romero cooking on a California-style barbecue pit, circa 1910. From *The 1910 Trip of the H.M.M.B.A. to California and the Pacific Coast* by George Wharton James.

The most famous of all California barbecue cooks is Joe Romero. The authors of old descriptions of him sound almost like they were describing a superhero. They tell of one side of Romero known as "Joe the cook" who, on ordinary days, served foods at a Spanish restaurant in Los Angeles. Then there is the other Romero, who "on high days and holy days" transformed into a Spanish caballero whom people called "Señor Romero the barbecue king."

Born in southern California in 1852, by the turn of the twentieth century Romero had been cooking barbecue in the classic western style for several decades. Romero and his crew would line a deep pit with rocks and build a large fire in it to create a bed of hot coals with which he buried the meats. A typical barbecue required two tons of beef, twenty bulls' heads and a dozen lambs and hogs. According to Romero, "in the old days" people used to barbecue whole beef carcasses in the pits. At some point, pit masters started cutting the meat into chunks before barbecuing it because it was easier to handle when cooking. It took twelve hours for Romero to barbecue all of the meat for his barbecues. While the meats barbecued, Romero and his crew of as many as twenty cooks prepared chili con carne, coffee and heaps of fresh lettuce and vegetables for salad. In 1910, a photographer snapped a photo of Romero cooking on a California-style barbecue pit. The style of pit in that photo inspired the design of backyard barbecue pits built all over the United States in the 1950s and 1960s. Joe Romero died in 1932.[65]

BACKYARD BARBECUE

In 1955, *Look* magazine printed an article entitled "America Is Bit by the Barbecue Bug."[66] The article includes colorful photographs of a family spending the day outdoors and enjoying a meal cooked up by Dad on his various grills. Dad even has a pair of asbestos gloves to protect his hands from the hot coals and hot cooking utensils.[67] Of course, asbestos is not recommended nowadays. With everything from pancakes and pan-fried chicken to steaks and kabobs on the grill, and a full array of side dishes, it's clear that this family was cooking outdoors. However, was Dad barbecuing? Since the modern backyard barbecue was born, people have continually debated that question.

The phrase from which we get our word *cookout* is "cooking out of doors." In 1879, an author wrote, "As the hot weather approaches" it is time to "get a Charcoal Furnace." "By using one of these," the author explained, "dinner

A 1942 backyard barbecue in California. *Library of Congress, Prints and Photographs Division, LC-USF34- 072729-D.*

can be cooked out of doors."[68] A later development leading to the modern backyard barbecue grill can be seen in the 1907 article from *Harper's Outdoor Book for Boys* entitled "How to Cook Out-of-Doors." The article explained, "Up-to-date campers will make a stone stove. This holds the fire within the stone enclosure."[69] A 1947 columnist referred to what we know today as a backyard barbecue grill as a "portable charcoal stove." A cook demonstrated its use at a Garden Club meeting in order "to demonstrate how easy it is to cook out of doors."[70] The 1947 theme for the Cookport 4-H Club was "Let's Cook Outdoors."[71] Sometime in the early twentieth century, the word *cookout*

became mainstream. In 1931, a writer told of the first time he heard the word: "In this rural community where I am writing there is a fad for 'cook-outs.' Today I heard the name for the first time."[72]

Clearly, the backyard barbecue developed more from outdoor cooking than it did from southern barbecuing. This is why southerners call events where people use a charcoal grill to cook steaks, hamburgers and hot dogs a "cookout."

In a 1906 article about "picnic dinners," we find "a pleasing innovation to serve something cooked over an open fire." The article contains recipes for what we would call today classic backyard barbecue foods such as planked fish, barbecued sheep ribs, roast corn, potato salad and even "old Virginia Brunswick Stew." The article describes these foods as what can be prepared at a picnic dinner, not a barbecue.[73]

By 1939, we find, "The irresistible fragrance of broiling steak on a charcoal grill is floating over public parks, private backyards and along the nation's shores. In other words, the cook is taking to the woods, and as a result, an entirely new set of recipes and culinary methods are being evolved for the out-door lover."[74] It looks like Henry Ford's idea of selling charcoal and charcoal grills with his cars was paying off.

In 1907, Basil V. Haislip of Stuart, Virginia, recalled when his family and some neighbors held a barbecue near a creek that "ran back of our house." The families built a fire using driftwood. The boys went fishing and, afterward, went swimming. The adults were busy "barbecuing" two chickens. They also prepared the side dishes to go with them. Haislip wrote, "They tied two chickens to them [stakes], so as to let them hang down close to the fire. They put some potatoes in the ashes to bake. A skillet was placed so as to catch the grease that dropped from the chickens, from which they made gravy."[75]

Haislip's barbecue probably occurred in the late nineteenth century. Although he didn't use the phrase "backyard barbecue," he did provide us with one of the earliest accounts of one complete with a debatable definition of the word *barbecue* because, technically, the chickens were roasted.

In 1919, Jefferson Bell wrote about what she called "miniature barbecues" held by her family in their backyard probably sometime around the end of the nineteenth century or very early twentieth century. Ms. Bell wrote, "Treasured in a storehouse of memories…is a fragrant recollection of small private barbecues in a backyard where there were great oaks and flower beds."[76]

By the turn of the twentieth century, the idea of the backyard barbecue was gaining momentum. In 1908, Emma Paddock Telford shared a recipe

Grilled vegetables. *Author's collection.*

entitled "Barbecue on a Small Scale."[77] The recipe calls for barbecuing a rack of sheep ribs basted with butter and vinegar whipped together until it was "frosty like a salad dressing" seasoned with salt, pepper and mustard.[78] In 1911, the mayor of Macon, Georgia, celebrated his birthday by giving "a barbecue dinner 'under a big oak tree in his backyard.'"[79] By 1919, the phrase "backyard barbecue" finally appears in print: "A novel 'backyard barbecue' was given Saturday evening…They served lamb, salad, frijoles and coffee."[80]

Backyard barbecue continued to grow in popularity in the first half of the twentieth century, prompting the publication of the first book in history dedicated to barbecue in 1939, entitled *Sunset's Barbecue Book*. A focus of the book is to provide instructions for building various types of barbecue grills and pits. With the publication of this book, there was no stopping backyard barbecue.

In 1940, when barbecues were "enjoying a wave of popularity," Dorothy Neighbors held a "Backyard Barbecue" show at a Seattle department store. She demonstrated how to prepare spare ribs, lamb shanks and steaks and shared instructions for building a barbecue grill.[81] Like other early promoters of backyard barbecues, Ms. Neighbors targeted her advertising at women. The 1940s soft drink advertisements depicting a woman standing near her barbecue pit handing out hot dogs to her adoring guests demonstrates the

marketing focus.[82] "You'll be surprised how the men will want to take charge of the broiling" was an enticement for women to fire up the grill.[83]

The biggest boost to backyard barbecuing came in California during World War II. By 1943, Californians had become "particularly addicted to backyard barbecues."[84] Another article noted in 1945, "Barbecue suppers and backyard picnics are a favorite western sport."[85] In 1942, fuel shortages caused by the war prompted one commentator to write under the heading "America Goes Backyardish" that "the charcoal grill craze has become epidemic."[86] Because of the scarcity of gasoline needed to take Sunday drives, it seems that people began cooking outdoors using wood or charcoal for fuel. Explaining in 1945 how "any meal tastes better if you eat it out-of-doors," the author asserted that barbecues are economical because you can serve "economy cuts" and "non-rationed items."[87]

As backyard barbecues became more popular, people who were used to the more traditional southern-style barbecues couldn't help but notice. Some lambasted the idea, and others tried to reconcile it. In 1952, a columnist prophetically lamented that barbecue would "suffer the fate of popularity and become so diluted in meaning as to lose its flavor" and that the word *barbecue* would be used to refer to "anything cooked outdoors."[88] In 1942, another reconciled the idea of a backyard barbecue by explaining that there is the large-scale barbecue "with a deep pit dug in the ground and large joint of meat roasting slowly on a revolving spit." In addition, there is "the small-scale barbecue to suit those sites where the great open spaces are not so 'wide.'" "These small-scale barbecues [that] feature frankfurters, hamburgers, steaks broiled atop a charcoal grill" are economical.[89]

By 1948, the *Dallas Morning News* had proclaimed, "Now, except for the great open spaces, it [barbecue] reverts once more to the small backyard pit or grill."[90] Another observed in 1952, "There are more recipes for [barbecue] sauce floating around the country than there are Truman jokes." By that time, the terms "barbecuing" and "outdoor cooking" had become interchangeable.[91]

In 1953, backyard barbecuers were "popping out like daisies" in Virginia.[92] One food editor observed in 1954 that Virginia's "dining rooms and kitchens are moving outdoors."[93] The notion of calling "cooking out of doors" a barbecue gained a big boost from 1950s magazine ads, such as the one that encouraged people to have an "Annie Oakley barbecue" complete with hot dogs and "barbecue" hamburgers.[94] By the late 1950s, much of the country had accepted the idea. We find in a 1958 newspaper column, "In the broadest sense, barbecue means to cook out of doors. In a more technical

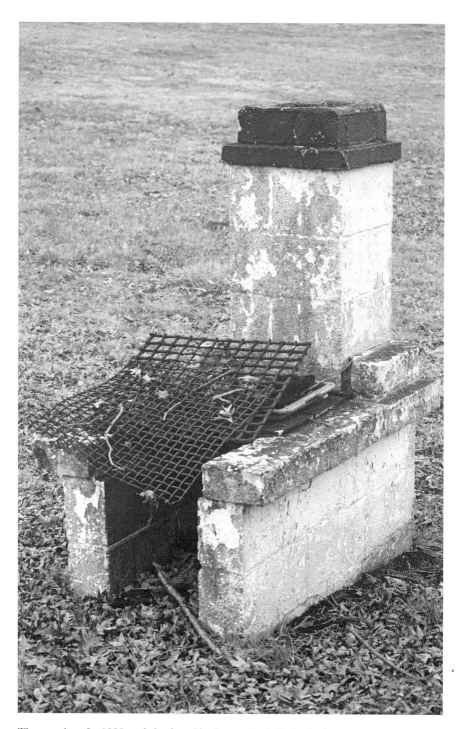

The remains of a 1950s-style backyard barbecue pit. *Author's collection.*

sense, barbecuing is cooking, especially meat, in a specially seasoned sauce."[95] However, to this day, southerners don't agree with such claims.

By the end of the 1950s, backyard barbecue enthusiasts had developed their own style of American barbecue and their own definition of the word *barbecue*. Although settled in many regions of the United States, the great backyard barbecue debate is still raging in the South. To this day, statements such as "barbecue means to cook out of doors" and "barbecuing is cooking, especially meat, in a specially seasoned sauce" prompts uncontrollable eye rolling and spontaneous head shaking among southern barbecue aficionados. Although southerners may never accept calling a cookout a barbecue, we have to admit that the practice is now so widespread that it has become a part of the American barbecue tradition.

KITCHEN BARBECUE

A casual search on the Internet reveals a large collection of recipes with instructions for cooking "barbecued" pork "low and slow" in a crockpot by submerging it in your favorite bottled barbecue sauce. Take a walk down the aisles of the local grocery store and you will find barbecue potato chips, barbecue beans and even barbecue tofu. Today, it seems that anything can become barbecue if you just put some barbecue flavorings on it. Known as "kitchen barbecue," these kinds of recipes have been around for a very long time.

In 1824, Virginian Mary Randolph shared a kitchen barbecue recipe entitled "To Barbecue a Shote" that called for baking a young pig in the kitchen oven.[96] Because Randolph wrote her book for busy homemakers, she modified recipes in ways that made things easier, and her barbecue recipe reflects that fact. Although Randolph's recipe contains the flavors of Virginia barbecue from her era, it doesn't reflect how barbecue was actually cooked.

People in England also cooked kitchen barbecue, and at least one English barbecue recipe noted, "if an oven can be depended upon, it will be equally good baked."[97] In 1913, Martha McCulloch Williams shared a kitchen barbecue recipe for barbecued lamb in her cookbook *Dishes & Beverages of the Old South*.[98]

Apparently, people have always looked for ways to enjoy the delicious flavors of southern barbecue without having to do all of the hard work it takes to prepare it.[99] Moreover, as it is today, there have always been southern

"Barbecued" potato chips. *Author's collection.*

barbecue aficionados around to criticize that practice. In 1896, Fannie Merrit Farmer authored *The Boston Cooking-School Cook Book*. It includes a kitchen barbecue recipe for barbecued ham cooked in a frying pan with a sauce made of vinegar, mustard, salt, pepper, sugar and paprika. Jefferson Bell wrote of Farmer's recipe that it "is evidence that she doesn't know a whole bookful [*sic*] about barbecued meat. She probably only called the dish barbecued ham for courtesy and she probably never went to a real barbecue."[100] In 1929, columnist Bridges Smith observed, "there is a vast difference in barbecue" pig and baked pig. He then went on to extol the virtues of a pig that has "been simmering and leaking its grease over a bed of hickory coals the night before and basted every few minutes with a swab soused in a tin bucket of sauce of salt, pepper, vinegar and Worcestershire, that permeates every fibre of the martyred porker of thirty pounds."[101]

By the turn of the twentieth century, the popularity of kitchen barbecue had begun to grow. Even Georgians had warmed up to the idea by 1936. Columnist Eugene Anderson wrote of Georgians that they would buy it even if it were nothing more than roast pork topped with pepper vinegar "if it is labeled barbecue."[102]

By the 1930s, kitchen barbecue recipes were showing up in newspapers all over the country, and no sacred barbecue tradition was immune from imitation in the home kitchen. In a 1931 article entitled "How to Serve

Barbecued Dishes," we find kitchen barbecue recipes for chicken, pork, mutton, squirrel, rabbit and Brunswick stew.[103] Although kitchen barbecue may not be "real" barbecue, it is real American barbecue and it goes back in the history of the United States for hundreds of years.

Recognizing the differences in barbecue styles and their origins helps to explain the diversity in the American barbecue mosaic. Californians may want to use a western barbecuing technique to cook bull's head barbecue, or Georgians may want to use a southern barbecuing technique to cook pork shoulder. As California barbecue has a very different heritage and path of development than Georgia barbecue, one should expect them to be different. Both are American barbecue styles, and as quoted by Cheryl Alters Jamison and Bill Jamison, the editors of *Sunset Magazine* had it correct when they wrote that American barbecue is in fact "like that other American classic, Walt Whitman: it is large, it contains multitudes."[104]

"A VIRGINIA BARBECUE"

Ye who love good eating, just go to a 'Cue–
Ye'll find and enjoy it there, I warrant you.
Who ever went there and ne'er got enough?
Who ever went there and found the meat tough?
Who ever went there and came mad away?
Who ever went there, and kept steady all day?
Who ever went there, discontent of distrest–
Who ever went there with sorrow opprest–
Who ever went there deep in love or grief–
And did not immediately find some relief?
Enjoyment here presides as the host,
And he who's least welcome is welcome the most.
Freedom and Frolic here hold their domain,
And good sense and wit all folly restrain:
Here, age may be youth and live o'er its days,
Here, virtue is honored and wisdom finds praise,
Here, wealth and poverty, meekness and pride.
Commingle in one and sit side by side.
Formality here, and modish nonsense
Is held in contempt, and banished hence;

"REAL" AMERICAN BARBECUE

Contention and strife must here have an end
While each is a neighbor and each is a friend.
Republican plainness and candor preside,
And all kind of precedence here is denied.
Here sweethearts are toasted and sweet wives are lov'd;
Virtue commended and vice is reproved.
Ye ball-room revels and parties of Lou,
Give me the Barbecue—Devil take you.

Robert Francis Astrop, Original Poems, on a
Variety of Subjects, Etc. (1835)

CHAPTER 2
BARBECUE

A "VIRGINIAN WORD"

By some, this species of entertainment [the barbecue] *is thought to have originated in the West India Islands. However this may be, it is quite certain that it was first introduced into this country by the early settlers of Virginia; and though well known throughout all the Southern States, it is commonly looked upon as a "pleasant invention" of the Old Dominion.*
—*Charles Lanman, from* Haw-Ho-Noo: Or, Records of a Tourist *(1850)*

The word *barbecue* can be a complicated and confusing thing to understand. For example, in the United States, as demonstrated in the previous chapter, the definition of the word *barbecue* changes from region to region. When studying barbecue history, the confusion compounds because the word's definition has changed so much over the centuries. Furthermore, many today confuse the birthplace of the word *barbecue* with the birthplace of barbecue itself.

Sometime in the first half of the seventeenth century, English speakers converted the Spanish word *barbacoa* into the English word *barbecue*. The Spanish learned the word *barbacoa* in the late fifteenth century from the Taino Indians in what is today Haiti. It is at this point in popular accounts of barbecue history that the confusion over where barbecue was born begins. Because Europeans learned the word *barbacoa* from natives in Haiti, many come to the specious conclusion that Haiti must also be the birthplace of barbecue. That leads them to the next unfounded assumption, which is that people from the Caribbean introduced barbecue to the North American

colonies. From there, the tale leads to the Carolinas. Apparently, the theory includes the Carolinas simply because North Carolina barbecue receives a generous amount of publicity nowadays. This, in turn, results in the fallacy that people brought barbecue from the Caribbean to North America sometime in the seventeenth century first in the Carolinas. Later, the theory continues, people in what is today North Carolina transformed Caribbean barbecue into southern barbecue before spreading it throughout the South. Although there are several variations of this version of barbecue history, it is inaccurate and relies on assumptions that history doesn't support.

To illustrate the errors in this version of barbecue history, let's consider a version of it using maize in place of barbecue. After all, the history of maize in the United States is similar, in some respects, to the history of southern barbecue. Both *barbacoa* and *maize* were originally Taino words. Like barbacoa, Europeans first learned about maize from Taino Indians in the late fifteenth century. However, unlike barbecue, no one concludes that Haiti is the birthplace of maize. They also don't jump to the conclusion that people from the Caribbean brought maize to the North American colonies. This is because it is a well-known fact that in addition to the Tainos in Haiti, Native Americans all over the Americas had been cultivating corn for centuries before Europeans arrived in the New World.

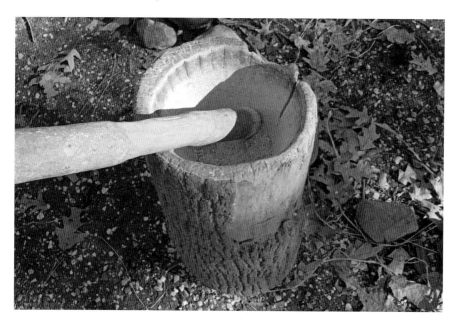

Wooden mortar and pestle used by Powhatan Indians to grind corn. *Jamestown-Yorktown Foundation, author's collection.*

As it is with maize, history is clear that Native Americans all over the Americas were preparing their styles of barbecue on wooden hurdles, or what the Tainos called barbacoa, long before the ancestors of the Taino Indians or Europeans first landed on the shores of Haiti. Further, for centuries Native Americans on the mainland American continents had access to large game animals that they could barbecue on hurdles. The Tainos in Haiti did not. Therefore, it makes no more sense to claim that Haiti is the birthplace of barbecue than it does to claim that Haiti is the birthplace of maize. Although we don't know when or where the basic barbecuing technique of slowly cooking meat on wooden hurdles was born, we do know where many of the various styles of barbecue first developed. The historical record informs us that Mexico is the birthplace of maize, Haiti is the birthplace of the Spanish word *barbacoa* and Virginia is the birthplace of southern barbecue. Caribbean-style barbecue is not the ancestor of southern barbecue at all because both barbecue styles developed independently and in different regions of the New World.

A summary of southern barbecue's origins that aligns with the historical record is as follows: The word *barbacoa* is the Spanish word from which we get the English word *barbecue*. Scholars trace the origin of the noun *barbacoa* back to the late fifteenth century when Spanish explorers were the first to witness Taino Indians in Haiti using wooden platforms made of sticks that they called "barrabakoa." In the early seventeenth century, English colonists in Virginia witnessed Powhatan Indians using wooden platforms made of sticks. Apparently unaware of the Spanish word *barbacoa* at the time, the English called the wooden Powhatan platforms "hurdles." What we call southern barbecue today was born when English colonists in Virginia combined their recipes for seasoning meat with the Powhatan technique of cooking meat on wooden hurdles set over a bed of hot coals. By the middle of the seventeenth century, Virginia colonists had adopted the noun *barbecue* from Barbados to refer to Powhatan hurdles similar to how they adopted the word *maize* from the Caribbean to refer to the "Indian corn" grown by Powhatan Indians. In the centuries that followed, millions of intrepid Virginians left the Old Dominion seeking new opportunities to the south and west and they took their barbecue tradition with them and shared it with others in the new regions wherein they settled. Therefore, the birthplace of southern barbecue is Virginia.

According to scholars, Virginia colonists were the first to import the word *barbecue* to North America. James Hammond Trumbull, a nineteenth-century American scholar and philologist, tells us that the word *barbecue* is a "Virginian word."[1] Another nineteenth-century writer stated, "A hog

barbecued is a West Indian and old Virginian term."[2] In the nineteenth century, Americans considered the phrase "a barbecue" to be "good old Virginia parlance."[3] Trumbull's assertion is rooted in the fact that the word *barbecue*, like so many other New World words, first came into the North American English colonies from the Caribbean through Virginia sometime in the early seventeenth century.

Englishman Edward Ward wrote in 1707 that barbecuing a pig is cooking "after the West Indian manner."[4] However, Ward was not being exhaustive in his description of *barbecuing*. Ward provided one piece of the puzzle and Trumbull provided another. People in both regions used the word to refer to their own ways of barbecuing meat.

After Virginia colonists started cooking meat with techniques learned from North American Indians, they imported the word *barbecue* to describe the cooking device. Later, colonial Virginians contributed to the confusing nature of the word *barbecue* by being be the first to use it as a noun, an adjective and a verb.[5] This evolution of the word *barbecue* in Virginia is why Trumbull wrote that *barbecue* is a "Virginian word."

Explorer John Smith wrote about the Powhatan Indian tribes he encountered in Virginia after arriving there in 1607. He mentioned a Powhatan Indian device that was a frame of sticks raised above the ground on posts with forked tops. He called the device a "hurdle." He described how Powhatan Indians used hurdles for drying fruit and nuts. He also described their beds, writing that they "lie on little hurdles of Reeds covered with a Mat borne from the ground a foote and more by a hurdle of wood."[6] In the late 1600s, the Anglican minister John Banister described the beds that Virginia's Indians used as "hurdles made of small reeds laid upon tressels, over which is spread a thin mat woven of single bull rushes."[7] The Virginia planter William Byrd also observed, "The Indians have no standing furniture in their cabins but hurdles to repose their persons upon, which they cover with mats and deer-skins."[8] Author Henry Forman described Powhatan beds, writing, "They were made by thrusting forked sticks into the ground, about a foot or two in height, to support a horizontal framework of small poles, tied to the saplings" that made up the frames of their houses.[9]

Native Americans also employed hurdles in burial rituals. The bodies of deceased Powhatan leaders were "dryed upon hurdles till they bee verie dry" in order to preserve the remains similar to the way Spanish conquistadors witnessed natives mummifying bodies in what is today Venezuela.[10] Powhatan Indians also constructed bridges that were made of hurdles. They pounded forked stakes into the mud with connecting poles lashed to them using

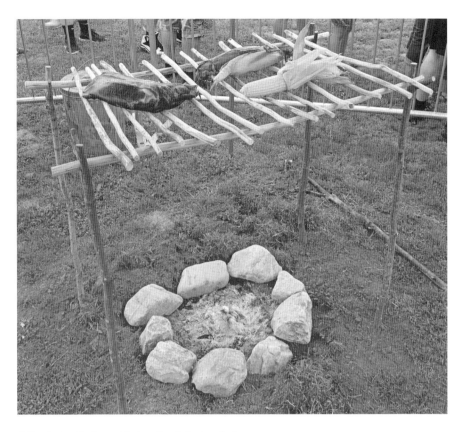

A Powhatan Indian–style hurdle. *Author's collection.*

"barkes of trees."[11] Englishman William Strachey described how the Powhatan Indians constructed a "high stage" raised above the ground "like a scaffold" with a mat hung above it for shade and shelter. He also described a "loft of hurdells" on which foods were laid to dry in order to preserve them.[12]

The noun *hurdle* derives from the old English word *hyrdel*, which means a "frame of intertwined twigs."[13] *Hurdle* is the earliest word used by English-speaking Virginia colonists to describe Powhatan Indian barbecue grills, beds, lofts, burial platforms, food dehydrators, shelters and bridges. In 1588, the English scholar Thomas Harriot described an illustration of eastern North American Indians drawn by John White around the year 1585: "After they have taken store of fish, they get them unto a place fit to dress it. There they stick up in the ground 4 stakes in a square room, and lay 4 sticks upon them, and others over crosswise the same like unto an hurdle, of sufficient

45

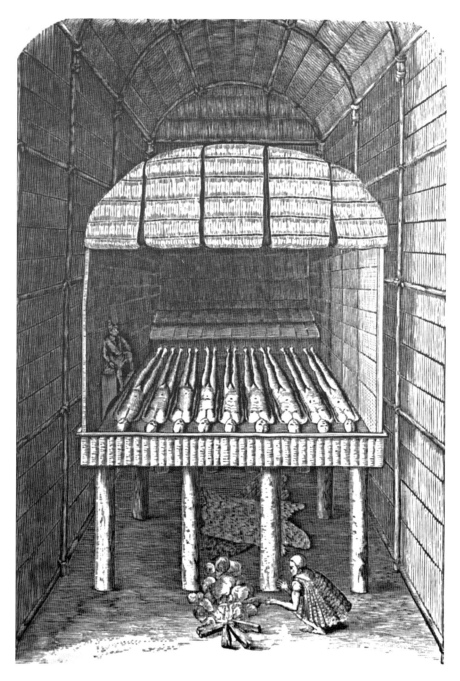

Native American "dead house." *From* First Annual Report of the Bureau of Ethnology to the Secretary of the Smithsonian Institution 1879–'80.

height, and laying their fish upon this hurdle, they make a fire underneath to broil the same."[14] Clearly, what the Spanish were calling a barbacoa, the English were calling a hurdle.

By the end of the sixteenth century, the English language was undergoing one of the most rapid periods of change in its history. The known world was growing larger as explorers returned to Europe with reports of newfound lands populated with "Indians." The newfound lands of the Americas presented a challenge for sixteenth- and seventeenth-century English speakers. With the New World came new things and new ideas that had no corresponding English words. The solution was simply to borrow words from the peoples of the New World.[15]

Common words that people in the United States use all the time such as *woodchuck*, *bayou*, *hickory*, *raccoon*, *opossum*, *persimmon*, *pone* and *squash* were borrowed from Native Americans, mostly from the Algonquian-speaking Indians of Virginia and the eastern seaboard.[16] If you ever visit counties and towns in the Tidewater region of Virginia, you will find overwhelming evidence that Algonquian-speaking Native Americans once ruled the region. In fact, there is probably no place in the United States today of an equal area where you can find as large a concentration of places still called by their Native American names.[17]

Even though the English colonists of Virginia lived side by side with the Algonquian-speaking Powhatan Indians, they didn't always adopt Powhatan or Algonquian words, especially if the Spanish had already popularized a New World word that they could use instead. The biggest proof of that is the use of the word *Indian* to refer to Native Americans. English colonists knew that North America wasn't a part of India. However, following the lead of the Spanish and Portuguese, they chose to call Native Americans who lived in Virginia "Indians."

Even though Powhatan Indians called their little boats "aquointan," the English chose to call them "canoes," which is an anglicized version of a Spanish word supposedly derived from the Taino word for boats.[18] The same is true of the word *apooke*, which is the Powhatan Indian word for a plant that they dried and smoked. However, the English chose to refer to it with the Spanish word borrowed from the Tainos: *tobacco*. The fact that the borrowed words originated in the Caribbean does not mean that those things to which the borrowed words refer also originated there.

According to scholars, the word *barbecue* is an anglicized version of the Spanish word *barbacoa* found in the earliest Spanish accounts of the New World. The Spanish account of the New World most readily available to

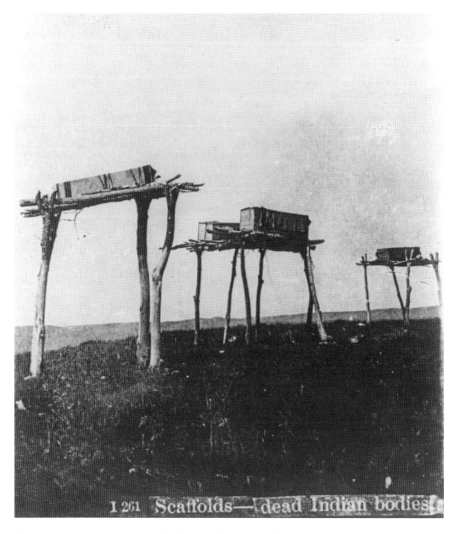

Native American mortuary made of "scaffolds," circa 1907. *Library of Congress, Prints and Photographs Division, LC-USZ62-57200.*

Englishmen in the 1500s and early 1600s was Peter Martyr's *Decades of the New World.*[19] In 1555, the English alchemist Richard Eden translated a portion of it into an English book entitled *The First Three English Books on America*. The word *barbacoa*, or any variation of it, never appears in that work. Instead, the words *hurdle* and *gridiron* appear when referring to the wooden frames used for preserving the bodies of deceased leaders in much the same way as Powhatan Indians dried the bodies of their dead leaders. Because there are no English writers who used an English version of the

word *barbacoa* in literature before 1648, it appears that most Englishmen in the first decade or so of the seventeenth century were unaware of the word *barbacoa* or an English word derived from it.

The Spanish word *barbacoa* first appeared in literature in the early 1500s in *A Natural History of the West Indies*, written by Gonzalo Fernando Oviedo y Valdés.[20] Later, other writers, including a Knight (or Gentleman) of Elvas and Luys Hernández de Biedma, wrote about Hernando de Soto's expedition through North America in 1539–42.[21]

Oviedo's writings focus on Cuba, Hispaniola (what is today the Dominican Republic and Haiti) and parts of Central and South America.[22] Elvas and De Biedma wrote about the parts of North America that include Florida, Georgia, the Carolinas, Virginia, Kentucky, Alabama, Mississippi and lands as far west as Texas. These early European accounts describe structures the writers called "scaffolds" and "hurdles," just like the Powhatan hurdles described by John Smith.

Smith informs us that Powhatan Indians used the word *tussan* (pronounced "too-sawn") to refer to hurdles used as beds. Strachey wrote that the Powhatan word *tussan* means "seat" and that the Powhatan word *cawwaiuwh* (pronounced "ke-why") means "bed." Powhatan Indians also referred to hurdles used as beds with the word *petaosawin* (pronounced "petō-saw-ween"). However, Virginia's colonists adopted none of those words. Our verb *barbecue* came from a Caribbean and South American Indian language noun, not a verb that originally referred to any kind of cooking. Just as the noun *rain* gave us the verb *raining*, so the noun *barbecue* gave us the verb *barbecuing*.[23]

In addition to Powhatans, Native Americans all over the Americas used hurdles for beds, storing provisions and for preserving the dried bodies of the dead. Some writers claimed that natives in the parts of the New World dominated by the Spanish called their houses, bridges and the platforms they sat on while guarding crops "barbacoa."[24] In his 1695 account of Native Americans in Florida, Gabriel Díaz Vara Calderón, the bishop of Cuba, wrote, "They sleep on the ground, and in their houses only on a frame made of reed bars, which they call barbacoa."[25] It's easy to see that the word *barbacoa* in sixteenth- and seventeenth-century accounts of Native Americans is a noun that refers to devices made of wooden frames with many different uses.[26]

The most widely accepted etymology of the English word *barbecue* comes from the English anthropologist Edward Tylor. In 1865, Tylor explained how the word *barbecue* derived from the word *barbacoa*, writing, "The Haitian name for a framework of sticks set upon posts, barbacoa, was adopted

Interior of a Powhatan house depicting the *tussan* covered with skins. *Jamestown-Yorktown Foundation, author's collection.*

into Spanish and English."[27] *A New English Dictionary on Historical Principles*, which was the original edition of the *Oxford English Dictionary* (*OED*), first popularized Tylor's claim.[28]

There are those who dispute the claim that the word *barbacoa* is a Haitian word. Tylor's citations in support of his claim refer us to the Swiss naturalist Johann Jakob von Tschudi and the English buccaneer William Dampier. However, neither of them wrote about people in Haiti.[29] The sixteenth-century German conquistador Nikolaus Federmann used the word *barbacoas* in the context of people who lived in what is now Colombia.[30] Other sixteenth-century writers used the word *barbacoa* when referring to hurdles used by people who lived in North America and Panama.[31] Moreover, Swedish anthropologist Sven Lovén asserted, "Spanish sources certainly do not mention the barbacoa as the gridiron of the Tainos."[32] This highlights the fact that Oviedo never claimed that the word *barbacoa* was a Haitian word, nor did he confine its meaning to only a cooking device.[33] In 1891, Walter Skeat, the preeminent English philologist of his day, suggested an authoritative source for the claim that *barbacoa* is a Haitian word by offering a Spanish dictionary and the glossarial index to Oviedo. However, even Skeat points out that the glossarial index to Oviedo is "not very accurately compiled, and [is] without references."[34]

Edward Tylor, 1917. *From* Folk-Lore *28 (March 1917)*.

Twenty-nine years before Tylor made his claim and fifty-five years before Skeat offered his sources, the word *barbacoa* had already been determined to be from the Arawak language of the Tainos in Haiti. The first authoritative source on the subject (that Tylor didn't mention) was Constantine S. Rafinesque's 1836 work *The American Nations, or, Outlines of Their General History, Ancient and Modern.* In it, Rafinesque argued that the word *barbacoa* is the Haitian word for bed.[35] Perhaps Tylor didn't like Rafinesque's definition of the word *barbacoa.* Perhaps, just as Daniel Brinton, a prominent nineteenth-century American archaeologist and ethnologist, he may have dismissed his work even though he and Brinton came to the same conclusion as Rafinesque that *barbacoa* is a Haitian word.[36] At any rate, the fact that the

Spanish made Haiti their headquarters in the New World also supports the claim that the word *barbacoa* is a Haitian word, and therefore, they must have learned the word while living among the Tainos before spreading it throughout the Americas.[37] This makes it likely that Native Americans in other parts of the New World, such as Mexico and parts of North America, learned the word *barbacoa* from the Spanish or Portuguese.[38]

French linguist Raymond Breton wrote in the 1600s that Island-Caribs, one of the Taino Indians' neighboring tribes, cooked on wooden grills set on "four forked sticks" that they called "aribel."[39] This indicates that different Caribbean tribes had different words for hurdles. It may also imply that the various uses of the device determined the word that referred to it. The point is, don't read too much into how widespread the word *barbacoa* may have been among Native Americans before contact with Europeans. The evidence implies that not only did colonial Virginians adopt a version of the Haitian word *barbacoa* to refer to their barbecue grills, but so did many Native American tribes who lived outside the Caribbean, learning it either from colonists or from Arawakan-speaking Native Americans who may have wandered to North American shores in canoes. However, the Native Americans who adopted the word *barbacoa* were using hurdles long before adding a version of the word to their vocabularies.

In addition to the Taino Indians, Brinton also associated most of the people who lived in the areas known today as northern South America, the Bahamas and the Greater and Lesser Antilles with the Arawak

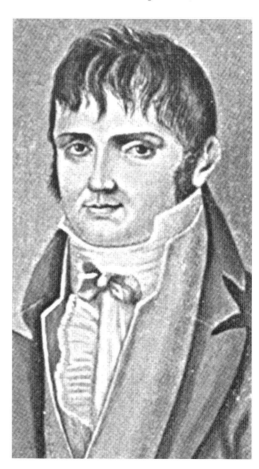

Constantine S. Rafinesque. *From* Analyse de la Nature *by C.S. Rafinesque, 1815.*

stock of languages. In 1870, Brinton claimed that the word *barbacoa* refers to "a loft for drying maize" and comes from the Arawakan word *barrabakoa*, which means "a place for storing provisions."[40] Although they offer different definitions, both Brinton and Rafinesque are correct because colonial-era writers often referred to storage devices and beds as hurdles, barbacoas and barbecues.[41]

Ultimately, Tylor's definition of the word *barbacoa* as "a framework of sticks set upon posts" is correct. The key point in all of this is the fact that devices called hurdles, barbacoas, boucans, berbekots, tussan, aribel and so on were simply frameworks of sticks set on posts, regardless of their purpose.

In addition to the English, Portuguese and Spanish, the French and Dutch also encountered Native Americans who used hurdles. In 1578, the French explorer Jean de Léry wrote about how the natives of South America built hurdles that they called "boucan." He described how they would make a "big wooden grill" using four forked branches about the size of a man's arm. They would thrust the supporting poles with forked tops into the ground, making four corners about four feet wide and two and a half feet high. They placed sticks on the forks horizontal with the ground, which created the platform on which more sticks were laid at intervals of about every inch. They used the wooden grills to cook meat or to dry foods in order to preserve them.[42] In his 1666 "A Caribbian Vocabulary," the French pastor Charles de Rochefort wrote, "The wooden frame which serves for a gridiron, and is by other Savages called Boucan, Youla."[43] The word *boucan* gave us the French word *boucaner*, which means "to dry red without salt," and our English word *buccaneer*, which refers to people who made their living by selling smoke-dried meat called boucan.[44]

In the 1670s, Dutch explorers observed South American natives cooking on hurdles. The English translation of one Dutch passage describes how they placed meat "on a berbekot," which is an "Indian grid consisting of small wooden sticks measuring 2 feet high."[45] What the Dutch heard as "berbekot," the British heard as "babracot."[46]

Some have rejected the claim that the word *barbecue* derives from the word *barbacoa* and have developed alternative theories that try to explain the origin of the word *barbecue* based on how it sounds when spoken. The *Westminster Review* suggested an often-repeated theory of this kind at least as far back as 1829.[47] The claim is that the French phrase *barbe à queue*, or "beard to tail," is the origin of the word *barbecue* simply because when you say *barbe à queue*, it sounds similar to the English word *barbeque*.[48] The *OED* rejects this claim as false. Another similar theory comes from a translation of the Taino "word" *barabicu*. Proponents of this theory claim that *barabicu* literally means "the

beginning of the sacred fire father" or "sacred fire pit."[49] However, syllables from words in a sentence comprise the "word" *barabicu* rather than it being a single Taino word.

Yet another incorrect theory traces the origin of the word *barbacoa* to the word *barbados*. Because natives in Barbados supposedly used the wood from fig trees that the Portuguese called "los barbados" to make grills for cooking, the assumption is made that the word *barbacoa* is a corruption of the word *barbados*.[50]

Of course, the fallacy with these and many other theories for the origin of the words *barbacoa* and *barbecue* is the mistake of trying to trace their origin back to something specifically related to fire and cooking. Such theories ignore the fact that the words *barbacoa* and *barbecue* used in sixteenth- and seventeenth-century literature were nouns used to refer to platforms, tables, beds, bridges, houses, corncribs and grills used for preparing foods. They often had no whole animal carcasses, as in "beard to tail," or fires involved in their use at all.[51] For example, in 1699, Welsh explorer Lionel Wafer described a barbecue as being a "Grate of Sticks made like a Grid-iron." He recorded how Native Americans in what is today Panama and Colombia made dinner tables by constructing "a great Barbecue, ten, twelve, or twenty Foot long, or more, as the Company is, and broad proportionally: They spread on it three of four Breadths of Plantain-leaves for a Table-Cloath."[52] Moreover, Jamaicans dried coffee and pimento on barbecues, which were often nothing more than flat, concrete or stone floors.[53] Author Annie Brassey wrote in 1886, "A barbecue is the name given, in Jamaica, to the house which contains the threshing-floor and apparatus for drying coffee."[54] Therefore, theories about the origin of the word *barbecue* that rely on fire, cooking or whole animal carcasses are incorrect.

THE FIRST USE OF THE WORD BARBECUE IN ENGLISH LITERATURE

In his 1609 translation of accounts of Spanish activities in the Americas, English author Richard Hakluyt was the first to use the word *barbacoa* in English literature. Hakluyt's translation includes the passage, "[A]nother got up with a lance to a loft made of canes, which they built to keepe their maiz in, which they call barbacoa." Another passage was translated as, "[T]hey have barbacoas wherein they keepe their maiz; which is an house set up in the aire upon foure stakes, boorded about like a chamber, and the floore of it is of cane hurdles."[55] The fact that Hakluyt didn't translate the word *barbacoa*

into an English word is proof that there was no corresponding English word available in 1609. Notice also that no one used Hakluyt's barbacoas for cooking. Another passage was translated as, "Ucita [the chief] commanded to bind John Ortiz hand and foote upon foure stakes aloft upon a raft, and to make a fire under him, that there he might bee burned."[56] Clearly, the "raft" referred to in the passage was a wooden barbecue grill, complete with the burning coals underneath, but Hakluyt didn't use the word *barbacoa* or *barbecue* to refer to it.

Often, people cite the *OED* in order to establish the first time a version of the English word *barbecue* appeared in English literature. According to the often-repeated telling of barbecue history, an English form of the word *barbecue*, not copied from Spanish or Portuguese sources, first shows up in English literature in 1661. English Chaplain Edmund Hickeringill wrote in *Jamaica Viewed*, "But usually their Slaves, when captive ta'ne, Are to the English sold; and some are slain, And their Flesh forthwith Barbacu'd and eat."[57] Hickeringill's passage shows that by 1661, the word *barbacoa* had entered the English language in its anglicized form, *barbecue*. The word had also undergone a functional shift, which means that it was now a verb in addition to a noun. We also see this in a graphic 1665 account from Guyana: "His naked carkase was ordered to be dragged from the Gaol [jail] by the common hangman…where a Barbacue was erected—where he was dry barbicued [*sic*] or dry roasted after the Indian manner."[58]

In spite of the claims made by the *OED*, two variations of the English word *barbecue* appeared in literature at least three times before 1661. The first time a form of the word *barbecue* was used in English literature—meaning not a rewriting or translation of non-English writings—was a whopping thirteen years earlier than 1661, and it was used as a verb. It is in a 1648 journal written about the Province of New Albion, which was located in what was then "North Virginia," entitled *A Description of the Province of New Albion*, authored by Beauchamp Plantagenet.[59] Plantagenet described how Indians, who lived around the Chesapeake Bay, preserved fish, writing, "The Indians instead of salt doe barbecado or dry and smoak fish."[60] Plantagenet's verb *barbecado* appears to be a mix of Hakluyt's transliterated word *barbacoa* and the English word *carbonado*, possibly forming a link between the words *barbacoa*, *carbonado* and *barbecue*.

During the winter of 1609–10, Jamestown colonists suffered "the Starving Time" during which they were so desperate for food that they resorted to cannibalism. John Smith callously wrote about a man who resorted to eating his dead wife's body, "[N]ow whether shee was better roasted,

A TRUE & EXACT

HISTORY

Of the Ifland of

BARBADOES.

Illuftrated with a Map of the Ifland, as alfo the Principal Trees and Plants there, fet forth in their due Proportions and Shapes, drawn out by their feveral and refpective Scales.

Together with the Ingenio that makes the Sugar, with the Plots of the feveral Houfes, Rooms, and other places, that are ufed in the whole procefs of Sugar-making; *viz.* the Grinding-room, the Boyling-room, the Filling-room, the Curing-houfe, Still-houfe, and Furnaces; All cut in Copper.

By *RICHARD LIGON*, Gent.

LONDON,

Printed, and are to be fold by *Peter Parker*, at his Shop at the *Leg* and *Star* over againft the *Royal Exchange*, and *Thomas Guy* at the corner Shop of *Little Lumbard-ftreet* and *Cornhill*, 1673.

Cover page from the 1673 edition of Richard Ligon's *A True & Exact History of the Island of Barbedoes*. Smithsonian Libraries.

boyled or carbonado'd, I know not, but of such a dish as powdered [salted] wife I never heard of."[61] Crassness aside, Smith mentioned three different cooking techniques in a single sentence: roasting, boiling and carbonadoing. Carbonadoing is what we would call grilling today. The verb *carbonadoing* comes from the English noun *carbonado*, just as the English verb *barbecuing* comes from the English noun *barbecue*. Because of the similarities between carbonadoing and barbecuing, it shouldn't be surprising that English speakers in the colonies would look to it as a way to understand the Indian technique of drying and cooking meat on a hurdle. This, it appears, gave us the first English version of the word *barbecue* in literature.

The first appearance of the actual English word *barbecue* and the first use of it as a noun in English literature appear in a book published in 1657 by the Barbados planter Richard Ligon entitled *A True and Exact History of the Island of Barbadoes*. Ligon wrote, "The place where they unload, is a little platform of ground, which is contiguous to the Mill-house, which they call a barbycu; about 30 foot long and 10 foot broad; done about with a double rayle [rail] to keep the Canes from falling out of that room."[62]

Ligon's "barbycu" was a flat "platform of ground" used to store sugar cane. The third time a version of the word *barbecue* appears in English literature, and the second time as a noun, is also in Ligon's work, where he wrote, "[B]eing laid on the barbycu, we work them out clean, and leave none to grow stale." Ligon's "barbycu" is a storage device similar to the platforms covered with mats used by Powhatan Indians, Hakluyt's corncribs called "barbacoa" and the Jamaican barbecues that were used to dry coffee.[63]

How *Barbecue* Became a Virginian Word

Based on culinary historian Karen Hess's law of culinary history, which holds that print always lags behind practice, it is clear that the words *barbecado* and *barbycu* were in use for some time before the 1650s. Ligon lived in Barbados in the 1640s and heard the word *barbycu* at that time. The word could have been in use for several decades before Ligon wrote it down. Clearly, English speakers adopted the word *barbecue* much earlier than the *OED* documents.[64]

The colony in Barbados was established in 1627, and like Virginia, it adopted the headright system. However, unlike Virginia, the first group of settlers in Barbados brought enslaved people (African and Native American) with them to the island.[65] As a result, many of the first enslaved people of

African descent to reach Virginia came from Barbados. Therefore, it is possible that enslaved people and indentured servants brought the word *barbecue* to the Virginia colony.

Because Barbados is an island, there was little opportunity for people there to start their own plantations after their indenture ended. Virginia, on the other hand, had a seemingly infinite source of land. Therefore, when servants in Barbados obtained their freedom, they frequently came to Virginia.[66] Because many indentures lasted from four to seven years, English speakers from Barbados who were familiar with the noun *barbycu* could have brought the word with them to Virginia as early as the 1630s.

Besides formerly indentured people, wealthy people came to Virginia from Barbados, often bringing enslaved and indentured servants with them. For example, William Eale signed a four-year indenture to serve Barbadian merchant John Lownes. Arriving in Barbados in 1648, Eale served there until he moved with Lownes from Barbados to Lower Norfolk, Virginia, sometime before the end of 1651. It is likely that this kind of migration from Barbados to Virginia was common, and as the Barbadians came to Virginia, they brought the noun *barbycu* with them.[67]

Interestingly, in 1705, Beverly claimed that Indians gave American colonists the verb *barbecuing*, writing, "This they, and we also from them, call Barbacueing."[68] Most scholars dismiss Beverly's claim, apparently assuming that Beverly was referring to the Algonquian-speaking Indians of Virginia and North Carolina, and point out that *barbecue* is not an Algonquian word.[69] However, Beverly, it appears, just saw "Indians" in general regardless of the language they spoke. Therefore, Beverly was correct in saying that the English word *barbecue*, or *barbecuing*, came from "them" because the Indian word from which the word *barbecue* derives was, as best as can be determined, originally used by Native Americans in South America and Haiti to refer to hurdles.

There are also other possibilities to explain Beverly's claim. Gabriel Díaz Vara Calderón's 1695 account of Indians in Florida informs us that they called their beds made of hurdles "barbacoa." In 1751–62, French explorer Jean-Bernard Bossu explored areas around the Mississippi River. Bossu reported that he heard Native Americans using the word *barboka* to refer to events during which they barbecued whole animals in exactly the same way Virginia colonists used the word *barbecue*.[70] In 1937, Bossu's account prompted Dr. J.M. Carriére, a leading authority on the French in the New World, to conjecture that the word *barbecue* didn't come from the Spanish *barbacoa* but instead derived from the North American Indian word *barboka*. However, because the word *barbecue* was in use in the American colonies

before that time to refer to barbecued food and social events, Indians may have learned it from traders and settlers who moved westward from Virginia and other eastern colonies.[71] There is also the possibility that enslaved Native Americans from the region around Florida and from the Caribbean, who may had already been using the word *barbacoa* or *barbecue*, brought the word to Virginia.

THE WORD *BARBECUE* THROUGH THE CENTURIES

The word *barbecue* has always had many meanings and many spellings, and it seems that Americans have never agreed on the proper spelling of the word regardless of what the dictionary specifies. The many ways Americans use the word has even caused at least one dispute that required litigation. In a 1965 lawsuit, it was stated, "Some of the difficulty in this case arises from the fact that the word 'barbecue' can be used as a noun, as a verb or as an adjective."[72]

As far as the written record tells us, Virginians first called the device we call a barbecue by the nouns *tussan*, *petaosawin*, *scaffold*, *stage* and *hurdle*. At some point, they adopted the verb *barbecado* and imported the noun *barbycu* from Barbados. By the mid-1600s, Virginians were using the verb *barbicued* and naming swamps and sections of rivers "Barbicue."[73] In 1675, Humphrey Griffin had 750 acres near "Barbicue Swamp." In 1695, Thomas Norfleet Jr. took ownership of 130 acres near "Barbicue Swamp" located in what is today Suffolk, Virginia.[74] In a 1723 will, Francis Williamson of Isle of Wight, Virginia, left to his son, Arthur, land on the west side of "Barbycue Branch."[75] The British playwright Aphra Behn published a play about Bacon's Rebellion in 1690 entitled *The Widdow Ranter*.[76] Bacon's Rebellion occurred in Virginia around the year 1676. The line "Let's barbicu this fat rogue!" is portrayed as being yelled by someone in a mob. Although published in 1690, it is clear that the author and those who watched the play and read the published version understood that the word *barbicu* was in use as a verb in Virginia at the time of Bacon's Rebellion in 1676.

By 1687, Virginians had added another variation of the word: *barbecuted*.[77] This may be a variation of the Guyana Indian word for barbecue, *barbacot*.[78] The words *barbacute* and *barbecuted* remained in use for a long time. They show up first in 1687 Virginia, in 1743 as a "[b]arbacute pig to be broiled," in 1919 as "barbecuted meat," in 1938 as "dining outdoors

on barbecuted pig," in 1947 as a "barbecuted chicken dinner" and in 1949 as "barbecuted bear."[79]

By the end of the seventeenth century, people in the American colonies had developed their own definitions for the word *barbecue*. Even Native Americans in North America had adopted the word from Spanish and English colonists by that time. By 1709, English colonists in North America were using the word *barbecue* to refer to barbecued meat. The English explorer John Lawson described "barbakues," writing, "The Fire was surrounded with Roast-meat, or Barbakues, and the Pots continually boiling full of Meat, from Morning till Night."[80] In 1733, the word *barbacue* first appeared in literature as a reference to an event where barbecue was cooked.[81]

When it comes to spelling variations, the English word *barbecue* has to be in the running for setting a record. The correct spelling of the word *barbecue* goes back to 1672 from *The Discoveries of John Lederer*.[82] In 1699, William Dampier used two different spellings in the same book. He spelled the word as "borbecu's" in one passage and "barbecu" in another, and both refer to chairs and beds made of hurdles, not barbecue grills.[83] In 1755, Samuel Johnson spelled the word as "barbecue" in the first modern English dictionary. Nevertheless, to this day, the word still has myriad other popular spellings and contractions.[84] For example, at the turn of the twentieth century, some were advertising Virginia barbecue events by simply calling them "cues."[85]

Virginia chicken "Bar-B-Q." *Author's collection.*

In the year 1900, many people attended "the Democratic barbecue at Macon" and wrote to the local newspaper about it. A columnist marveled at the "remarkable" number of spellings used for the word *barbecue*, including "bober-q," "barbcue," "barbyku," "barbakue," "barberque" and "bobbykue."[86] Even though Georgians had some inventive ways of spelling the word *barbecue*, when the spelling "Bar-B-Q" began showing up on signs there in front of barbecue stands after World War II, it caused no small stir. In Atlanta, there was an organization devoted to boycotting any roadside stand that displayed a sign with "BAR-B-Q" printed on it. It claimed that such a sign means the place is offering nothing more than underdone pork roast slathered with an unpleasant-tasting hot and bitter sauce. One member of the organization could hardly control his emotion when he described one roadside stand's sign with hand-painted images on it; first was a drawing of an iron bar, next was a drawing of a honeybee and the last was a picture of a billiard cue.[87]

The spelling "Bar-B-Q," referring to food rather than the cattle branding iron used by a ranch in Texas, shows up in newspapers first around 1898. The Chicago planners of a "Jubilee Barbecue" apparently ran out of planning time for the event, so they canceled it.[88] This prompted a writer for the *Chicago Tribune* to sarcastically write, "Whatever is done ought to be done p. d. bar b. q."[89] The message deciphered is "pretty darned bar-b-quick," which is obviously a play on the word *barbecue*. Writers at the *Chicago Tribune* seemed to enjoy making plays on the word *barbecue*. In 1892, the newspaper printed, "A New York man who had never seen a barbecue went all the way to Kentucky to attend one. He must have had a great deal of barbecuriosity."[90]

By 1902, the use of the spelling "Bar-B-Q," to the dismay of many Georgians, was well underway.[91] By 1929, the spelling "Bar B-Q" (missing a dash as in previous versions) shows up in newspapers.[92] In 1934, another contraction shows up in a newspaper advertisement for "La Bounty's B'B'Q."[93]

The contraction "BBQ" shows up by 1934 in an advertisement for "Free BBQ to Everyone," which was apparently devised in order to reduce the number of letters required in newspaper advertisements.[94] One such advertisement from a 1950 newspaper tells of a house equipped with a "BBQ FIREPLACE."[95] In the 1940s, the strange spelling "barber-qu" was printed, but thankfully, it was abandoned.[96] Some today also use the spelling "B-B-Q."

Louis Armstrong recorded the song "Struttin' with Some Barbecue" in 1927 wherein he uses the word *barbecue* as a slang word.[97] In the 1930s, Cab Calloway included the word *barbecue* in *The Hepster's Dictionary*, with

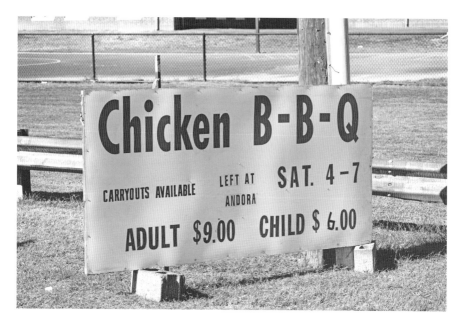

Virginia "B-B-Q." *Author's collection.*

the definition of "the girl friend, a beauty."[98] However, the first use of the word *barbecue* as slang occurred in Virginia from as far back as 1833, and it meant the same thing in 1833 as it did in 1933. In 1833, one fellow wrote of a beautiful woman that she was "the belle of Williamsburg, the toast of Norfolk, and the barbacue [*sic*] of all that part of Virginia."[99]

THE WORD *BARBECUE* THROUGH THE CENTURIES

Spelling	Usage	Year	Source
barbecado	verb	1648	Plantagenet, Beauchamp. *A Description of the Province of New Albion.* London, 1648. First Hand Accounts of Virginia, Virtual Jamestown, Virginia Center for Digital History, University of Virginia.
barbycu	noun	1657	Ligon, Richard. *A True and Exact History of the Island of Barbadoes.* Reprint, London: Parker, 1673. Originally printed in 1657.

BARBECUE

Spelling	Usage	Year	Source
barbacu'd	verb	1661	Hickeringill, Edmund. *Jamaica Viewed.* London: printed for John Williams at the Crown in St. Paul's Church-yard, 1661.
barbicued	verb	1665	Rodway, James, and Thomas Watt. *Chronological History of the Discovery and Settlement of Guiana.* Georgetown, Demerara: "Royal Gazette" Office, 1888.
barbecue	verb	1672	Lederer, John, and William Talbot. *The Discoveries of John Lederer.* Charleston, SC: Walker, Evans & Cogswell Company, 1891. Originally printed in 1672.
barbaque	noun	1687	Taylor, John. *Jamaica in 1687: The Taylor Manuscript at the National Library of Jamaica.* Edited by David Buisseret. Kingston, JM: University of West Indies Press, 2010.
barbecuted	verb	1687	Clayton, John. "A Letter from the Revd Mr. John Clayton, to Dr. Grew, in Answer to Several Queries Relating to Virginia." *Philosophical Transactions* 41 (1753): 143–62.
borbecu; barbecu	noun	1699	Dampier, William. *A New Voyage Round the World.* Vol. 1. London: Knapton, 1699.
barbecue; barbecuing	noun; verb	1699	Wafer, Lionel, and Edward Davis. *A New Voyage and Description of the Isthmus of America.* 2nd ed. London: printed for James Knapton, 1704.
barbikew'd	verb	1702	Mather, Cotton. *Magnalia Christi Americana, Or, The Ecclesiastical History of New-England from Its First Planting in the Year 1620, Unto the Year of Our Lord, 1698.* London: printed for T. Parkhurst, 1702.
barbacueing	verb	1705	Beverly, Robert. "The History and Present State of Virginia— Robert Beverley, Ca. 1673–1722." Documenting the American South.
barbikewing	verb	1715	Wodrow, Robert. *The Correspondence of the Rev. Robert Wodrow.* Vol. 2. Edinburgh: Wodrow Society, 1843.
barbycue	noun	1723	*Sons of the Revolution in State of Virginia Semi-annual Magazine* 5–7 (1927).

Spelling	Usage	Year	Source
barbygu'd	verb	1726	Mist's Journal, February 9, 1726. From Larwood, Jacob, and John Camden Hotten. "Miscellaneous Signs." *The History of Signboards, from the Earliest Times to the Present Day. With One Hundred Illustrations in Facsimile by J. Larwood.* London: John Camden Hotten, Piccadilly, 1867.
barbecu; barbecu'd	verb	1732	Brickell, John. *The Natural History of North-Carolina.* Raleigh, NC: reprinted by Authority of the Trustees of the Public Libraries, 1911. Originally printed in 1732.; Burney, James. *History of the Buccaneers of America.* London: Printed by Luke Hansard & Sons, For Payne and Foss, Pall-Mall, 1816.; Pope, Alexander. *The Works of Alexander Pope Esq.* Edited by William Warburton. London: Printed for J. and P. Knapton, H. Lintot, J. and R. Tonson, and S. Draper, 1751.
barbeque	noun	1744	*Boston News-Letter*, October 18, 1744.
barbicu	noun	1764	Foote, Samuel. "Act I." *The Patron, a Comedy in Three Acts [and in Prose].* 2nd ed. London: printer for G. Kearsley, in Ludgate Street, 1764.
barbequi	noun	1788	Norris, J.E., ed. *History of the Lower Shenandoah Valley Counties of Frederick, Berkeley, Jefferson and Clarke.* N.p.: Warner & Company Pubishers, 1890.
barbique	noun	1817	Bradbury, John, and John Bywater. *Travels in the Interior of America, in the Years 1809, 1810, and 1811.* Liverpool: printed for the Author by Smith and Galway, 1817.
barbacot	verb	1832	Hilhouse, William. "Notices of the Indians Settled in the Interior of British Guiana." *Journal of the Royal Geographical Society* 2. (1832): 233, 239.

Spelling	Usage	Year	Source
babracot	noun	1883	Thurn, Everard Ferdinand. *Among the Indians of Guiana, Being Sketches Chiefly Anthropologic from the Interior of British Guiana.* London: Kegan Paul Trench & Company, 1883.
barber-qu	noun	1942	*Macon Telegraph,* "Barbecue of 1942 Loses Main Attraction—Crowd," July 25, 1942.

BARBECUING "IN THE INDIAN MANNER"

Their fish and flesh they boyle either very tenderly, or broyle it so long on hurdles over the fire; or else, after the Spanish fashion, putting it on a spit, they turne first the one side, then the other, til it be as drie as their jerkin beefe in the west Indies, that they may keepe it a month or more without putrifying.
—John Smith's account of Powhatan Indians in the early 1600s

There are several theories to explain how the Americas were first populated. However, many scholars assert that the first Native American ancestors arrived in North America around 15,500 years ago. By 12,000 years ago, they had spread all the way to North America's east coast, including the area that is today Virginia.[1] Maize was first domesticated about 10,000 years ago in what today is the Tehuacán Valley in Mexico, and from there it spread over much of the American continents.[2]

The Taino Indian civilization in the Caribbean was a relative newcomer compared to other civilizations in the mainland American continents. Although some scholars assert that what is today Haiti was at least sparsely populated as long as 5,000 years ago, it wasn't until about 2,500 years ago that direct ancestors of the Taino Indians first paddled away from northeastern South America to settle on several Caribbean Islands, including the Dominican Republic and Haiti.[3] The Tainos brought canoes, tobacco, maize and the barbacoa with them to Haiti from the mainland continents.

The true origination place of the Native American hurdle—or barbacoa, aribel, tussan or whatever it was called by the many different tribes that

employed it—is somewhere in the mainland American continents, not the Caribbean. When sixteenth-century Spanish explorers witnessed the Taino Indians growing maize and tobacco and using the barbacoa, they were witnessing a small sample of ancient Native American practices that had existed all over the Americas for centuries before being practiced by the Tainos in Haiti.

The barbacoa is a Native American device, not merely a Taino Indian device. Although the words *barbacoa* and *barbecue* may have passed down to us from the Arawakan-speaking Tainos, Native Americans who lived on the mainland American continents gave the knowledge of the barbacoa to both the Taino in Haiti and colonists in Virginia. Virginia's Indians and their ancestors had been using wooden barbecue grills for centuries before the Tainos ever made their way to Haiti.

John Smith described three techniques employed by Powhatan Indians to prepare fish and meat: boiling, broiling and drying.[4] Boiling fish and meat in soups and stews was a practice shared by the English and the Powhatans.[5] So was at least one of the Virginia Indian techniques for roasting meat. For example, Colonel Henry Norwood arrived in Virginia in 1649. He described how Indians roasted venison in a way similar to Europeans.[6] However, although Europeans were familiar with dried foods, the Native American way of preparing foods on a "hurdle" was not familiar to them, apparently, and many felt the need to describe it to readers back in Europe.

In contrast to the early English colonists in Virginia, who preserved fish and meat with salt or vinegar, Powhatan Indians didn't have large quantities of salt required to do so. Eighteenth-century historian Robert Beverly wrote that they have "no Salt among them, but for seasoning, use the Ashes of Hiccory [hickory], Stickweed, or some other Wood or Plant, affording a Salt ash."[7] Native Americans in what is today Brazil made salt in much the same way.[8] Therefore, rather than using salt, Native Americans all over the New World preserved foods by drying them in the air often employing smoke in the process.[9]

Europeans who visited the New World in the sixteenth and seventeenth centuries struggled to find adequate words to describe the way that Indians dried meat on hurdles, often using the words *cooking*, *broiling* or *roasting*. For this reason, we must take care when reading colonial-era accounts of Native American cookery. The words *cooking*, *broiling* and *roasting* do not always accurately describe what was actually happening. Therefore, the context in which the words appear is important when interpreting old accounts of Native American cookery.

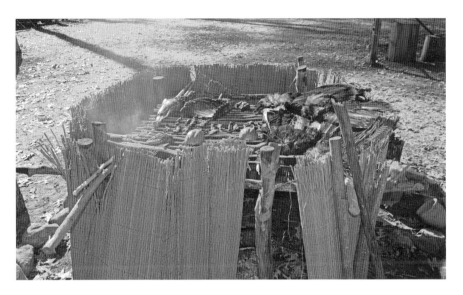

Powhatan Indian–style hurdle. *Jamestown-Yorktown Foundation.*

John Smith wrote that Virginia's Indians "roast their fish and flesh upon hurdles as before is expressed, and keep it till scarce times." Although Smith used the word *roast*, what he actually described in this particular account was a food preservation technique that allowed Powhatans to store meat and fish "till scarce times."

Groping for words, Louis Hennepin, a French missionary who explored the Mississippi River in 1673, described how Native Americans dried bison meat "in the Sun, or broil upon Gridirons. They have no Salt, and yet they prepare their Flesh so well, that it keeps above four Months without breeding Corruption; and it looks then so fresh, that one wou'd think it is newly kill'd." The best words Hennepin had to describe what he saw was *gridirons* and *broil*. In another passage, he wrote, "We never eat but once a few Scraps of Meat dry'd in Smoak after their Fashion."[10] A careful reading of the following seventeenth-century French account of Caribbean Indians leaves no doubt that they were preserving fish rather than barbecuing them as we do today:

> *They so patiently endure hunger, that after they are returned from fishing they will have the patience to broil their fish over a soft fire on a wooden frame made like a gridiron, about two foot high, under which they kindle so small a fire, that sometimes it requires a whole day to make ready their fish as they would have it…It is observable generally in all their meat, that they dress all with a very gentle fire.*[11]

Some have commented that this is an account of "low and slow" cooking comparing what the writer was describing to the way we cook southern barbecue today. However, it is actually a description of a fish preservation technique using a hurdle set over smoky coals. The Caribbean Indians knew that fish spoil quickly. Therefore, they immediately started the preservation process even though they may have been tired after a day of fishing.

A 1556 account of Native Americans drying meat describes it as "a way of roasting unknown to us."[12] Martyr wrote in one of his sixteenth-century accounts of Native Americans in the Caribbean, "When asked why they cooked the fish they were to carry to their cacique [chief], they replied that they did so to preserve it from corruption."[13] Obviously, the fish were being preserved rather than merely being cooked. We see the same thing in 1547, when explorer Hans Staden used the word *cook* to describe how Native Americans in what is today Brazil prepared food. Staden wrote, "When they want to cook any food, flesh or fish, which is to last some time, they put it four spans high above the fire-place, upon rafters, and make a moderate fire underneath, leaving it in such a manner to roast and smoke, until it becomes quite dry. When they afterward would eat thereof, they boil it up again and eat it, and such meat they call Mockaein."[14] The Native American process of drying meat for preservation purposes witnessed by Europeans isn't necessarily a cooking, roasting or broiling technique at all.[15] The process simply called for a hurdle, sunshine and air to dry the meat and, sometimes, smoke to ward off insects.

JERKY AND INDIAN BARBECUE

In addition to referring to it as roasted or broiled, English speakers eventually began referring to meat and fish dried on hurdles in the air or over smoky coals as being "jerked." John Smith first noticed the similarity when he compared the dried meat made by Powhatans to "jerkin beefe." The word *jerkin* is an anglicized version of the Peruvian words *ccharquini* and *charqui*, which refer to meat dried in the air.[16] To English speakers, "jerkin" or "jerky" is apparently easier to pronounce than "charqui."[17]

In 1778, a writer, using the penname "Agricola," proposed that the Continental army adopt the Indian method of preserving meat in lieu of the English method of salting it as a way to address the salt shortage brought on by the Revolutionary War. Agricola's proposal included detailed instructions on how to "jerk" pork and beef in order to preserve it.[18]

The first step in the process is to build a "stage." Others called it a hurdle, a barbecue or barbacoa. The second step is to spread live coals under the hurdle in order to produce smoke to repel insects with just enough heat to dry the meat, not cook it. Next, cut the meat into strips and hang it on the hurdle until "the pores are sufficiently stopped."

The last step in the process is to hang the meat "up in the smoke to dry through," which seems to imply the use of a smokehouse or simply the act of moving the meat farther away from the heat of the coals so that it can cure in the smoke. Due to moisture loss, the jerked meat weighed less than fresh. People could eat it as is, add it to soups or fry it after tenderizing it.

> The practice of jerking meat too, may be gone into with success. The mode of curing it in this way is easy and certain; in summer it may be dried in the sun, making a smoke to keep off the flies, but in winter it is done by fire. Erect a stage, large or small, according to the quantity you have to cure, about four feet from the ground, this you may do by planting posts with crotches in the earth, and laying poles or sticks across so as to admit the heat, and let them be so small, as not to cover too much of the surface of the meat; make your fire under this stage, so as to distribute the heat equally, and let it not be so great as to roast or broil, but gently to dry the flesh; and when the pores are sufficiently stopped, and both surfaces dry, hang it up in the smoke to dry through. The Hunters, and Indians, of choice take provisions of this kind with them, as the carriage is light, one pound being of equal nourishment with six pounds of salted meat. The meat intended to be jerked, must be boned and sliced, so as to extend as large a surface as possible, but not so as to render it too thin. It may be eaten without further process, or it may be soaked and boiled. When pounded in a mortar, or on a block, it is excellent, fried with butter, hogs lard, or fresh bear's oil. Were salt as plenty as land, I am of the opinion this meat would the best for some uses in our army.
>
> Agricola, Dunlap's Maryland Gazette, January 27, 1778

The next word used by English speakers to refer to dried foods was *barbecued*. For centuries, the words *jerked* and *barbecued* were interchangeable when used to refer to meat dried on hurdles using the Native American technique. Author E.W. Mellor wrote as late as 1906, "The name 'barbecue' is derived from the aboriginal Indian name for the places on which they dried fruit and fish and hogs. Hence we have the term 'barbecued pig' for dried pig."[19]

Even though Richard Ligon was the first to write the English noun *barbycu* in 1657, in the same book he was still referring to dried beef as "jerkin beef," just as John Smith did almost fifty years earlier. By the 1680s, in Jamaica dried meat continued to be called "jerk," even though they called the drying device a barbecue. For example, John Taylor described how Jamaicans preserved salted pork in the 1680s "with smoke they dry it on a barbaque." They wrapped the dried pork in cabbage so that it would "keep long" and called it "jerck't hog."[20]

The British physician Hans Sloane recorded how wild hogs in Jamaica were jerked in 1707, writing that they were "cut open, the Bones taken out, and the flesh is gash'd on the inside into the Skin, fill'd with Salt and expos'd to the Sun, which is call'd Jirking. It is so brought home to their Masters by the Hunters, and eats much as Bacon, if broil'd on Coals."[21] By 1699, William Dampier was using the words *barbecu* and *borbecu* to refer to beds and seats while in the same work describing pork that had been dried on a hurdle as having been "jerk'd."[22]

Accounts of Indian-style barbecue demonstrate the interchangeable nature of the words *jerked* and *barbecued*. Beverly wrote that barbecuing meat on a hurdle "drys up the Gravy."[23] Karen Hess explained that in colonial times the word *gravy* referred to the "running juices of roast meat."[24] Therefore, what Beverly called barbecuing was the same meat preservation technique that Agricola called jerking. Buccaneers did the same thing when they "boucaned" meat by cutting it into long strips before hanging it on barbecues made of "green sticks" in order to expose it "to the smoke of wood." When thus cured, it was usually a "bright red" color and would last "for a long time."[25] In 1711, Lawson wrote of how Native Americans stored "barbakued or dried Venison" in their homes.[26] "Barbakued" refers to dried and preserved meat, not tender, juicy barbecue as is cooked in the South today. We see this yet again when early American naturalist William Bartram wrote, "As for provisions, I had saved one or two barbecued trout; the remains of my last evenings collection in tolerable good order, though the sultry heats of the day had injured them; yet by stewing them up afresh with the lively juice of Oranges, they served well enough for my supper."[27]

BARBECUING "IN THE INDIAN MANNER"

In 1769, John Bartram, William Bartram's father, wrote in his journal, "We staid here all day to barbacue our meat to serve us down the river, which would soon spoil if not preserved either by fire or salt."[28] Clearly, notions of what is and is not barbecue have changed over the last few centuries.

In the seventeenth century, Wafer described how Native Americans in the American Isthmus barbecued meat, writing of how they "erect four forked Sticks 8 or 9 Foot asunder, on which they lay two parallel Staves that shall be above a Foot from the Ground, and so they make a Barbecue." Meat was suspended on the barbecue over "a few live Coals" and was barbecued "for three or four Days, or a Week, till the Meat be as dry as a Chip, or like our soak'd Beef."[29] Although reminding us of "cooking" very "low and slow," Wafer's account makes it clear that the Native American hurdle was as much a food dehydrator as it was what we would call a barbecue grill. Writing about his 1669–70 march from Virginia to the south and west, explorer John Lederer warned, "But you must not forget to dry or barbecue some of these [game animals] before you come to the Mountains, for upon them you will meet with no Game, except a few Bears."[30] By 1737, even John Wesley had taken up Indian ways, writing in his diary, "[B]ut having a little barbecued bear's flesh, (that is, dried in the sun) we boiled it, and found it wholesome food."[31]

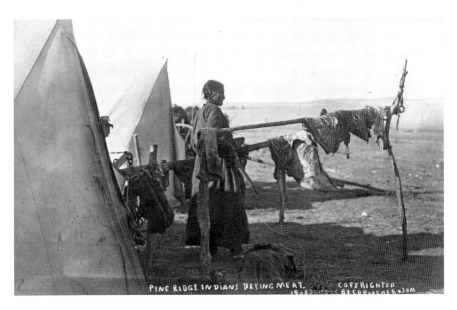

Pine Ridge Indians drying meat, circa 1908. *Library of Congress, Prints and Photographs Division, LC-DIG-ppmsca-08384.*

Like Agricola's description of jerked meat, Beverly explained that when Indians traveled, "If they carry any Flesh in their marches, they barbicue it, or rather dry it by degrees, at some distance, over the clear Coals of a Wood fire." The reduced weight of jerked meat made the burden of carrying it lighter as Indians journeyed back to their villages from hunting trips. This is a great benefit for people who followed game animals as they migrated or otherwise roamed long distances. The adoption of agriculture allowed Native Americans to settle in fruitful areas rather than constantly being on the move in pursuit of game. This implies that the invention of the hurdle occurred before the cultivation of maize became widespread.[32]

It seems that Native Americans and colonists "jerked," "barbecued" or dried all kinds of things on hurdles. Although he didn't use the word *barbecue*, Harriot wrote that Native Americans dried acorns "upon hurdles made of reeds with fire underneath."[33] Lawson told us that Indians barbecued peaches, writing, "We found great Store of Indian Peas, (a very good Pulse) Beans, Oyl, Thinkapin Nuts, Corn, barbecu'd Peaches." Here, Lawson's "barbecu'd" peaches had been preserved by drying them. The naturalist Bernard Romans wrote in 1776 that Native Americans "barbacue" leaves "to make a strong decoction of them."[34] Writing of plantains in 1749, a newspaper columnist wrote, "Now to roast them they are bread, and to boil them they are sauce; or marmalade may be made; but to barbacue [*sic*] or dry them in the sun you may rub them to a flour."[35] Powhatan Indians had the gruesome custom of drying hands taken from their dead enemies, as John Smith told us that some had "the hand of their enemy dryed."[36] In the 1700s, the British-Dutch soldier John Gabriel Stedman wrote about hands that had been "barbecued or dried in smoke" during a revolt of slaves in Surinam.[37]

Ultimately, Agricola's proposal failed because of George Washington's disapproval of the Indian way of preserving meat. In 1758, during the French and Indian War, then colonel Washington wrote a letter to his British commander in which he complained, "[W]e have not an Oz. of Salt Provisions of any kind here, and that it is impossible to preserve the Fresh, (especially as we have no salt neither) by any other Means than Barbacuing it in the Indian manner; in doing which it loses near a half; so that a Party who receives 10 days Provisions will be obliged to live on little better than 5 days' allowance of meat kind, a thing Impracticable."[38]

Washington called Agricola's process for making jerked meat barbecuing "in the Indian manner." Washington didn't approve of it because the meat "loses near a half" of its weight, which made it more difficult to supply his men with their daily ration of one pound of meat.[39]

Washington wasn't the first to distinguish between "barbecuing" and "barbecuing 'in the Indian manner.'" As far back as 1665, there existed such a distinction. In the unsettling account describing the punishment of a man who had attempted to murder Lord Willoughby, the captain-general of Guyana, we read, "A Barbicue was erected,—where he was dry barbicued or dry roasted after the Indian manner."[40] This implies that by 1665, European colonists had developed their own way of barbecuing that was different from the way Indians barbecued meats. Maria Nugent, the daughter of a prominent New Jersey Loyalist, also made a distinction between barbecued and jerked hog. She wrote of Jamaica in 1803, "A long table was spread on the green, with all their most favourite dishes, of barbecued hog, jerked hog, pepper-pot, yams, plantains, etc."[41] Clearly, in those days there was a difference between Jamaican barbecued hog and Jamaican jerked hog.

Old-World Words Describe New-World Barbecue

Although the context in many old accounts of Native American cookery makes it clear that they were often preserving foods rather than merely cooking them, some accounts are not so easily interpreted. A sixteenth-century engraving made by the Flemish artist Theodor de Bry, based on works by Jacques le Moyne and John White, is a perfect example. De Bry's engraving exhibits European interpretations of Native American cookery that seem impossible to reproduce successfully. The intense heat would consume a wooden hurdle sitting closely and directly over roaring flames, which would also scorch the food. The engraving also depicts logs and sticks with sawed edges rather than broken, burned or chopped edges. Because Native Americans didn't have saws, they used wood that they could break or chop with stone axes or they used larger pieces that they dragged to the cooking area, lit on fire and scraped up the coals to move them to the cooking fire.[42] Whether the artists were embellishing for the sake of their European audience or exaggerating the size of the fires is unknown. However, the details depicted in the engravings do not fully agree with the details of the written records.

A translated 1540s account of Spanish explorers in the area of what is now Georgia in the United States written by De Soto's private secretary, Rodrigo Rangel, tells us that on one occasion the explorers ate "loins of venison that they found roasted on a barbacoa, which is like on a grill."[43]

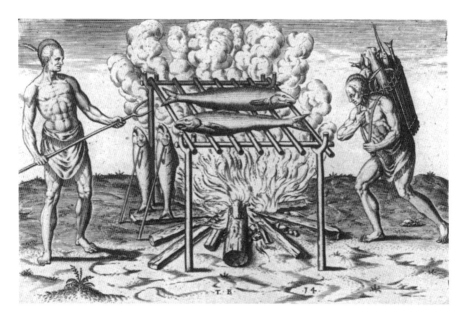

How they cooked their fish, circa 1590. *Library of Congress, Rare Book and Special Collections Division, LC-USZ62-53339.*

This could be a description of barbecuing in a way similar to how we do it today. However, it could also be describing how Native Americans made jerky. The same passage was translated in the nineteenth-century as, "some strips of venison which they found placed upon a framework of sticks, as for roasting on a gridiron."[44] In this translation, it appears that the strips of meat were being dried or jerked. The exact interpretation of the passage is inconclusive simply because the author, apparently, didn't clearly describe what he witnessed.

Lawson makes little sense, at least to modern readers, in his description of how Native Americans in North Carolina made bait to catch crawfish, writing, "When they have a mind to get these Shell-fish, they take a Piece of Venison, and half-barbakue or roast it."[45] Lawson seems to be saying that when meat was placed on a hurdle only long enough to be cooked rather than dried, it was "half" barbecued, and the result was more similar to roasted meat than beef jerky. It's difficult to determine exactly what he meant.

In the late sixteenth century, an unnamed French artist sailed to the New World with Sir Francis Drake. He made illustrations of the people and places that they visited. The work includes a depiction of a Native American "cooking" fish and meat on a hurdle set over burning coals. The translated caption for the illustration reads:

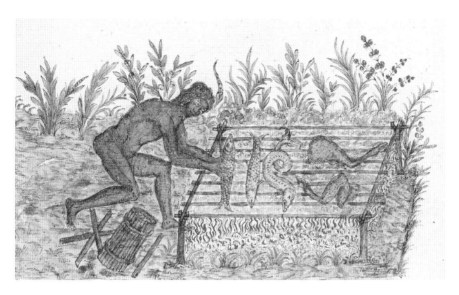

A Native American in the Caribbean barbecuing meat and fish on a hurdle. From *Histoire Naturelle des Indes*, circa 1586. *Piermont Morgan Library, New York, MA 3900, bequest of Clara S. Peck, 1983.*

> *The Indians make a big fire and when they see the wood turning to charcoal, they take four wooden forks, drive them into the earth and lay several sticks across the forks at a foot and a half above the fire. Then they spread out their fish and meat upon it and when they feel the heat of the fire, the smoke of the fat dropping into the fire smokes or roasts the meat and the fish which are good eating. They turn them often for fear of burning them and when the meat and fish are cooked, they have the color of a red herring.*[46]

Notice the similarities between this account of Indian barbecue and the instructions for barbecuing a sheep southern style from 1877:

> *Dig a hole in the ground, in it build a wood fire, and drive four stakes or posts just far enough away so they will not burn; on these build a rack of poles to support the carcass. These should be of a kind of wood that will not flavor the meat. When the wood in the pit has burned down to coals, lay the meat on the rack.*[47]

The similarities are striking. The way the sixteenth-century native cook continuously turned the food is reminiscent of Will Hill's instructions for cooking southern barbecue in the nineteenth century using the "continuous

performance" of turning the meat.[48] However, the meat and fish developed a red color. I have seen unseasoned pork barbecued at low temperatures that developed a reddish tint on portions of the outside surface, but it wasn't red all over; there were spots that were tinted red, and the rest was a golden brown. Southern barbecue also develops a smoke ring, which is a reddish streak that develops just under the surface of barbecued meats, not the outer surface of it. The native cook's "barbecue" was the exact color of boucaned meat dried by buccaneers. Moreover, the depiction of the native using only his hands to turn the fish indicates that the food was not very hot, implying the use of a low-temperature heat source, much like that used with cold smoking.

Indian Barbecue Served at Festivals

In addition to barbecuing meat and fish to preserve them, Native Americans also cooked a style of barbecue that is similar to southern barbecue. John Smith's phrase "broil it so long on hurdles over the fire" is a perfect way of describing the traditional way of barbecuing in the South directly over coals if you have to describe it without using the word *barbecue*. It clearly describes a "low and slow" cooking method, with meat resting on a grill set over coals. Beverly contrasted how Native Americans barbecued meat directly "upon the coals" with the process of hanging it on hurdles, or "sticks raised upon forks at some distance above the live coals," in order to dry it. Lawson wrote, "I have been often in their Hunting-Quarters, where a roasted or barbakued Turkey, eaten with Bears Fat, is held a good Dish." He also described an Indian woman who was cooking Indian-style barbecue, writing, "The Fire was surrounded with Roast-meat, or Barbakues, and the Pots continually boiling full of Meat, from Morning till Night."[49] William Bartram described a meal served to him by Indians as "the ribs and choisest [*sic*] fat pieces of the bullocks, excellently well barbecued." In another passage, he wrote about "the ribs and the choice pieces of three great bears, already barbecued or broiled" served to him by his Indian host.[50] These accounts clearly describe meats barbecued in a way that is similar to how we cook southern barbecue today at relatively low temperatures.

There are practical reasons for why Native Americans slowly cooked meat on hurdles over hot coals. For example, Native Americans didn't have set meal times. When the custom is to eat whenever you are hungry, ready

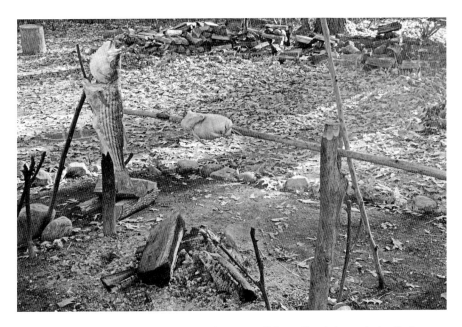

Powhatan spit for cooking meats and fish. *Jamestown-Yorktown Foundation, author's collection.*

access to hot food is very practical.[51] Barbecuing large cuts of meat for hours extends the period of time in which it is safe to eat. It also remains hot and ready to eat whenever hunger strikes.

Far above the USDA recommended safe temperature of 145°F, southern barbecued pork must reach an internal temperature in the range of 190°F to 200°F to become pull tender.[52] This means that meat cooked "low and slow" is safe to eat for a long period. The meat can be safely "stored" over a "low and slow" bed of coals, providing meals for many hours once the internal temperature reaches a minimum of 145°F. Of course, Native Americans in ancient times didn't understand USDA food handling guidelines. However, they did understand that food spoils, and letting it slowly cook on a barbecue for many hours was a way to prevent that outcome. The meat would become more tender after eight hours of cooking compared to after just two. However, in either case, it would remain fully cooked and safe to eat for a long period as it sat for many hours over low-temperature coals. For cultures that didn't have set mealtimes, this method of cooking and holding food was ideal. It also prevented spoiling in warm months and prevented freezing in cold ones.

BURIED BARBECUE

Both Jamaicans and Native Americans in North America buried meat in order to barbecue it. English author Monk Lewis wrote of a Jamaican barbecued pig in 1816: "It was dressed in the true Maroon fashion, being placed on a barbecue, or frame of wicker work, through whose interstices the steam can ascend,—filled with peppers and spices of the highest flavour, wrapped in plantain leaves, and then buried in a hole filled with hot stones, by whose vapour it is baked; no particle of the juice being thus suffered to evaporate."[53] Of course, the "frame of wicker work," provided an easy way to remove the meat just as people in Hawaii today use chicken wire wrapped around kalua pig so that it is easier to remove from the pit.

In 1903, ethnographic photographer George Thornton Emmons observed Indians in Alaska who cooked meat wrapped in leaves overnight in holes lined with hot coals with a fire above it made of heavy logs.[54] The Mayas, who lived in what is today southeastern Mexico and northern Central America, cooked meats in pits filled with hot stones they called a "piib."[55] Naturalist John Bradbury traveled along the Mississippi Valley from 1809 to 1811 and wrote about "barbique" events held by Indians in that region where meat was cooked "after the Indian method" in a covered pit filled with hot stones.[56]

Clergyman John Clayton wrote that Virginia's Indians "barbecuted" venison by wrapping it in leaves and roasting it in embers. This could be Clayton's way of describing how venison was barbecued in an earthen oven of some kind. This is supported by the context of Clayton's remarks: "At all Hours of the Night, whenever they awake, they go to the *homing-pot* [hominy pot]…or else a Piece of Venison *barbecuted*, that is, wrapped up in leaves, and roasted in the Embers."[57] Clayton described venison that was in the process of being "barbecuted" overnight just as the hominy pot was always slowly simmering overnight. As the Indians awakened in the middle of the night or in the morning, a hot meal was always waiting for them.

The accounts of burying meat in order to barbecue it demonstrate that Indian barbecuing techniques were very practical. Burying meat as it cooked made it less likely that animals would be attracted to it and steal it away. In addition, the hot stones and embers in the pit cooked the meat slowly, which means that as people slept, the meat was cooking rather than decaying, as might happen on warm nights if left out in the air. Another benefit was realized when people wanted to eat. All they had to do was uncover the meat to enjoy a delicious meal whether it was the

middle of the night or the next morning, which explains the bull's head breakfast barbecues in the Southwest.

A characteristic shared by all of these Native American cooking techniques is the fact that they were all a way to keep foods ready and safe to eat for relatively long periods. Today, we do that using our crockpots, refrigerators and freezers. Native Americans did it with smoke and fire. Take, for example, British explorer Everard Thurn's account of Indians in Guyana:

> *Half the booty, a young tapir, was given to the Indians, who, as usual, immediately boiled and began to eat it…The other half of the tapir was put on a babracot to dry. A babracot is a small stage of green sticks, built some two feet above the fire, on which the flesh is placed and smoked. Flesh treated in this way, though it loses its distinctive flavour, keeps good for many days even in that climate.*[58]

Like Smith, Thurn tells us that Indians both boiled and dried meat. However, what's interesting about Thurn's account is how they boiled half of the meat for immediate consumption and dried the remainder for later use. Native Americans in California did the same thing.[59] This apparently ubiquitous Indian practice was necessary in a time without refrigeration. Today, if we have leftover food, we put it in the refrigerator or the freezer. In cold weather, Native Americans could keep meat outside without fear of it spoiling. However, in warm weather, they had to dry and smoke foods to preserve them. Thurn's Guyana Indians were simply using the food dehydrator of their day, which they called a babracot, also known as a hurdle, barbecue and barbacoa. In 1674, Virginian Abraham Wood wrote of Indians encountered while on a hunting trip, "Here they killed many swine, sturgin and beavers and barbicued [*sic*] them."[60] Just like the Guyana Indians, these hunters immediately ate some of the meat and then dried, or barbecued in the Indian manner, the rest of it in order to take it back to their village for later use. Lawson described the same practice when he wrote:

> *Those Indians that frequent the Salt-Waters, take abundance of Fish, some very large, and of several sorts, which to preserve, they first barbakue, then pull the Fish to Pieces, so dry it in the Sun, whereby it keeps for Transportation; as for Scate, Oysters, Cockles, and several sorts of Shell-fish, they open and dry them upon Hurdles, having a constant Fire under them. The Hurdles are made of Reeds or Canes in the shape of a Gridiron. Thus they dry several Bushels of these Fish, and keep them for their Necessities.*[61]

The Perpetual Stew Pot

In addition to barbecuing, Virginia Indians boiled foods as well. Beverly wrote of the slow-cooked Indian stews, "They boil, broil, or toast all the meat they eat, and it is very common with them to boil fish as well as flesh with their homony; this is Indian corn soaked, broken in a mortar, husked, and then boiled in water over a gentle fire for ten or twelve hours."[62]

The long cook times used for stews were more practical than culinary. It was a way of having a hot meal ready to eat whenever someone was hungry. Powhatan Indians often added meat to stews that Europeans described as "roasted."[63] However, as we have seen, you cannot put a lot of faith in colonial-era writers' descriptions of Indian cooking without context. Therefore, it is probable that the "roasted" meat added to stews was actually meat barbecued in the Indian manner. Some cite the following passage from Lawson in discussions about southern barbecue. However, a careful reading of it reveals that Lawson was describing how Indians used dried meat in recipes by pounding it in a mortar and cooking it in a stew. He wasn't describing meat barbecued as we think of it today. Similar to Agricola's instructions that jerked meat can be "soaked or boiled," Lawson wrote, "They came out to meet us, being acquainted with one of our Company, and made us very welcome with fat barbecu'd Venison, which the Woman of the Cabin took and tore in Pieces with her Teeth, so put it into a Mortar, beating it to Rags, afterwards stews it with Water, and other Ingredients, which makes a very savoury Dish." The Indian cook used her teeth to rip the dried meat into shreds along the grain, just as someone might use them to rip fabric. She then pounded the smoke-dried meat in a mortar and cooked it in a stew much the same way as we use smoked meat in soups and stews today.[64]

In addition to having a meal ready to eat at any time, a simmering stew pot is also a way of preserving food. In 1695, Dutchman Adriaan Berkel wrote about the Indians in Guyana:

> Be it hare, rabbit, hog, deer, etc., its hair is burnt off, the guts washed and the meat placed on a berbekot. This is an Indian grid consisting of small wooden sticks measuring 2 feet high. On it they place their food, flesh and fish, without salting it,; being half roasted, they crumble it into the pepperpot to eat on the spot or to keep it for more convenient times because the pepperpot is the only recourse.[65]

Powhatan stew pot. *Jamestown-Yorktown Foundation, author's collection.*

Here, Berkel tells us that the pepper pot preserved food for later consumption. Although Berkel doesn't note it, some Caribbean recipes for a pepper pot call for a seasoning made from cassava root known as cassareep. Cassareep has qualities that preserve food if the pot boils at least once each day.[66] However, even without cassareep, simply continually simmering the pot will keep its contents safe to eat for as long as needed. Isn't that the principal behind our modern crockpots? As long as the Indian stew pot was simmering, the contents would be safe to eat. As people ate from the stew pot, the cook added additional water, fruits, vegetables and meats as they became available. The constantly simmering pot enabled Native Americans to hold food safely for extended periods.

SMOKY HOUSES

Besides storing fresh meat in cold weather, barbecuing it on a hurdle and simmering it for long periods in pots of stew, Powhatan Indians had yet another method of preserving food inside their houses using smoke. John Smith wrote, "Their houses are built like our Arbors, of small young springs bowed and tyed, and so close covered with Mats, or the barkes of trees very

handsomely, that notwithstanding either winde, raine, or weather, they are as warme as stooves [stoves], but very smoaky, yet at the toppe of the house there is a hole made for the smoake to goe into right over the fire."[67]

In addition to Powhatan Indians, Native Americans all over the Americas lived in smoky houses.[68] Native Americans who lived near the Ohio River in the 1600s actually built houses on hurdles with a slow fire burning under them. Hennepin wrote, "They drive into the Ground big Poles, very near one another, which support a large Hurdle, which serves them instead of a Floor, under which they make their Fire; and the Smoak drives away those Creatures, who cannot abide it. They lay upon that Hurdle, the roof whereof is cover'd with Skins against the Rain, and serves also to shelter them against the Heat of the Sun."[69] The eighteenth-century Baptist pastor John Gill tells us of western tribes who lived in houses, writing, "a hole in the roof let out some of the smoke, but they usually had fish hanging from the poles overhead, so that they made their smoky houses serve in curing their food."[70] Methodist missionary Thomas Crosby wrote of Indians in Canada, "I retired to the woods to sleep, thinking we would have a better chance to rest there than in the smoky houses, where there were hundreds of dried salmon hanging over the smouldering [sic] fire and the quarreling dogs upon the floor." Prairie Indians also stored foods in the top of their tipis.[71]

In the winter of 1608, John Smith and other colonists sought refuge with the local Indians. Smith later wrote fondly of their "dry, smoaky houses."[72] The smoke in Powhatan houses came from the fire that continually burned inside them.[73] The center of the roofs had a hatch for letting excess smoke escape.[74] The continual fire not only warmed the dwellings but also produced smoke that lingered in the upper portions of the structures. That also happens to be where Powhatan Indians stored food.[75] Besides repelling insects during warm months, the smoke also cured the foods stored in it.[76] Englishman William Wood wrote of Indians in New England in the 1630s:

In the summer, these Indian women, when lobsters are in plenty and prime, they dry them to keep for winter, erecting scaffolds in the hot sunshine, making fires likewise underneath them, by whose smoke the flies are expelled till the substance remains hard and dry. In this manner they dry bass and other fish, without salt, cutting them very thin to dry suddenly, before the flies spoil them, or the rain moist them, having a special care to hang them in their smoky houses, in the night and dankish weather.[77]

Smoke hatch in the roof of a Powhatan house. *Jamestown-Yorktown Foundation, author's collection.*

Apparently, the smoky houses of the Powhatan Indians served in the exact same way. The constant presence of smoke cured the fish and meat stored in the ceilings of their houses. It is not a stretch of logic to conclude that Powhatan Indians didn't just live in "smoky houses" but literally lived in smokehouses.

Strachey described how Powhatan Indians built a "high stage" near their houses. It was "a loft of hurdles" over which they put a covering of mats that made "a shadow." The structure was "a shelter" that Powhatan Indians used for drying foods.[78] The covered nature of this structure sounds suspiciously like a dedicated, detached smokehouse. Strachey's "high stage" conjures up images that are reminiscent of Agricola's instructions for jerking meat, which were to "hang it [the meat] up in the smoke to dry through" far away from the heat of the coals. Karl Bernhard, the Duke of Saxe-Weimar Eisenach, described an Indian meat smoking technique in 1826 that is similar to the way Virginia hams are smoked. He wrote that Indians put large cuts of pork on hurdles above smoky fires so that "the smoke may draw through them."[79]

As late as 1839, Lettice Bryan stated that the process of smoking salted venison hams in a smokehouse is a form of barbecuing, explaining that it is important to "salt fresh venison and barbecue it immediately" before putting it in storage.[80] She, like Mary Randolph, also called for rubbing the meat with hickory ash. There is obvious Native American influence in Bryan's process.

Hogs hanging on a wooden hurdle curing over a smoky fire in Halifax, Virginia, circa 1939. *New York Public Library.*

In 1939, people in Halifax County, Virginia, were still hanging carcasses of freshly slaughtered hogs on wooden hurdles and using small fires under them to generate smoke to repel insects just like Powhatan Indians.

Native American–style barbecue also included sauce served on the side. Strachey wrote of Indian "barbicue," "Their Sauce to this dry Meat, (if they have any besides a good Stomach) is only a little Bears Oyl, or Oyl of Acorns."[81] According to eighteenth-century frontiersman Colonel James Smith, some Indians served sweet barbecue sauce. In a 1799 account of his experiences in captivity, he described how Indians mixed maple sugar with bear fat and dipped their "roasted" and "dried" venison in it. He wrote, "The way that we commonly used our sugar while encamped, was by putting it in bears fat until the fat was almost as sweet as the sugar itself, and in this we dipped our roasted venison." In another passage, he wrote, "dried venison, bears oil and sugar, is what they offer to everyone who comes in any time of the day."[82]

> *About midnight following, the king sent to invite me to his fire. He placed me near him as before, and in the first place shewing me quarters of a lean doe, new brought in. He gave me a knife to cut what part of it I pleased, and then pointing to the fire, I inferr'd, I was left to my own discretion for the dressing of it. I could not readily tell how to shew my skill in the cookery of it, with no better ingredients then appear'd in sight; and so did no more but cut a collop [steak] and cast it on the coals. His majesty laugh'd at my ignorance, and to instruct me better, he broach'd the collop on a long scewer, thrust the sharp end into the ground (for there was no hearth but what nature made) and turning sometimes one side, sometimes the other, to the fire, it became fit in short time to be served up, had there been a dining-room of state such as that excellent king deserved.*
>
> Colonel Norwood, A Voyage to Virginia (1649)

There was much more to Native American cookery than met the European eye. To sixteenth- and seventeenth-century Europeans, "Indians" slept in smoky houses and roasted, broiled, smoked and boiled foods in the most rudimentary ways. However, a closer look reveals the reasons behind the methods.

The written record doesn't tell us much about the seasonings that Powhatan Indians used in their foods, leading some to conjecture that they enjoyed food for its texture as much as its flavor.[83] Nevertheless, one thing is certain: Powhatan Indians used smoke as much for a seasoning as they did for a preservative in the same way it is a seasoning and a preservative in southern cookery today.

CHAPTER 4
VIRGINIA'S RICH BARBECUE TRADITION

There was hardly a neighborhood in which there was not some favorite spring devoted to barbecuing purposes. The barbecue season generally commenced in May, before which time fish fries and squirrel stews were the order of the day. In every neighborhood there was some person noted as a skillful barbecue cook. The squirrel stew, when well concocted, formed a delicious repast. All sorts of savory condiments were thrown into the cauldron, and its steam was sufficient to make the mouth of an epicure fairly water.

The barbecue proper consisted of shotes and lambs, dressed with a super abundant supply of pepper, and cooked over a large fire built up in holes five or six feet long and three or four deep. Sticks were placed over these, and the shote or lamb laid on it. Vegetables in abundance were always to be had, and the foot of the table was usually graced by a ham of bacon. The table was a temporary affair, made of rough planks, laid upon scantling, and the seats were of the same character. The plates, knives, forks, dishes, pots, etc., were of course contributed by the givers of the feast, and in the evening an ox cart or two generally drove up to take all the materials home. The drink was almost entirely mint juleps, that delicious beverage which is now never had as it used to be in the days of yore.

The principal amusements were ninepence loo, quarter whist, and conversational upon all manner of subjects. It was very rare to see anybody intoxicated, and if one became so, and made himself disagreeable, he was not invited again. Neighborhoods took it by turns to give barbecues. This neighborhood would begin this Saturday, and invite the adjoining neighborhood.

That neighborhood would reply next Saturday and then a third, a fourth, and so on. Thus nearly every Saturday would witness a barbecue somewhere in the county, and it was kept up until frost came.

–New York Herald, *"The Old Fashioned Barbecue in Virginia,"*
April 29, 1858

For centuries, Virginia was renowned for its barbecue. Since at least the seventeenth century, barbecue has been "common to Virginia festivals."[1] When Virginians held a barbecue in East Rockingham in 1873, the newspaper described it as "Old Virginianism, in primitive style, broke out in East Rockingham, in the shape of a Grand Barbecue."[2] "The barbecue loving democracy of Chesterfield" was the name given to that county in 1878 because the people who lived there were so fond of barbecued pork and Brunswick stew.[3] According to nineteenth-century authors, barbecue is "an Old Dominion Institution," "one of the ancient and honorable institutions of Virginia" and a "rural entertainment" that was "so frequent among the country people of Virginia." As far back as 1825, Americans considered Virginia to be barbecue's "original habitat."[4] The word *barbecue* itself is a "Virginian word," and even the practice of calling an event that features barbecued meat "a barbecue" is "good old Virginia parlance."[5]

By 1841, Virginia was so well known for barbecues that people referred them as "that Virginian Saturnalia—a Barbecue."[6] Virginia barbecue enjoyed "world-wide fame," and even people in Hawaii said that barbecue made Virginia famous.[7] One writer explained in 1860 that the word *barbecue* "means nothing more nor less than an entertainment where hogs are roasted whole—a totum porcum process, sir! Hence to 'go the whole hog' is pre-eminently a characteristic of the people in our good old Commonwealth—God bless her—from the point of the 'Pan Handle' down to the depths of the Dismal Swamp."[8]

Presidents George Washington and James Madison were very fond of Virginia barbecues (sometimes called "spring parties").[9] Archaeologists have even discovered a barbecue pit in Montpelier's south yard that was in use during President Madison's lifetime.[10] Madison's barbecues were grand events. Male servants would dress in colorful clothing with shiny brass buttons and clean aprons. Female servants would wear impressive and colorful dresses.[11] Dolley Madison's niece, Mary Cutts, wrote:

Barbecues were then at their height of popularity. To see the sumptuous board spread under the forest oaks, the growth of centuries, animals roasted

whole, everything that a luxurious country could produce, wines, and the well filled punch bowl, to say nothing of the invigorating mountain air, was enough to fill the heart…with joy!…At these feasts the woods were alive with guests, carriages, horses, servants and children—for all went— often more than an hundred guests…If not too late, these meetings were terminated by a dance.[12]

Virginia plantation records are full of entries about barbecues that were "given in turns by owners of plantations."[13] Virginians called the period from May to October "the barbecue season." The place selected for a barbecue was near a spring or pleasant grove. African Americans, respected for their skill at the pits as those who "rule the roasts," did the cooking. "Hogs of middling size," or shoats, were barbecued, as were lambs, sheep, chickens, steers and wild game. When it was time to partake of the feast, the Virginian custom was to serve women first. After partaking of the delicious meal, dancing commenced.[14]

Among the pleasure parties which bring together a large number of farmers in the seasons of fine weather, I shall not forget the one at which members of both sexes and of all ages are gathered. The families of a district agree to meet in the woods in the neighborhood: the site is good if there is a spring whose clear and cold water can contain the punch, beer, rum and wine. The old people, women, young people and children set out on horseback, in carriages and in wagons and proceed merrily to the meeting place. The one who is giving the feast has borrowed horses to convey the food and drink, the table service, the cooking utensils and the boards with which must be fashioned the tables and the benches. That deserted place is filled with people in an instant. The horses graze freely around the banqueting hall whose ceiling is formed by the bushy tops of beautiful trees.

Not far from there, Negroes can be seen digging a pit: others are felling trees to fill it, and soon sheets of flame will rise from that furnace: when it no longer contains anything but live coals, there will be placed thereon a half of beef, a veal and some suckling pigs, attached firmly together on the trunk of a young oak which serves as a spit. The women go by turns to the pit of live coals

to baste the meats, then return to the spring to put the bottles in order. The young ladies squeeze the lemons in large porcelain bowls. The young men help the Negro boys place the plates on long tables made of boards placed on upright stakes.

The old people sit in a group on the grass and their grand-children play around them. The married women assign themselves to all the places where the young ladies are occupied, and encourage them to work.

When everything is prepared for the dinner, the women take the right side, and the men the left. The old people of both sexes face each other. The children under the care of their nurses, have the grass as a substitute for a table and benches. Everyone eats with a good appetite and with gaiety. The men, under the eyes of their wives and watched by their children, leave the table without drinking and intoxication. The Negroes show signs of the feast; meat grease gives a gloss to their ebony cheeks, and a few glasses of rum make their eyes sparkle. Lovers meet again after the feast and take a walk into the woods to talk about their love.

Ferdinand Bayard, 1791

Colonial Virginians spent a great deal of time traveling to neighboring plantations and farms to visit friends and family who often lived long distances away. Traveling on foot, on horseback or by horse-drawn carriage meant that traversing the long distances could take days. Therefore, visits often lasted for long periods.[15] As one author wrote, "[L]iving so isolated, [Virginians] are fond of company, [this] produces a course of visiting for weeks afterwards. A Virginian visit is not an afternoon merely; but they go to week it, and to month it, and to summer it."[16]

After long-distance trips, travelers would be tired and hungry. When the number of visitors was large, cooking and serving foods outside was the most efficient manner of feeding the crowd, and the best way to do that was with barbecue. American missionary Hamilton Pierson commented on the efficiency of feeding people with barbecue in 1881:

It [barbecuing] *is the simplest possible manner of preparing a dinner for a large concourse of people. It requires neither building, stove, oven, range,*

Colonial-era travelers in Virginia. From *Our Country* by Benson John Lossing, circa 1875. *New York Public Library*.

> *nor baking-pans. It involves no house-cleaning after the feast. It soils and spoils no carpets or furniture. And in the mild, bountiful region where the ox and all that is eaten are raised with so little care, the cost of feeding hundreds, or even thousands, in this manner is merely nominal.*[17]

Therefore, the Virginian custom of holding barbecues was very practical, and this probably contributed to their popularity.

WEDDINGS AND FUNERALS

Two events especially suited for barbecues were weddings and funerals. On March 6, 1731, Mary Ball, George Washington's mother, married Captain Augustine Washington at Sandy Point in Westmoreland, Virginia. The

couple celebrated their wedding with barbecues, "as was the custom in those days."[18] Holding barbecues for wedding celebrations was practical because well-wishers often had to be entertained for several days or even weeks.[19]

Holding barbecues for mourners was also practical.[20] At John Smalcomb's funeral in 1645, mourners consumed a barbecued steer and a barrel of strong beer and used up "considerable [gun] powder."[21] In 1647, Richard Leman provided an ox for a barbecue worth the tidy sum of eight hundred pounds of tobacco. John Michael, of Northampton, took another approach. His will specified that there should be no immoderate drinking nor shooting at his funeral, which implies that there would have been had he not made his request.[22] In 1675, Edmund Watts of York County also forbade the serving of drinks at his funeral. In 1678, the colonial Virginia mourners of Mrs. Elizabeth (Worsham) Epes barbecued a steer and three sheep. Along with the barbecue, the host served "five gallons of wine, two gallons of brandy, ten pounds of butter and eight pounds of sugar."[23] In 1667, Daniel Boucher, of Isle of Wight County, willed the cost of furnishing an old Virginia barbecue consisting of "one loaf of bread to every destitute person" and a barbecued ox for the "whole number of poor residing there."[24]

> *A funeral at this time was a splendid, and for many of the attendants a highly enjoyable, occasion. The shadow of death had no place among those sunny spirits. Barbecues were given and rum liberally dispensed by the afflicted family, and a general spree was indulged in at the expense of the estate of the deceased. The more boisterous mourners usually carried their fowling pieces and fire-arms to the funeral, and after the feast and bowl had somewhat assuaged their sorrow and enlivened the solemn occasion, a barbaric celebration ensued.*
>
> *Jennings C. Wise*, Ye Kingdome of Accawmacke or, The Eastern Shore of Virginia in the Seventeenth Century *(1911)*

There is a modern myth that discharging firearms at barbecues in seventeenth-century Virginia was illegal. According to one source, Virginians established the law in the 1690s.[25] Another source notes that Virginians established the law in the 1650s.[26] According to another source, the Virginia

House of Burgesses passed the law in 1610.[27] However, such claims are not entirely true.

Of course, the English word *barbecue* didn't exist in 1610. The Virginia House of Burgesses didn't exist at that time either and wouldn't hold its first session until 1619. The House of Burgesses established the first gun law in Virginia in 1623. It was a response to the loss of a quarter of the population of the colony during the 1622 Indian attack. The law required all plantations to have firearms and ammunition on hand for self-defense. The House of Burgesses established the first law prohibiting the firing of guns at "drinking or entertainments" in 1631. "Entertainments" is what early Virginians often called barbecues. The purpose of the law was to conserve gunpowder and eliminate false Indian attack alarms. However, by 1655, the law had been modified to exclude weddings and funerals—two prime events for holding barbecues.[28]

A Rural Entertainment

Philip Fithian was born in New Jersey. He lived in Virginia from October 1773 to October 1774, employed as a tutor for the family of planter Robert Carter in Virginia's Northern Neck. Fithian's accounts of Virginians make it clear that frequent community festivals were an important part of social life. Hunter Dickinson Farish was the first to edit a work that included Fithian's entire journal.[29] Farish observed that Virginia barbecues and fish feasts were frequent and, sometimes, elaborate events that often lasted for several days. With feasting, dancing and games, Virginians from all walks of life participated in the private entertainments, including some of the most prominent Virginia families such as the Washingtons, the Lees and the Tayloes.[30]

Barbecue in Virginia

Advancing, you hear shouts, merriment, and "tweedle dum and tweedle dee." Music and dancing are near, and if there are no nymphs and dryads, pass on, and you see, glancing around, groups or constellations of ladies, such as you will see only in Virginia or Spain. These are attended by the satellites that usually follow

in the train of beauty. You discover a large circular space, covered with canvass boughs, where the light of heart and foot are dancing to the violin and fife, while under the trees at a distance are the more sedate, and grave in years, sitting at tables by fours, and looking intently on little parallelograms of pasteboard, which, ever and anon, they rap down with force upon the board. You will not fail to see a range of tables that would feast a regiment, and camp fires at which all flesh and fowl is roasting, including a "whole hog," that constitutes the barbecue which gives name to this feast.

When the banquet is ready you devote yourself to the constellations, as the first course is for the ladies, upon whom the gentlemen attend, as the genius waited upon Aladdin. The second course is for the lords, upon whom the managers and slaves attend. After all, the managers dine also, and they have servants no less exalted than the ladies. A barbecue has from three to eight hundred people, and it is only where a very social life is led that this feast could be so well filled.

J.M., New-England Magazine (January 1832): 37–45.
Courtesy of Cornell University Library, Making of America
Digital Collection.

As settlers moved farther inland, barbecues spread all over Virginia with them. In 1808, John Edwards Caldwell (son of the Revolutionary War's "Fighting Parson" James Caldwell) shared his account of a barbecue near what is now Stephens City, Virginia, in the Shenandoah Valley.[31] He described how people gathered from miles around for a day of entertainments such as conversation, dancing and feasting on "refreshments of every kind." He ended his brief account with the observation, "A Virginia Barbicue [sic] seems a day of rejoicing and jubilee to the whole of the surrounding country."[32]

In 1850, American author and artist Charles Lanman wrote that the early settlers of Virginia first introduced what we call today southern barbecue in the American colonies. As a result, Americans thought of barbecue as a "pleasant invention of the Old Dominion."[33] Writing that "it was not unnatural that the feast should eventually have become known as a barbecue," Lanman realized that Virginians were cooking barbecue

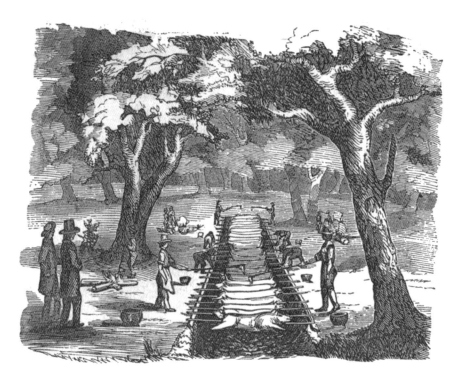

A Virginia barbecue, circa 1860. From *My Ride to the Barbecue*, 1860.

I passed through Stephensburgh, a decayed looking village, and at Slaughter's mills, three miles further, I witnessed a scene to me altogether novel and equally pleasing. There were assembled about 400 ladies and gentlemen, from round the country, to the extent of 30 miles, as elegantly and fashionably dressed, as good taste and good clothes could make them: they met at this place in the morning, and had been the entire day engaged in dancing, conversation or other amusements. Refreshments of every kind had been liberally provided by the guests themselves. I understood these merry meetings (termed Barbicues) were very frequent during the summer, and I observed that the hope of soon assembling at another, took the sting from adieu when about to part. A Virginia Barbicue seems a day of rejoicing and jubilee to the whole of the surrounding country.

John Edwards Caldwell, A Tour through Part of Virginia,
in the Summer of 1808 (1809)

and holding barbecues even before they used the English word *barbecue* to describe the cooking method or the events.

The locations selected for Virginia barbecues were very important. A hospitable spot in a grove under the shade of trees and near a flowing spring was most preferred. One writer observed of springs, "No barbecue is complete without this rock-encased living stream of water."[34] Springs provided a source of water for soups, stews, punch, mint juleps and toddy. The spring water also kept meats cool while the fire burned down to coals and was used to chill watermelons and barrels of refreshing drinks.[35] In 1851, a writer commented, "a spring of pure water is nearby, and a mint bed, fresh and verdant, is immediately contiguous," indicating that Virginians planted mint near springs to ensure that it was readily available to make mint juleps.[36]

An 1811 account of a Fourth of July barbecue held in Staunton, Virginia, describes soldiers enjoying a barbecue near "Mr. Peter Heiskell's spring," while the civilians "enjoyed a barbecue feast at Mr. John McDowell's spring."[37] In typical Virginian fashion, there was plenty of gunfire and many toasts made by the revelers. Dorrel's spring in Fairfax County, Virginia, was the location chosen for many antebellum barbecues.[38] A Fourth of July barbecue took place in 1809 near Fredericksburg, Virginia, at Captain Lewis's spring after a public reading of the Declaration of Independence.[39] Morgan's spring is the site of several notable old Virginia barbecues. Alexander R. Boteler, a nineteenth-century Virginia politician and author, described it as it appeared in 1858:

> At the base of the hill on which the house is situated, beneath a shelving mass of moss-grown rock and the gnarled roots of a thunder-riven oak, a glorious spring leaps out into sunlight, as if glad to be released from the dark prison-caves of earth and flowing over the smooth sides of an artificial reservoir, it runs rippling along, making merry music as it tumbles over its rocky bed into the placid waters of the lake. This is "Morgan's Spring;" and such has been its designation for more than a century.[40]

In 1775, Hugh Stephenson raised a volunteer company of Virginians and gave a barbecue for them near Morgan's spring before "making a bee-line for Boston." Surviving members of the company (who were healthy enough to travel) met there again fifty years later to commemorate the event with a barbecue.[41] In 1858, Boteler described a "mammoth poster" advertising a barbecue at Morgan's spring that read, "Grand Civic and Military

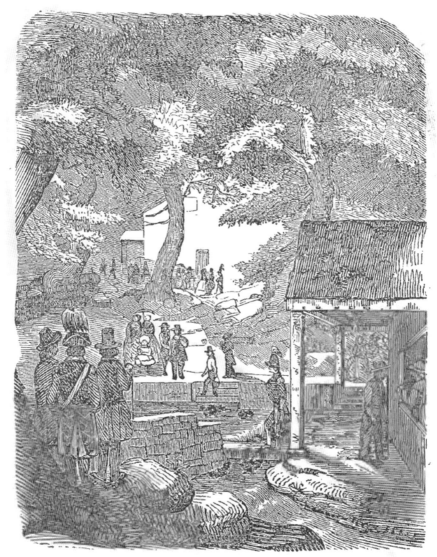

THE MORGAN SPRINGS.

Morgan's spring, circa 1860. From *My Ride to the Barbecue*, 1860.

BARBECUE, At Morgan's Springs, Near Shepherdstown, Jefferson County, Virginia, On Thursday the 2d of September, 1858. &c, &c, &c, &c." He called the attendees "mutton munchers" and the barbecue cooks "those who ruled the 'roasts.'"[42]

At least until around the middle of the twentieth century, most Virginians who "ruled the roasts" were African Americans.[43] John Duncan visited Virginia from Scotland in the early 1800s. He was the guest of George Washington's nephew, Bushrod Washington, at a barbecue held near Alexandria, Virginia, in 1818 and commented on the fact that all of the hardworking cooks were African Americans. The barbecue took place under the shade of trees near a spring. The cooks made "tubfulls of generous toddy" with the cool spring water. The meats barbecued over hickory wood coals included fowl, pork, lamb and venison. Another lesson Duncan learned was that hosts always served women first at old Virginia barbecues. When Duncan violated that protocol, his hosts quickly put him in his place.[44]

After having spent an hour or two at Mount Vernon, Judge Washington politely invited us to accompany him to a Barbecue, which was to take place in the afternoon close by the road to Alexandria. The very term was new to me; but when explained to mean a kind of rural fête which is common in Virginia it was not difficult to persuade us to accept the invitation.

The spot selected for this rural festivity was a very suitable one. In a fine wood of oaks by the road side we found a whole colony of black servants, who had made a lodgement since we passed it in the morning, and the blue smoke which was issuing here and there from among the branches, readily suggested that there was cooking going forward.

Alighting from my horse and tying it under the shadow of a branching tree I proceeded to explore the recesses of the wood. At the bottom of a pretty steep slope a copious spring of pure water bubbled up through the ground, and in the little glen through which it was stealing, black men, women and children, were busied with various processes of sylvan cookery. One was preparing a fowl for the spit, another feeding a crackling fire which curled up round a large pot, others were broiling pigs, lamb, and venison, over little square pits filled with red embers of hickory wood. From this last process the entertainment takes its name. The meat to be barbecued is split open and pierced with two long slender rods, upon which it is suspended

across the mouth of the pits, and turned from side to side till it is thoroughly broiled. The hickory tree gives, it is said, a much stronger heat than coals, and when completely kindled is almost without smoke.

Leaving the busy Negroes at their tasks—a scene by the way which suggested a tolerable idea of an encampment of Indians preparing for a feast after the toils of the chase. I made my way to the outskirts of the wood, where I found a rural banqueting hall and ball room. This was an extensive platform raised a few feet above the ground, and shaded by a closely interwoven canopy of branches. At one side was a rude table and benches of most hospitable dimensions, at the other a spacious dancing floor; flanking the long dining table, a smaller one groaned under numerous earthen vessels filled with various kinds of liquors, to be speedily converted, by a reasonable addition of the limpid current from the glen judiciously qualified by other ingredients, into tubfulls of generous toddy.

A few of the party had reached the barbecue ground before us, and it was not long ere we mustered altogether about thirty ladies and somewhere about an hundred gentlemen. A preliminary contillon or two occupied the young and amused older, while the smoking viands were placed upon the board, and presently Washington's March was the animating signal for conducting the ladies to the table. Seating their fair charge at one side, their partners lost no time in occupying the other, and as there was still some vacant space, those who happened to be nearest were pressed in to occupy it. Among others the invitation was extended to me, and though I observed that several declined it, I was too little acquainted with the tactics of a barbecue, and somewhat too well inclined to eat, to be very unrelenting in my refusal. I soon however discovered my false move. Few except those who wish to dance choose the first course; watchfulness to anticipate the wants of the ladies, prevent those who sit down with them from accomplishing much themselves, the dance is speedily resumed, and even those who like myself do not intend to mingle in it regard the rising of the ladies as a signal to vacate their seats. A

> *new levy succeeds, of those who see more charms in a dinner than a quadrille, and many who excused themselves from the first requisition needed no particular solicitation to obey the second.*
>
> *John Duncan, 1823*

Virginia barbecues were a reflection of the hospitality of the people of Virginia, who had a reputation for hosting grand feasts with generous portions. In an 1836 account of a Virginia barbecue, we find, "The table not only groaned with the barbecue and bacon common to Virginia festivals, but all kinds of preserves, pies, sweet meats, and floating islands, &c."[45] Such bounties explain why writers called the rush when people eagerly filled their plates with their share of the delicious "viands" "the attack."

Virginians have barbecued untold tons of pork over the last four hundred years. They have also barbecued their share of other meats, including wild game, poultry, veal, lamb and mutton. Virginians have been barbecuing beef using the southern barbecuing technique since the early seventeenth century—longer than any other state in the Union, including Texas. The hosts of a nineteenth-century barbecue held near Fredericksburg in Bowling Green, Virginia, required five hundred waiters to serve eight barbecued oxen to the large crowd that attended.[46]

From the very beginnings of the colony of Virginia, sturgeon was also an important food. Isaac Weld, an Irish writer and explorer, visited Virginia between 1795 and 1797. According to him, a Virginia barbecue may have included a barbecued pig or a barbecued sturgeon:

> *The people in this part of the country, bordering James River, are extremely fond of an entertainment which they call a barbacue [sic]. It consists in a large party meeting together, either under some trees, or in a house, to partake of a sturgeon or pig roasted in the open air, on a sort of hurdle, over a slow fire.*[47]

About one month after colonists first arrived in Virginia, they found sturgeon that were huge and abundant. John Smith told us that they once took fifty sturgeon at a draught and at another sixty-eight.[48] The colonists were catching sturgeon that were as long as three yards. From that time,

Old Virginia Brunswick stew. *Author's collection.*

sturgeon, also known as Charles City bacon, became a very important part of Virginians' diets. One writer noted, "When Charles City bacon was plentiful, everyone was happy."[49] Because sturgeon in Virginia's waters grew to as much as fourteen feet long and often weighed hundreds of pounds, it's easy to see why Virginians barbecued them low and slow just as they would a hog.[50] In the 1890s, the sturgeon population in Virginia's rivers began to dramatically decline due to overfishing, and by the turn of the twentieth century, the sturgeon population had crashed. In 1926, operators closed the last sturgeon fishing operation on the Potomac.[51]

Without Brunswick stew, originally known as squirrel stew or soup, "a Virginia barbecue would not be complete."[52] At a barbecue held at Powhatan Courthouse in 1840, an attendee recalled the "tripods made of three forks in the ground" from which were "suspended the pots of Brunswick stew, the scent of which would make any man hungry."[53] At an 1885 barbecue, the bill of fare included Virginia smoked ham, fried chicken, catfish chowder, fried fish, Brunswick stew (called squirrel soup in the account), barbecued beef and barbecued mutton.[54]

Virginia barbecues reminded many colonial- and federal-era eyewitnesses of Native Americans. Lanman described how Virginians barbecued meats by "laying them upon sticks across the fires" just as colonists witnessed Powhatan

Indians doing in the seventeenth century. Duncan also commented on Virginia's "Indian-like" barbecuing technique, writing, "Leaving the busy Negroes at their tasks—a scene by the way which suggested a tolerable idea of an encampment of Indians preparing for a feast after the toils of the chase." After watching barbecue cooks near Richmond, Virginia, in the early 1800s, Colonel Thomas H. Ellis compared Virginia's barbecuing technique to the Powhatan Indian method of cooking on a platform made of sticks.[55] As late as the 1950s, Virginians were still barbecuing meats on wooden hurdles set directly over hot coals. The design of the early twentieth-century Virginia barbecue "grills" remained very similar to those used by Virginians for hundreds of years before.

According to Boteler, the cooks employed "large log fires," or what we call today "feeder fires." From these, barbecue cooks made embers used to replenish coals in the barbecue pit. Although some famous Virginia barbecue cooks used chestnut wood, most preferred white oak or hickory when cooking barbecue, and they were careful to let it burn down to glowing coals that had no visible smoke rising from them before putting the meat on the barbecue grill.[56] Some Virginians took the extra effort to line their barbecue pits with stones.[57] In addition to barbecuing meat over coals, Virginia barbecue was sometimes "cooked on the coals" as described in 1883: "The old Virginia barbacued [sic] meats are of world-wide fame, and the system is simply to cook on or near coals in the open air."[58]

Since the early 1600s, Virginians have been using the classic Virginia barbecue sauce made of "vinegar, peppers, and other spicy condiments."[59] Cooks applied the sauce to meats as they barbecued. Some versions of the sauce included some type of oil, such as butter or lard. Virginians called the basting sauce "the seasoning" or "gravy" and applied it using "long switch mops"—or, as Boteler called them, "flexible wands."[60]

Virginians often took a minimalist approach to barbecue. In an 1839 account of a Virginia barbecue, it is stated, "Nothing else eatable accompanies the hogs, except plain bread."[61] An example of this practice still existing today is found in the famous Virginia barbecued chicken. Virginians barbecue chicken directly over coals on an open pit, seasoning it while it cooks with an old-school Virginia barbecue sauce made of oil, vinegar, salt, peppers, herbs and spices. Generally, hosts do not serve sauce on the side with it. The color of Virginia barbecue also demonstrates the minimalist approach. The barbecue cooked in Richmond in 1849 by a ruler of the roasts named Ben Moody was cooked until it had "just enough of the brown" before it was ready to eat.[62] The brown color of

MY RIDE TO THE BARBECUE:

OR,

REVOLUTIONARY REMINISCENCES

OF THE

OLD DOMINION.

BY AN EX-MEMBER OF CONGRESS.

With Twenty Illustrations.

NEW YORK:

PUBLISHED BY S. A. ROLLO,

169 AND 170 FULTON STREET,

OPPOSITE ST. PAUL'S CHURCH.

1860.

Cover page of *My Ride to the Barbecue*, 1860.

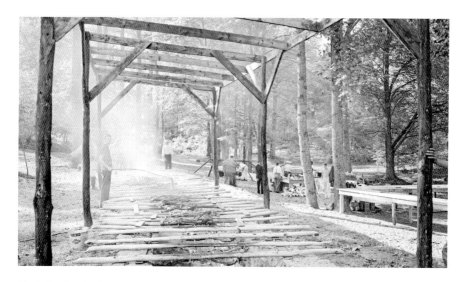

Cooks basting barbecuing meats with "flexible wands" at a barbecue in Charlottesville, Virginia, circa 1920s. Holsinger Studio Collection. *Special Collections, University of Virginia Library.*

the barbecued meat indicates that Virginia barbecue cooks didn't use elaborate rubs.

In colonial and federal times, well-to-do Virginians used expensive ingredients such as sugar, spices, sweet herbs, red wine and various ketchups in their barbecue recipes. Worcestershire sauce became commercially available in 1837.[63] By 1844, shops in Virginia were selling it with the pitch, "This sauce possesses a peculiar piquancy, and, from the superiority of its zest, is more generally useful than any other sauce."[64] Virginians were quick to begin using the sauce in their barbecue recipes as a replacement for the mushroom ketchup they used in earlier times.

An 1844 account of Virginia barbecue describes how the cooks allowed the barbecued meat to rest: "When the roasting is completed the fire is allowed to die out, but the ox remains upon the spit…until it is time to cut up the meat for dinner."[65] Resting meat allows the fat and collagen to cool and gelatinize, resulting in a moister product. Recently, people outside Virginia have called resting barbecue a "new barbecue truth."[66] However, in Virginia, resting barbecued meats is an old barbecue truth long practiced by Virginians.

On rare occasions, some nineteenth-century Virginia barbecue cooks boiled meat before barbecuing it. An 1872 account tells us:

> *There were five fat mutton, two beef and veal frizzing fragrantly over the fire all morning, the sweet savor sharpening the appetite…A deep, wide*

Old Virginia barbecued beef. *The Evening World,* August 18, 1906. *Library of Congress.*

ditch had been dug some three or four feet in the ground, and filled nearly with bark and dry sticks and set on fire. At one end of the ditch several large boilers were filled with the meat and parboiled. Across the other half of the trench stout green sticks were placed close together, and over the live coals the smoking embers having been raked away, was laid the meat, after having been boiled and gashed through and through. As it roasted over the fire, several Negro men were constantly busy with long switch mops, sopping a gravy of black pepper, butter, salt and vinegar from the bowls near by [sic] *and saturating the browning meat as fast as it dried. Near by were great hampers of bread and cold ham, buckets of lemonade, and long tables of pine planks spread under the trees.*[67]

Boiling meat before barbecuing is an old practice. People all over the South have been boiling meats before barbecuing them for hundreds of years—they just won't admit it.

Besides being known for pull-tender barbecued beef, Virginians have a tradition of serving higher-quality cuts of beef barbecued to the perfect doneness appropriate for the cut. An account of a barbecue held at Sandy Point in Westmorland County, Virginia, at Christmastime in the year 1900 mentions the practice. At this barbecue, cooks barbecued a deboned ox on a rotating spit rather than on a hurdle, and "one could have served at once, steak rare or well done, the rib roast, sirloin or porterhouse."[68] Barbecued brisket is a relatively new thing in Virginia. More traditional beef cuts served by Virginia barbecue cooks include beef ribs, chuck and top sirloin.

DRINKING PARTIES

Most accounts of Virginia barbecues from the eighteenth and nineteenth centuries describe wholesome events with very little rowdiness or bad behavior. For example, in French traveler Ferdinand Bayard's 1791 account of Virginia barbecues, he referred to them as "pleasure parties…without drinking and intoxication." This indicates that the Virginia barbecues witnessed by him were wholesome festivals.[69] However, that is not true of them all.

George Washington's diary entries for a few days after he attended Virginia barbecues indicate that he was relatively idle. After one barbecue, he even felt the need to go to church. One author has noted that this could be a subtle hint that some barbecues attended by Washington were quite rowdy and that he took time afterward to recuperate.[70]

In 1801, the South Carolina politician Ralph Izard wrote to his mother, "In Virginia they have once a fortnight what they call a fish feast or Barbicue [sic] at which all the Gentry within twenty miles round are present with all their families." He went on to comment, "I was very much surprised to see the Ladies young and old so fond of drinking Toddy before dinner."[71] Weld also mentioned that a Virginia barbecue "generally ends in intoxication."[72] At a 1788 Fourth of July barbecue in the Shenandoah Valley held near Federal Spring at General Wood's Plantation, the "jovial bowl and glass went briskly round after the repast."[73] Because of the heavy drinking that occurred at some Virginia barbecues, people took to calling some of them "drinking parties." In 1798, the architect of the United States Capitol, Benjamin Latrobe, recorded in his diary while in Alexandria, Virginia:

> About half-past eight the Philadelphia company of players who are now acting in a barn in the neighborhood came in in a body. They had been at a "drinking party" in the neighborhood. Once, in Virginia, these drinking parties had a much more modest name—they were called "barbecues." Now they say at once a "drinking party."[74]

John Burke wrote of eighteenth-century Virginia barbecues:

> Drinking parties were fashionable in which the strongest head or stomach gained the victory. The moments that could be spared from the bottle were devoted to cards. Cock-fighting, was also fashionable. I find in 1747, a main of cocks advertised to be fought between Gloucester and James River.

The cocks on one side were called Bacon's Thunderbolts, after the celebrated rebel of 1676.[75]

Clearly, Virginia barbecues could get rowdy at times. In another account of colonial Virginia, we find:

At all the county towns, east of the mountains, fairs were held at regular intervals, accompanied by sack and hogshead races, greased poles, and bull-baiting. In fine weather, barbecues in the woods, when oxen, pigs and fish were roasted, were frequent, and were much enjoyed by all, ending usually, among the lower classes, with much intoxication. Another great source of delight was the cock-fight. The small farmers assembled at the taverns to play billiards and drink. The monthly sessions of the courts filled the towns with a miscellaneous crowd.[76]

John Kirkpatrick was George Washington's military secretary. In 1750, he wrote to Washington complaining about life in Alexandria, Virginia, "We have dull Barbecues—and yet Duller Dances."[77] Apparently, Kirkpatrick was attending the tamer version of old Virginia barbecues. According to Washington, there was a time when Virginians made it a point of honor to send guests home drunk. In fact, Virginians had an informal "barbecue law" that held that the only excuse for refusing a round of drinking was unconsciousness.[78]

In colonial and federal times, Virginians would often engage in the post-dinner custom called "drinking healths." François-Jean de Chastellux (a French military officer) wrote:

These healths or toasts…have no inconvenience, and only serve to prolong the conversation…But I find it an absurd, and truly barbarous practice, the first time you drink, and at the beginning of dinner, to call out successively to each individual, to let him know you drink his health.[79]

Chastellux's reaction to drinking healths is amusing, although they didn't amuse him. He recounted how George Washington "usually continues eating for two hours, 'toasting' and conversing all the time." He waited a half hour after a round of toasting before being served supper with more bottles of "good claret and madeira wine."[80] Senator William Maclay recounted one of Washington's presidential dinners held around 1789:

Then the President, filling a glass of wine, with great formality drank to the health of every individual by name round the table. Everybody imitated him, charged glasses, and such a buzz of "health, sir," and "health, madam" and "thank-you, sir," and "thank-you, madam," never had I heard before.[81]

By the end of the eighteenth century, drinking healths was not as popular as in earlier times. In 1788, Washington explained, "People no longer forced drinks on their guests."[82] This change in attitude toward drinking at dinnertime eventually resulted in fewer barbecues that featured heavy drinking.

Thomas Jefferson was well acquainted with Virginia barbecues. He had at least one spring at Monticello that provided a popular spot for hosting them.[83] However, there are some indications that Jefferson wasn't fond of attending barbecues. This could be because he "was a man of sober habits." According to Peter Fossett, who lived enslaved at Monticello for eleven years until Jefferson's death in 1826, "No one ever saw him under the influence of liquor."[84] President Jefferson even abolished the practice of drinking healths at the presidential dinner table by replacing the "barbecue law" with the "health law." At one of Jefferson's dinners, a Mr. Carter asked a Mrs. Randolph to drink a glass of wine with him. Jefferson informed her that she was acting against the "health law." Jefferson then informed her that three laws governed his table: "no healths, no politics, no restraint." In an 1802 letter, John Latrobe described to his wife one such dinner: "I enjoyed the benefit of the law, and drank for the first time at such a party only one glass of wine, and, though I sat by the President, he did not invite me to drink another."[85] Physician and politician Samuel Mitchill left us his account of dinner with Jefferson:

The dinners are neat and plentiful, and no healths are drunk at table, nor are any toasts or sentiments given after dinner. You drink as you please, and converse at your ease. In this way every guest feels inclined to drink to the digestive or the social point, and no further.[86]

In 1808, President Jefferson's sister Anne Scott Jefferson attended an Independence Day barbecue in Charlottesville, Virginia. Jefferson chose not to attend. After consuming their share of the old Virginia barbecue, the men drank at least seventeen toasts.[87] That many toasts would certainly have been too many for "a man of sober habits." In reference to the event, Thomas Jefferson wrote to Ellen Wayles Randolph, "I thank heaven that

Richmond, Virginia, barbecue advertisement, the *Daily State Journal*, 1872. *Library of Congress*.

the 4th. of July is over. It is always a day of great fatigue to me, and of some embarrassments from improper intrusions and some from unintended exclusions." Sometime before 1820, Jefferson had stopped attending Virginia barbecues altogether, as evidenced by Elizabeth House Trist's letter to Nicholas P. Trist wherein she wrote, "Mr. Jefferson had an invitation to a barbecue near Charlottesville which he declined as he had long given up attending these festivals."[88]

By the end of the nineteenth century, people were not observing Virginia's "barbecue law" as stringently as in previous years. From 1879 we read, "A Virginia barbecue of the present day is hardly so rude as such occasions used to be."[89] By 1884, the only drink served at one Virginia barbecue was coffee.[90] However, in 1915 some Virginia Rotary Club members were visiting colleagues in Raleigh, North Carolina. The North Carolinians gave a barbecue for them so the Virginians could "see how the connoisseurs of the trenches prepare the stuff here [in North Carolina] without the liquid accompaniment that must always attend the Virginia barbecue."[91]

Augustus John Foster, a traveling Englishman, wrote of old Virginia barbecues in the very early 1800s that although horseracing and gambling were still a part of the festivals, cockfighting was on the decline.[92] The cruel game known as a "gander pull" was also nearing its end in Virginia.[93] A gander pull was a game where men on horseback would compete to be the first to pull the greased head off a goose that was hanging upside down from a limb or pole as they galloped past. As early as 1793, gander pulling contests were sparking criticism.[94] A writer in 1850 wrote insultingly of some people of whom he did not approve, "They would find themselves much more at home at a Virginia 'Gander Pulling.'"[95] Starting in seventeenth-century Virginia, gander pulling contests at barbecues eventually spread all around the United States.[96] The cruel game gave rise to the old saying, "Everything is lovely and the goose hangs high."[97] Some of the contests

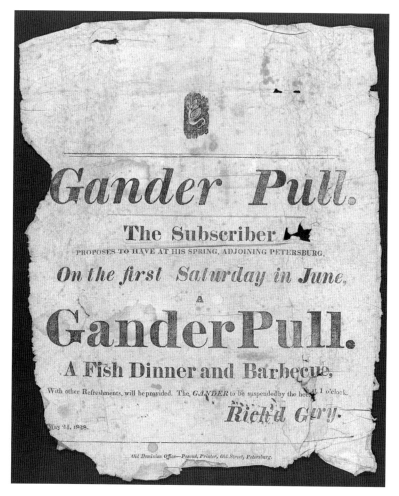

An advertisement for a gander pull, fish dinner and barbecue at Petersburg, Virginia, circa 1828. *Albert and Shirley Small Special Collections Library, University of Virginia.*

lasted as long as three hours with the same poor goose being tortured all that time. The practice was slow to die and would even linger in some parts of the country as late as the twentieth century.[98] A church festival, of all occasions, held in the year 1877 in Waco, Texas, featured a gander pulling contest. The Sunday school superintendent won.[99] This all happened in spite of claims made just a few months earlier that the cruel game "will not occur here [in Waco] again."[100]

A gander's whole neck is stripped of feathers, and whose head is well soaped, is suspended by the feet to a strong elastic branch or twig, about the height of a man's head on horseback; one of the company then sets off, full gallop; and the speed of his [illegible; gallop?] is urged by the application of the whips of his companions. In passing the gander, he endeavors to get hold of its head, and wring it off, the probability is, that the gander will elude his grasp; if, however, he gets hold of the head, he will either pull it off, or be dragged off his horse. In the event of pulling off the head, he is crowned victor, and the subscription money is devoured to a drinking match. If he does not succeed, another of the company follows close on his heels with equal speed, to try his fortune.

General Advertiser, "Description of a Gander Pulling,"
June 13, 1793

The cruelty of games like cockfighting and gander pulling, along with the drinking that went on at some Virginia barbecues, no doubt contributed to the negative impression of barbecues held by northerners. In 1825, a New Yorker commented, "In the minds of people in this part of the country, scenes of riot and intemperance are generally connected with the idea of a 'barbecue.'"[101]

GANDER PULLING CONTEST RULES

"A gander's head is offul hard to fetch," he said, "and the feller what gits it will yearn what he gits; but I don't say this to discourage any of you. I want you all to pull and show your spunk. It will add to the success of the pullin' to have you all in it." The rules were as follows:

First—Thou shalt not pull at the gander till thou hast paid a quarter a piece.
Second—Thou shalt ride each his own hoss and each one for hisself.

*Third—Thou shalst not pull at the gander if thy hoss is not in
 a gallop.*

Fourth—Thou shalst have five pulls at the gander for one quarter.

*Fifth—If thou pullest off the hed of the said gander thou shall have
 $2.50 for a quarter chance and $5 for two chances.*

Sixth—The hed of the said gander shall be greased.

Plain Dealer, *January 14, 1879*

Barbecue Clubs

By the middle of the eighteenth century, Virginians had officially established the first barbecue club in the history of the United States. It began early in the eighteenth century as informal meetings of community members near Richmond, Virginia. In the year 1788, members officially chartered the Buchanan's Spring Barbecue Club.

Buchanan's spring was located on a farm owned by Parson Buchanan about one mile outside Richmond. It was near what is today the 1000 block of West Broad Street.[102] The water that flowed from Buchanan's spring "was pure, transparent, cool and delightful, embowered under old oaks." It was a favorite spot for barbecues "because of its fine water, magnificent shade, perfect quietude and exemption from dust."[103]

Members of the barbecue club met every other weekend between the months of May and October (Virginia's barbecue season) in order to relax, converse, play games and enjoy Virginia barbecue. Two African Americans, Robin and Jasper Crouch, were the club's regular "caterers."[104] Chief Justice John Marshall was a founding member of the club, and his personal records indicate that he gave generous amounts of money to support it. In 1786, on one occasion he paid nine shillings for a barbecue, seven shillings for another and six shillings for yet another barbecue that year.[105]

Typical club meetings consisted of playing games such as quoits and backgammon and enjoying the company of friends. Dinner was usually ready around three o'clock in the afternoon and often consisted of "a fine fat pig" that was "highly seasoned with cayenne." An account of one meeting tells us that the barbecued mutton was "cooked to a turn," and the pork was "highly seasoned with mustard, cayenne pepper" and had a "slight flavoring

Right: Chief Justice John Marshall. Painting by Henry Inman, circa 1834. *Library of Virginia*.

Below: The Cool Spring Barbecue Club, circa 1880. Notice the Indian-style hurdle and forked posts. *From the Duke Family Papers, Albert and Shirley Small Special Collections Library, University of Virginia*.

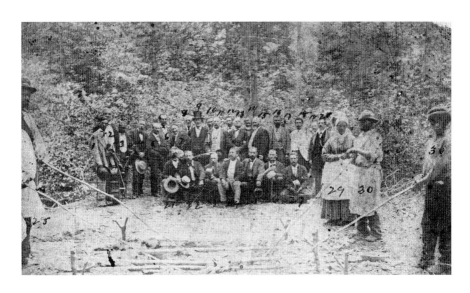

of Worcester sauce" probably imparted by mushroom ketchup.[106] Desserts consisted of melons and fruits followed by punch, beer and toddy, as well as mint juleps made using the cool waters from Buchanan's spring.[107]

Club meetings continued at least until the early months of the Civil War, although by that time the meeting place had changed to an island in the James River. As late as 1862, "Respectable strangers, and especially foreigners, are always invited to the feast of the Barbacue," and club members were still enjoying Virginia barbecue, toddy, juleps and quoits.[108] Richmond was also home to the Clarke's Spring Barbecue Club, established a few years after Marshall's club.[109]

Colonel Richard Thomas Walker (R.T.W.) Duke Sr. was born in Charlottesville, Virginia, in 1822. He was a graduate of the Virginia Military Institute. In his lifetime, he was a lawyer; the commonwealth attorney for Albemarle County, Virginia; a Congressional representative; and a veteran of the Civil War. In the period of 1899–1926, his son, R.T.W. Duke Jr., wrote in detail about Virginia barbecues held after Virginia's Reconstruction era at his father's estate in Albemarle County, Virginia, named SunnySide.

In the 1870s, Duke and his friends and neighbors established the Cool Spring Barbecue Club with Duke as its first president. The club met at the "Barbecue Spring" located about half a mile away from SunnySide. The spring, with its "exceedingly cold" waters and located at the foot of a hill surrounded by trees, was perfectly suited for "old fashioned Virginia barbecues," which were held near it for longer than anyone could remember.

Duke wrote a detailed account of how the Virginia barbecue cooks worked their magic at the pits and shared their recipe for Brunswick stew. The barbecued meats included young pigs, lambs and chicken basted with a mixture of the classic Virginia barbecue baste of butter, vinegar, salt and pepper.

The Brunswick stew recipe called for squirrel when it was available. If no squirrels were available, chicken filled Duke's pot. The stew recipe is a classic Virginia style that includes middling (described as a "streak o'fat & streak o'lean"), Worcestershire sauce, tomatoes, butter beans and red pepper. Duke commented, "You were tempted to eat so much of it, that it took away your appetite for the delicious barbecued meat."[110] Duke's accounts also make it clear that the club still observed Virginia's barbecue law.

There are many long-held and wonderful barbecue traditions in the United States, but Virginia's is the longest. Virginia's barbecue traditions set the standard for southern barbecues and provided the model for them all throughout the South. Because Virginia is "the Mother of Commonwealths," "the Ancient Dominion," "the Old Dominion," "the pride of the Union,"

"the nursery of Republican statesmen" and "the Mother of the South," it is easy to see how Virginia's influence and barbecue tradition spread throughout colonial America.[111]

"A GANDER PULL!!!"

You've heard of cock-fights-baits of bull—
Did you ever, of a Gander pull?
If you havn't, I have, so I'll tell,
And mind you understand me well.
A pole is cut, tall, limber, sound—
And one end fastened to the ground;—
A fork about the middle's placed,
And 'tother end is upwards raised.
A rope from upper end's let loose
And holds the legs of the gander or goose,
Whose neck is of its plumes released,
And then made slick by being greased.
One on each side, with whip in hand,
To urge the horses, takes the stand—
And now all preparation's done,
Each rider mounts—and now the fun!
Bestride on horse, or mule, or ass,
Each round the circle swift doth pass,
And as each comes by the goose quite,
Gives her a pull with all his might;
Who straight doth squall, but squalls not long,
For death soon interrupts her song.
And now the crowd full of delight,
Gaze on enraptured at the sight;
And in each changing of the game
Join in the laugh and loud acclaim.
Here comes a whiskered son of man,
The foremost of the hopeful clan,
Who gives a pull both hard and long,
That head must come were neck not strong.

His knees rise o'er his donkey's mane,
And neck as arched as a crane;
His stirrups short, his heels appear
Far out behind his horse's rear.
With six inch spurs he is supplied,
But can't for life, touch horse's side.
Next rides a youth, with no less grace,
With sanguine hope marked in his face—
A mouth that might tempt fair one's kisses—
So eager, lo! the head he misses,
And passes on—and close beside
Comes something like a man astride.
At this unlucky time, alas!
The goose doth squall—the horse won't pass—
And whip, and spur, and cane, and curse,
But tend to make the matter worse,
For backward, like a crab he goes,
His rump where ought to be his nose.
Next comes a Yonker on a mule,
His beast, by much, the lesser fool,
With pendent ears and meekest face
That well attest his honored race.
His gait is borrowed from the snail,
And nothing moves him but a frail.
The knowing ones back well his rider,
Whose face is marked with grog or cider;
Whose heaving chest is full and wide,
And well his brawny arm was tried,
His hair hung flowing o'er his face,
His nose was in the proper place—
His head too was on nature's plan,
Upon the shoulders of a man.
And round and round they move amain,
And pull and pull, but all in vain.
(A head of twenty summers' growth
To leave its parent stock is loth.)
While some were landed in the dirt,

Some tore a coat and some a shirt;
And once our friend of the long hair
Had been suspended in the air
Before the manly sport was done—
Before the prize was lost and won.
At last a waiter-jointed fellow,
With countenance savage, meagre, sallow,
Having slyly roughed his soapy hand
By rubbing thoroughly with the sand,
Stretching thin as any slab—
Reached up and gave the head a grab,
And bore it down upon his hip
With claws of a most giant grip—
With clenched teeth and glaring eyes
He bore away the bleeding prize.
The earth did tremble with the shout,
And thunders seemed to burst about.
"Huzza!" was heard on every side,
And rode the victor in his pride.
Ye that have witnessed no such scene
Have not been blessed as I have been:
And should you hear of one about
You'll go and see—yourself—no doubt.
Good-night unto you old and young,
Just read the song which I have sung;
And should it not be neat and plain
Then are my labors all in vain.

Robert Francis Astrop, *Original Poems, on a Variety of Subjects, Etc.* (1835)

CHAPTER 5
BARBECUING IN THE VIRGINIAN MANNER

The mode of roasting, too, was primitive—reminding one of the picture in
Captain John Smith's True Travels, Adventures, and Observations,
wherein is given the Indian method of cooking fish, which was simply to build a
platform by laying sticks across four stakes driven in the ground, and make a fire
beneath the platform, and place the fish upon it to be broiled.
–Colonel Thomas H. Ellis commenting on how Virginians cooked barbecue in
the early 1800s, from the Virginia Cavalcade *(Summer 1965)*

In order to understand how southern barbecue first developed in Virginia,
we must focus on interactions between Europeans, Native Americans,
Africans and African Americans who lived together in early seventeenth-
century Virginia. Together, they gave us cornbread, Virginia hoecake,
Virginia smoked ham and Virginia barbecue. Just as Virginia hospitality
would spread to become southern hospitality and Virginia smoked ham
would spread to become country ham, so would Virginia barbecue spread
throughout the South to become southern barbecue.[1] The "mingling" of
Indians and colonists explains why Europeans in seventeenth-century
Virginia, who were accustomed to cooking with equipment made of metal,
suddenly started cooking meat on "a framework of sticks suspended upon
forked posts." In recognition of the collaboration between Virginia's Indians
and Virginia's colonists, the 1887 edition of *A New English Dictionary on*
Historical Principles (the original edition of the *OED*), noted, "The Virginia
barbacue [*sic*] and the French boucan were all derived from the names of

the high wooden gridiron or scaffolding on which Indians dried, smoked, or broiled their meats."[2]

The learned scholars who painstakingly compiled the original edition of the *OED* recognized that Virginia colonists employed Powhatan hurdles to become the first to cook southern barbecue.

GRAND BARBECUE

At the expense of being tedious, I will undertake to tell briefly how this is done in Virginia: A pit is dug in the ground with a surface measurement of about 6x8 feet, and a depth of about 7 feet. On the night before the day of the barbecue the pit is filled with white-oak or hickory wood, or both, which is burnt to live coals, so that when the meat is placed in position for cooking the coals reach within two feet of the top of the pit. The ox is split down the backbone just as old hare is prepared to be barbecued. Poles long enough to extend across and rest on the sides of the pit are thrust through the animal and he is then suspended over the fire, from which no smoke arises. As the cooking progresses he is basted at short intervals with a rich, aromatic dressing. The time consumed in the barbecue is about eight hours.

About 3 o'clock the guests were assembled on both sides of long tables and invited to indulge themselves in the following bill of fare: Ox roasted whole, mutton roasted whole, old Virginia ham served as it is in old Virginia and nowhere else, fried chicken, catfish chowder, squirrel soup, Caroline chub thrown from water into the pan, and all vegetables which belong to this season.

Richmond Dispatch, *"Grand Barbecue," September 6, 1885*

CARBONADO

Virginia colonists brought European cooking techniques and recipes with them when they arrived in Virginia during the early years of the seventeenth century. In colonial times, Virginians endeavored to emulate European customs, especially when it came to entertaining guests at

THE ENGLISH
HOVSE-VVIFE.
CONTAINING

The inward and outward Vertues which
ought to be in a compleate Woman.

As her skill in Phyſicke *,* Surgery *,* Cookery*,*
Extraction of Oyles, Banqueting ſtuffe, Ordering of
great Feaſts, Preſeruing of all ſorts of Wines, Concei-
ted Secrets, Diſtillations, Perfumes, ordering of Wooll,
Hempe, Flax, making Cloth, and Dying, the know-
ledge of Dayries, office of Malting, of Oates,
their excellent vſes in a Family, of Brew-
ing, Baking, and all other things
belonging to an Houſhold.

A Worke generally approued, and now the fourth time much
augmented, purged and made moſt profitable and
neceſſary for all men, and the generall good
of this Kingdome.

By G. M.

LONDON.
Printed by *Nicholas Okes* for IOHN HARTSON, and are to
be ſold at his ſhop at the ſigne of the golden
Vnicorne in Pater-noſter-row 1631.

Cover page from *The English Housewife. Library of Congress.*

meals.[3] Because most colonists were not trained cooks, they made good use of cookbooks. Of course, for much of the seventeenth and eighteenth centuries, most Virginians didn't have the means to set an elegant, European-style table. Therefore, less well-to-do Virginians improvised using American ingredients, such as corn and wild game, in European-style recipes.

By 1620, Virginians had imported *The English Housewife*, a cookbook written by Englishman Gervase Markham.[4] Another cookbook that most likely influenced colonial Virginia cooks, first published in 1584, is entitled *A Book of Cookrye*. These cookbooks contain numerous recipes for carbonadoing and roasting foods that would become colonial Virginia staples such as venison, beef, mutton and pork, all with sauces made of spices, vinegar, pepper and butter. Some called for mustard and/or sugar added to the mix.[5] The English of the sixteenth century also liked to mix mustard with horseradish and vinegar or wine for use as a sauce for roast beef.[6]

Markham's carbonado recipe requires the cook to "scotch" (score) the meat before seasoning it with salt and melted butter. Markham recommended against the traditional way of carbonadoing meat on a gridiron because fat dripping into the coals below it will make it "stink." Therefore, he recommends hanging the meat on a broiling iron and setting it close beside the fire in a way similar to roasting. A broiling iron is a sheet of iron with hooks on it to hold the meat. The broiling iron, with the meat hanging on it, is set before the fire so that smoke could not reach the meat while the broiling iron reflected heat toward it.[7] The recipe calls for serving the carbonado with a sauce made of butter and vinegar on the side.[8]

The admonition to avoid smoke flavor and a smoky smell in carbonadoed meat was common. Sixteenth-century English writer and inventor Sir Hugh Platt wrote a book published in 1602 entitled *Delights for Ladies*. Sir Platt devised his own technique for preventing the dreaded smoke smell and flavor in carbonado. He prescribed "dipping-pans of paper" using starch to hold the corners together, wetting them and placing them on the gridiron. By shielding the meat from smoke using a "pan," there is a reduced possibility of smoke making it "stink."[9]

Carbonado goes back to at least the fifteenth century. An Italian cookbook of that era includes a recipe for meat cooked "in carbone" or on the coals. According to some scholars, this is the origin of the sixteenth- and seventeenth-century English carbonados. Most old English recipes for carbonado call for scoring or beating the meat with the back of a knife

Colonial Virginia gridiron. *Jamestown-Yorktown Foundation, author's collection.*

before grilling it on a gridiron without Markham's broiling iron or Platt's paper pans.[10]

Scoring meat, as prescribed in carbonado recipes, increases its surface area, exposing more surface to high heat. This improves the flavor of the meat due to the increased area subject to caramelization and browning. Some carbonado recipes called for elaborately spicing the meat with things like ginger, fennel, mace and cloves in addition to the vinegar, salt, pepper and butter.

In the 1822 edition of *The Cook's Oracle*, carbonadoing is synonymous with broiling and grilling meat after scoring it. However, the old warning, "never hasten anything that is broiling, lest you make smoke and spoil it" is still given. Therefore, this book recommends an upright gridiron. The author also recommends boiling the meat before grilling it, writing, "Boil it—score it in checkers about an inch square."[11]

The eighteenth-century recipes for broiled meats shared in Mary Randolph's *The Virginia Housewife* clearly show that old English carbonado recipes influenced Virginia cookery. For example, the recipe for "Beef Steaks" instructs the reader to "beat them a little" before broiling them. While the steaks are broiling, you must be careful to prevent fat from dripping into the coals because it will "cause a bad smell." In her recipe for "Veal Chops," Randolph advised the reader to wrap the chops in paper after beating them and to broil them "taking care the paper does not burn."[12] This is similar to Platt's paper "dipping-pans."

```
                THE

        VIRGINIA HOUSEWIFE:

                OR,

          METHODICAL COOK.

       ━━━━━━━━━━━━━━━━━━

        BY MRS. MARY RANDOLPH.

         ━━━━━━━━━━━━━━━

     METHOD IS THE SOUL OF MANAGEMENT

      ────────────────────────

           STEREOTYPE EDITION,
        WITH AMENDMENTS AND ADDITIONS.

      ────────────────────────

            BALTIMORE:
       PUBLISHED BY PLASKITT, & CUGLE.
              218 Market Street.
               • • • • •
                 1838.
```

Cover page of the 1838 edition of *The Virginia Housewife*.

Carbonado recipes influenced Virginia barbecue recipes. Harkening back to *barbecado*, the first known use of an English version of the word *barbecue* in literature, colonists recognized the similarities between a barbecue grill and a carbonado grill. Heeding the carbonado warnings against smoke causing the meat to "stink," Virginians were careful to let the wood in barbecue pits burn down to glowing coals that had no visible smoke rising from them before putting the meat on the barbecue. Colonial Virginians also used the carbonado sauce recipes made of salt, vinegar, butter, peppers, herbs and spices to baste barbecuing meats while they cooked. By combining the Powhatan Indian cooking technique using a hurdle with English carbonado recipes, Virginians gave the world what we now call southern barbecue.[13]

VIRGINIA-STYLE EUROPEAN FESTIVALS

To antebellum Virginians, barbecue was a community food, and a barbecue was a community event. Because fresh meat will spoil quickly in hot Virginia summers, barbecues were a way to enjoy summertime feasts of fresh meat. Because diners consumed the meat in one sitting, there was no need to store leftovers.

There is strong European influence on old Virginia barbecues. In England, people held feasts to celebrate the end of harvest time. Virginians added their own touch to this practice by holding barbecues after harvest. Drinking

Ox Roasted Whole.

At the Democratic Barbecue at the Fair Grounds next Saturday, an ox will be roasted whole. The Republican party will be treated in like manner on the 8th of November. Some of the fagots for that purpose will be provided by Messrs. Breckinridge and Conrad on Saturday.

An 1892 advertisement for a Virginia barbecue from the *Staunton Spectator*, October 12, 1892. *Library of Congress.*

"healths" at dinner was a practice imported from England. Colonial Virginians commemorated important English events with barbecues and games such as foot races, horse races, boat races, shooting matches, quoit games, nine pence loo, greased poles, bull baiting, cockfights and gander pulls.[14] Those were "rough, honest English sports" often engaged in for nothing more than a jug of whiskey. Upper-class Englishmen were the first to engage in the cruel game called gander pulling. An account recorded in King Edward VI's diary for June 4, 1550, tells of a group of men who competed to be "the first to take away a goose's head which was hanged alive on two crossed posts."[15]

The phrase "ox roasted whole" is an old English phrase that goes back at least to the seventeenth century.[16] Even though Virginians barbecued beef at barbecues rather than roasting it, the phrase caught on in Virginia before spreading throughout the other colonies.

The Virginian custom of holding barbecues at weddings comes from English customs. For example, in celebration of Queen Victoria's marriage to Prince Albert in 1840, revelers feasted on "an ox roasted whole," a "very fine sturgeon" and plum pudding washed down with generous quantities of ale, porter and punch, much as had been done for centuries before.[17] Even though Virginia barbecue was cooked in a different manner than English roast ox, Virginians retained the English phrase "ox roasted whole" when

referring to barbecues where beef was served. Colonial Virginians were also famous for their barbecued sturgeon because it was particularly delicious when barbecued.

The custom of firing guns at funerals is another European custom. Gunfire often accompanied barbecues given for mourners in Virginia. In fact, weddings and funerals were the only colonial Virginia "entertainments" where it was legal to discharge firearms. Today, the custom of firing guns at funerals takes the form of the twenty-one-gun salute. The American tradition goes back to colonial Virginia's earliest history. In 1608, when one of John Smith's companions died while they were on an expedition near what is now Fredericksburg, Virginia, Smith wrote, "[W]ee buryed him with a volley of shot."[18]

AMERICANIZATION

No matter how hard Virginians may have tried to maintain a purely English identity, the facts of life in Virginia made it impossible. Based on more than one hundred years of ethnographic, historical and archaeological research, scholars who have studied seventeenth-century Chesapeake culture have clearly identified Native American influences among Virginia colonists. The adopting of Indian ways was most prominent in several contexts, including food, hospitality, trade, plantation life and interactions between male Europeans and female Indians.[19]

Nineteenth-century American historian Frederick Jackson Turner wrote, "In the crucible of the frontier the immigrants were Americanized, liberated, and fused into a mixed race, English in neither nationality nor characteristics." Turner continued, "The wilderness puts a European in a canoe and strips off the garments of civilization" and "arrays him in the hunting shirt and the moccasin." The next thing you know, those European settlers are "planting Indian corn and plowing with a sharp stick," and the "outcome is not old Europe." What results is a "new product that is American."[20] Turner's observations summarized the experience of Virginia colonists and frontier settlers.

The "Americanization" of Virginia colonists began early in the colony's history. John Smith mimicked Indian behavior when he dispersed the population of settlers away from Jamestown in 1609. This gave the colonists a larger area from which to gather resources while moving them to healthier environments, just as it did for the Powhatans.[21]

"The Virginia Mountaineer" in "Indian dress." *From* Harper's New Monthly Magazine *(June 1876)*.

When Englishman William Strachey arrived at Jamestown in 1610, he described how the colonists had adapted their houses after the way Powhatan Indians built and decorated their homes. He wrote, "A delicate wrought fine kind of mat the Indians make, with which (as they can be trucked for, or snatched up) our people do dress their chambers and inward rooms…they have found the way to cover their houses, now (as the Indians) with barks of trees, as durable and as good proof against storms and winter weather as the best tile."[22]

By 1610, colonists were making tobacco pipes with techniques learned from Powhatan Indians. In fact, archaeologists often have difficulty determining if colonists or Powhatans made the pipes that they discover. One archaeologist remarked that Virginia's colonial era pipes show "how much those two societies [European colonists and Powhatans] were mingling."[23]

Powhatan Indians even taught colonists how to catch fish by constructing nets and weirs and how to dry them on hurdles to preserve them.[24] It makes sense that if Powhatan Indians taught the colonists how to fish, part of the lesson would have involved the construction and use of canoes. As late as

1774, an eyewitness tells us that at that time Virginians were still fishing from canoes just like Powhatan Indians.[25] The cultural exchange between Powhatan Indians and English colonists was apparently much greater than John Smith ever admitted.

Archaeologists discovered the only canoe recovered in Virginia from the early colonial period near the James River in the 1960s. Its construction exhibits traditional Powhatan techniques, but some parts of it show unmistakable signs of metal tools.[26] Authorities disagree over whether Powhatans constructed the canoe before colonists modified it or if Powhatans constructed it using tools they acquired from colonists. However, there is the possibility that colonists constructed it using a mix of Powhatan and English techniques.

Early colonial Virginians also adopted Powhatan Indian farming techniques.[27] According to John Smith, in 1609, two enslaved Chickahominy Indians named Kemps and Tassore "taught us how to order and plant our fields."[28] In 1588, Harriot wrote that Indian farmers "neither plow nor digge it as we in England."[29] The tools Powhatan Indians used for farming included primitive digging sticks and hoes. They didn't use plows, and they did not have beasts that could pull them.

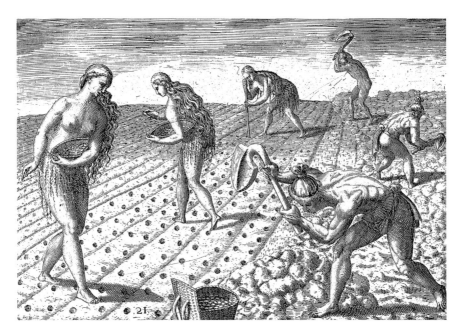

Native Americans planting seeds, circa 1591. *Library of Congress, Rare Book and Special Collections Division, LC-DIG-ppmsca-02937.*

Virginia colonists almost completely abandoned the English way of plowing fields and adopted a very "Indian-like" way of farming. As early as 1615, there were only "three or foure Ploughes [plows]" in all of Virginia. In the 1620s, Virginians used oxen mainly for hauling heavy loads rather than for pulling plows. By the 1650s, there were only about 150 plows in the entire colony of twelve thousand people. It was said in 1686 that Virginians "do not know what it is to work the land with cattle," which, of course, implies the use of plows.[30] As late as 1732, an eyewitness reported, "They dont generally Plow their Land but Manage it with the Broad Hough, tho I have seen some Ox ploughs."[31] In 1776, Virginia planter Landon Carter recorded that his father never used a plow but reaped more than he could with them.[32] In the early 1770s, Englishman Nicholas Cresswell observed farmers near the Potomac River planting tobacco by hoeing the soil into little hills and then using a small stick to make a hole for the seed.[33] Colonists learned this farming technique from Native Americans.

As colonists and settlers moved westward and staked out plots of land, they often "tomahawked" trees in order to mark property boundaries.[34] That was the method originally used by Indians to mark trails and boundaries. Colonists and frontiersmen called it trail blazing.[35] As colonists took over Indian lands, even their settlements resembled Indian villages.[36]

In 1749, Moravian missionaries were traveling through the edge of the colonial frontier in what is now Bath County and Allegheny County, Virginia. They encountered a camp of settlers whose closest neighbors were Native Americans. The account illustrates how isolated settlers adapted in Virginia:

> *Then we came to a house, where we had to lie on bear skins around the fire like the rest. The manner of living is rather poor in this district. The clothes of the people consist of deer skins. Their food of Johnny cakes, deer and bear meat. A kind of white people are found here, who live like savages. Hunting is their chief occupation.*[37]

These "Americanized" settlers adopted Indian foods and Indian ways of living off the land. Another account of the Virginia frontier tells of German and Scotch-Irish settlements where women went "naked" and had Indian hairstyles. The men wore Indian-style breeches and moccasins about which one settler humorously commented that in wet weather they were "a decent way of going barefooted." The men would wear war paint and deerskins when they went to war on behalf of their Indian friends. In addition, we

General Washington greeting Morgan's Virginian Riflemen in their "Indian clothing." *From Harper's New Monthly Magazine (June 1876).*

are told, they were so proud of their "Indian like dress" that they even wore it to church services. Their diet included Native American foods such as hoecakes and "jerked" meat.[38]

Marching off to fight during the Revolutionary War, Virginians put on their hunting shirts "fringed around the neck and down the front, leather leggings, and moccasin…Each wore a buck tail in his hat, and had a tomahawk and scalping knife in his belt." Others painted themselves "like Indians."[39] Even George Washington was known to "set out on foot in Indian dress" from time to time during the French and Indian War.[40] Virginians in Fairfax, Virginia, distinguished themselves from the English by wearing uniforms that included "painted Hunting-Shirts and Indian Boots." Upward of one thousand "brave hearty men" gathered at Fredericksburg, Virginia, with their "hunting shirts Belts and Tomahawks fixed off in the best manner."[41] Daniel Morgan's famous Virginia riflemen dressed in "Indian clothing," which included hunting shirts, leggings and moccasins, and all were equipped with tomahawks and scalping knives. George Washington recommended to Morgan that he should dress a "[c]ompany or two of true Woods Men…

Indian style," and when they attack, they should be "screaming and yelling as the Indians do."[42] Clearly, Morgan's strategy against the British included tactics he learned from the Indians.[43] The "uniforms," equipment and tactics used by Virginia's Revolutionary War soldiers sent a clear message to the

Ole Virginny Barbecue: A Characteristic March and Cake Walk, circa 1899. *York University Libraries, Clara Thomas Archives and Special Collections, John Arpin fonds, JAC001015.*

British that Virginians were no longer English subjects of the king; they were Americans.

Dancing was a favorite pastime of Virginians of all ranks, from enslaved people to the common planter to the gentry. Just as it was in Europe, each group had its own preferred dance styles. As one writer put it, "Virginians are of genuine Blood—they will dance or die!"[44] This is similar to how Powhatan Indians, the original Virginians, also loved to dance, as they, too, often gathered for "lively games, music and dancing."[45] Following the Powhatan Indian practice, Virginia colonists gathered for "lively games, music and dancing" at barbecues. Even today, Cherokee Indian influence remains in the folk dance style known as clogging.[46]

A practice of several Native American tribes when greeting guests was to pass a pipe filled with tobacco and a bowl of spring water, or other drink, around as a show of hospitality.[47] Colonists in the Chesapeake region had a similar custom at barbecues and fish fries, described in 1791 by Bayard:

> As soon as a guest arrives he is offered cold punch in a large porcelain bowl. This large drinking vessel, which often holds three or four bottles, is passed around in the circle of guests and is pressed to all the lips. Few Frenchmen can adapt themselves to this ancient manner of drinking; and in America, where nearly all the men chew tobacco, it is extremely nasty…as for me, when I was thirsty, and when lips, still stained with tobacco juice, bathed themselves in the drink which immediately afterwards was to be offered to me, I would curse very heartily that sharing of the vessel.[48]

Bayard's European repulsion to the shared punch bowl custom is understandable. Here you have a clear account of colonists in the Chesapeake region practicing Native American customs while engaging in an outdoor feast.

Virginia Hospitality

Virginia's Indians were the first to practice Virginia's famous hospitality.[49] Hospitality was an integral part of Powhatan Indian culture that allowed Indian leaders to show their people generosity, display their prestige among the tribes, build political ties and return favors. Because the early colonists were guests in Tsenacommacah (what Powhatans called Virginia;

pronounced "Sen-ah-cóm-ma-cah"), they had to observe Powhatan customs in order to be good neighbors.

John Smith wrote fondly of the hospitality shown to him and his group by the Kecoughtan Indians: "[W]e were never more merry, nor fed on more plentie of good Oysters, Fish, Flesh, Wilde foule, and good bread." Another feast given for John Smith by the Powhatan Indians was so lavish that he had the absurd suspicion that they were fattening him up to eat him.[50]

Virginia hospitality developed very early in the history of the colony, as we read from as far back as 1624 that "neither have new Comers any reason to complain, when every Man's House is, without Recompense, open to the Stranger, even to the disaccommodating [inconveniencing of] ourselves. So that we may with Modesty boast, that no People in the World do exercise the like Hospitality."[51]

Dutchman David Peterson de Vries traveled through Virginia in 1632 and wrote, "At noon we came to Littleton, where we landed and where resided a great merchant named Mr. Menife, who kept us to dinner and treated us very well."[52] Beauchamp Plantagenet told of the "kind entertainment" he received at the houses of Captain Matthews and Master Fauntleroy in Newport News and how he received "free quarter everywhere."[53] After his arrival in Virginia in 1649, Colonel Henry Norwood commented on the hospitality of Virginians, writing, "As we advanced into the plantations that lay thicker together, we had our choice of hosts for our entertainment, without money or its value; in which we did not begin any novelty, for there are no inns in the colony; nor do they take other payment for what they furnish to coasters."[54] Hugh Jones wrote in 1724, "No People can entertain their Friends with better Cheer and Welcome."[55] Lord Adam Gordon wrote of Virginia in the 1760s, "The inhabitants are courteous, polite and affable, the most hospitable and attentive to Strangers of any I have yet seen in America."[56] Francis Louis Michel wrote of Virginians in the eighteenth century, "It is possible to travel through the whole country without money."[57] Dolley Madison sometimes worried that she and her husband, President Madison, would be "eaten out of house and home" because of the constant stream of visitors that they graciously entertained.[58]

In addition to strong hospitality customs, Powhatan Indians also had a strong custom of reciprocity. When one would give a gift to another as a sign to acknowledge and reinforce their relationship, the custom required that the recipient offer a gift in return. According to Professor Joan Pong Linton, the reciprocity custom is on display in a conversation John Smith had with Chief Powhatan. Powhatan complained to Smith that although he had treated

Smith with much kindness, Smith responded with the "least kindness" and would only offer him nothing but "what you regard not, and yet you will have whatsoever you demand."[59] Although they eventually learned their lesson, the early failure of the colonists to understand this reciprocal aspect of Powhatan culture played a role in the deterioration of relations between them and the Indians.[60] Similar to Powhatan Indians, colonial Virginians

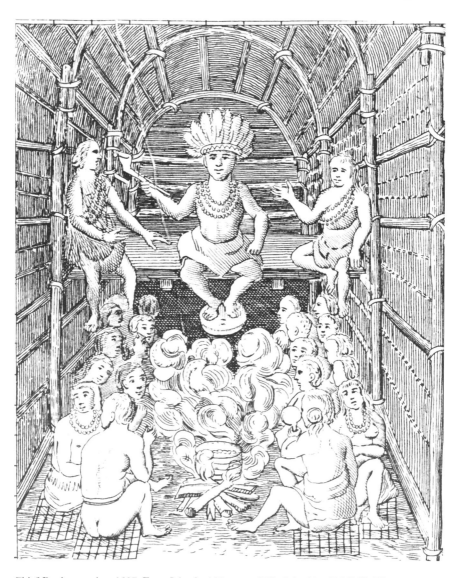

Chief Powhatan, circa 1607. From John Smith's map of Virginia. *New York Public Library*.

eventually formed similar interconnecting social networks based on family, neighborhood and financial ties. These networks resulted in the emergence of a shared sense of mutual interdependence and community that fostered the popularity of barbecues and the custom of hosting them in turns as described in 1858: "This neighborhood would begin this Saturday, and invite the adjoining neighborhood. That neighborhood would reply next Saturday and then a third, a fourth, and so on."[61]

In 1656, English colonist John Hammond wrote about Virginia hospitality, Virginia's system of reciprocity and interdependence:

> *In summer when fresh meat will not keep (seeing every man* [kills] *of his own, and quantities are inconvenient), they lend from one to another, such portions of flesh as they can spare, which is* [repaid] *again when the borrowers kils his. If any fall sick, and cannot compasse to follow his crope* [cannot work his fields] *which if not followed, will soon be lost, the adjoyning neighbour, will either voluntarily or upon a request joyn together, and work in it by spels, untill the honour* [the ill neighbor] *recovers, and that gratis* [free of charge], *so that no man by sicknesse loose any part of his years worke. Let any travell, it is without charge, and at every house is entertainment as in a hostery* [tavern], *and with it hearty welcome are stranger*[s] *entertained.*[62]

Taking turns sharing fresh meat for barbecues supports historian Jan Lewis's assertion that an unspoken reciprocal pledge was the basis of colonial Virginia society where each favor had a corresponding reciprocal expectation.[63]

Hog and Hominy

Colonists in Virginia, either out of necessity or taste, developed an appetite for Powhatan foods and recipes. This fact indicates that food culture, in particular, can provide insight into the cultural exchange between colonists and Indians.[64] The colonial Virginia diet is a view into how people of different cultures collaborated to develop a uniquely American cuisine that persists to this day. Two of the best representations of that cuisine is Virginia smoked ham and the Virginia smokehouse.

Even though English cooks of the past warned that smoke makes carbonado "stink," Virginia colonists eventually developed a ravenous taste

for pork barbecued or preserved with hickory smoke and salt. "Indian corn" made into hoecakes (johnnycakes) using a Powhatan Indian recipe was also ubiquitous in colonial Virginia. This is highlighted by the eighteenth- and early nineteenth-century historian William Dunlap when he described Virginia as "the land of Hog, homminey [sic] & hoe-cake," indicating the importance of smoked pork and "Indian corn" in Virginians' diets.[65] In the late 1700s, a poet quipped, "It's bacon, bacon, is their fare; They'd sooner choose to live on air, Than too much fresh, or too much fish, For bacon's the Virginian's dish."[66] Dunlap's description of Virginia indicates that even from the earliest times, colonial Virginia cookery was, in many respects, a mix of Native American and European cookery, with African influences becoming prominent as more and more people of African descent entered the colony.

Virginians used to have a saying: "We had a hog killin'est time!" It harkens back to the times when community members gathered from November to January for hog killing time and made a party of it. The hams, shoulders and bacon were smoked and other parts cut up for sausage and middling. The fat was used to make lard, and the fat around the entrails was used to make soap.[67]

During the Civil War, Union soldiers in Virginia encountered so many hogs that they called them "Virginia rabbits."[68] Falmouth, Virginia, was nicknamed "Hogtown" in colonial times because of all the hogs that used to run freely around the area, and that name stuck well into the twentieth century.[69] Hog Island in Northampton County, Virginia, gained its name because early Jamestown settlers kept their "hogges" there.[70] In 1796, the town of Fredericksburg, Virginia, had so many hogs roaming the streets that it passed an ordinance requiring authorities to capture them.[71] If the owner failed to claim her or his hog within ten days, authorities sold it at auction. Of course, this meant that barbecues were very popular.[72]

President John Tyler's son explained how colonial- and federal-era Virginians raised hogs and cured hams. Hogs ran free in the woods, where they feasted on foods such as acorns, herbs, chestnuts and roots in the first summer and fall of their lives. On mornings and evenings, the farmer trained the hogs to come to him by calling to them while feeding them corn. Farmers kept the pigs in shelters with bedding on winter nights. During the second fall after harvest time, the pigs were free to forage in the cornfields. Besides the leftover corn, the pigs also ate black-eyed peas planted between the rows of corn. After the pigs had depleted the peas, farmers fed them almost exclusively on corn until slaughter time in December. The pork was cured in salt before being smoked using hickory wood. After the smoking

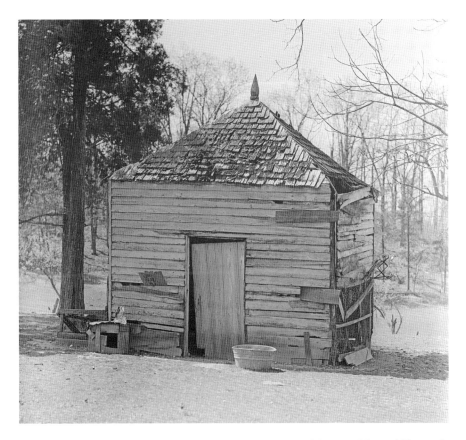

Smokehouse in Fredericksburg, Virginia, circa 1930s. *Library of Congress, Prints and Photographs Division, HABS VA,89-FRED.V,3--2.*

process ended, the farmer rubbed the hams with sugar before returning them to the smokehouse or the meat house for storage.[73]

Although the colonial Virginia practice of allowing hogs to run free was brought from England, the way Virginians smoked pork in a detached smokehouse was not.[74] The meat curing techniques brought to Virginia by early English colonists involved preserving meat in salt or pickling it in vinegar.[75] Because salted pork often spoiled in Virginia's climate, colonists sought alternative ways of preserving it.[76] They found inspiration from the Powhatan Indians.

The earliest use of the phrase "smoak house" exists in a York County, Virginia plantation's records from the year 1716.[77] Archaeologists discovered the oldest archaeological evidence for detached smokehouses in Virginia at "Pope's Clifts Plantation," which dates to at least 1670.[78] However, well

before the 1670s, Virginians were smoking pork in buildings dedicated for the purpose.

As early as 1639, Virginians were exporting smoked pork to England, which strongly implies the use of detached smokehouses.[79] By 1649, the sale of Virginia smoked pork could enable a man to earn enough money to "woo a good man's daughter."[80] By 1688, Virginia smoked pork was well known and considered to be among the finest in the world. John Clayton wrote of Virginians in that year, "Swine, they have now in great abundance, Shoats or Porkrels are their general Food; and I believe as good as any Westphalia, certainly far exceeding our English."[81] When we consider Karen Hess's culinary law that print always lags behind practice, it's clear that smokehouses have been in use in Virginia much longer than the written and archaeological records have been able to determine.

Seventeenth-century European smokehouse designs included tall, slender structures with a detached firebox situated to the side of the building and, sometimes, below the surface of the ground. Other Europeans made "smokehouses" by framing out a portion of a house's attic above the fireplace. A hole in the chimney allowed smoke to enter.[82] However, there is no written or archaeological evidence that Virginians adopted either of those European designs.

Colonial-era smokehouses in Virginia were eight to fourteen feet square, often with steep pyramidal roofs that channeled smoke around the cuts of meat hanging from overhead structures.[83] A pit or fireplace in the center of the floor generated smoke. Vents in the roof or around the perimeter allowed excess smoke to escape. The design of Virginia smokehouses strongly resembles the design of Powhatan Indian houses, down to the location of the fire inside them.

The perpetual fires that burned in Powhatan Indian homes resulted in smoke lingering in the upper portions of the structures.[84] Benefits of Powhatan smoky houses included how the smoke preserved not just the roofs of the houses but also the foods that were stored in the ceilings. Colonists, in their search for a better way to preserve pork in Virginia's hot and humid climate, noticed this proven design.[85]

The old saying, "When in Rome do as the Romans do" highlights the principle at work. In other words, when in Tsenacommacah, do as the Powhatans do. Soon, the colonists were building their own "smoky houses" modeled after Indian homes and smoking meat rubbed with hickory ash in much the same way as Indians smoked and preserved meat.[86] As late as the 1820s, Mary Randolph's recipe for smoked pork still included a rub made

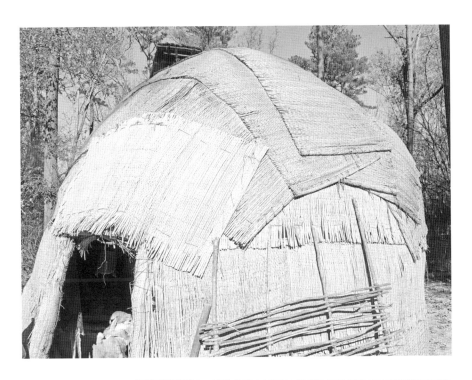

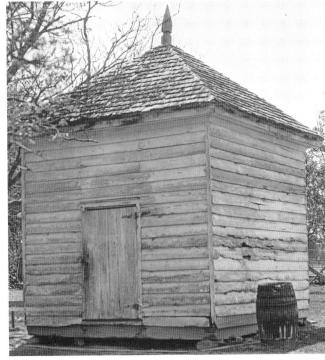

Above: Powhatan Indian house with smoke vent in roof. *Jamestown-Yorktown Foundation, author's collection.*

Right: Smokehouse near New Kent County, Virginia, circa 1930s. *Library of Congress, Prints and Photographs Division, HABS VA,64-BAR,1--1.*

with hickory ash.[87] Virginia colonists developed Virginia's famous smoked pork by combining Indian meat preservation techniques with their own meat preservation techniques using salt (when it was available) and, eventually, saltpeter and sugar.[88]

Enslaved Cooks

Unlike the Spanish, who decided at the start that enslaved Native Americans and Africans would provide the labor required for their endeavors in the New World, the Virginia Company in London initially rejected that approach. Instead, it devised the headright system as the official method used to bring laborers to the colony. After Bacon's Rebellion broke out in 1676, Virginians took steps that put the colony firmly on the path to officially adopting slavery.[89] However, for decades before 1676 and the official recognition of slavery in 1661, colonial Virginians were enslaving Native Americans; that practice started as early as 1609.[90] This is why Thomas Jefferson wrote, "An inhuman practice once prevailed in this country of making slaves of the Indians."[91]

The early development and growth of slavery in Virginia was a complex process with multiple phases and significant differences from region to region.[92] Before Virginians enslaved large numbers of people of African descent, Virginians had already enslaved untold numbers of Native Americans.[93]

The latest research on slavery in Virginia separates it into three main stages. In the first stage, the enslaved population was almost exclusively Native American. In the second stage, the enslaved population was a mix of Native Americans and people of African descent. In the third stage, the enslaved population was mainly people of African descent.[94]

Colonists kept some Native Americans enslaved in North America. They sold some to plantations in the Caribbean. Slave traders even sold them away to places as far away as China.[95] We may never know the entire scope and scale of Native American slavery in the North American colonies due to the lack of detailed records, but all indications imply that it was vast. Current estimates indicate that 40 percent of all enslaved people in some parts of late seventeenth-century Virginia were Indians, and as many as half of all enslaved children in most seventeenth-century Virginia counties were Indians.[96]

The category of "Indian" was finally recognized and added to the federal census in 1870. However, before and even after that development, record keepers listed Native Americans as "Black," "Negro" or "Mulatto" in official records.[97] This common practice sometimes blurs our ability today to determine if an enslaved person listed in historical records was of African or Native American descent. This wasn't only a Virginia practice; emerging research implies that on occasion, Caribbean plantation bookkeepers who originally recorded some slaves as being "Indian" later crossed that out and wrote "Negro" in its place.[98] Historian Edmund Morgan commented on the inaccurate documentation of race in official records based only on skin color, "Indians and Negroes were henceforth lumped together in Virginia legislation, and white Virginians treated black, red, and intermediate shades of brown as interchangeable."[99] Because slave owners assigned cooking duties to enslaved people, we should expect contributions to Virginia cookery from Native Americans, Africans and African Americans.

The African American influence on the development of southern cuisine is well established and documented. Up until the early twentieth century, African Americans made up the largest group of barbecue experts in Virginia. Their expertise has left an indelible mark on southern barbecue that persists to this day. Karen Hess observed that African Americans "changed the English palate into the Virginia palate." Because enslaved people did the cooking, it is only natural that each cook's unique abilities—what Hess calls "wok presence"—would shine.[100] It is a fact that enslaved people all across the South perfected southern barbecue. However, the first enslaved people to cook what we would call today "southern barbecue" were enslaved Native Americans in Virginia.

In early seventeenth-century Virginia, men outnumbered women by as much as four to one.[101] This was no doubt difficult for Englishmen, as they traditionally considered "men's work" to be of more value than "women's work." The lonely young male colonists looked to Powhatan women as a source of companionship and labor for cooking and cleaning. As a result, colonial-era men often took enslaved Indian women as wives. Powhatan women did most of the cooking and farming for their tribes. Therefore, they were very capable of filling those roles for colonists. Sometimes through marriage, sometimes through trade and sometimes through enslavement, Powhatan women played a significant role in shaping the unique culture that developed in Virginia.[102]

From the earliest days of colonization, colonial leaders sent colonists to live with Powhatan Indians in their homes in order to learn their language

and customs. Often, Powhatan Indians reciprocated by sending Indians to live with the colonists, apparently for the same reasons. As early as 1612, upward of fifty Virginia colonists had married Indian wives.[103] There were many more marriages and affairs between colonists and Indians in the years that followed. For example, heartbroken Alice Clawson of North Hampton, Virginia, divorced her husband in 1655 because he refused to give up his Indian concubine.[104]

As settlers moved farther west in Virginia, it was important to keep peace with nearby tribes by becoming their allies. Part of those arrangements included trading for enslaved Indians from enemy tribes farther south and west. Even though the Virginia legislature established laws against enslaving Indians, apparently, those laws referred only to Indian tribes who were in proximity to settlements. Europeans wanted to remain at peace with them at least until the settlers' numbers grew enough to be able to force the Indians out of the region.[105] Colonists in South Carolina also adopted this practice. In the very early 1700s, rather than enslaving Native Americans who lived in South Carolina, plantation owners there enslaved Native Americans who came from a "far distance from us, belonging to the *French* and *Spanish* Tearitories [territories] in *America.*"[106]

In 1673, French explorers, led by Father Jacques Marquette, met the Chickasaw Indians on the Mississippi River. The Chickasaws fed the Frenchmen with barbecued buffalo and fresh plums. The wide array of European equipment carried by the Chickasaws impressed Father Marquette. The neighboring Shawnee Indians didn't have the European trade goods or guns from which the Chickasaws benefited. Marquette recorded, "The Iroquois are constantly making war upon them, without any provocation…and carrying them into captivity." When asked about how they received their European goods, the Chickasaws explained that they "bought their goods from the Europeans, who live towards the east." Marquette noted, "I did not see anything about them that could persuade me that they had received any instructions about our holy religion," which pretty much eliminated the Spanish and French as the source of the European goods.[107] That means that the likely trading partners with the Chickasaws who exchanged European goods for enslaved Shawnee Indians were Protestant English traders from Virginia.[108]

In 1675, the fall line of the Rappahannock River at what is today the city of Fredericksburg, Virginia, was on the edge of the colonial frontier. A part of the mission of an army stationed there was to kill and enslave Indians. In fact, by 1682, a trader who managed an outpost there named

Cadawallader Jones claimed that "indyan children prisoners" were among his most valuable goods.[109]

Virginians were enslaving Indians from places as far away as the areas known today as Florida, Alabama and Mississippi. A Tawasa Indian named Lamhatty escaped from enslavement by the Shawnees. He made the long journey all the way from what is today Alabama to a plantation in Virginia near the Mattaponi River in the winter of 1708. Not only was Lamhatty eventually enslaved by Virginians after he arrived there, but to his surprise, he also found others of his own people in Virginia who were also enslaved. He recounted how the Tuscaroras had taken him captive and traded him to Creek Indians, who then traded him to the Shawnees.[110] Beverly wrote:

> *After some of his* [Lamhatty's] *Country folks were found servants… he was sometimes ill used by Walker* [the Virginia plantation owner who enslaved him], *became very melancholly after fasting & crying several days together sometimes useing little Conjuration & when warme weather came he went away & was never more heard of.*[111]

Early in Massachusetts history, some wealthy families employed Indians as cooks. Colonial-era newspapers in New England occasionally printed advertisements such as "[a]n Indian woman who is a very good cook," "[a]n Indian woman…fit for all manner of household work," "[a] lusty Carolina Indian woman fit for any daily service" and "[a]n Indian woman and her child…is a good cook."[112] A pamphlet written in order to lure colonists to South Carolina recommended that new plantation owners purchase "[t]hree Indian Women as Cooks for the Slaves."[113] These records strongly imply that the male majority among Virginia colonists also employed or enslaved Native Americans as cooks.

As late as 1833, we find in a description of Virginia fish feasts a reference to African American and Native American cooks where the author gave praise to them, writing, "After the fisherman comes the cook! And no matter what may be his color—an Indian or African sun may have shown [*sic*] upon him. He is yet more entitled to the 'highest consideration.'"[114] This statement strongly implies that Indians were enslaved and employed as cooks in Virginia even as late as 1833.

Clearly, enslaved African Americans made an indelible and defining mark on southern cookery. However, we shouldn't ignore the Native American impact on Virginian and southern cookery. It is as certain that enslaved Indians put their mark on Virginian and southern cookery as it is that enslaved African Americans made their mark.

Because Indian women cooked the only way they knew how, they most certainly constructed hurdles from time to time on which to prepare foods for colonists, as well as a "high stage" on which to smoke meats. Because Native Americans from many regions of what is today the United States were slaves in Virginia, Virginia's culinary history includes influences from many different Native American cultures in addition to Virginia's Powhatan Indians.

Virginia-Style Native American Festivals

The exchange of food cultures laid the foundation for Virginia cookery as colonists in Virginia added Native American foods, cooking techniques and seasonings to their European and African recipes and cooking methods. The use of sassafras as a seasoning by frontiersmen in the Blue Ridge along with the use of maple sugar and the use of hickory wood for salt and smoke are all Native American contributions to Virginia barbecue seasonings.[115]

Native Americans who lived in and around Virginia taught colonists how to dig pits in the ground to hold the burning coals under barbecue grills. Indians in the James River Valley used to burn hardwood down to coals in shallow pits before placing meat on hurdles over them. In fact, Indians were more likely to barbecue meats over open pits when they were cooking for festivals attended by many people. The large "roasting pits" or "barbecue holes," as archaeologists call them, were shallow and usually one to two meters in diameter. Indians used them for special occasions, and they were different from the stone hearths they used during day-to-day cooking.[116]

William Bartram wrote about the special-occasion barbecue cooking technique used by Indians. Although he described how they barbecued foods by drying them, when he described how the meats were prepared at feasts, he described meat barbecued in a way that is similar to how we cook southern barbecue, writing that it was "excellently well barbecued." In another passage, he wrote, "The ribs and the choice pieces of three great bears, already barbecued or broiled, were brought to the banqueting house."[117]

Virginia colonists adopted Indian "barbecue holes," which they would call barbecue pits. Like Indian "barbecue holes," southern barbecue pits are also different from the hearths used for day-to-day cooking. All of this is another testament to the North American Indian origins of southern barbecue and supports the assertion that Virginia colonists not only adopted the barbecue

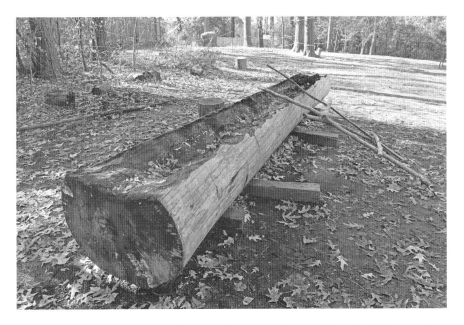

The Powhatan method of burning logs to make canoes also served as a feeder fire to make coals used for cooking. *Jamestown-Yorktown Foundation.*

cooking method from Native Americans but also adopted the Indian practice of serving tender and juicy barbecued meats when holding large feasts and celebrations. Virginians even adopted the Powhatan Indian custom of giving leftovers from barbecue feasts to poor and enslaved people.[118]

A Virginia Barbecue

An agreeable and retired place is selected, near some spring and pleasant grove. On the previous day, some favorite Negro man of reputation for skill and experience in the business, is sent up with his assistants, who proceed to make a sort of kiln or pit of stones. Hogs of middling size, having due proportion of fat and lean, are then selected, dressed, and put to roasting, and constantly watched and turned during the night, and until they are ready, on the next day noon. They are sopped or basted with a sort of preparation of vinegar, peppers, and other spicy condiments, every moment during the cooking until the attack. When the proper

147

time arrives (and every estated gentleman prides himself on telling at a glance whether the thing is done right, 'with just enough of the brown') the animals are laid whole upon boards, and the company assembled round to feast. It then becomes the duty of every gentleman to feed the ladies, that, to carve out those fat, spicy, rich and delicious morsels from the right places, and with ready tact. Nothing else eatable accompanies the hogs, except plain bread, with a few bottles of liquor for those who like it. These occasions are not usually large, but quiet and social; somewhat like a Massachusetts picnic party, and commonly given in turns by the owners of plantations. Sometimes the cost is previously estimated, and an assessment is made upon each gentleman for the amount. This is generally the arrangement when the party is given for political purposes, by the friends of a candidate for office. The feasting over, if the weather be fine, singing claims attention, or the company adjourn to the neighboring house for a dance, leaving the remains of the entertainment to the Negroes, who, in their turn, feed, rejoice, and make merry.

Huron Reflector, *July 2, 1839*

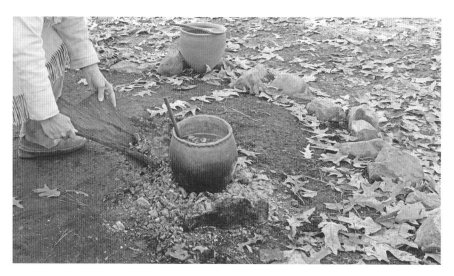

How Powhatan Indians moved coals from the "feeder fire" to the cooking area. *Jamestown-Yorktown Foundation, author's collection.*

We can see another glimpse of Native American influence on southern barbecue in the "feeder fire." A feeder fire is a separate fire used for burning large pieces wood down to coals for replenishing barbecue pits as the cook progresses. Boteler wrote in 1860 about a Virginia barbecue pit that "was a bed of glowing coals that was replenished from time to time from large log fires kept constantly burning close by for that purpose."[119] Because they didn't have iron tools, Native Americans would often burn fallen trees. As the large pieces of wood burned, they used shells or sticks to scrape away coals for use in the cooking area. As the coals in the cooking pit burned out, they replenished them from the larger fire.[120]

> Adjacent to the spring is a shady grove, in which we found the principal improvised tables arranged for dinner in the form of a quadrangle, inclosing an area of at least an acre, in the center of which was a large tent or booth, filled with a great variety of provisions. In convenient proximity to the tables the culinary operations were progressing upon a scale of profuse abundance, and after a fashion that was no less primitive than profuse.
>
> There appeared to be about half a hundred whole carcasses of full-grown and well-fattened sheep and hogs, each having two long iron rods run through its length—"barbe à queue"—so as to keep it spread open in the position termed by heraldic writers "displayed." These were all laid across a trench (the projecting ends of the rods resting upon each side thereof), which was about a hundred feet in length by four deep, and in the bottom of which was a bed of glowing coals, that was replenished from time to time from large log fires kept constantly burning close by for that purpose. At suitable intervals along the sides of the trench were iron vessels, some filled with salt, and water; others with melted butter, lard, etc., into which the attendants dipped linen cloths affixed to the ends of long, flexible wands, and delicately applied them with a certain air of dainty precision to different portions of the roasting meat. This part of the process was done with such earnest solemnity of manner, as to impress a beholder with the conviction that there was some important mystery meant by the particular mode in which the carcasses were so ceremoniously touched with the saturated cloths. During this operation, other attendants were

> *busily engaged in turning over the huge roasts, one after another,*
> *so that all sides of each should be done equally alike.*
>
> Alexander R. Boteler, My Ride to the Barbecue, or,
> Revolutionary Reminiscences of the Old Dominion (1860)

Native Americans were also the first to employ the old Virginia method of barbecuing meats directly on coals. Robert Beverly described the technique when he wrote that Indians "have two ways of Broyling, viz. one by laying the Meat itself upon the Coals, the other by laying it upon Sticks rais'd upon Forks at some distance above the live Coals."[121]

THE IMPORTANCE OF CHILI PEPPERS

Just about every southern barbecue sauce today includes some combination of vinegar, salt, black pepper and red pepper. This is also true even in central Texas. Although some barbecue restaurants there take pride in not offering barbecue sauce on the side, you can still find a bottle of hot sauce on the table made of vinegar, salt and hot peppers. Even Alabama white barbecue sauce has vinegar, salt and red pepper in it. This custom of flavoring barbecue with a mixture of vinegar, salt and peppers originated in Virginia in the early 1600s. Virginia colonists began using chili peppers in their cookery after "red-pepper" seeds were gifted to the governor of Virginia by Bermuda's governor in 1621.[122] In colonial times, red pepper served as a substitute for black pepper. Apparently, black pepper wasn't widely used in colonial America until after Hannah Glasse's English cookbook arrived around the 1750s and 1760s.[123]

Mary Randolph included a Virginia recipe for "Pepper Vinegar" made with chili peppers in her classic 1824 cookbook *The Virginia Housewife*. In a nod to how Virginians used red pepper to substitute for black pepper, she wrote that pepper vinegar's flavor is "greatly superior to black pepper."[124] Spices such as black pepper were often scarce in colonial Virginia, especially during the first few decades, and they were expensive simply because they had to be imported.[125]

Not only were spices expensive, but they were also relatively difficult to acquire, especially for enslaved people and those who lived closest to the

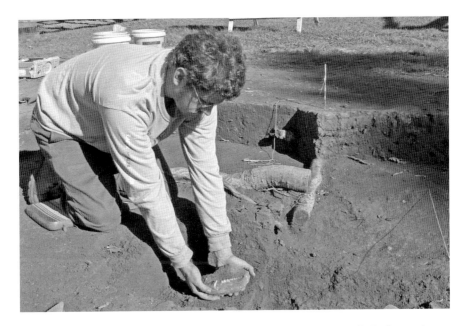

Archaeologist Matt Greer recovering a juvenile pig's (shoat's) jawbone from the barbecue pit discovered in Montpelier's South Yard. The pit was in use during President James Madison's lifetime. *Photo by Matthew Reeves, courtesy the Montpelier Foundation.*

frontier regions. Even salt was scarce at times.[126] Colonists could make vinegar and butter, but black pepper and salt, except for small quantities made using seawater, had to be imported. However, some people in areas of Virginia farther inland and in mountainous regions were able to acquire salt from springs. In 1786, Lawrence Butler of Westmorland, Virginia, explained that if settlers in western Virginia didn't have access to the salt springs in the region, they would have to carry "[s]alt from Philadelphia or Alexandria to fort Pitts which is 300 miles over very bad Mountainous Country and then 700 miles down the Ohio by Water which would make the Salt very high [in price]."[127]

If salt was hard to get on the frontier, black pepper must have been even more difficult to acquire. Therefore, instead of buying black pepper, settlers grew chili peppers and dried them to make red pepper. This sheds light on Karen Hess's assertion that "the use of hot peppers in traditional Virginia cookery was highly skilled and discreet, just enough to brighten the taste, not to set it afire."[128] Hess's conclusion reflects the fact that Virginians used just enough red pepper in recipes to mimic the slight burn of black pepper. In fact, that practice is rooted in why chili peppers have the name "peppers" in the first place.[129] Because they could grow red peppers at little cost, Virginians

dried and crushed them to make what they called "home-grown" or "home-raised" pepper.

Enslaved people did not often have access to expensive ingredients and seasonings. Louis Hughes was born enslaved in Virginia. When he was twenty-two, a plantation owner in Mississippi bought him at a slave auction in Richmond. In 1897, Hughes wrote of antebellum Fourth of July barbecues held on plantations, "[T]he cooks basted the carcasses with a preparation furnished from the great house, consisting of butter, pepper, salt and vinegar."[130] In another account of Independence Day barbecues shared by an unnamed former slave, we are told, "Yes, honey, dat he did gib us Fourth of July—a plenty o' holiday—a beef kilt, a mutton, hogs, salt, pepper, an' eberyting."[131] These statements imply that slave owners only gave enslaved people fresh meat on special occasions, and the same was true of black pepper.

The fact that plantation owners would not provide expensive black pepper to the people they enslaved, at least unless there was a special occasion, gave rise to the spicy recipes developed by African Americans in colonial times as much as flavor preferences did. Slave owners found it cheaper to let enslaved people grow their own red pepper than to buy black pepper for them. Even in the twentieth century, there were African Americans in South Carolina born as late as 1914 who still had never seen black pepper.[132] Because of the expense and difficulty of acquiring black pepper, people from all walks of life in colonial Virginia grew chili peppers. George Washington and Thomas Jefferson grew cayenne peppers and bird peppers.[133] Enslaved African Americans in Virginia grew both of those chili pepper varieties, as well as fish peppers, and therefore used them in their barbecue recipes.[134]

THE FIRST SOUTHERN BARBECUE SAUCE

From the earliest colonial times, Virginians held "entertainments" and feasted on Virginia barbecue basted with a sauce made from humble ingredients that they grew or made, such as butter, vinegar and red peppers. This is the Virginia origin of the first southern barbecue sauce in history, and it eventually spread throughout the colonies and has been the basis for barbecue bastes and sauces all over the southern United States for hundreds of years.

Recalling life on an antebellum plantation in North Carolina during the first half of the nineteenth century, Confederate chaplain James Battle

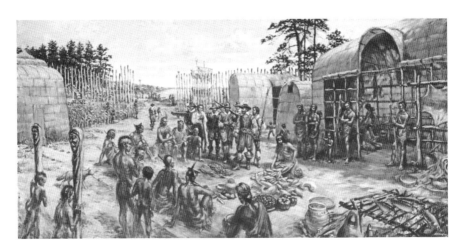

"Trading with the Indians," by Sydney E. King. *National Park Service, Colonial National Historical Park, Jamestown Collection.*

Avirett recounted how an enslaved man named Uncle Shadrac used to barbecue hogs and bullocks basting them with a long-handled mop after dipping it into a pan of "vinegar, salt and home grown red pepper."[135] As late as 1884, barbecue cooks in Georgia were basting barbecue with a sauce "made of homemade butter, seasoned with red pepper from the garden and apple vinegar."[136] Virginians, who had been using that basic recipe for barbecue "sauce" since the early 1600s, taught those old recipes to cooks in Georgia and North Carolina.

As mentioned, Virginia barbecue developed when Virginians combined Native American cooking techniques with English recipes and seasonings. African American cooks perfected it. This explains how barbecuing "in the Indian manner" developed into barbecuing in the Virginian manner. Historian Charles Campbell observed, "Their [Powhatan Indians'] cookery was not less rude than their other habits, yet pone and hominy have been borrowed from them, as also, it is said, the mode of *barbecuing* meat."[137] Columnist Irvin S. Cobb wrote in 1913, "From the Indian we got the original idea of the shore dinner and the barbecue, the planked shad and the hoecake. By following in his footsteps we learned about succotash and hominy."[138] Virginia barbecue demonstrates the "mingling" of European and Indian cultures as strongly as any other colonial practice, including the making of pipes, eating hoecakes and wearing buckskins.

CHAPTER 6

VIRGINIA'S NINETEENTH-CENTURY BARBECUE MEN

Juba—whose face is blurred stands in front & to the side of her [his wife Mandy]. *With the death of these Negroes the art of "barbe'cuing" has welnigh passed away, only Caesar Young—my servant—surviving to remember the art. He is one year younger than I am & when Caesar goes, as far as Albemarle is concerned the "barbecue" will practically go out of existence—that is the barbecue in its best form.*
–R.T.W. Duke Jr., Recollections *(courtesy the University of Virginia, Albert and Shirley Small Special Collections Library)*

There was a time when Virginia barbecue was famous all over the country and around the world. Thirty thousand people were enticed to attend a barbecue held in 1856 outside Boston by advertisements that Virginia barbecue cooks were preparing the barbecue.[1] In 1897, the *Saint Paul Globe* reported plans for an "old-fashioned Virginia barbecue" at the Minnesota state fair that year.[2] In 1900, organizers of the World's Fair in Paris, France, chose Virginia barbecue cooks to represent American barbecue cooks.[3] In 1909, more than thirty thousand people enjoyed "a Virginia barbecue" in Harrisburg, Pennsylvania.[4]

Today, history has forgotten most of the names of the countless Virginia barbecue cooks who have lived over the last four centuries. However, those people who did the hard work of digging the trenches, chopping the wood and staying up all night ruling the roasts are who made Virginia barbecue famous.

VIRGINIA BARBECUE

The first barbecue cooks in Virginia were either enslaved Native Americans or Native Americans employed by colonists. Later, the job of cooking barbecue transitioned to indentured servants and enslaved Africans and African Americans. By the early nineteenth-century, Virginia's barbecue men had opened barbecue restaurants long before the first recorded barbecue restaurant in North Carolina opened in 1899. In fact, the earliest American restaurant known to advertise barbecue on the menu did so in 1798 in Alexandria, Virginia.[5]

RICHARD STRATTON

Richard Stratton began cooking Virginia barbecue and Brunswick stew in the year 1869. One of his satisfied customers boasted, if you have never tasted Brunswick stew cooked the way "old Uncle Dick" prepared it, you "have not yet tasted one of the most savory dishes known to the human palate." Just as other Virginia barbecue cooks of his era, Stratton used to lay hickory sticks across a pit filled with hot coals in order to support the barbecuing meats. Stratton's happy patrons also raved about his Virginia-style barbecued sheep, which "was as sweet as the tenderest venison."[6]

WILLIAM "BLACK HAWK" HAISLIP

Around the turn of the twentieth century, "an aged white-haired native of Spotsylvania Courthouse" known as "the best barbecue cook in the state" was William Haislip—or, as his friends called him, Black Hawk. By the turn of the twentieth century, Black Hawk was eighty years old and was often the master of ceremonies at large barbecues in Virginia. Like so many other Virginia barbecue cooks, he was very proud of his skill at the pits and boasted that he was "the only man in the state competent to cook a whole ox properly." In 1900, Black Hawk invited President William McKinley to one of his barbecues held in October of that year. Black Hawk, we are told, "had no trouble seeing the President."[7]

In 1855, the People of Fredericksburg and the surrounding counties held a Fourth of July barbecue. So much food was served that it required twelve cooks working two days to prepare it and one hundred and fifty waiters to serve it. The bill of fare illustrates why Virginia barbecues were so famous.

8 Saddles Mutton	16 Fore Quarters Mutton	20 Roasted [barbecued] pigs
32 Quarters of Shoat	8 Shoat Hind Hashed and Stewed	26 Fore Quarters of Lamb
20 Hind Quarters of Lamb	500 Chickens	16 Quarters of Veal
4 Veal Heads– Stewed	30 Hams of Bacon	20 Pieces of Beef (10 lbs. each)
750 Loaves of Bread	6 lbs. Black Pepper	50 lbs. Lard
60 lbs. Butter	10 Bushels Potatoes	6 Bushels Beets
5 Bushels Onions	320 Heads of Cabbage	10 Gallons of Vinegar
120 lbs. Crushed Sugar	1 Gallon Currant Jelly	3 lbs. Mustard
1 Gallon Sweet Oil	2 Boxes Lemons	150 Quarts Wine
40 Gallons Whiskey	14 Bottles Brown Stout	6000 Feet of Lumber for Tables

Fredericksburg Herald, *July 9, 1855*

JASPER CROUCH

Jasper Crouch was a famous caterer in Richmond, Virginia, during the early 1800s known for his skill in barbecuing shoats and for his old Virginia toddy.[8]

Two unidentified soldiers of the Richmond Light Infantry Blues, circa 1862. *Library of Congress, Prints and Photographs Division, LC-DIG-ppmsca-37395.*

He was the barbecue cook and "major-domo" for the Buchanan's Spring Barbecue Club and the Richmond Light Infantry Blues. The Richmond Light Infantry Blues, also called "the Blues," was formed sometime around the year 1790 and often hosted festive gatherings. A famous relic at outings hosted by the Blues was their thirty-two-gallon punch bowl known as "his majesty." Crouch, as the "special attendant of his majesty," often filled it with

punch, julep or toddy. Crouch made his famous punch with "four-fifths of brandy to one of rum" and just a splash of Madeira. A bowl one-third full of ice cooled the sweet mixture. Crouch's hospitality and kindness "could not be surpassed." Crouch's delicious barbecue was often "highly seasoned with mustard, cayenne pepper" and mushroom ketchup. When Jasper Crouch died, the Blues buried him with full military honors.[9]

Charles W. Allen

Charles W. Allen of Lexington, Virginia, was a highly sought-after Virginia barbecue cook in the late nineteenth century. Described as a mulatto man who knew "all that is to be known about conducting a barbecue," he was much in demand all over the eastern United States.[10] He was about fifty years old in 1894 when hired to travel to Boston to prepare an old Virginia barbecue feast hosted by Father John Cummins in Boston, Massachusetts. Cummins was determined to bring one of the "real old Southern festivities" to Boston. To ensure that outcome, he hired Charles Allen, a Virginia barbecue cook. Allen and his team of six assistants barbecued a one-thousand-pound ox and several shoats. His wife and his brother, Joel, assisted him. Allen continued as Cummins's barbecue cook for several years at his "genuine old time Virginia" barbecues that he hosted in Boston.

Allen employed two methods for barbecuing an ox, and both methods took about twelve hours to complete. One of Allen's techniques was to barbecue the ox by spitting the carcass on a large tripod. He would then barbecue it "feet up" with the interior filled with corn, sweet potatoes and other vegetables.

His other technique was to split the ox carcass much as a hog is split before barbecuing it. He would then lay the carcass on the barbecue grill directly over burning coals. He and his assistants would fasten a pipe lengthwise in the carcass, and with the help of ropes and pulleys, four men could move the ox into just about any position Allen desired. Allen and his cooks would use a knife to make incisions in the meat that were filled with salt, pepper and other secret ingredients, much as some in our times inject meats before barbecuing them. He also basted the meat with a "savory sauce" made from a secret recipe that he claimed to have acquired from a famous French chef; that claim was probably an embellishment.[11] In 1897, Allen cooked "the largest ox ever barbecued in Boston."[12] If true, that must have been a very large ox. In 1895, Allen barbecued an ox in Boston that weighed more than 1,400 pounds.[13]

CHARLES W. ALLEN OF LEXINGTON, VA.,
WHO WILL "BARBECUE" THE OX.

Left: Charles W. Allen, the *Boston Herald*, August 27, 1894. *Boston Public Library.*

Below: Beef being barbecued nineteenth century style, referred to as the "ox roasted whole." *From* Harper's Weekly *(November 11, 1876).*

The official program for Father Cummins' Sixth Annual Barbecue, circa 1899. *Boston Public Library.*

JOHN DABNEY

John Dabney, born in Hanover County, Virginia, in 1824, was "a celebrated

cook and caterer" in Richmond, Virginia, who was described as "universally polite and courteous." Author Thomas Nelson Page wrote that Dabney "was the best caterer I ever knew."[14] For many years, he managed nearly all of the big barbecues given in and around the Richmond area. He was "the best man living to mix mint juleps" that had "the real old Virginia flavor."[15] Dabney's mint juleps were so delicious that they were literally fit for royalty. During his visit to Richmond, Virginia, in 1860, the Prince of Wales, who would become King Edward VII, praised Dabney's mint juleps.[16] Dabney was "a real old-fashioned Virginia cook," and he, like Jasper Crouch, often prepared meals for the famed Richmond Light Infantry Blues.[17]

Sometime before the start of the Civil War, Dabney purchased freedom for himself and his wife. He was allowed to make payments over time for the agreed-on amount, which he did until the entire debt was paid. During the war, Dabney continued to make payments on the debt he owed. By the end of the Civil War, he had paid the full amount for his wife's freedom but still owed several hundred dollars for his own. However, because Confederate money became worthless as the war progressed, his old master asked him to discontinue payments until after the war was over, which he did.[18]

At the close of the Civil War, even though all formerly enslaved people were free, Dabney felt that he still owed several hundred dollars to the person who had enslaved him. In spite of the financial difficulties of the times, by 1866 he had saved enough money to repay the debt he believed that he owed and delivered it to his former master. She returned the money to him with the explanation that he was free either way now and owed nothing. Nevertheless, Dabney insisted that she accept the money because, he explained, he was always taught to pay his debts.[19] Interestingly, although Dabney prospered, his

MINT JULEP.

"Mint Julep" from *How to Mix Drinks, or The Bon-Vivant's Companion*, 1862.

former master was "in indigent circumstances" after the war.[20]

Before the start of the Civil War, Dabney owned several Richmond restaurants, which gave him the reputation of being "unquestionably one of the best and most artistic purveyors in this country."[21] In 1862, he opened "a first-class restaurant" called the Senate House Restaurant on Eighth Street in Richmond.[22] Another of his restaurants, named the Dabney House, was located on the south side of Franklin Street and near Fourteenth Street.[23] He closed it just after the end of the Civil War and quit the restaurant business to become a full-time caterer until opening another successful restaurant in 1870.[24]

In 1859, Dabney was given two silver goblets inscribed with the words, "Presented to John Dabney by the citizens of Richmond" as "a mark of their appreciation of his courteous behavior and uniform politeness."[25] John Dabney died on June 7, 1900. One of his sons, Milton, took over his catering business.[26] The people of Richmond felt the loss of Dabney well into the twentieth century.[27]

George Bannister

In an 1885 edition of the *Richmond Dispatch*, there is an advertisement for a restaurant on 15 North Thirteenth Street in Richmond, Virginia.[28] The proprietor was a nineteenth-century Virginia barbecue man named George Bannister. His advertisement boasted of his renowned turtle soup and barbecued Charles City bacon, which is what Virginians used to call sturgeon. His hot slaw and baked beans were famous as well.[29] In 1903, he served his famous Virginia barbecue and Brunswick stew for the forty-second anniversary of the Fighting Fifteenth Virginia Infantry regiment's deployment during the Civil War.[30]

Bannister was born in 1848. During the Civil War, he served as a drummer boy for the Forty-Ninth Virginia Infantry Regiment. He joined up when he was about fourteen years of age. After the war, he became a restaurateur and caterer in Richmond, Virginia. Over the years that followed, Bannister played a part in every Civil War memorial parade held in Richmond until his death in 1949 at the age of 101. He lived to become the oldest living Confederate veteran in that city.

In 1886, after a winning night of gambling, an attacker shot Bannister in an attempted robbery.[31] In 1941, he claimed that he didn't realize that the gunman's bullet had hit him until the next morning, when he found the

Turtle-Soup To-Day

from 10 till 2 o'clock—the first of the season ; Barbecued " Charles City Bacon," at GEORGE BANNISTER'S, 15 north Thirteenth street.

Above: George Bannister's April 25, 1885 *Richmond Dispatch* advertisement for barbecued Charles City bacon. *Author's rendering.*

Left: George Bannister distributing cigars to new fathers on Father's Day in 1947, from the *Richmond Times-Dispatch*.

bullet in his coat pocket. A gold badge that he wore on his chest, one of his many awards, saved him by acting as a shield. However, in an 1886 version of the account, it states that he was shot in the left breast and left forearm.[32] At any rate, in spite of the scuffle and gunfire, the would-be robber fled empty-handed.[33] Although he may have engaged in gambling on occasion,

in 1941 Bannister still claimed that he had "never tasted liquor," although he was charged with selling it on Sundays on several occasions and fined for keeping his establishment open on Sunday at least once.[34] If how a man treats others is the ultimate judge of his character, Bannister was a good man. His employees expressed their respect for him in 1893 when they presented him with a Knights of Pythias badge as a token of their appreciation.[35]

A few months before he died in 1949, Bannister reminisced about his life as a young man. His most vivid memories of the Civil War were of General Robert E. Lee. Recounting the time that the general complimented him on his drum playing, he began to sing:

> *Ole General Lee,*
> *A fine man is he,*
> *Can't get a wife,*
> *And he can't get me!*[36]

George Bannister lived a long and eventful life, and he enjoyed the respect of his family, friends and colleagues. He is also one of the men who helped make Virginia barbecue famous in his times. It's hard to say just how much of the cooking Bannister personally did. Following the custom of his times, he probably employed African American cooks who were experts at preparing old Virginia barbecue. However, he most certainly influenced the recipes, and by all accounts, the barbecue and Brunswick stew prepared by him and his cooks was among the best in the country.

Shackleford Pounds

A result of the Virginia Constitutional Convention of 1901–2 was the disenfranchisement of poor people, especially people of color. If a man couldn't pay the poll tax, he couldn't vote. However, Confederate veterans of the Civil War were exempt from the tax. Nevertheless, soon after the new state constitution was established, officials turned away Shackelford Pounds, a heroic African American veteran of the Civil War, when he attempted to register to vote in his Pittsylvania County, Virginia, voting precinct.

In 1861, Frederick Douglass commented on the many African Americans in the Confederate army who, at the time, were serving as cooks, servants, laborers and soldiers.[37] In our times, neo-Confederates cite Douglass's

A Confederate soldier forcing enslaved men to serve as soldiers in the Civil War. From *Harper's Weekly* (May 10, 1862). *Reprinted with permission of Applewood Books, Carlisle, MA, 01741.*

Pittsylvania County, Virginia Courthouse, circa 1930s. *Library of Congress, Prints and Photographs Division, HABS VA,72-CHAT,1--1.*

comments in an effort to insinuate that African Americans willingly fought for the principles of the Confederacy. However, it is a stretch of logic to think that slaves would risk life and limb fighting to remain enslaved. According to an enslaved man named John Parker who fought for the Confederacy at Bull Run, slave owners often forced African American men to serve as Confederate soldiers.[38] Although a freeman by the time the Civil War started,

Shack was aware of the consequences that might have resulted in his refusal to serve in the Confederate army.

By the 1850s, Shack was "a first-class barbecue cook," often preparing barbecue all over the Pittsylvania County region of Virginia. He was also a popular barbecue cook among North Carolinians, as they, too, often called on him to come to their state to cook old Virginia barbecue.

At the start of the Civil War, the commander of the Thirty-Eighth Virginia Regiment, Captain Jones, enlisted Shack to be the cook at his headquarters. Shortly thereafter, the regiment endured heavy fighting. Although he performed his cooking duties well, when the bullets started flying Shack dropped his cooking utensils and took up a musket. However, he would never fire it. Whenever he went to the battlefield, Shack went there to save lives, not to take them.

When Shack saw a man fall from a Minié ball or shrapnel, he would rush out in the rain of bullets, take up the wounded man and carry him to the rear. He cared for each man until he was transported to a field hospital. Witnesses say that Shack never once dropped his musket in spite of dodging bullets and artillery fire as he carried wounded man after wounded man to safety.

Shack endured the entire war by saving, cooking for and caring for wounded men. When there was a break from fighting, he joined other soldiers in target practice and did "as good shooting on the firing line as any man in the old Thirty-eighth Virginia Regiment." At Appomattox, Shack joined the line with all the other soldiers and wept as he surrendered his musket. However, unlike the other soldiers, Shack was probably shedding tears of joy because he knew that the South's defeat meant the end of slavery.

During Reconstruction, Shack became a farmer while continuing to cook barbecue. However, on the day that officials tried to rob him of his right to vote as a citizen and veteran of the Civil War, there just so happened to be several other Confederate veterans there who had also come to register to vote. About a dozen of them recognized Shack. Upon hearing that officials had turned Shack away, they were incensed. One of the men rushed up to the clerk with tears in his eyes demanding that he register Shack to vote, declaring, "By thunder, he shall register as a Confederate soldier, for no braver one followed old Mars' Bob…from Bethel to Appomattox." Surrendering to the demands of the angry crowd, the clerks registered Shack as a voter with no further questions asked.[39]

Thomas Griffin

AN "OLD VIRGINIA" BARBECUE

The first glance satisfied us that an old fashioned Virginia Barbecue was on foot. We were soon conducted into the depth of the forest, and on a gentle slope we enjoyed the grateful sight of the feast which was to refresh the travelers. Across a pit filled with burning coals were suspended two fine porkers ("leetle hogs," as a venerable French friend of ours was wont to call them)— they were put on early in the morning, and at 4, P.M. were still getting brown. Hard by were delightful silver-perch caught in the mill-pond;—but the pride and boast of the feast was the huge and ponderous iron pot, in which steamed with delightful fragrance a "Brunswick Stew"—a genuine South-side dish, composed of squirrels, chickens, a little bacon, and corn and tomatoes, ad libitum. The whole kitchen department was under the direction of the venerable 'Uncle Ben Moody,' to whose skill and taste, after a full and eager discussion of the subject matter around the snow-white table cloth, an unanimous vote of thanks was tendered by the company. Before, during, and after the abundant meal, there was a running accompaniment of the violin—on which "Scott" and "Manuel," happy Negroes, with red flannel shirts and their whiskered faces begrimed with coal dust, performed alternately with most wonderful perseverance and enthusiasm. The music was, of course, not very scientific; but the tune was so excellent, and the airs spirit-stirring—so much so, that the little Negro boys, standing around, caught the inspiration, and 'heeled and toed' it, amidst a cloud of dust themselves had raised!

Alexandria Gazette, *September 14, 1849*

On July 1, 1869, Moses Rison, a member of the Committee of Arrangements, was distributing flyers in Richmond, Virginia, advertising a "Grand Barbecue of the Walker Colored Voters!! Of Richmond and Henrico." Organizers scheduled the grand barbecue for Friday, July 2, at three o'clock in the afternoon on Vauxhall Island, located in the James River in Richmond, Virginia.[40]

By 1869, Virginia was on the verge of being reaccepted into the Union. The economy was in shambles, and the Old Dominion was still struggling to recover from the effects of the Civil War and Reconstruction. From the start of the war to the end of the Reconstruction era, big barbecues in Virginia were rare. That made the Vauxhall Island barbecue even more enticing.

The Vauxhall Island barbecue was meant to foster "a sincere, lasting peace between the White and Colored race." A large banner was prepared depicting a Caucasian and African American shaking hands with the slogan, "United we stand, Divided we fall."[41] Orators were to give political speeches on Vauxhall Island. Hosts were to serve the barbecue on nearby Kitchen Island.[42] Colonel James R. Branch, a candidate for the Senate, was there to speak about his desire to unite whites and African Americans in the interest of both races. As Moses Rison distributed the flyers on July 1, 1869, no one would have imagined that the highly anticipated barbecue would end in tragedy before it even started.

On the day of the barbecue, hundreds of people arrived in the hopes that they could participate. The barbecue committee had distributed tickets for the event. Organizers instructed the police to allow only ticket holders across the narrow footbridge to Vauxhall Island from nearby Mayo's Island. By the time 175 people had crossed the bridge, Colonel Branch realized that many supporters remained on Mayo's Island who couldn't attend because they didn't have tickets. Colonel Branch made his way to the bridge and began to cross over it. He beckoned to the police when he was about halfway across to let the rest of the crowd cross over the bridge.

As the eager crowd rushed the bridge, the weight of so many people on it at one time caused it to collapse. Suddenly, there were as many as fifteen people trapped beneath heavy timbers in danger of drowning. Dazed from a severe blow to his head, Colonel Branch struggled in the water to free himself from the debris. Several men rushed to rescue him. As they got close enough to reach him, their combined weight caused the debris that trapped Branch to sink under the water, and he drowned. Five others would die of their injuries that day.[43]

Colonel Branch's death so saddened the people of Richmond that his funeral procession was almost two miles long. His friends and colleagues met on July 5, 1869. They drafted a written resolution that reads, in part, "[W]e could not have asked a nobler fate for our lamented friend than that his gallant, generous life should end with a sacred effort to inaugurate peace between the races in his native State."[44]

GRAND BARBECUE OF THE WALKER COLORED VOTERS!! OF RICHMOND AND HENRICO.

We, a portion of the Walker Colored Voters of Richmond City and Henrico County, intend giving a Barbecue to our Colored Political friends, on

FRIDAY AFTERNOON, AT 3 O'CLOCK, JULY 2, ON VAUXALL ISLAND, MAYO'S BRIDGE.

Every colored voter in favor of the equal political and civil rights of the colored and white man; who is in favor of expurgating from the Constitution the Test Oath and the Disfranchising Clause; who is in favor of the adoption of the Constitution when amended; who favors the election of the **WALKER TICKET**, and desires a sincere, lasting peace between the White and the Colored race, is earnestly invited to attend and participate. Good speakers, white and colored, will address the meeting. The committee of arrangements will take all necessary measures to insure good order and the comfort of the guests.

COMMITTEE OF ARRANGEMENTS.

Lomax B Smith, Chm'n · R C Hobson · Jno H Cooley · Joseph Louis · F C H Cole · John Clark · Abram Hall · Jas H Clark · George Keys · John Scott · Jas Hopes · Isaac H Hunter · Robt P Bolling · Wm Bradley · Elmore Brown · Wm Thornton · Albert Cook · Moses Rison · Patrick Jackson · John West · John Jackson

LIST OF SUBSCRIBERS.

Elmore Brown, John Jackson, Pat Jackson, R C Hobson, Jas Bundy, Moses Rison, Albert Cook, John West, R Roney, Stephen Jones, Warner Allen, James Winnie, Frederick Burger, Theodore Hopes, Wm Young, E Walker, James Hopes, B Randolph, E Froman, Jas H Clark, John Clark, Saml Booker, Fleming Mitchell, Robt P Bolling, John Johnson, Joseph Louis, Abram Hall, Wm Bradley, Frederick C Cole, J B Mason, Theodore Scott, Thos Griffin, Robt Hamilton, Dorson Gardner, George Page, George Keys, Henry Washington, G W Hughes, Horace Johnson, Andrew Johnson, Jeff Sheppard, Jack Watkins, Richard Chiles, Daniel Davis, Joseph Walker, Henry Chamberlain, Stephen Nicholas, Frank Hancock, John H Smith, John Cowley, John J Scott, John W. Cooley, Jesse Bailey, Stephen Nelson, Cornelius Parrot, Edward Hill, Jas Hill, Jos Hill, Edward Stevens, Frank Hill, John Watkins, James Chester, Tho-Bean, Chas Taliaferro, Wm Taylor, John Cooper, Richard Meekins, Sam Patch, Benj Coots, Wm Chelser, Wm Coots, Wallace Jones, Frank Backman, Nathaniel Johnson, R Harris, Jas Butler, Wm Mitchell, Coleman Tinsley, Ed Henderson, Stephen Sett, James Traylor, Wm Hayes, John Butler, Frank Johnson, James Johnson, Benj Chester, Isaac H. Hunter, Henry Anderson, James Mitchell, Wm. Lee, S Mitchell, A Watkins, Nelson Davis, John Davis, and 200 others.

Left: "Grand barbecue of the Walker colored voters!! of Richmond and Henrico County," broadside, 1869. *G73, Albert and Shirley Small Special Collections Library, University of Virginia.*

Below: Thomas Griffin's barbecue advertisement from the *Daily Dispatch*, 1853. *Author's rendering.*

AMERICAN SALOON, No. 84, Main st., gives to its customers every day for dinner —

ROAST BEEF — fresh, nice and tender.
ROAST TURKEY,
ROAST DUCK,
HAM and CABBAGE,
FRIED FISH,
" TRIPE.

VEAL CUTLETS,
STEWED SQUIRREL,
Barbacued do.
" SHOAT,
Stewed VENISON,
CORN BEEF and TUR-NIPS, &c.

THOMAS GRIFFIN, Proprietor.

oc 29 — 1t★ 3 doors below Purcell, Ladd & Co.

The man who made Vauxhall Island known for barbecues and parties was "a freeman of color" named Thomas Griffin. For years, Griffin enjoyed a reputation as the "long and favorably known Restaurateur and caterer for the public."[45] In 1853, "the hospitable and whole-souled" Griffin was the proprietor of a Richmond restaurant named The American Saloon, No. 84, located on Main Street. Griffin specialized in barbecued shoat, barbecued squirrel, barbecued shad and Brunswick stew (what he called in those days, stewed squirrel), all of which was prepared in "true Virginia hospitable style."[46]

By 1859, Griffin had opened another restaurant by the name of Tom Griffin's Restaurant, and he was advertising his catering services for "[w]edding parties, public dinners, clubs, parties, etc." In 1860, Griffin opened an establishment on Vauxhall Island.[47] The barbecue and Brunswick stew that he served there were so popular that by 1864, people were calling Vauxhall Island "Griffin's Island."[48]

Thomas Griffin was born in Williamsburg, Virginia, in the year 1791. In 1812, he moved to Richmond, where he lived for sixty years and became one of the most popular restaurateurs in the city. He died on May 28, 1872, at the age of eight-one.[49] In 1881, a writer for the *Daily Dispatch* wrote fondly of "the past glories of old Tom Griffin's incomparable concoctions," paying homage to Griffin's old Virginia barbecue and Brunswick stew.[50]

It's difficult to say whether Thomas Griffin was the pit master at the fateful Vauxhall Island barbecue. However, it's equally difficult to think that he played no role in such an important event that was to take place on "Griffin's Island." Perhaps a clue lies in the long list of names on Moses Rison's flyer. Found under the heading "List of Subscribers" is the name Thomas Griffin.[51]

BILLY GARTH, CAESAR YOUNG AND JOHN GILMORE

In 1921, the University of Virginia celebrated its centennial with an old Virginia barbecue. Organizers cleaned up the "old Barbecue Grounds back of the Cemetery" and dug a 150-foot-long barbecue pit needed to barbecue forty shoats and lambs. They also served two hundred gallons of Virginia Brunswick stew. Among the organizers of the event were William (Billy) Garth, known as the "prince of barbecuers," and Billy Duke. Two of the lead cooks were Caesar Young and John Gilmore. As late as 1931, Billy Garth was still serving his Virginia barbecue after basting it with

Brunswick stew events are a centuries-old Virginian tradition. The Proclamation Stew Crew of Brunswick County, Virginia, cooks hundreds of gallons of stew for special events and charity fundraisers every year. *Author's collection.*

vinegar, pepper, salt and butter, just as Virginians had been doing since the seventeenth century.[52]

Billy Garth of Charlottesville, Virginia, was more of a barbecue cook supervisor than a hands-on barbecue cook. One of Garth's ancestors, Elijah Garth, was the famous pit boss at an Independence Day barbecue in Charlottesville, Virginia, in 1808.[53] Many dignitaries attended, including relatives of Thomas Jefferson. The author named no other barbecue cooks in that account. However, in the late 1800s, R.T.W. Duke Jr. mentioned a famous barbecue cook named Juba Garth. Juba and his wife, Mandy, gained their freedom at the end of the Civil War. Because fathers passed barbecuing skills down to their sons, it is highly probable that Juba's ancestors were among the barbecue cooks at the 1808 barbecue in Charlottesville.

John Gilmore was born in 1857. Caesar Young was born in 1854. Caesar was the son of an enslaved woman named Maria. Maria claimed that John Yates Beall was Caesar's father. During the Civil War, Union authorities in New York accused Beall, a white man, of being a Confederate spy and arrested him. They hanged him there in February 1865.

Young and Gilmore gained freedom from slavery at the close of the Civil War, after which they became celebrated barbecue and Brunswick stew

The "continuous performance" of basting and turning the meat at a barbecue in Charlottesville, Virginia, circa 1920s. Holsinger Studio Collection. *Special Collections, University of Virginia Library*.

Left to right: Caesar Young, Judge R.T.W. Duke Jr., W.R. Duke and John Gilmore. *Lucy D. Tonacci*.

cooks.[54] They were also lead cooks at barbecues held by the Cool Spring Barbecue Club. Rather than simply placing shoats, lambs and chickens on hurdles over the coals, Young and Gilmore tied the carcasses "to two green poles about 6 or 7 feet longer than the pit was wide," which made the job of frequently turning the meat easier. Each carcass had two assistant cooks assigned the job of frequently turning it as it barbecued. Another cook, called the "baster," anointed the meat with the original old Virginia barbecue sauce made of vinegar, butter, salt and pepper using "long handled swabs" that had been dipped in the vinegary sauce kept in buckets beside the pit. As one of the pit masters explained, the heat from the coals "drove the sauce in."[55] Several forked posts made of tree limbs driven into the ground surrounded the barbecue pit. The forked posts suspended the poles that supported the meats above the pit, just as Virginia's Indians had done for centuries before.[56]

In their times, the team of John Gilmore and Caesar Young were known as the finest Brunswick stew cooks in the region. One author wrote, "John and Caesar hand the palm to 'Oscar' of the Waldorf on Hollandaise sauce but they will spot him cards and spades when it comes to Brunswick stew."[57] Caesar Young died on Christmas Eve 1935 at the age of eighty-one. John Gilmore was eighty years of age when he died in Madison, Virginia, in 1937. Just as was predicted by R.T.W. Duke Jr., with the death of Caesar Young and John Gilmore, although barbecues continued to be popular in Virginia, the grand old Virginia barbecues were almost entirely gone.

CHAPTER 7
VIRGINIA

THE MOTHER OF SOUTHERN BARBECUE

A beautiful grove was selected. Plank was laid down for a dancing floor, with a platform for the musicians, and a large number of boards were laid down on logs for seating the crowd. For cooking the meats, a long trench was dug, in which a fire of seasoned wood was made, and whole sheep and shoats were placed over the fire by means of sticks run through them. Men were employed for hours to attend to the cooking and turning the meat, and in basting with pepper, vinegar and salt. Meat prepared this way is very delicious. The feast when prepared consisted of these meats with bread, pickle, tomatoes, together with cakes, pies and jellies. All were free to partake, and people assembled from quite distant places.
–H.H. Farmer, Virginia Before and During the War *(1892)*

Virginia supplied the southern and western United States with untold thousands of pioneers and settlers. Historian James Winston observed, "What the New England states have been by way of a nursery from which home-seekers have gone to settle the Middle West, that Virginia has been to the states of the South and the Southwest."[1] As a result, Virginia's influence on the United States up to the end of the nineteenth century is not "approached in importance by that of any other Commonwealth in the Union."[2]

Between the years 1830 and 1840 alone, no fewer than 375,000 Virginians moved west. "At this rate," wrote educator Henry Ruffner in 1847, "Virginia supplies the West every ten years with a population equal in number to the population of the State of Mississippi in 1840." From 1790 to 1840, Ruffner

continued, Virginia had "lost more people by emigration, than all the old free States together."[3] As more and more Virginians moved west, Virginia itself paid a price as its sons and daughters departed. The author of an 1825 letter to the editor of the *American Farmer* wrote:

> *The revival of lower Virginia is now looked upon as near at hand. You know what a depopulating tide of emigration has set from it to the West for the last 20 years. Many of its former inhabitants are now enterprising, respectable citizens of North Carolina, Tennessee, Alabama, Mississippi, Kentucky, Missouri, Indiana, Illinois, Michigan and Ohio. There is scarcely a neighborhood in any of the new states, which has not some family from old Virginia.*[4]

When Virginians left Virginia, they took their way of life with them, preserving some aspects of their Virginian culture and adapting other parts of it to their new home. This was demonstrated by a Virginian "pioneer and maker" of Arkansas named Barnett Wilson. Wilson held himself in the "ranks of old time Virginians bound by the laws of old time Virginia hospitality." As result, he often hosted dinners that he couldn't afford because of the "law which bound him." In his Arkansas home, "he maintained every form of Virginia life, and died a true Virginian."[5]

Although Virginians moved to new lands, their influence didn't result in a replication of Virginia's culture. Rather, they contributed ideas, customs and institutions in their new homes that persist to this day.[6] One of those institutions is Virginia barbecue.

> "No taste for a barbecue!" exclaimed Major Heyward. "You surprise me, Mr. Fennimore; no taste for a barbecue! Well, that shows you were not raised in Virginia. Time you see a little of the world, sir; there's nothing in life equal to a barbecue, properly managed—a good old Virginia barbecue."
>
> Hall, James. The Harpe's Head a Legend of Kentucky. Philadelphia, PA: Key & Biddle, 1833.

Even though northerners loved Virginia barbecue, the South embraced it and made the dish its own. As Virginians established farms and plantations in other colonies and, later, in other states, they continued to host Virginia's

rural entertainments and barbecues.[7] Before long, barbecuing in the Virginian manner became barbecuing in the southern manner. This is evident in old accounts of southern barbecues all over the South, from the way cooks dug the pit; the hickory sticks used as a grill; the vinegar, salt and pepper baste; and the required cool spring. No wonder people have called Virginia "the Mother of the South."[8]

Proponents of a South Carolina barbecue origination theory argue that barbecue was introduced to mainland North America first in what is today South Carolina through a collaboration of Native Americans and the Spanish conquistadors who occupied Santa Elena in the last half of the sixteenth century.[9]

The South Carolina origination theory is strongly rooted in the hogs brought to Santa Elena by the Spanish. Because you can't have barbecue without pork (according to some), they make the case that barbecue must have first originated only after pigs were available. However, as has been discussed, barbecue in the United States has always referred to "an ox or perhaps any other animal dressed in like manner."[10] In addition, Mary Terhune defined barbecue as "[t]o roast any animal whole, usually in the open air."[11] In 1898, another author wrote, "In America a kind of open-air festival, where animals are roasted whole, is styled a Barbecue."[12] Because pork is not a requirement for "real" southern barbecue everywhere in the South, hogs are not vital to southern barbecue's existence.

The first domestic hogs in what is now the United States came with the Spanish to Florida in 1540. Hogs didn't arrive in Santa Elena until 1566. Although Indians who traded with the Spanish, or those enslaved by them, may have cooked pork using Indian techniques, the Spanish abandoned the Santa Elena colony in 1587, and none of that colony's hogs survived its demise.[13] In reality, Native Americans were barbecuing meat for centuries before the Spanish briefly showed up with their hogs, but they weren't cooking southern-style barbecue, even if they did eventually barbecue Spanish pigs. Santa Elena–style pork barbecue, if it existed at all, ceased to exist when the Spanish abandoned the colony. In addition to those facts, there are few, if any, early eighteenth-century accounts of life in South Carolina that mention barbecues like those found in accounts of Virginia during the same era.[14]

In 1773, William Richardson attended a barbecue and horse race in Charleston. His account indicates that the barbecue was a failure. He wrote to his wife about the "quarter of beef" that was "nicely browned" not by the coals in the barbecue pit but rather by clouds of dust. He also complained

about the dirty tablecloths and remarked that the "two Hogs & Quarter of Beef" were the color of "a piece of Beef Tied to a string & dragged thro' Chs Town [Charleston's] streets on a very dry dusty day & then smoke dried." The barbecued hog had "blood running out at every cut of the Knife."[15] Although not appetizing, notice that those South Carolinians served beef at this early South Carolina barbecue, which contradicts the modern notion that barbecue in the Carolinas must be made with pork.

By 1778, South Carolinians had worked out the barbecue thing. Revolutionary War veterans, some of whom were Virginians, who lived around Beaufort at that time were fond of hunting clubs and barbecues. For several years, they maintained a "barbecue house" that was eventually destroyed by a hurricane in 1804.[16] Of course, it's difficult to believe that people in South Carolina independently developed barbecue customs that were almost identical to those that Virginians had been practicing for over one hundred years before. It's no coincidence that the first large-scale migration from Virginia, which occurred in the 1700s, was predominately to the Carolinas and Georgia. There can be little doubt that the four native-born Virginians who served as South Carolina's congressional representatives in the years 1795–97 were successfully employing their Virginian way of politicking with barbecues in South Carolina.[17] At any rate, it appears that South Carolina barbecue is a latecomer in the history of southern barbecue. As late as 1801, the idea of a barbecue seemed to be a new thing to the South Carolina senator Ralph Izard (born in Charleston, 1741) when he wrote, "In Virginia they have once a fortnight what they call a… Barbicue [*sic*]."[18]

VIRGINIA BARBECUE IN NORTH CAROLINA

When settlers first moved into what is today North Carolina, it was known at that time as Virginia's Southern Plantation.[19] The first permanent white settler in North Carolina was a Virginian by the name of Nathaniel Batts.[20] In the early 1650s, Batts built a home at the western end of the Albemarle Sound and recorded the first deed in the region. By the 1660s, five hundred Virginians had joined Batts as settlers there.[21]

In 1662, the Virginia Assembly appointed Virginian Samuel Stephens as the "Commander of the Southern Plantation." In 1663, King Charles II granted eight loyal subjects the territory of Virginia between latitudes 31° North and 36° North from the Atlantic to the South Seas. With the appointment of Virginian

William Drummond as the first colonial governor of Albemarle Sound, the colony of Carolina was officially established.[22] However, as late as the year 1700, the population of settlers in Carolina was still only around eleven thousand people compared to fifty-nine thousand in Virginia.[23]

As Virginians moved into the region that would become North Carolina, they took their customs with them, including Virginia barbecue. The modern eastern North Carolina barbecue sauce, which is little more than a mixture of vinegar, salt and peppers, clearly exhibits characteristics of Virginia's original barbecue sauce. North Carolinians love that particular sauce so much that they now claim it as their own, even though its origins are in colonial Virginia.

From the nineteenth century to the early twentieth century, North Carolinians enjoyed their share of authentic Virginia barbecue. North Carolinians often hired the famous Virginia barbecue cook Shackleford Pounds to cook Virginia barbecue for them. The *Times Dispatch* records that in 1905 at Oak Grove Church in Northampton County, North Carolina, "an old fashioned Virginia barbecue was served, which was greatly enjoyed by the large attendance."[24]

1752 Barbecue in Woodstock, Virginia, displays its logo on signs and menus that depicts early pioneers and settlers in the Shenandoah Valley who contributed German and Scotch-Irish influences to Virginia cookery. *Craig George.*

VIRGINIA BARBECUE "GONE TO KENTUCKY"

In 1806, family, friends and neighbors gathered in Kentucky for an old Virginia barbecue feast to celebrate the wedding of two native Virginians. They enjoyed a generous spread of good things that included bear meat, venison, wild turkey, ducks and eggs. However, the pièce de résistance was a sheep barbecued old Virginia style. The cooks placed it on a hurdle over a pit filled with glowing coals. The appointed "ruler of the roasts" covered the meat with green boughs "to keep the juices in." Gourds full of peach syrup and honey served as sauce for the meat. The table was made of puncheons cut from solid logs, and the next day, workers used them to construct the floor of the newlyweds' cabin. The happy couple was Tom and Nancy Lincoln, the parents of Abraham Lincoln.[25]

Kentucky became the fifteenth state in the Union after separating from Virginia in 1792. Some Virginians went to Kentucky in search of land and prosperity. Others went there to escape trouble. For example, officials wrote "Gone to Kentucky" beside the names of several delinquent taxpayers from Buckingham County in 1787.[26]

Historians have well established that Kentucky received its barbecue tradition from Virginia. Tom and Nancy Lincolns' wedding celebration is an example of how Virginians introduced barbecue there. Even *The Kentucky Encyclopedia* notes, "The earliest settlers from Virginia brought the cooking and social tradition of barbecue to Kentucky."[27] Mint juleps were a favorite drink served at Virginia barbecues well before they were popular in Kentucky. This explains the Kentucky tradition of making mint juleps at barbecues. When Virginians moved to Kentucky, they also took the tradition of planting mint near springs, which provided a ready supply of it to make cool mint juleps at summertime barbecues.[28]

Thomas Lincoln, Abraham Lincoln's father, Born in Rockingham County, Virginia, 1778. *Library of Congress, Prints and Photographs Division, LC-DIG-ppmsca-19418.*

Virginia Barbecue in Georgia

In the nineteenth century, Georgians called Wilkes County, Georgia, "the Barbecue Country." It is a long-held Georgian tradition that the very first barbecue ever held in Georgia took place in Wilkes County sometime in the eighteenth century. For decades, the people of Wilkes County held two or three barbecues per week during the summer months. People would meet at some "delightfully cool and shady place" with "a spring nearby" because "no barbecue is complete without this rock-encased living stream of water."[29]

Wilkes County barbecue cooks dug pits in which they burned hickory wood down to glowing embers. They kept a feeder fire going beside the pit used to replenish the coals during the cook. Hog and sheep carcasses were "speared through by hickory limbs" and placed over the coals. One Georgia pit master's secret was to dip the barbecued meats in large dishes of a mixture of butter and vinegar that was highly seasoned with salt and pepper before serving them.[30]

It's not difficult to recognize the similarities between Georgia barbecues and Virginia barbecues of the same era. The spring, the shady grove, the old Virginia barbecue baste, the hickory and the hurdle made of hickory sticks are all telltale signs of Virginia barbecue influences. There is a very good reason for those striking similarities.

Many Virginias moved to Georgia, especially after the end of the War for Independence. Virginians from Westmoreland County, Virginia (an area in Virginia where barbecues were very popular in colonial times), established the first settlement near the city of Washington in Wilkes County in 1774—which, by the way, is an area in Virginia where barbecues were very popular in those days.[31] In the 1780s and 1790s, people from all over Virginia were arriving in Wilkes County. The Virginian migration to Georgia continued for many years, and by the 1850s, parts of Cherokee and Cass Counties had become known as "Little Virginia."[32]

Historian Ellis Merton Coulter wrote of Virginians who settled in Georgia that they were "a remarkable group…whose importance is hard to overestimate."[33] The Virginian influence on Georgia's history is reflected in Wilkes County barbecue customs. In recognition of their Virginian roots, Georgians used to hold what they called "old Virginia barbecues." In an advertisement for a barbecue held in Augusta, Georgia, in 1840, we find:

The Barbecue today, will be strictly after the old Virginia style, in the olden time, those therefore who intend to participate should not go unprovided

Georgia barbecue in Atlanta, 1896. *New York Public Library.*

[sic] *with a knife, with which to, "cut their way," into the delicious legs of mutton &c., which will be served for the occasion.*[34]

In 1840, the citizens of Baldwin County, Georgia, assembled to appoint delegates to an anti–Van Buren convention. One of the resolutions made by those Georgians reads:

Resolved, *That the meeting indicate the* Old Virginia Barbecue *as the mode of offering our hospitality to the Convention.*[35]

Describing a Georgia barbecue he attended in 1826, author George Darien wrote of his stay in Georgia while visiting a friend there who was

Gravestone of an early Virginian settler of Greene County, Georgia. *Library of Congress, Prints and Photographs Division, LC-USF34-044333-E.*

from Virginia. While enjoying his friend's "true Virginian hospitality," he accepted an invitation to a barbecue held the following day. After enjoying the barbecued meats followed by speeches, the attendees turned to playing sports, including foot races, wrestling and rifle shooting. At one match, sixty men gathered with their rifles for a chance to win a pail of apple toddy.[36] The Virginia influence on this Georgia barbecue is easy to identify. The Georgians had even picked up the habit of discharging firearms at barbecues, just as Virginians had been doing since the early 1600s.

Like North Carolinians, Georgians also claimed Virginia's original barbecue sauce recipe, as well as Virginia's barbecuing technique. Just

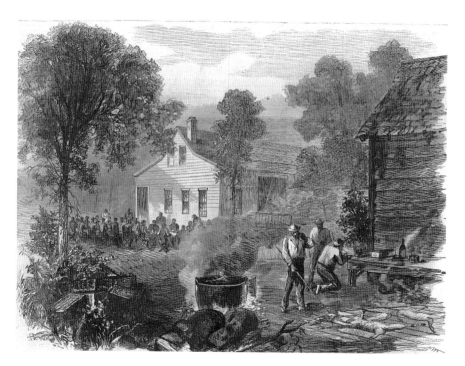

A barbecue at Augusta, Georgia, circa 1866. Sketch by Theodore R. Davis from *Harper's Weekly* (November 10, 1866).

as was done in Virginia, "roast pig and Brunswick stew" became an oft-used expression when advertising Georgia barbecues.[37] An article in an 1896 newspaper reads, "Kill and dress a fat Georgia pig and roast whole over a bed of wood coals. While cooking, baste with a sauce made of butter, vinegar, pepper and salt. Serve with an apple in its mouth. This is Georgia's dish de resistance."[38] Of course, Virginians developed that recipe long before James Oglethorp led the first settlers to Georgia in the 1730s.

VIRGINIA BARBECUE IN TENNESSEE

The first settlements in Tennessee were the North Holston settlement in what is today the county of Sullivan and the South Holston settlement in what is today the county of Washington. Virginians settled both of those regions because they believed at the time that they were a part of Virginia. Consequently,

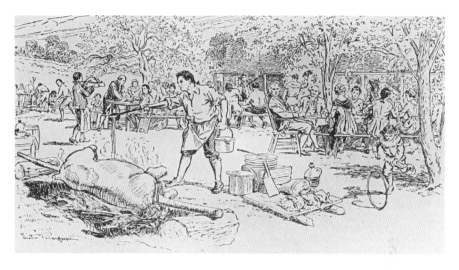

An illustration of a barbecue hosted by John Sevier in 1780. *From* Stories of American History *by Wilbur Fisk Gordy, 1917.*

Virginians were the first to settle Tennessee.[39] Virginians would also lead the first settlements in Middle Tennessee in the years 1779–80. Therefore, it should be no surprise that Virginian James Robertson, born in Brunswick County in 1742, is considered to be the "Father of Tennessee."[40]

The first governor of Tennessee was a Virginian by the name of John Sevier. Born in 1745 in Rockingham County, Virginia, Sevier and his family relocated to Fredericksburg, Virginia, when he was young in order to escape the threat of Indians. In Fredericksburg, Sevier was educated in the same schools as George Washington.

In the 1790s, Sevier moved west and eventually settled in what is today Sullivan County, Tennessee. Sevier would show himself to be a natural leader, warrior and brawler. As Sevier gained prominence among the backcountry settlers, he delighted in hosting Virginia barbecues for them. His barbecues featured oxen "roasted whole" accompanied by horse races and were most festive at weddings and other celebratory occasions in keeping with Virginia's customs. The barbecue feasts were set under the shade of trees. Venison, wild fowl, bear meat, beef, Virginia hoecakes, hominy and applejack were some of the foods served.[41]

Virginians continued to move west through Tennessee and on into Arkansas. The first Fourth of July barbecue held in Phillips County, Arkansas, occurred in 1821. Just like barbecues in Virginia, it took place near a spring "where a fine quality of Kentucky mint had taken hold." One of the earliest

settlers and leaders in the area, a Virginian named W.B.R. Horner, gave the address for the occasion.

Horner was from Falmouth, Virginia (aka Hogtown). Living in Arkansas from the time that it was still a part of the Louisiana territory, he was the principal figure in the creation of Phillips County. He spent his time in Arkansas "with all the courtesy and dignity of old Virginia life." In the traditional Virginia fashion, revelers made many toasts at the Independence

"The Pioneer" from *Harper's Weekly* (January 11, 1868). *Library of Congress, Prints and Photographs Division, LC-USZ62-78067.*

Day barbecue, followed by the discharge of three to nine guns.[42] There should be little doubt that a Virginian from an area in Virginia known as Hogtown took his barbecue traditions with him.[43]

Virginia Barbecue "Gone to Texas"

Many Virginians left for Texas to find prosperity. Many went there to escape trouble in Virginia. The practice was apparently so prevalent that sheriffs in Virginia resorted to simply writing the initials "G.T.T." (slang for "Gone to Texas") on official papers regarding such cases.[44]

In the early twentieth century, there was a restaurant in El Paso, Texas, located at 401 East Second Street run by a fellow named E. Scott. Scott used to run advertisements in the local newspaper in which he listed his menu of hot tamales, chile con carne and enchiladas. However, the first offering above all others at the top of Scott's menu was "OLD VIRGINIA BARBECUE."[45] In addition, just as Virginians had been doing for more than one hundred years before, by 1913, the people of El Paso had even started their own barbecue club.[46]

Southern barbecue was popular in Texas long before the famous barbecue restaurants in central Texas opened at around the turn of the twentieth century. It came to Texas along with settlers from the east. Many came from Virginia. Others came from Kentucky, Missouri and Tennessee, and most of those settlers were descended from Virginia families. In 1885, as much as 75 percent of the population of Texas in the western and southwestern regions was descended from Virginians.[47] No wonder the president of the State Society of Texas-Virginians requested that all ex-Virginians attend "Virginia Day," celebrated in 1899 at the Texas State Fair.[48]

Virginia's influence on Texas lingers to this day. There are more than thirty counties and towns in Texas named after Virginians. At least seventeen Virginians sacrificed their lives at the Alamo, and seven more died at Goliad.[49] The first American-born governor of the Mexican territory of Texas was Henry Smith, born in Virginia in the year 1788.[50] At least twelve of the fifty-nine signers of the Texas Declaration of Independence were native-born Virginians.[51] The "Father of Texas," Stephen Austin, was also a native-born Virginian. The first president of the Republic of Texas was a native-born Virginian by the name of Sam Houston.[52] Peter H. Bell, the third governor of Texas, was born in Culpeper County, Virginia, in 1812.[53] Even the capital of Texas bears the name of a native-born Virginian. No wonder E. Scott was cooking old Virginia barbecue in El Paso.

Barbecued Meats.

OLD VIRGINIA BARBECUE.
HOT TAMALES, CHILE CON CARNE AND ENCHILADAS.

Give us 6 hours notice on special orders.

E. Scott.

Phone 4854. 401 E. Second St.

Old Virginia barbecue for sale in El Paso, Texas, in 1914. From the *El Paso Herald*, July 18, 1914. *Author's rendering.*

One of the most important people in El Paso, Texas, in the 1800s was a Virginian named Zachariah Taliaferro White. White arrived in El Paso, Texas, in 1881 with $15,000 sewed into the lining of his vest for safekeeping. That money was the seed money that would finance White's vision to grow El Paso from a town of fewer than 1,000 people in 1881 into a thriving city of close to 1 million people just under forty years later.

White was born in Amherst County, Virginia, in 1850. His family had deep roots there that went back to the early decades of the seventeenth century. When White was thirty years of age, he learned that the convergence point of railroads from all directions was focusing on El Paso, Texas. That is what brought him to the little town. Through White's vision and spirit, El Paso became a thriving modern city.[54] E. Scott's old Virginia barbecue is recognition that Virginians like Zach White brought their barbecue to Texas and that Texans strongly embraced it.

Virginians in Texas were eager to share their barbecue, apparently. Randolph B. Marcy was an officer in the United States Army in the 1850s. While traveling through Texas, he encountered a "Texas-Virginian" named Mr. McCarty. He wrote the following:

> *In 1854 I passed over this road again and stopped for dinner at a plantation owned by a Mr. McCarty, from Virginia, who, upon my arrival, seemed highly delighted to see me again, remarking that if I had only notified him I was coming that way, he would have given me the biggest barbecue that country had ever seen.*[55]

In 1883, Alexander Edwin Sweet wrote a detailed account of a barbecue in Texas. The cooks didn't barbecue the meat using the western technique of burying meat with hot rocks. Nor were they cooking it in a Texas-style horizontal smoker. They were cooking Virginia-style barbecue.[56] Here is a

list of the Virginia barbecue influences:

- all kinds of meats were barbecued, not just beef;
- people came from miles away to attend;
- the event was held near a spring;
- African Americans did all of the barbecuing;
- the meat was basted with Virginia's mixture of butter, vinegar, salt and pepper;
- long, rough pine tables were constructed;
- the meat was barbecued directly over hot coals;
- no sauce was served on the side, just bread and meat;
- ladies were served first; and
- so much food was served it was said that the table "groaned."

Sweet's description of the 1883 Texas barbecue sounds very similar to descriptions of Virginia barbecues from as early as two hundred years before Texas became a part of the Union.

> We arrived on the barbecue-grounds at about ten o'clock. More than two thousand people had already arrived, some from a distance of forty to fifty miles,—old gray-bearded pioneers, with their wives, in ox-wagons; young men, profuse in the matter of yellow-topped boots and jingling spurs, on horseback; fair maidens in calico, curls, and pearl-powder, some on horseback, others in wagons and buggies. These, with a liberal sprinkling of howling, bald-headed babies in arms, made up the crowd that met in a shady grove on a hillside to participate in the barbaric rites of the barbecue.
>
> A stand had been erected for the speakers. Around it the ladies were provided with seats borrowed from a neighboring schoolhouse. To the left was a rough pine table, forming the four sides of a square, each side of which was two hundred and fifty feet long. It was calculated that one thousand people could at one time dine around this "ample board." At some distance from the stand a deep trench, three hundred feet long, had been dug. This trench was filled from end to end with glowing coals; and suspended over them on horizontal poles were the carcasses of

forty animals,—sheep, hogs, oxen, and deer,—roasting over the slow fire. The animal being skinned and cleaned, the whole carcass is placed about two feet above the coals, and cooked in its entirety.

The process is slow, taking twelve hours to cook an ox. Butter, with a mixture of pepper, salt, and vinegar, is poured on the meat as it is being cooked. It is claimed that this primitive mode of preparation is the perfection of cookery, and that no meat tastes so sweet as that which is barbecued.

When sufficiently roasted, the carcasses are carried on poles, manned by stalwart Negroes, and placed on small tables inside the square formed by the dining-tables. Here a force of carvers soon cut the meat into slices; others distribute it on plates, and arrange these plates on the long table, a huge slice of corn-bread being apportioned to each plate. That is all.

The dinner is served. No long bill of fare to hesitate over; no knives, no forks, no napkins; nothing but bread and meat. Water in barrels was brought from a spring at the foot of the hill. These barrels placed around the tables at intervals, a single drinking-cup being attached to each, provided the guests with the only beverage allowed on the grounds.

The ladies were admitted to the table first, and dined standing up. The doctor was horrified to see an excited female leave the table, approach a male friend, and, after whispering in his ear, return to the table with a villainous-looking bowie knife, ten inches long, in her hand. The doctor thought he detected fire in her eye, and intimated, that, if she were not quickly suppressed, blood would be spilled. But there was no murder in her heart. She merely borrowed the knife that she might cut her "chunk" of meat into reasonable mouthfuls.

After the ladies had dined, the men were turned loose on the eatables. To see them, in their rude playfulness, scramble for a choice rib,—the victor going off gnawing it ; the unsuccessful one pouncing on a waiter carrying a large trayful of beef, and relieving him of his load in a second,—forced one to think of one o'clock in a menagerie.

There was enough and to spare for all the vast crowd; and I would be lacking in my duty as a veracious reporter of

the event if I failed to say, that "the hospitable board fairly groaned beneath the load of good things," etc. The dinner was free to all; and more than twenty thousand greasy fingers testified their owners' appreciation of the eatables, and gave at least one-third of the guests a reasonable excuse to get off that venerable truism about fingers being made before forks,—to get it off, too, as if it were a happy and original thought that had just then occurred to them.

Alexander Edwin Sweet and J. Armoy Knox, On a Mexican Mustang, through Texas, from the Gulf to the Rio Grande (1883)

Virginia Barbecue in the Midwest

In 1796, Virginians established the town of Chillicothe, which was to become the first capital of Ohio. Soon after its founding, Chillicothe became the "fountain head of Old Dominion culture west of the Blue Ridge Mountains."[57] Settlers built the town on a land grant owned by Virginian Nathaniel Massie. Before he died, Massie had established fourteen towns in what would become the state of Ohio.[58] One year later in 1797, Virginian Thomas Worthington arrived in Ohio and would become the "Father of Ohio statehood."[59] Virginians, known as the "Virginia Clique," became a powerful group in Ohio in the early nineteenth century. By 1850, there were 85,762 Virginians living in Ohio. That number excludes deceased Virginians who were living in Ohio before 1850. It also did not count their children and grandchildren who were born in Ohio.[60]

Although settling far away from their home state, Virginians in Ohio continued to practice their Virginian way of life. In 1836, a traveler passing through Chillicothe wrote of a Virginia barbecue held there, "We did not expect great things here, so far from the seaboard. But, the table not only groaned with the barbecue and bacon common to Virginia festivals, but all kinds of preserves, pies, sweet meats, and floating islands, &c."[61]

As early as 1798, Virginians were settling in what is today Missouri. As was the case in other regions, Virginians played a key role. People eventually called an area of central Missouri comprising thirteen counties "Little Dixie." However, according to the authors of *Bound Away*, due to the number

of Virginians living there, it was more like Virginia than the Deep South.[62] A writer for the *Springfield Republican* highlighted the Virginian roots of barbecue in Missouri in 1906:

> *In the venerable days when Virginia, Kentucky and Tennessee were contributing to the steady stream of sturdy men and women who settled on Missouri to make glad this land with the manners and customs of the old South, the barbecue was preserved as a traditional and sacred institution.*[63]

Uncle Bill Mulkey arrived in Missouri "before Kansas City was on the map." In 1899, he recounted the first Thanksgiving feast in Kansas City's history that took place within what would become the borders of the city. Sitting in an office on the second floor of the Hall building on Ninth and Walnut Streets, Uncle Mulkey rested his feet, wearing his "old style boots braced against the window sill," and recalled the details.

"It was a sort of a barbecue affair," started Uncle Mulkey. Gazing down in a seemingly absent-minded way, he recounted that the barbecue occurred in 1864 "in Tom Smart's pasture," which "was in this same eighty." When asked what "in this same eighty" meant, he replied:

Pioneer life in Missouri in 1820. *Library of Congress, Prints and Photographs Division, LC-USZ62-69024.*

```
┌─────────────────────────────────────────────┐
│           VIRGINIA BARBECUE                   │
│              606 E. 31st                      │
│           OPEN NEW YEARS                      │
│            8 A. M. to 3 A. M.                 │
│           Complete Dinners                    │
│          Featuring Our Delicious              │
│     Barbecue Ribs and Barbecue Meats          │
└─────────────────────────────────────────────┘
```

Virginia barbecue advertised in Kansas City, Missouri. From the *Kansas City Star*, January 1, 1946. *Author's rendering.*

This same eighty that this building is on—Old Tom Smart's pasture was over there on Twelfth Street, about Twelfth and Holmes, I guess. It was this side of the old fair grounds…there wasn't any building where we are now. What buildings there were in town were down on the river and this up here about the Junction was still in the woods. There were a few residences as far out as Twelfth Street. There was no railroad then, but steamboats came up the river.

Uncle Mulkey told of the barbecued beef and barbecued sheep. He also mentioned, "The brewery man's wife was sent off the grounds because she 'hollered' for Jeff Davis. The war wasn't over then, you know, and there were a lot of soldiers, Union soldiers, at the barbecue."[64]

The Tom Smart mentioned by Uncle Mulkey was none other than Judge Thomas Smart of Jackson County.[65] Thomas Smart was born in Virginia in 1806. He arrived in Missouri around the year 1834 with his brother, James. He owned property that was "bounded by 11th, 12th, Main, and Grand Avenue." Therefore, the first Thanksgiving barbecue held in what would become Kansas City was a Virginia barbecue hosted by a Virginian. Tom Smart's Virginia barbecue legacy was still alive in Kansas City as late as the 1940s. From around 1930 to the late 1940s, there was a barbecue restaurant in Kansas City located at 606 East Thirty-First Street named Virginia Barbecue. The restaurant featured "Delicious Barbecue Ribs and Barbecue Meats."[66]

POLITICAL BARBECUES

The political barbecue originated in Virginia. A grand barbecue was the one event that brought rural populations together like no other. Sometime in the eighteenth century, politicians from other regions, who saw how effective it was for gaining votes, adopted it as well. Charles Lanman described two types of Virginia barbecues: the social and the political. James Hammond Trumbull contrasted the development of the political caucus in the New England colonies with the political barbecue that first developed in Virginia.[67] Playwright Robert Munford satirized Virginia's political barbecues in his comedic play *The Candidates* in 1770.

Although some may overlook the importance of barbecue in the history of American politics, America's founders didn't overlook it. When Virginian George Washington laid the cornerstone of the Capitol in 1793, cooks barbecued a five-hundred-pound ox as part of the celebration. Moreover, just as Virginians had been doing for almost two hundred years before, there was much celebratory gunfire.[68] Another testimony to

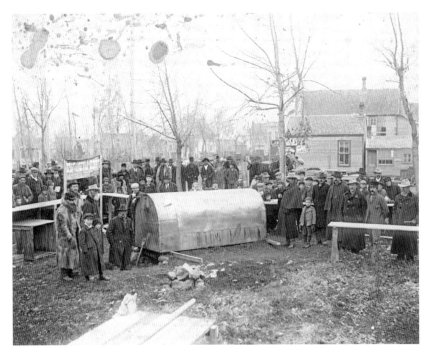

One of the earliest known covered barbecue pits. It was used to cook barbecue at a Republican campaign rally for President McKinley in Minnesota, 1896. *Cottonwood County Historical Society.*

the importance and influence of Virginia's political barbecues exists in the "Barbecue Trees." In 1903, the *Washington Times* reported:

> *South of the Washington Elm are the Barbecue Trees planted during Jackson's Administration by James Maher, a Jolly Irishman who owed his appointment as superintendent of the Capitol Grounds to the President's personal friendship. These trees are relics of two circular groves intended for barbecue celebrations one for Democrats the other for Whigs.*[69]

In 1874, the government commissioned Frederick Law Olmsted to oversee a renovation of the Capitol grounds. He commented on the existing vegetation:

> *South of the "Washington Elm," adjoining the East Court of the Capitol, there were a dozen long-stemmed trees, relics of two circular plantations introduced in the midst of Foy's largest "grassplats," by Maher, for "barbecue groves," one probably intended for Democrat, the other for Whig jollifications.*[70]

Maher planted the Barbecue Trees on the Capitol's East Grounds. They were "relatively fast maturing trees, closely planted and [by 1874] were not effectively thinned or pruned. About forty years after their planting the larger number of those remaining alive were found to be feeble, top heavy, and

The "Barbecue Trees" are depicted in this 1861 pencil drawing of the U.S. Capitol as two groves in the lower left. From *Harper's Weekly* (July 27, 1861). *Reprinted with permission of Applewood Books, Carlisle, MA, 01741.*

ill grown."[71] The poor condition of the trees was probably due to neglect during the Civil War and Reconstruction. Sadly, Olmsted demolished the groves in the 1870s along with much of the rest of the Capitol grounds as his renovation work progressed. Incidentally, in addition to ordering the planting of the Barbecue Trees, Andrew Jackson is the first president recorded to host a barbecue at the White House, which occurred on Independence Day in 1829.[72] Although there are claims that Jefferson was the first, there are no primary records to support them.

VIRGINIA BARBECUE AND THE SLAVE TRADE

Before the Civil War, Virginia played a leading role in the domestic slave trade, exporting far more slaves than any other state. Lorenzo Ivy was a slave who lived in Danville, Virginia. As an old man in his eighties, he recalled how slave traders would bring slaves from Virginia bound in chains, walking two by two in lines as far as the eye could see, as they were loaded into trains. He remarked, "Truly, son, de haf has never been tol'."[73]

Karl Bernhard wrote in 1828 of the slave "nurseries" that existed in Virginia from which the Deep South was supplied with slaves.[74] In 1859, a Texas newspaper reported, "An almost endless outgoing of slaves from Virginia to the South has continued for more than two weeks past"[75] Between the years 1800 and 1809 alone, it is conservatively estimated that sixty-six thousand slaves were traded between states, of which forty-one thousand came from Virginia.[76]

Because most barbecue cooks in antebellum Virginia were African Americans, the enslaved people sent from Virginia throughout the South played a major role in spreading Virginia's barbecue. This fact helps explain why the Virginia barbecuing technique and the Virginia barbecue baste of butter, salt, peppers and vinegar were used all over the South.

A VIRGINIA BARBECUE

Of the genus barbecue, as it exists at the present time, we believe there are only two varieties known to the people of Virginia, and these may be denominated as social and political. The social barbecue is sometimes given at the expense of a single individual, but more commonly by a party of gentleman, who desire to gratify

their friends and neighbors by a social entertainment. At times, the ceremony of issuing written invitations is attended to; but, generally speaking, it is understood that all the yeomanry of the immediate neighborhood, with their wives and children, will be heartily welcomed, and a spirit of perfect equality invariably prevails. The spot ordinarily selected for the meeting is an oaken grove in some pleasant vale, and the first movement is to dispatch to the selected place a crowd of faithful Negroes, for the purpose of making all the necessary arrangements.

If the barbecue is given at the expense of half a dozen gentlemen, you may safely calculate that at least thirty servants will be employed in bringing together the good things. Those belonging to one of the entertainers will probably make their appearance on the ground with a wagon load of fine young pigs: others will bring two or three lambs, others some fine old whisky and a supply of wine, others the necessary tablecloths, plates, knives, and forks, others an abundance of bread, and others will make their appearance in the capacity of musicians. When the necessaries are thus collected, the servants all join hands and proceed with their important duties.

Charles Lanman, Haw-Ho-Noo: Or,
Records of a Tourist (1850)

Virginia Cookbooks and Southern Barbecue

Virginia cookery was very influential in the 1700s and 1800s.[77] Mary Randolph's cookbook *The Virginia Housewife* was particularly popular and influential. *The Improved Housewife*, written by "A Married Lady" and published in 1844, is a witness to that fact. That book includes Mary Randolph's barbecued pork recipe almost word for word and describes it as no longer merely a Virginian dish but rather "a Southern Dish."[78] Randolph's influence also exists in foods served with barbecue. For example, in 1850, a writer described "southern barbecues," which, at that time, often featured another Mary Randolph recipe: turkey with oyster sauce.[79] Another example of Virginia's influence on southern cookery exists in the

oldest American cookbook written by an African American. The author, Mrs. Malinda Russell, was born in Tennessee to a family originally from Virginia. She published her cookbook in 1866. Mrs. Russell was taught to cook by a woman from Virginia named Fanny Steward. As a result, the Tennessean Mrs. Russell explained that she cooked "after the plan of *The Virginia Housewife*."[80]

The Decline of Grand Barbecues

One of the earliest contributors to the decline of big barbecues in Virginia was religious revivals. During Virginia's Great Awakening in the 1740s, preachers railed against the customs practiced at Virginia barbecues such as cockfighting, gambling, drinking and horseracing.[81] In 1844, Dr. James Jones described the people of Nottoway, Virginia, before he helped found the Presbyterian Church there in 1825: "The county was irreligious throughout its length and breadth. Periodical jockey club meetings, reveling, balls, parties, barbecues, card and drinking parties, with a host of other dissipations of the most grossly immoral tendencies, obtained everywhere; but after this reformation all this disappeared."[82]

In 1858, an author commented on Virginia barbecues as "another of the institutions of Virginia," writing:

> *We are well aware that there are many persons of the present day who lift up their hands in holy horror at the wickedness of their predecessors, in this article of barbecues. If they can make out, to our satisfaction, that the present generation is either better, or wiser, or more sober, we give up the point. But, until that can be done, we shall cling pertinaciously to the memory of those good old days. We are not ashamed to confess that some of the most pleasant hours of life have been spent at these old fashioned barbecues.*[83]

Because Virginia barbecues were often rowdy events accompanied by rough sports and games, it is easy to see why evangelists and churches would encourage people to avoid them.

Other factors that contributed to the decline of barbecues in Virginia, and throughout the South, were the Civil War and Reconstruction. In 1876, a writer commented, "Pity if so good an institution [Virginia barbecues] has gone down, as we fear it has in its original simplicity, among the other wrecks

of the war."[84] R.T.W. Duke Jr., of Albemarle, Virginia, wrote in his memoirs, "War and its damnable successor, 'Reconstruction' stopped Barbecues until about 1873 or 74."[85] In 1910, a writer observed, "The picturesqueness of the olden-time political meetings and the necessary barbecue passed away with the Civil War."[86] Although this was an exaggeration, it does reflect the fact that after the end of the Civil War, barbecue events occurred in much less frequency. For example, in 1907, while discussing the possibility of holding a Labor Day barbecue at the Virginia State Fairgrounds, the planners wanted "a huge barbecue, such as has not been seen in many a day."[87]

By 1863, the people of Richmond, Virginia, were engaging in food riots and things would only get worse for Virginians in those days before they

Civil War destruction of the Richmond and Petersburg Railroad depot, 1865. *Library of Congress, Prints and Photographs Division, LC-DIG-cwpb-02700.*

would get better.[88] By all accounts, Virginia, which had been the main Civil War battleground, was in ruins at the close of the Civil War. The fighting resulted in the destruction of homes, towns, public records, libraries and plantations. Virginia had no civil government, and Confederate money was worthless. Farmers had little or no money, stock or seeds, and there was no way to secure credit. Before the war, Virginia's railways were among the finest in the world. After it, they were in ruins.[89]

The residents of "Military District Number 1"—the federal designation for much of Virginia during its Reconstruction era—were in no mood to hold barbecues, even if they could have afforded them. In 1865, a writer observed, "It is now some years since the people of Virginia have

Destruction caused by the Civil War at Fredericksburg in 1862. *Library of Congress, Prints and Photographs Division, LC-DIG-ppmsca-35109.*

participated in a regular old fashioned 4th of July celebration…We shall have no volunteer reviews nor target shooting, but we have seen too much of the genuine article of war."[90]

The "Glorious Fourth" had always been a day for barbecues in Virginia, going back to the earliest times in the history of the United States. However, that wasn't the case during the Civil War and Reconstruction. Even after the war ended, Virginians were not quick to resume the celebration of Independence Day. One writer noted:

> *When the war came there were no holidays for the masses; it was all fighting and no frolicking. After the first year there were few new or clean uniforms to parade in, and no powder and caps to spare for salutes which would kill nobody. Hostilities ended, the Confederate flag furled, Richmond people looked at the un-turfed graves in Oakwood and Hollywood and at the burnt district in their city, and at the Federal troops quartered in the suburbs, and could not all at once revive Fourth-of-July patriotism in their breasts.*[91]

It took more than two decades after the Civil War ended for "the Fourth" to become the "Glorious Fourth" again in Virginia. In fact, the *Richmond Dispatch* took note that in 1886 in Richmond, Virginia, "the day was more generally observed than any Fourth since the war":

> *But as nature and human industry covered the scars of war, and the great majority of the North and of the South buried their differences, the observance of the Fourth again became general here. At first no attention was paid to it. Few closed places of business. Now, it is the most generally observed holiday of the year, Christmas alone excepted.*
>
> *In these times, as of old, the stars and stripes float from every flag staff and masthead; but the crowds which used to picnic near the city [a reference to barbecues] now take excursion trains and fly to Washington, to Old Point, to the White Sulphur, to Fredericksburg, to Petersburg—indeed anywhere to be out of Richmond. The colored troops, ever burning with patriotism and ever indifferent to the burning sun, have usually stayed at home and paraded and marched and picnicked.*[92]

Times were difficult in Virginia during its Reconstruction years. The Panic of 1873 and the depression that followed further negatively affected Virginia's economy. Things were so bad in parts of Virginia that many of

the poor people in Alexandria had "not a stick of wood or a pint of meal."[93] The lack of jobs and money, as well as the scarcity of food and livestock decimated by war, all played a role in the decline of old Virginia barbecues. In 1884, a writer for the *Washington Post* wrote of the attendees at a Virginia barbecue, "To them a barbecue was a novelty. They had attended these gatherings when they were boys, and now as grown men had come once again to listen to the speeches and eat a barbecue dinner."[94]

At the close of the Civil War, many newly freed African Americans left Virginia and took Virginia barbecue with them. In 1879, ten barbecue men, enslaved in Virginia until the end of the Civil War, made their way to Cincinnati. There, they had steady work cooking old Virginia barbecue. On one occasion, they barbecued two oxen and eight sheep. The barbecue "was a great success, and fully 5000 people partook" of the Virginia-style barbecue.[95]

Because most accomplished Virginia barbecue cooks of the nineteenth century were African Americans, one must consider the possible effect of prejudice and Jim Crow laws in the decline of Virginia barbecues. A possible example of this is the experience of the Gordonsville, Virginia chicken vendors.[96]

The Gordonsville chicken vendors—or "waiter carriers," as they called themselves—became famous for their delicious Virginia-style fried chicken, sold to train passengers who stopped at the local junction. They started their business after the end of the Civil War, and it continued until the 1920s. Mothers and daughters spent their days cooking delicious foods such as biscuits, hoecakes, pies, coffee and fried chicken. The women would present the foods to train passengers using large platters they carried on their heads. Passengers often remained in the trains and this was a way to put the food within reach of the customers leaning out of the windows.

The chicken vendors' business thrived for about five decades, with only a brief interruption caused by World War I. In the early twentieth century, the Gordonsville Town Council took notice of the women's business and levied a tax on it. It wasn't long before the tax was increased. Others took note of the thriving business and coveted it. After the end of World War I, a restaurant and hotel purchased exclusive rights to sell foods on the train station platform from which the chicken vendors had previously operated. Nevertheless, that didn't stop the determined women. They simply sold their fried chicken from the side of the tracks opposite the station and did better business than the restaurant. Eventually, the restaurant closed, leaving the women again as the only food vendors for train passengers. It is estimated

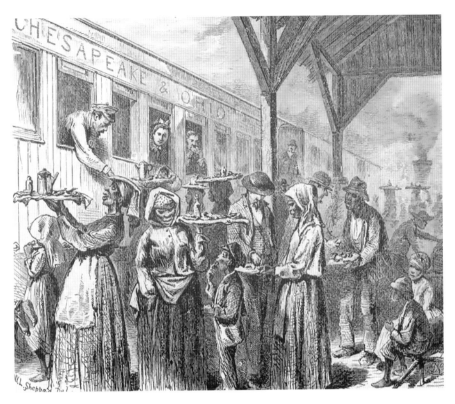

Gordonsville, Virginia's "waiter carriers." *From* The Great South *by Edward King, 1875.*

that they sold as much as one thousand chickens per week, fried using their secret recipe.

Eventually, another local restaurant acquired exclusive rights to sell food at the train station. This, along with high taxes and the fact that by the 1920s trains had added dining cars, eventually put the women out of business. It was a loss not only for the women and their families but also for Virginia. Many merchants in Gordonsville benefited from the women's business—from the poultry merchants to the wrapping paper sellers; the vendor who sold the lard, salt, pepper and flour; and the town of Gordonsville itself, which received taxes from the women's endeavors. All were a little poorer. Highlighting the loss is the fact that before the waiter carriers went out of business, Gordonsville was a chief supplier of chicken in the region. In 1920, the planners of a Charlottesville barbecue stated that they had "secured a special option on the chicken market in Gordonsville."[97] When the waiter carriers closed down, the lucrative Gordonsville chicken market closed with them.

The Town of Gordonsville, Virginia, remembers the waiter carriers today by holding an annual fried chicken festival in their honor. *Author's collection.*

Virginia lawmakers didn't make it easy on the famous Gordonsville chicken vendors. In fact, one could make the case that they were determined to close them down. It's possible that Virginia barbecue cooks of the same era experienced similar difficulties.

At the turn of the twentieth century, even though Virginia had endured war, the turmoil of Reconstruction and the injustices of Jim Crow, Virginians, on occasion, were still holding grand Virginia barbecues. However, World War I and Prohibition would deal another blow to them. Duke Jr. commented about the "iniquitous, hypocritical, tyrannical & fanatical Legislation known as the 18th Amendment" and complained that "a Barbecue without something to drink was…a d-mn dreary place."[98]

The death of the generation that was most expert at cooking Virginia barbecue also played a role in its decline, just as was predicted by Duke Jr.[99] It is no coincidence that the loss of so many accomplished Virginia barbecue cooks of Caesar Young's generation coincided with fewer mentions of Virginia barbecue in literature. For example, after the authors of the cookbook *America Cooks* wrote of Virginians in 1940, "Their favorite picnic is a barbecue," there is a noticeable reduction in the publicity given to Virginia barbecues.[100] In 1951, a Pennsylvania restaurant was bragging

about its "tangy Virginia barbecue," and an Arizona restaurant was advertising its James River pork barbecue with "[t]hat Fine, Old Virginia Barbecue Flavor."[101] However, as the 1950s ended, there were fewer and fewer advertisements for Virginia barbecue in other states. This did not go without notice from Virginians. In 1978, a columnist for the *Richmond Times Dispatch* noticed an increase in the number of barbecue restaurants opening in Richmond that served North Carolina–style barbecue. She commented that North Carolina–style barbecue had "not only crossed the state line, but kidnapped the market as well."[102]

Perhaps another clue to the causes of the decline of grand Virginia barbecues exists in the story of the Brunswick stew master George Rogers. Rogers began cooking Virginia Brunswick stew in Halifax County around the year 1910. For decades in and around the Jamestown, Virginia area, he simmered, stirred and served Virginia Brunswick stew outdoors in large copper pots. When a reporter asked his son, Charles, if he was going to assume his father's role, he replied that there is "too much work involved."[103]

Often, fathers passed the art of barbecuing to their sons. Cooking barbecue and Brunswick stew for large events requires a tremendous amount of very hard work. Because of that, just like George Rogers's son, young people sought other opportunities and pursuits. For example, John Dabney's daughters became schoolteachers in Richmond. One of his sons became a professional baseball player, and another became a musician, writer and the founding editor of two Cincinnati newspapers.[104]

URBANIZATION AND BARBECUES

Urbanization took its toll in Virginia just as it did in other parts of the South. Thomas Jefferson wrote that in his day, Virginia towns were "more properly our villages or hamlets."[105] By the end of the eighteenth century, all cities in Virginia were still no more than small market towns compared to northern cities such as Philadelphia, New York and Boston.[106] The populations of Richmond, Norfolk, Petersburg and Alexandria wouldn't reach at least thirty thousand each until about 1860. It wouldn't be until 1950 that the federal census would record for the first time that more Virginians were living in cities and towns than in rural communities.[107]

Moreover, as urbanization spread, the old Virginia barbecues were set aside in favor of other amusements. In 1891, a columnist wrote, "Railroads

have almost revolutionized the Fourth of July." He went on to explain how "country folks rush to the towns and the city folks dash to the country. Thus have excursion rates underdone the old-time 'celebrations.'" In 1872, one writer observed that barbecues in the South were more common "before the late war than now."[108] In 1893, the American Historical Association noted, "The barbecue feast was a much more popular observance among the people in colonial times than at present," and in 1899, another commented that barbecuing in the South "is now a lost art." In the times before the Civil War, Chatham, Virginia, was famous for big barbecues. However, when people there hosted an "old-fashioned" Virginia barbecue in 1905 to welcome dignitaries, the novel event reminded attendees of the legendary barbecues that they had only heard of from their fathers.[109]

As far back as 1860, in an article in *De Bow's Review* entitled "Country Life," the author complained about how life had changed over the previous forty years, writing, "The pursuits and amusements of our parents are not our pursuits and amusements." Offering a reason for the change, the author explained that it "consists in the country having become more and more dependent on the towns." As a result, "The private social festive board is rarely spread; the barbecue, with its music and dance, is obsolete and almost forgotten."[110] Although such claims were, to an extent, exaggerations, they do reflect the impact of urbanization and the Civil War on southern barbecue.

In 1887, a columnist for the *Louisville Courier-Journal* declared, "The day of the barbecue in campaigns is over." The reason for the decline, cited by the author, was "[t]he development of the national character."[111] By the turn of the twentieth century, political barbecues in Virginia were also on the way out. In 1910, a newspaper columnist asked, "[Are we] never again to have an old time political barbecue in Virginia?"[112] As more and more people moved away from rural areas to cities and towns, fewer and fewer "old Virginia" political barbecues were held. Although urbanization didn't end political barbecues in Virginia, they did become less frequent.

Author, food editor and journalist Raymond Sokolov observed that the preservation of authentic regional cooking requires thriving rural communities.[113] In the twentieth century, Virginia's barbecued meats moved from mostly "rural entertainments" to urban and city stands and restaurants. This resulted in changes to Virginia barbecue.

By 1941, Mechanicsville, Virginia, had transitioned from a very rural community filled with farm wagons and stables to a region filled with gasoline stations and barbecue stands.[114] As Virginia's barbecue made that

A MONTAGUE BARBECUE

LAWRENCEVILLE, AUG. 2,

Governor A. J. MONTAGUE will address the citizens at Lawrenceville, **Wednesday Aug. 2nd.** No citizen of Virginia is held in as high esteem and is admired as much by the people of his state as is Mr. MONTAGUE and the reason is that he is fighting the fight of his life in the present Senatorial campaign in THEIR INTEREST and CLEAN POLITICS.

All come on that day and hear Virginia's purest statesman and peerless orator. After the address an

OLD FASHIONED VIRGINIA BARBECUE

Will be served and all are assured that they will have not only the best that the noted cooks of Brunswick can prepare, but as much as they desire. Take this day off and bring your family and hear **Virginia's Ideal Statesman** and meet old friends and renew ties of former days.

A SPECIAL INVITATION IS EXTENDED TO THE LADIES.

Please Post.

A flyer for an old-fashioned Virginia barbecue hosted by Governor Montague, 1905. *Library of Virginia.*

transition, some of it lost its uniqueness. However, that's true of barbecue all over the South, where the same transition occurred. A clear lack of barbecue diversity from region to region exists today. Just take a casual look through barbecue recipes posted on the Internet and in cookbooks. Beginning in about the 1950s, newspapers and magazines generously shared identical

barbecue recipes all over the country. Barbecue cookbooks became popular, and national brands of bottled barbecue sauces were on shelves in every supermarket. These developments have blurred and, in some cases, erased the lines between many regional barbecue styles. This brings us to the fact that you can find barbecue in Virginia *and* you can find Virginia barbecue in Virginia. Although there are restaurants that sell Texas-style brisket and North Carolina–style pork, you can still find restaurants that proudly serve authentic Virginia-style barbecue. Although time has changed barbecue traditions in Virginia, in spite of what some barbecue "experts" might say, it hasn't erased them.

The only unbroken line of southern barbecue history begins in Virginia. Barbecuing in the Indian manner became barbecuing in the Virginian manner. As settlers from Virginia spread farther south and west, barbecuing in the Virginian manner spread with them and gave birth to barbecuing in the southern manner. At one time, what we call today "southern barbecue" only existed in the cultural hearth of the Tidewater region of colonial Virginia.[115] However, Virginia's barbecue monopoly didn't last long. From its beginnings among Virginia's "Chesapeake Creoles," Virginia's way of cooking barbecue spread throughout the South to become an enduring and cherished tradition for an entire region of the United States.[116] Indeed, Virginia's barbecue history and traditions have earned the Old Dominion yet another nickname: the "Mother of Southern Barbecue."

Today, the number of barbecue restaurants and vendors who celebrate Virginia's barbecue history by proudly serving authentic and delicious Virginia-style barbecue is growing. In April 2016, the Virginia General Assembly reaffirmed a long-held Virginia barbecue tradition by unanimously passing House Joint Resolution No. 169 designating May through October, in 2016 and in each succeeding year, as Virginia's Barbecue Season. The proclamation sends a message that Virginians are still proud of their rich barbecue traditions and will continue to preserve them for future generations.

CHAPTER 8
AUTHENTIC VIRGINIA BARBECUE RECIPES

The barbecue is one of our old Virginia institutions, which dispenses with form, ceremony and display. A plenty to eat, well cooked, and a plenty to drink, well mixed, with toasts and speeches, constitute the entertainment. This social gathering is held in the open air, near a spring and at a well shaded spot.
–Richmond Whig, *"Barbecues," July 20, 1869*

Barbecue cooks have always had their secrets. For hundreds of years, most barbecue cooks in Virginia were enslaved African Americans. As a result, they couldn't record their recipes in written form, so they passed them on by word of mouth or chose not to share them at all. Although some accounts mention the vinegar, butter, salt and peppers, writers didn't often reveal many of the other secret spices and herbs in the sauce. Compounding the problem of discovering Virginia barbecue recipes is the fact that most Virginia barbecue cooks today also cherish their secrets. In fact, the secret nature of several Virginia barbecue recipes that I am privy to prevents me from publishing them in this book. For those reasons, and others, published research into Virginia barbecue recipes is and probably always will be incomplete. Even so, observation, experimentation and a diligent study of old diaries, books, magazines and newspapers can reveal many of the finer points of genuine Virginia barbecue recipes from as far back as the seventeenth century.

As new ingredients became available and as Virginians' prosperity grew, so did the variations they used in their barbecue recipes. In colonial and federal

times, more prosperous Virginians used relatively expensive ingredients compared to Virginians who were less well to do. At around the turn of the twentieth century, when food manufacturers realized that sugar makes just about everything taste better, Americans developed a sweet tooth, and sugar consumption soared. Consequently, barbecue sauce manufacturers all over the country increased the amount of sugar in their recipes. Virginia barbecue was no exception. Today, Virginia barbecue sauces range from thin and vinegary to thick and sweet, often including "all sorts of spices."[1] They reflect both the simple Virginia pepper vinegar sauces and those that meet the modern expectations of kick, sparkle, spice, zest and zing.[2]

VIRGINIA BARBECUE SAUCES THROUGH THE CENTURIES

Virginia's vinegar-based sauce tradition is older than North Carolina's. Although North Carolina's vinegar-based sauces are delicious, Virginia's vinegar-based sauces are special, too. Nineteenth-century Virginia barbecue sauces contained "vinegar, peppers, and other spicy condiments."[3] The "other

Pork barbecue sandwich topped with Virginia peanut barbecue sauce at Benny's Barbecue in Richmond, Virginia.

Using a patented design that creates an incredibly "stable, uniform, and efficient cooking environment," 270 Smokers manufactures high-quality barbecue cookers in Virginia. *Stephanie and Terry West.*

spicy condiments" could include herbs, spices, mustard, Worcestershire sauce and even horseradish.

Oils traditionally used in Virginia barbecue sauce recipes include butter, lard and bacon fat. Modern substitutions include canola oil, soybean oil and peanut oil. Virginians have used such sweeteners as sugar, molasses, honey and stewed or jellied fruits for hundreds of years. This is illustrated in a description of a Virginia barbecue from 1836 where the author told of barbecued meats served with "all kinds of preserves."[4]

According to eyewitnesses, the oldest Virginia barbecue sauce is a combination of water or vinegar, butter or lard, salt and red pepper. Some recipes used all of the ingredients. Some used only a few. Sometimes cooks added additional ingredients, such as black pepper, mustard, sugar and herbs. Virginians derived the basic recipe from English recipes from the sixteenth-century published in cookbooks that colonists brought with them from England. For example, in a 1675 recipe entitled "To Broyl a Leg of Pork," we find a sauce recipe consisting of butter, vinegar, mustard and sugar.[5] Those old English recipes for grilling and carbonadoing meats are the ancestors of the original Virginia barbecue sauce that became the foundation for barbecue sauces all over the South.

I have been very happy since my arrival in Virginia, I am continually at Balls & Barbecues (the latter I don't suppose you know what I mean) I will try to describe it to you, it's a shoat & sometimes a Lamb or Mutton & indeed sometimes a Beef splitt into & stuck on spitts & then they have a large Hole dugg in the ground where they have a number of Coals made of the Bark of Trees, put in this Hole, & then they lay the Meat over that within about six inches of the Coals, & then they Keep basting it with Butter & Salt and Water & turning it every now and then, untill its done, we then dine under a large shady Tree or an harbour made of green bushes, under which we have benches & seats to sit on when we dine sumptuously, all this is in an old field, where we have a mile Race Ground & every Horse on the Field runs, two & two together, by that means we have a deal of diversion, and in the Evening we retire to some Gentle's House & dance awhile after supper, & then retire to Bed, all stay at the House all night (it's not like in your Country) for every Gentleman here has ten or fifteen Beds which is aplenty for the Ladies & the Men ruff's it, in this manner we spend our time once a fortnight & at other times we have regular Balls as you have in England.

Lawrence Butler, "Letters from Lawrence Butler, of Westmoreland County, Virginia, to Mrs. Anna F. Cradock, Cumley House, near Harborough, Leicestershire, England" (1784)

Mary Randolph's cookbook *The Virginia Housewife* sheds much light on Virginia barbecue. Randolph was born in Goochland County, Virginia, in 1762. She was kin to Thomas Jefferson and Mary Lee Fitzhugh. Randolph's cookbook was, according to Karen Hess, the most influential cookbook of the nineteenth century. Randolph died in 1828.

A versatile sauce shared by Randolph is Virginia pepper vinegar. The recipe calls for simmering Virginia chili peppers (cayenne peppers, bird peppers or fish peppers) in vinegar—after which the sauce is to be strained to remove the remains of the peppers. Pepper vinegar was used as an ingredient in ketchups and sauces. It was also used as a sauce on meats of all kinds, including barbecued meats. According to Randolph, its flavor is "greatly superior to black pepper," which illustrates how Virginians often substituted chili peppers for black pepper.

Virginia-style barbecue sauces served at 1752 Barbecue in Woodstock, Virginia. *Craig George.*

Randolph's "barbecue shote" was seasoned with garlic, pepper, salt, red wine, mushroom ketchup and browned sugar. Randolph's mushroom ketchup contains mushrooms, salt, garlic and cloves. The "shote," or young pig, was stuffed with minced meat seasoned with sweet herbs, mace, nutmeg, lemon peel, salt and pepper. "Sweet herbs" could be any combination of parsley, sage, thyme, savory, marjoram, spearmint, dill, fennel, tarragon, balm, basil, coriander, bay leaves, chervil and rosemary. In the 1800s, sage was "the universal flavoring" and "the seasoning par excellence for rich meats such as pork." Virginians used mint mainly as a seasoning for peas, lamb, roast pork and in mint juleps.[6] Therefore, any of the sweet herbs are appropriate for use in authentic Virginia barbecue recipes.

Mushroom ketchup was popular in Virginia barbecue recipes for a long time. However, by the late nineteenth century, many Virginians had replaced mushroom ketchup with Worcestershire sauce. By 1885, the *Virginia Cookery-Book* included several ketchup recipes but, unlike earlier Virginia cookbooks, no recipes for mushroom ketchup. Instead, there is a recipe for Worcestershire sauce. Interestingly, the Worcestershire sauce recipe calls for fresh tomatoes in the mix.[7] Because old recipes for Worcestershire sauce

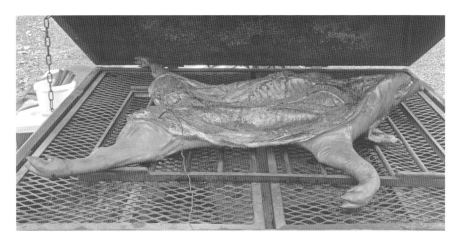

Virginia-barbecued whole hog in Louisa, Virginia. *Bill Small.*

often included mushroom ketchup and/or walnut ketchup as an ingredient, it turned out to be a good, easy-to-acquire substitute for both.[8] For example, by 1913, one author gave the cook a choice of using either "a tablespoon of Worcestershire sauce or mushroom-ketchup."[9] A kitchen barbecue recipe from 1898 calls for a sauce made of ketchup, butter and sherry. The author of the recipe allows for Worcestershire sauce or mushroom ketchup as substitutes for the sherry.[10] Apparently, Virginia's influence on barbecue flavors includes not just vinegar and red pepper but also mushroom ketchup and Worcestershire sauce.

Randolph's method for roasting a pig is more like a traditional Virginia barbecuing method than is her kitchen barbecuing method. When roasting a pig, Randolph instructs us to baste it "at first" with salted water before switching later to rubbing it frequently with lard "wrapped in a piece of clean linen." Of course, Virginia barbecue cooks had been basting barbecuing pigs with salt, water and lard using clean linen attached to mops for at least two hundred years before Randolph published her roast pig recipe.

Stuffing a pig with a mixture of minced meat, herbs and spices is a part of Randolph's kitchen barbecue recipe. However, there are no records of Virginians using minced meat when barbecuing pork outside on a barbecue pit. Because Randolph's kitchen barbecue recipe re-creates Virginia barbecue flavors in the kitchen, seasonings such as sweet herbs, lemon peel, lemon juice and spices such as mace, cloves and nutmeg can be used to season barbecue without using the minced meat as a carrier.

Randolph also shared a "white sauce for fowls" made with veal or fowl stock, mace, anchovies, celery, sweet herbs, lemon, pickled mushrooms, nutmeg, cream and black pepper. The sauce is an appropriate accompaniment for any kind of fowl, including chicken, no matter whether it was boiled, roasted or barbecued.

Marion Cabell Tyree's 1879 cookbook *Housekeeping in Old Virginia* contains several barbecue recipes. Tyree, born in 1826, was Patrick Henry's granddaughter. Her cookbook is a compilation of recipes shared by nearly 250 Virginian women in which is found "many names famous through the land." The recipes in Tyree's cookbook came from "the best housekeepers of Virginia." In 1879, they represented the "garnered experience" of the previous one hundred years.[11] Tyree died in 1912.

Tyree shared a "meat-flavoring" recipe that includes onions, red pepper pods, brown sugar, celery seed, ground mustard, turmeric, black pepper, salt and cider vinegar. Cooks included this sauce in many recipes for stews, gravies and barbecue.

Other barbecue recipes shared by Tyree call for walnut or tomato ketchup as an ingredient. She also shared a sauce that uses currant jelly as a sweetener. The ingredients in her various walnut ketchups include horseradish, mustard, garlic, shallots, allspice and ginger. One recipe calls for "any kind of spice you like." Although we may not use walnut ketchup nowadays, we can use a combination of the flavors that were in it and still make a tasty and authentic Virginia barbecue sauce.

Tomato ketchup recipes in Tyree's cookbook include various ingredients: "spices," brown sugar, horseradish, mustard, ginger, cloves, celery seed and red pepper. Adding a combination of those ingredients to tomato ketchup can stand in for Tyree's homemade ketchups for use in modern versions of Virginia barbecue sauces.

Mary Virginia Terhune's two cookbooks are rich primary sources for old Virginia barbecue recipes. Terhune was born in Amelia County, Virginia, in 1830. She wrote several books under the penname Marion Harland. Like Mary Randolph, she also shared kitchen barbecue recipes. Terhune died in 1922.

By 1917, paprika was "used extensively" in the United States in sauce and pepper vinegar recipes. Terhune's Virginia barbecue recipes reflect that fact. They include ingredients such as vinegar, butter, salad oil, salt, pepper, onion juice, mustard and paprika. Terhune's recipe for barbecued rabbit calls for turning it often as it barbecues. The barbecued rabbit should be put in a dish with "pepper and salt and butter profusely" added before letting it rest for five minutes, after which you are instructed to "anoint" it with a mixture of

The BBQ Jamboree is one of the largest barbecue competitions in the state of Virginia. It is an annual event that takes place in Fredericksburg, Virginia. *Jeremy Bullock and James Sharon.*

butter, vinegar, mustard and minced parsley.[12] Her kitchen barbecue recipe for barbecued ham calls for vinegar and sugar in the sauce.

Lettice Bryan's 1839 cookbook *The Kentucky Housewife* is a valuable resource for Virginia barbecue recipes. Lettice Bryan was the wife of a native-born Virginian named Edmund Bryan. Her father's family has roots in Virginia from times long before Kentucky became a state in 1792. Many of Bryan's recipes are much older than the nineteenth century, and as was the custom of her times, her parents' and her husband's families handed them down to her.[13] For those reasons, as well as the fact that Kentucky received its barbecue tradition from Virginia, it is appropriate to use Bryan's cookbook to shed light on old Virginia barbecue.[14] The Virginia influence in Bryan's barbecue recipes shines in her basting sauce of salt water and pepper and her use of stewed fruits in sauces served with the barbecue. Her barbecue

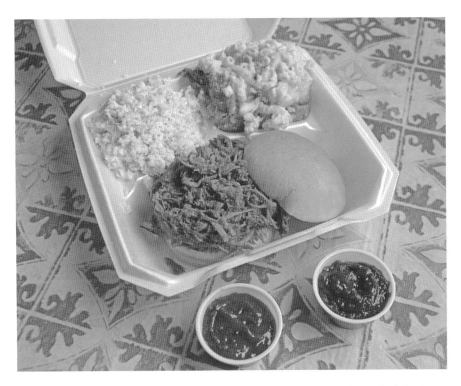

Virginia red and Virginia mahogany sauces at Paulie's Pig Out in Afton, Virginia. *Author's collection.*

recipes include an Indian barbecue recipe for venison hams, as well as a barbecue recipe used for both pork and beef.

Bryan's bread sauce recipe, recommended for barbecued pork and beef, calls for the optional ingredient of Madeira wine. Bryan's use of Madeira wine demonstrates English influences. In the 1770s, a French translator described a Virginia barbecue as (roughly translated) "a barbarous amusement where they tenderize pork by beating pigs to death with sticks." The author of the book, Englishman Andrew Burnaby, corrected the record, explaining, "In justice to the inhabitants of Virginia, I must beg leave to observe, that such a cruel and inhuman act was never, to my knowledge at least, practiced in that country. A Barbecue is nothing more than a porket killed in the usual way, stuffed with spices and all rich ingredients, and basted with Madeira wine."[15] Burnaby described English barbecue, not Virginia barbecue. Alexander Pope wrote, "hog barbecu'd" is "a hog roasted whole, stuffed with spice, and basted in Madeira wine."[16] Again, Pope, an English poet, is referring to an old English barbecue recipe. We also have the British

author who, in 1771, wrote about English "barbicue" that was "thoroughly impregnated with Madeira."[17] Ward's *The Barbacue Feast, or, The Three Pigs of Peckham, Broil'd Under an Apple-Tree*, published in 1707, describes English sailors cooking barbecue while basting it with Madeira wine. This stands in contrast to Virginia's barbecue sauce of butter, vinegar, salt and peppers. Virginians rarely used wine in barbecue recipes. When they did, red wine was preferred.

Bryan's pork and beef barbecue recipes exhibit a true Virginia style of barbecuing over "a bed of clear coals." She exhorts the reader to "not barbecue it hastily" but rather let it "cook slowly for several hours." Before barbecuing, rub the meat with salt, pepper and molasses; rest for a few hours; and wipe dry before barbecuing it. As it cooks, she advises that we turn it occasionally while basting it with the old Virginia mixture of salt water and pepper. Before serving the barbecue, she instructs us to squeeze "a little lemon juice" over it. To accompany the barbecue, Bryan recommends melted butter, wine, bread sauce, coleslaw, cucumbers and stewed fruit.

In 1839, barbecue sauce as we think of it today didn't exist. It wasn't until around 1871 that "barbecue sauce" was a product that could be purchased, and there are no recipes specifically for "barbecue sauce" in any cookbooks until around the 1870s. Before that time, people served whatever sauces they liked rather than something they called "barbecue sauce." This practice started with the original barbecue sauce derived from carbonado recipes. It continued in Bryan's sauce suggestions for her barbecued shoat. Her recipes for both barbecue shoat and roast pig call for bread sauce and fruit sauce made with stewed fruit served on the side. We can also see this practice in the 1825 Schuylkill, Pennsylvania barbecue where attendees enjoyed "a fine barbacue [*sic*] with spiced sauce" but not a "spiced barbecue sauce" as we would call it today.[18] This implies that sauces served with roasted meats and barbecued meats were often the same. From colonial times, people referred to barbecued ox using the phrase "ox roasted whole." Terhune defined barbecue as "to roast any animal whole, usually in the open air."[19] This association of roasted meat with barbecued meat implies that the recipes used with both were similar. See Randolph's roast pig and barbecued shote recipes for other examples.

Virginians have served jellies and fruit syrups as a sauce or used them as ingredients in sauces for barbecued meats for centuries. As you will recall, the hosts of Thomas and Nancy Lincoln's marriage celebration served peach syrup along with the barbecued sheep. From several accounts, we see that Virginians often served fruit syrups and jellies with mutton, venison,

Shenandoah Valley–style barbecue baste. *Author's collection.*

beef and pork, which, of course, introduced a sweet flavor to the barbecue. Although common today, it's hard to say how widespread the practice of using fruit jelly as an ingredient in barbecue sauce was in the nineteenth century outside Virginia and Kentucky. In 1921, a Philadelphia newspaper printed a Virginia-style barbecue recipe that calls for currant jelly as an ingredient in the barbecue sauce. According to the author, such ingredients in barbecue sauce were "unusual."[20]

Many Virginia barbecue recipes include mustard. In Virginia, mustard isn't a base for barbecue sauce as it is in South Carolina. It's one of the "spicy condiments" used as a flavoring in Virginia barbecue sauces. Accounts of John Marshall's Buchanan's Spring Barbecue Club tell us that the barbecue was "highly seasoned with mustard, cayenne pepper, and a slight flavoring of Worcester sauce."[21] English and German immigrants brought the practice of using mustard in sauces served with roasted meats to Virginia. Of course, the

King's Famous Barbecue of Petersburg, Virginia, serves delicious barbecue cooked "the Virginia Way." *Matt Keeler.*

early English colonists used mustard, and it was very popular in sixteenth- and seventeenth-century England.[22]

In addition to Englishmen, several Germans were among the first settlers to arrive with Captain Christopher Newport on his second voyage to the Virginia colony in 1608. Between 1714 and 1721, several larger groups of German settlers made their way to Virginia. By 1727, the German settlement, known as Germanna, reached from Spotsylvania County all the way to the Blue Ridge Mountains.[23] Before the start of the Civil War, there were so many German immigrants in Richmond, Virginia, that one writer commented, "To judge from the conversation heard in the streets, one might be at a loss to ascertain whether German or English was the language of the country."[24] Therefore, it should be no surprise that they, too, had some influence on old Virginia barbecue flavors.

The oldest-known recipes for Virginia barbecued rabbit call for barbecuing it on a hurdle directly over coals, turning it frequently while basting it with and/or serving it with a mixture of butter, vinegar and mustard.[25] In 1888, an eyewitness shared an account of Virginians barbecuing a rabbit. First, they gashed the carcass with a knife with strokes about one inch apart so that the sauce could penetrate the meat. The cooks were careful to make sure that none of the coals was smoking or smoldering because the dense smoke might "destroy the flavor," which is a holdover from the seventeenth-century carbonado recipes. The barbecuing rabbit was basted with a sauce made of a combination of mustard, "all sorts of spices," vinegar, pepper, salt and brandy, or whatever liquor is preferred to give it a "high flavor." This baste was called "the seasoning." The host served currant jelly with the barbecue on the side.[26] As far back as at least the early 1800s, some also served rabbit barbecued the same way but with currant jelly or brown sugar added as an ingredient mixed into the sauce that they poured over the meat before serving it.[27] Although this is an account of Virginia-style rabbit barbecue, the ingredients and barbecuing technique were used for other meats as well. The same is true of Virginia-style squirrel barbecue recipes.

Virginians have used some ingredients that many don't usually associate with barbecue, including anchovies, shallots, maple syrup, peanuts and sassafras. Sassafras and shallots grow wild in Virginia, so it shouldn't be surprising that they made it into Virginia barbecue from time to time. "For centuries," Blue Ridge mountain men used to insert stalks of sassafras and other "yarbs" (herbs) into meat before barbecuing it.[28] Incidentally, Kentucky frontiersmen used sassafras in burgoo, too.[29]

Virginia Red barbecue sauce at Ace Biscuit & Barbecue in Charlottesville, Virginia. *Author's collection.*

The hardwoods traditionally used to cook Virginia barbecue include hickory and white oak. Other varieties of hardwoods used for barbecue include chestnut, apple and pecan. Virginia barbecue cooks were always careful to make sure that the fires in their pits had burned down to glowing embers with little or no visible smoke rising from them before putting meat on the pit. With Virginia barbecue, smoke and seasoning play a background role in the flavor of the meat.

Even though sassafras leaves and "yarbs" have been used to season Virginia barbecue, it is doubtful that cooks ever used sassafras wood to cook it. Both Cherokee Indians and white settlers avoided using sassafras wood as fuel probably due to its tendency to burst and "pop" out of the fire.[30]

Some of the recipes listed in *Beverages and Sauces of Colonial Virginia* no doubt made it to many a plank table erected beside a spring, including the recipe for "House of Burgess's Mint Julep." Because Virginians were fond of serving fruit-based sauces with barbecue, some probably served "Sauce for the Goose and Sauce for the Gander" with barbecue from time to time. The recipe calls for apples, butter and sugar to taste. Several sauces for wild game are in the book, including a sweet sauce for venison and a sauce that's "good with all kinds of game" made with vinegar, lemon, orange peel, mace, cloves, cayenne, mustard, tarragon, laurel leaves, shallots, garlic and white wine.

The Barbeque Exchange in Gordonsville, Virginia, serves "slow cooked Virginia goodness" and has been named one of the top one hundred barbecue restaurants in the United States. *Author's collection.*

"Newport's Sauce for Game" is suspiciously similar to Mary Randolph's "barbecue shote" sauce. It calls for port wine, mushroom ketchup, sugar, lemon juice, cayenne and salt. There are also white sauce recipes, a sauce made with bacon and various ketchup recipes, including a walnut ketchup recipe with cloves, nutmeg, vinegar, ginger, pepper, horseradish, shallots, port wine and anchovies. A "sauce for steaks" recipe includes vinegar, mustard, salt, pepper and lemon juice.[31] All of those ingredients have been used in Virginia barbecue recipes from time to time.

In the late 1920s, President Hoover settled into his vacation house in Virginia on the headwaters of the Rapidan River known as his Summer White House, where he often enjoyed Virginia barbecue.[32] By then, Virginia barbecue recipes were beginning to change with the times. Although the original Virginia barbecue sauce of vinegar, butter, salt and peppers was still in use—with additional ingredients such as tomato ketchup, sugar and Worcestershire sauce—Virginians, as they always had, began to incorporate modern customs and ingredients, such as barbecue sauce on the side, paprika and even chili powder.

A Virginia barbecue sauce recipe first published in the 1930s combines Randolph's colonial-era Virginia pepper vinegar recipe and Tyree's 1879 meat flavoring recipe. This sauce calls for ingredients such as one hundred long, hot red peppers; vinegar; ground onions; dry mustard; black pepper; Worcestershire sauce; and celery salt.[33]

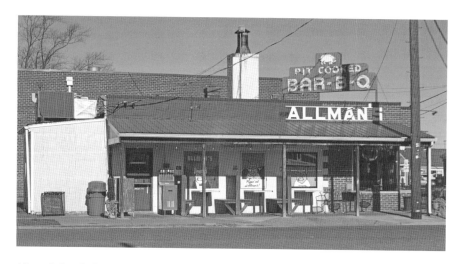

Allman's Bar-B-Q of Fredericksburg, Virginia, has been serving its delicious central Virginia–style barbecue sauce since 1954. *Author's collection.*

The *Richmond Times Dispatch* columnist Emma Speed Sampson shared a barbecue sauce recipe in 1935 that was apparently quite popular in Virginia at the time. The recipe includes onion, butter, vinegar, brown sugar, ketchup, Worcestershire sauce, mustard and celery. Sampson explained that people modified the basic recipe to their personal tastes. Some people liked more sugar in the recipe, some more Worcestershire and some people added garlic.[34] In the 1930s, the Virginia barbecued rabbit recipe was still popular. The Ginter Park Women's Club of Richmond, Virginia, published a recipe for it that is very similar to the nineteenth-century recipe, calling for soaking the rabbit in salted water and serving it with a sauce made of vinegar, mustard, butter and "currant or any acid jelly."[35]

In *Virginia Cookery Past and Present*, published in 1957, there are several delicious Virginia barbecue recipes.[36] One sauce recipe calls for dry mustard, sugar, black pepper, celery seed, salt, red pepper and vinegar. The mop recipe given for barbecued lamb calls for butter, vinegar, Worcestershire sauce, red pepper and the optional ingredient of garlic. The recipe for barbecued chicken calls for salt, pepper, paprika, sugar, chopped onion, tomato puree or ketchup, "fat," Worcestershire sauce and vinegar and/or lemon juice. The recipe for barbecued pheasant calls for tomato, onion, lemon, sage, mustard, salt, cayenne, sugar, garlic, pepper, butter and rosemary. The recipe included for barbecued rabbit is pretty much the same as the nineteenth-century recipes, calling for vinegar, salt, butter, mustard and red pepper, with the more modern addition of Worcestershire sauce.

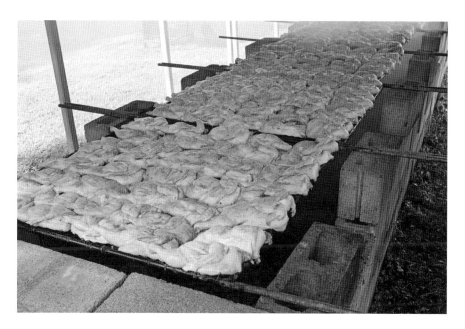

Chicken being barbecued Virginia style at Tabernacle United Methodist Church in Spotsylvania County, Virginia. *Author's collection.*

There is no mention of currant jelly. The recipe "Barbecue Filling for Buns" is more properly a Virginia-style barbecue hash recipe than strictly a barbecue recipe. It, too, includes the typical Virginia ingredients but with the addition of chili powder.

In keeping with the Virginian "spiced" barbecue sauce theme, a recipe shared in *A Taste of Virginia History: A Guide to Historic Eateries and Their Recipes* includes ketchup, brown sugar and mustard, with spices such as cloves and allspice. Interestingly, the recipe does not call for vinegar.[37] The author of *Eat & Explore Virginia* shared a recipe that includes Mary Randolph's "sweet herbs" such as basil, oregano and thyme along with tomato ketchup and wine vinegar.[38] A Virginia recipe for barbecued squirrel shared by the Patawomeck Indians of Virginia includes onions, brown sugar, Worcestershire, hot sauce, lemon juice, mustard and blackberry wine.[39] A Fredericksburg-region barbecue sauce shared in 1985 includes tomato ketchup, Worcestershire sauce, sugar or honey, vinegar, salt and pepper.[40]

The Women's Society of Christian Service of Virginia published the delightful cookbook *Kitchens by the Sea* in 1962. A kitchen barbecue recipe in it includes onions, celery, green pepper, vinegar, tomato sauce, garlic, dry mustard and brown sugar. Other barbecue sauce recipes in the book include

Early morning pork butts seasoned with a Virginia-style rub ready for the barbecue pit. *Author's collection.*

vinegar, Worcestershire sauce, molasses, lemon juice, ketchup, mustard, celery, brown sugar and "hot pepper."[41]

Virginia is also a producer of maple sugar, so it should be no surprise that a Virginia barbecue sauce recipe published in 1975 includes it, as well as other ingredients such as mustard, celery seed, black pepper and tarragon vinegar.[42] A Virginia-style barbecue sauce recipe for beef published in 1976 is made of beef broth, tomato ketchup, garlic, mushrooms, onion, green pepper, hot sauce, mustard and black pepper.[43] The mushrooms are apparently an homage to Randolph's mushroom ketchup. In the popular cookbook *Virginia Hospitality*, first published in 1975, are several Virginia barbecue recipes. One recipe calls for bacon drippings, and dry sherry is required in another.[44]

There are several commercial Virginia-style barbecue sauces on the market. One is "an old Virginia recipe with roots in Tidewater" and has been unchanged since it first appeared on shelves in the 1950s.[45] For decades, people as far away as Boston have been enjoying it on barbecue and roast beef sandwiches. It is a Virginia brown sauce with a delightful tang typical of Southside barbecue sauces. There is a commercial central Virginia/ Piedmont-style sauce that was "extrapolated from an old slave recipe."

It is slightly sweet and spiced.[46] There are some Northern Virginia–style commercial barbecue sauces available too.

Not only does Virginia have unique barbecue sauces, but Virginians also have their unique ways of cooking barbecue. Tyree shared a recipe for barbecued ribs. The recipe states that one should "always par-boil ribs" before broiling them seasoned with salt and pepper. By 1947, barbecued spareribs had become a staple in Virginia, whether boiled or not.[47] A 1931 Virginia barbecued rabbit recipe calls for soaking the rabbit in a brine before searing it in a frying pan and parboiling it before barbecuing it, at which time it should be basted with a mixture of vinegar, tomato ketchup, Worcestershire sauce, salt, mustard, red pepper and a little water.[48]

Nowadays, barbecue cooks turn up their noses to the idea of parboiling meat, calling it "faux-que." However, there are good reasons for boiling some meats before barbecuing them. The modern taboo against boiling meat before barbecuing it is a reflection of modern times, when we have easy access to high-quality cuts of meat. People weren't always so fortunate in earlier centuries. In 1909, an old-school barbecue expert explained, "Tough meat is previously parboiled in large pots."[49] Before the times of ubiquitous refrigeration, people would barbecue whatever meat they could get. In those times, you couldn't run down to the local grocery store and pick up an eight-pound pork shoulder cut from a hog that was specially bred, fed and raised to produce a consistent quality of meat. The lower the quality of the meat, the higher the chances were that it could benefit from boiling. In addition, slaughtering older animals for barbecues was a frequent occurrence. That means that the meat was stringier and tougher than the meat of young animals, and boiling it in a seasoned broth before barbecuing it made a lot of sense because boiling tenderizes meat.

There used to be a vacant lot in Staunton, Virginia, that was used to impound stray cattle called "Stuart's meadow." In 1840, the Whigs couldn't pass up the opportunity to eat free beef. They "slaughtered many" of the stray cattle there and threw a barbecue.[50] One has to wonder how tough the meat was from those stray animals and if boiling played a part in its preparation.

Many southern states, in addition to Virginia, have a long tradition of boiling meats before barbecuing them, and it is as much a part of the southern barbecue tradition as hickory wood and vinegar sauces.[51] In 1971, boiling meat before barbecuing it was a popular practice among barbecue cooks in Atlanta, Georgia.[52] Boiling meat before barbecuing it was commonplace in some Texas circles, and it still occurs, though many "won't admit it."[53] The famous Texas barbecue cook Walter Jetton shared his "Texas Beef

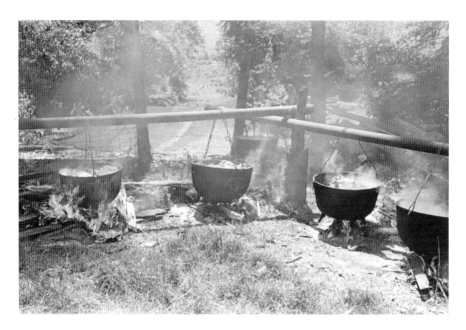

Beef and lamb boiling at a Kentucky barbecue, circa 1940. *Library of Congress, Prints and Photographs Division, LC-DIG-fsa-8a42934.*

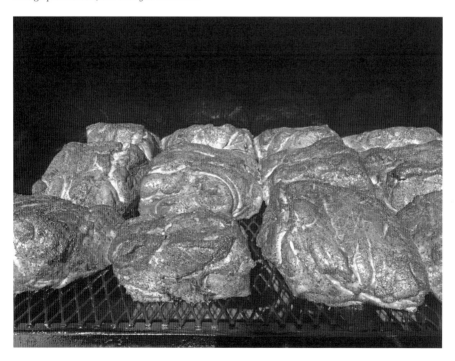

Virginia-style barbecued pork on the barbecue pit at 1752 Barbecue in Woodstock, Virginia. *Craig George.*

Barbecue" recipe in 1965 that calls for boiling a beef brisket in a Dutch oven before finishing it on the grill.[54] All-encompassing declarations that you should never boil meat before barbecuing it are not in keeping with "old school" southern barbecue tradition. However, with the high-quality meat available today, there is little need to boil it before barbecuing it. In Virginia, boiling meat before barbecuing it is the exception, not the rule. I am not aware of any restaurants or vendors today that serve the parboiled version of Virginia barbecue.

Virginians have been wrapping meat while barbecuing it for centuries. The account of the wedding of Abraham Lincoln's parents tells of how the cook covered the meat with leaves as it barbecued. John Clayton recorded as far back as 1687 how Virginia Indians wrapped venison in leaves "barbecuting" it in embers.[55] Several hundred years before wrapping barbecue while cooking it became the "Texas crutch," the practice was first the Virginia crutch, apparently.[56]

In 1883, a newspaper columnist extolled Virginia barbecue, writing, "The old Virginia barbacued [sic] meats are of world-wide fame, and the system is simply to cook on or near coals in the open air."[57] Barbecuing directly on coals is a Virginia technique first practiced by Virginia's Indians and continued by Virginia barbecue cooks in colonial and federal times.

Virginia barbecue cooks nowadays prefer to serve barbecued beef, pork and chicken. Brisket is relatively new in Virginia and is not a traditional beef cut used for barbecue in the state. Barbecued beef ribs, chuck, round and sirloin are Virginia's barbecued beef specialties. Virginia's barbecued pork specialties include pork shanks, shoulder cuts, ribs and pork belly. The Barbeque Exchange in Gordonsville serves a mouth-watering Virginia-style barbecued pork belly that is delicious.

Of course, there is also the famous Shenandoah-style barbecued chicken. Silas David Shirkey (1910–1990) is famous in the Shenandoah Valley for his Virginia barbecued chicken. Shirkey began barbecuing chicken for fundraisers back in the 1940s in and around the Harrisonburg, Virginia area. His famous Virginia-style barbecue sauce—which includes vinegar, pepper, herbs, garlic and lemon juice—is tangy and addictive.[58] Nowadays, barbecue cooks all over the state use variations of Shirkey's basic recipe when they are "flippin' chicken" (as we say in Virginia) over open pits.

I will never forget the barbecued beef chuck sandwiches that a local barbecue restaurant used to serve in my hometown years ago. The delicious and tender, chopped beef sandwiches were tangy with a hint of sweetness from the sauce and topped with coleslaw. In addition to barbecuing beef

until it is tender enough to pull, Virginians have a tradition of barbecuing beef to a medium-rare and medium level of doneness. A 1901 account of a barbecue in Westmoreland, Virginia, tells of a barbecued ox that "was done to a turn. From this savory lump one could have served at once, steak rare or well-done, the rib roast, sirloin or porterhouse."[59] You can still find Virginia-style barbecued beef served medium-rare to medium in Virginia barbecue restaurants today. King's Famous Barbecue in Petersburg has served pork and beef since it opened in 1946. One of its specialties is a delicious Virginia-style barbecued beef made from top butt sirloin.

A Virginia Barbecue

The place was a Virginia picnic resort in the heart of the woods, not many miles from Washington. It was particularly fitted for a barbecue, being furnished with a pavilion and a bountiful spring, while through the hollow ran a little stream, a tributary of the Potomac. The woods around were clothed in all the gorgeous dress of autumn. Early in the day the farmers began to arrive, bringing their wives and families in commodious farm wagons, and picketing their horses in the grove. To them a barbecue was not a novelty. They had attended these gatherings when they were boys and now as grown men had come once again to listen to the speeches and eat a barbecue dinner.

The night previous to the barbecue an ox weighing 600 pounds had been slaughtered and dressed. A trench about three feet deep, three feet wide, and six feet long had been dug in the ground, and an iron grating laid in it a few inches from the bottom. Upon this grating an immense fire of logs had been built. The carcass of the ox had been "spitted" with a long pole, which was supported on tripods at each end of the trench. At one end of the spit was a crank, and this was turned steadily by relays of men during the entire night, the fire being kept at as near a uniform heat as possible.

From twelve to fifteen hours are required to roast an ox in this manner. The seasoning of pepper and salt is mixed in a bucket and applied liberally while the crank is being turned. The flesh soon assumes a rich brown, and the smell is a most savory one. Great

care must [be] taken not to cook the beef too quickly. Generally a man who has experience in barbecues is engaged specially for the occasion, and he must give the cooking his entire attention if he wishes to make his work satisfactory. When the roasting is completed the fire is allowed to die out, but the ox remains upon the spit, the admiration of a large crowd, until it is time to cut up the meat for dinner.

In the same way three or four sheep are roasted whole. But simply bread and meat will do for a barbecue dinner. The immense iron pot...is filled to the brim with sweet potatoes. A barrel and a half of these are consumed at the barbecue which is now being described. The coffee, too, is made on a large scale. Ten or fifteen pounds are wrapped up in a cloth and thrown into a pot holding nearly 100 gallons of boiling water. By this means there are no loose grounds in the pot, and the coffee in the cloth looks like an immense plum pudding....The dinner is served on wooden plates, each person being given a tin-cupful of coffee, a pickle, a sweet potato, a piece of beef and mutton, bread in abundance, and sometimes cheese. The coffee is taken from the pot to the long tables in buckets, and the bread is sliced and carried in barrels.

Jackson Citizen Patriot, *December 12, 1884*

CONTEMPORARY VIRGINIA BARBECUE

Virginia's regional barbecue sauces became famous first in the region of the state where restaurants or vendors first served them. Therefore, the Virginia barbecue map depicts the regions of Virginia with restaurants and vendors who are famous for originating each particular regional sauce style—not necessarily just the regions where they can be found today. Moreover, all of the regional styles have roots in Virginia that go back to colonial times.

Today, you can find the various regional Virginia barbecue sauces just about anywhere in the state, fortunately. Therefore, in addition to calling them by their home region, Virginia barbecue sauces are often named from their color or consistency. For example, you can find Virginia red sauces, Virginia brown sauces and Virginia mahogany sauces.

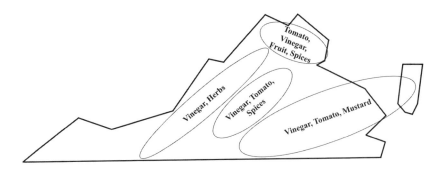

Virginia's regional barbecue styles. *Author's collection.*

The Shenandoah Valley and Mountain Regions

Virginia's Shenandoah Valley and Mountain regions are home to delicious Virginia-style, vinegar-based barbecue sauces. The famous Shenandoah Valley barbecued chicken calls for a vinegar-based sauce that has a rich mixture of herbs. Some add tomato juice to it. A few others add a little red wine. The Mountain and Shenandoah Valley's vinegar-based sauces may also include sweet spices and celery seed. However, I'm treading into top-secret territory, so I should move on to the next regional style.

The Southside and Tidewater Regions

Virginia's Southside and the Tidewater regions gave us their vinegar/tomato-base sauces flavored with a hint of mustard. Of course, Virginians have used mustard in their barbecue sauces for hundreds of years. Unlike South Carolina, however, Virginians never used mustard as a base for barbecue sauce. Rather, they prefer to use it as a flavoring. For years, the owners of a barbecue restaurant in Hillsborough, North Carolina, served a Southside Virginia–style barbecue sauce. The restaurant owner won the secret recipe in a game of horseshoes played in Virginia.[60]

Central Virginia and the Piedmont Region

Central Virginia and Piedmont region sauces are reminiscent of the barbecue flavors found in Mary Randolph's cookbook. Some are on the

sweet side and may include a rich mixture of spices. Don't be surprised if you find some with a good amount of sassafras or Worcestershire sauce in them, too. Another unique central Virginia barbecue sauce originally found in restaurants in the Chesterfield and Richmond areas is Virginia peanut barbecue sauce. It is a delicious tomato- and vinegar-based Virginia-style barbecue sauce with a hint of peanut butter, which pays homage to Virginia's famous peanuts.

Northern Virginia

Northern Virginia barbecue sauces are usually tomato based and often sweeter than the other Virginia varieties. They, too, are seasoned with sweet herbs and sweet spices and may include fruit in some form.[61]

VIRGINIA-STYLE BARBECUE RECIPES

The resources cited here provide many delicious recipes for authentic Virginia barbecue, and the reader should refer to them for recipes. Inspiration for the recipes that follow came from delicious Virginia barbecue served by restaurants and vendors today. The recipes are not exact clones but do represent the flavors and styles of the regional Virginia barbecue sauces. I recommend that you add your own "wok presence" to the basic recipes while taking care to maintain their Virginian character. Ingredients like agave nectar, jalapeño powder, truffles, teriyaki and pineapple may taste good, but they have no place in authentic Virginia barbecue sauces.

A Virginia Barbecue, in a shady grove, near a cool spring, with good speakers, who are gentlemen, and a gathering of Virginia ladies and Virginia farmers, kindness, courtesy, and hospitality prevailing, tops all other political assemblages or mass meetings! There is nothing like it elsewhere!

Alexandria Gazette, *June 30, 1860*

Virginia-Style Barbecue Rub

You'd be surprised at how many Virginia pit masters there are who don't put rubs on meats before barbecuing them. Nevertheless, if you want to use a rub, here is one made of the flavors that are in traditional Virginia barbecue. Experiment with the quantities of ingredients to suit your own taste. Also, try celery salt or seasoned salt in place of the table salt.

> *1 part table salt*
> *2 parts coarse ground black pepper*
> *½ part red pepper flakes*
> *1 tablespoon of molasses (optional)*

Mix the salt and peppers well. An optional step is to apply a thin coating of molasses to the meat before seasoning it with the rub. Use on all meats.

Virginia Mountain–Style Barbecue Sauce: Thin Virginia Red

Add a hint of mustard to this recipe for a Southside twist.

> *1¼ cups apple cider vinegar*
> *1 cup tomato juice*
> *1 teaspoon brown sugar*
> *1 teaspoon black pepper*
> *1 tablespoon celery salt*
> *1 teaspoon sweet paprika*
> *1 teaspoon Worcestershire sauce*
> *½ teaspoon poultry seasoning (or any sweet herbs you like)*
> *½ teaspoon ground cayenne pepper or a pinch red pepper flakes (optional)*

Mix all ingredients well and serve.

Shenandoah Valley–Style Barbecue Sauce: Thin Virginia Brown

½ cup oil (peanut, soybean or canola)
2 cups apple cider vinegar
3 tablespoons salt
1 teaspoon black pepper
1 teaspoon red pepper flakes
2 teaspoons poultry seasoning (or whatever sweet herbs you like)
1 teaspoon granulated garlic
juice of 1 lemon
1 cup tomato juice (optional)

Mix all ingredients well. Use as a basting liquid for chicken or pork. "Anoint" the barbecue with the sauce every 30 minutes while cooking. To use as a table sauce, reduce the salt by half.

Southside-Style Barbecue Sauce: Tangy Virginia Brown

1¼ cups apple cider vinegar
¾ cup tomato ketchup
2 tablespoons yellow mustard
2 tablespoons water (or to taste)
1 teaspoon black pepper
1 teaspoon table salt
1 teaspoon sweet paprika
1 teaspoon brown sugar (optional)
fine ground cayenne pepper to taste

Mix all ingredients well and serve. If the sauce is too acidic, add water to taste.

Central Virginia–Style Barbecue Sauce: Sweet Virginia Red

1 cup tomato ketchup
1 cup apple cider vinegar
1¼ cups light brown sugar
4 tablespoons mushroom ketchup or Worcestershire sauce
1 teaspoon sweet paprika
1 teaspoon black pepper (or to taste)
1 teaspoon salt
dash fine ground cayenne pepper (or to taste)

Mix all ingredients in a saucepan. Bring to a simmer, stirring as needed. Remove from heat, cool and serve.

Northern Virginia–Style Barbecue Sauce: Sweet Virginia Mahogany

1½ cups tomato ketchup
½ cup apple cider vinegar
½ cup apple butter
¾ cup dark brown sugar
1 teaspoon black pepper
1 teaspoon salt
1 tablespoon lemon juice

In a saucepan, mix all ingredients except the lemon juice. Bring to a simmer, stirring as needed. Remove from heat, stir in lemon juice, let cool and serve.

NOTES

Chapter 1

1. Noah Webster, *Noah Webster's First Edition of an American Dictionary of the English Language* (reprint, Anaheim, CA: Foundation for American Christian Education, 1967; originally published in 1828).
2. Sidney W. Mintz, *Tasting Food, Tasting Freedom: Excursions into Eating, Culture, and the Past* (Boston, MA: Beacon Press, 1996); Sylvia Lovegren, "Barbecue," *American Heritage Magazine* (June/July 2003).
3. *Federal Republican*, "Manners, Feelings and Principles," July 11, 1815.
4. Courtney P. Winston, "Meat and Meat Substitutes," *Food Science: An Ecological Approach*, ed. Sari Edelstein (Burlington, VA: Jones & Bartlett Learning, 2014).
5. Mary Randolph, *The Virginia Housewife: Or, Methodical Cook*, stereotype ed. (Baltimore, MD: Plaskitt, Fite & Company, 1838).
6. Lettice Bryan, *The Kentucky Housewife* (reprint, Bedford, MA: Applewood Books, 1991; originally published in 1839).
7. Theodore Francis Garrett, ed., *The Encyclopædia of Practical Cookery: A Complete Dictionary of All Pertaining to the Art of Cookery and Table Service* (London: L. Upcott Gill, 1898).
8. Bryan, *Kentucky Housewife*.
9. William Kitchiner, "Shoulder of Lamb Grilled," *The Cook's Oracle*, last Londen ed. (Boston: Munroe and Francis, 1822).

10. B.W. Higman, "Preservation and Processing," *How Food Made History* (Chichester, West Sussex: Wiley-Blackwell, 2012).

11. Jennifer Lerman, "Food Preservation and Packaging," *Food Science: An Ecological Approach*, ed. Sari Edelstein (Burlington, VA: Jones & Bartlett Learning, 2014).

12. Michael Ruhlman and Brian Polcyn, "Smoke: The Exotic Seasoning," *Charcuterie: The Craft of Salting, Smoking, and Curing* (New York: W.W. Norton, 2005); Susan Westmoreland, "Meat," *The Good Housekeeping Cookbook: 1,039 Recipes from America's Favorite Test Kitchen*, rev. ed. (New York: Hearst Books, 2007).

13. Sarah Edelstein, "Food Preservation and Packaging," *Food Science: An Ecological Approach* (Burlington, MA: Jones and Bartlett Publishers, 2014); "Curing and Smoking Meats for Home Food Preservation," National Center for Home Food Preservation.

14. *Evening News*, August 25, 1909, an advertisement for "smoked brisket bacon," which sold for fifteen cents per pound; *Catalogue of Copyright Entries*, part 4 (Washington, D.C.: Government Printing Office, 1936), 53. John H. Sieber Jr., "portable barbecue smoker."

15. Michael H. Stines, "What's What," *Mastering Barbecue Tons of Recipes, Hot Tips, Neat Techniques, and Indispensable Know How*, unabridged ed. (New York: Ten Speed Press, 2013), 7.

16. Maureen Ward, "No Grits, No Glory," *Suddenly Southern: A Yankee's Guide to Living in Dixie* (New York: Simon & Schuster, 2004).

17. Works Progress Administration, *Slave Narratives: A Folk History of Slavery in the United States from Interviews with Former Slaves: Volume XIV, South Carolina Narratives, Part 3* (Washington, D.C.: Library of Congress, 1941).

18. Wilbur Kurtz, *Interview with Will Hill*, March 27, 1938, courtesy of the Atlanta History Center, Margaret Mitchell House.

19. *Everyday Housekeeping: A Magazine for Practical Housekeepers and Mothers*, vols. 5–6, "Southern Prize Recipes."

20. J.L. Herring, *Saturday Night Sketches—Stories of Old Wiregrass Georgia* (Boston: Gorham Press, 1918), 227.

21. *Chicago Daily Tribune*, "To Please the Palate," January 23, 1888.

22. Alexander Edwin Sweet and J. Armoy Knox, "A Barbecue," *On a Mexican Mustang, through Texas, from the Gulf to the Rio Grande* (Hartford, CT: S.S. Scranton & Company, 1883).

23. *Boston Post*, July 17, 1840.

24. *New York Tribune*, "The Douglas Barbecue," September 13, 1860.

25. Irvin S. Cobb, *Those Times and These* (New York: Review of Reviews, 1917), 313–14.

26. *Leavenworth Times*, "Placed 5,000 LBS. Beef in Barbecue Pits at Midnight," September 1, 1922.

27. *Bryan Daily Eagle and Pilot*, "Big Emancipation Celebration," June 19, 1909.

28. Robb Walsh, *Legends of Texas Barbecue Cookbook: Recipes and Recollections from the Pit Bosses* (San Francisco, CA: Chronicle Books, 2002); Elizabeth S.D. Engelhardt, *Republic of Barbecue Stories beyond the Brisket* (Austin, TX: University of Texas Press, 2009).

29. William Eleazar Barton, *The Paternity of Abraham Lincoln; Was He the Son of Thomas Lincoln? An Essay on the Chastity of Nancy Hanks* (New York: George H. Doran Company, 1920), 342.

30. "A Member," *An Authentic Historical Memoir of the Schuylkill Fishing Company* (Philadelphia, PA: Judah Dobson, 1830), 92.

31. *Bolivar Bulletin*, August 24, 1871.

32. A.P. Hill, *Mrs. Hill's Southern Practical Cookery and Receipt Book*, ed. Damon Lee Fowler (Columbia: University of South Carolina Press, 1995).

33. Laura T. Knowles, *Southern Recipes Tested by Myself* (New York: George H. Doran, 1913).

34. *Sunday Oregonian*, "Here's Smoke in your Eye," August 3, 1952.

35. *Independent Press*, "Plantation Barbecues," July 27, 1860.

36. *Federal Union*, "A Country Barbecue," August 8, 1865.

37. *Times-Picayune*, "Barbecue Sauce Recipes Recall Outdoor Delights," October 1, 1927.

38. Randolph, *Virginia Housewife*, 1838.

39. Bryan, "To Barbecue Shoat," *Kentucky Housewife*.

40. *Worcester Daily Spy*, "Swells Who Can Cook," November 17, 1895.

41. *Daily Messenger*, "Honeoye Man Enjoys Grilling Meats Outdoors All Year," February 6, 1974.

42. *Fairbanks Daily News*, "Barbecue Sauce," June 21, 1958.

43. Elizabeth S.D. Engelhardt, *Republic of Barbecue Stories beyond the Brisket* (Austin: University of Texas Press, 2009).

44. *Miami Herald*, "People and Events," August 18, 1919.

45. *San Francisco Bulletin*, "A Kentucky Burgoo," December 13, 1884.

46. *Washington Times*, July 1, 1911, 6.

47. J. Lee Anderson, "The Manly Art of Barbecuing," *Orange Coast Magazine* (May 1, 1984).

48. Diane Garner, "Chapter 9—Mary Susan Landrum as an Orphan," *Letters from the Big Bend Legacy of a Pioneer* (Bloomington, IN: Iuniverse Inc., 2011. The cooking method of filling a pit with hot rocks, placing meat in it and then burying it is called "a method to barbecue a goat or pig"

in southwestern Texas; Edward Tylor, "Chapter 4," *Anahuac or Mexico and the Mexicans, Ancient and Modern* (reprint, London: Logmans, Greene, Reader and Dyer, 1877; originally published in 1861); *American Magazine* 154 (August 1952): 112; Roy Matoy, "For September Have a Western Barbecue Round-Up," *Boy's Life* (September 1950).

49. Matoy, "For September Have a Western Barbecue Roundup," 60.

50. Dave DeWitt, "Bombastic Barbecues, Presidential Palates, and Scurrilous Scandals," *The Founding Foodies: How Washington, Jefferson, and Franklin Revolutionized American Cuisine* (Naperville, IL: Sourcebooks, 2010); Robert F. Moss, "Introduction," *Barbecue: The History of an American Institution* (Tuscaloosa: University of Alabama Press, 2010); Carlos Manuel Salomon, "A California Family," *Pío Pico: The Last Governor of Mexican California* (Norman: University of Oklahoma Press, 2010); Kevin Starr, "A Troubled Territory," *California: A History* (New York: Modern Library, 2005).

51. *White Cloud Kansas Chief*, "Thirty Years Since," September 7, 1871; Neal Harlow, *California Conquered: The Annexation of a Mexican Province, 1846–1850* (Berkeley: University of California Press, 1989).

52. *Daily Capital Journal*, "Wind Up with Big Barbecue," July 17, 1909.

53. Michele Anna Jordan, *California Home Cooking 400 Recipes that Celebrate the Abundance of Farm and Garden, Orchard and Vineyard, Land and Sea* (Boston, MA: Harvard Common Press, 2011).

54. *Los Angeles Herald*, "Autoists Enjoy Run to Malibu," April 24, 1910.

55. Alejandro Morales, "Chapter 4," *The Brick People* (Houston, TX: Arte Publico Press, 1988); *San Francisco Call*, "Restoring El Rancho," August 8, 1909; "History of Pio Pico's 'El Ranchito,'" Pio Pico State Historic Park, 2012.

56. *San Francisco Call*, "Restoring El Rancho," August 8, 1909.

57. *Miami Herald*, "People and Events," August 18, 1919.

58. *Los Angeles Herald*, "Knights Hold a Wonderful Feast," June 8, 1905.

59. *The Herald*, "A California Feast," October 2, 1898.

60. *Hickory Democrat*, May 9, 1907.

61. *San Francisco Chronicle*, "Cloverdale Society People in a Mock Bullfight," August 23, 1903.

62. Eve Zibart, "Appendix: American Regional Cuisine," *Ethnic Food Lover's Companion a Sourcebook for Understanding the Cuisines of the World* (New York: Menasha Ridge Press, 2001); *Arizona Sentinel*, "Fourth of July Barbecue in Dome," July 6, 1911.

63. *Deseret Evening News*, "California's Tramping Labor Army," June 4, 1904.

64. Gary Paul Nabhan, "Acorn Nation," *Renewing America's Food Traditions:*

Saving and Savoring the Continent's Most Endangered Foods (White River Junction, VT: Chelsea Green Pub. Company, 2008).

65. *Evening Tribune*, "Joe Romero Dies in North; Famed as Barbecue King," June 20, 1932; *Evening Tribune*, "He Cooks Whole Cows," April 16, 1916; George Wharton James, *The 1910 Trip of the H.M.M.B.A. to California and the Pacific Coast* (San Francisco, CA: Press of Bolte & Braden, 1911).

66. *Look*, "America Is Bit by the Barbecue Bug," July 12, 1955, 57–60.

67. George A. Sanderson and Virginia Rich, eds., *Sunset's Barbecue Book*, 5th ed. (San Francisco, CA: Sunset Magazine, 1942), 47.

68. *Public Ledger*, April 11, 1879.

69. *Daily Republican*, "How to Cook Out-of-Doors," October 9, 1907.

70. *Maryville Daily Forum*, "Garden Club Is Told How to Prepare Meals in Outdoor Kitchen," March 5, 1947.

71. *Indiana Gazette*, "4-H Club News," June 21, 1947.

72. *Newport Mercury*, September 11, 1931.

73. *Kansas City Star*, "Recipes for Picnic Dinners," August 24, 1906.

74. *Daily Notes*, "Ideas for Meals," July 28, 1939.

75. *Times Dispatch*, "A Barbecue," March 24, 1907.

76. *Miami Herald*, "People and Events."

77. Emma Paddock Telford and M.A. Armington, *The Evening Telegram Cook Book* (New York: Cupples & Leon Company, 1908).

78. *Daily Republican*, "Barbecue on a Small Scale," October 8, 1908.

79. *Atlanta Constitution*, "Moore to Give Barbecue," May 10, 1911.

80. *Evening Tribune*, "Backyard Barbecue," September 17, 1919.

81. *Seattle Daily Times*, "Backyard Barbecue," June 18, 1940.

82. *Evening Star*, October 2, 1944.

83. *Times-Picayune*, "Home Barbecue, Outdoor Broiler, Fine for Summer," August 1, 1942.

84. *San Bernardino County*, "Charcoal Shortage to Hit Barbecues," March 1, 1943.

85. *Oregonian*, "Barbecue Aids Long on Color, Variety and Uniquity," July 20, 1945.

86. *Evening News*, "The Once Over," June 20, 1942.

87. *San Francisco Chronicle*, "Hints for the Campfire or Barbecue Home Chef," July 22, 1945.

88. *Sunday Oregonian*, "Here's Smoke in your Eye."

89. *Vidette Messenger*, "Hold a War Bond Barbecue; Then Give Bonds for Prizes," September 11, 1942.

90. *Dallas Morning News*, "Time Has Come to Think about Barbecue Sauces," April 23, 1948.

91. *Omaha World Herald*, "About Barbecue Sauces," May 18, 1952.

92. *Richmond Times Dispatch*, "Another Masculine Cook Submits His Banner Dish," June 7, 1953.

93. *Richmond Times Dispatch*, "Eating Moves Outdoors with Spicy Barbecue a Favorite," June 13, 1954.

94. *Life* (July 26, 1954).

95. *Lola Register*, "Several Foods Good at Barbecue Meals," July 10, 1958.

96. Randolph, *Virginia Housewife*, 1838.

97. Charlotte Campbell Bury, *The Lady's Own Cookery Book…*, 3rd ed. (London: H. Colburn, 1844).

98. Martha McCulloch Williams, "Barbecued Lamb," *Dishes & Beverages of the Old South* (New York: McBride, Nast & Company, 1913), 159–60.

99. Don Eddy, "Come and Get It," *American Magazine* (September 1952).

100. *Miami Herald*, "People and Events."

101. *Macon Telegraph*, "Just Twixt Us," July 30, 1929.

102. *Macon Telegraph*, "Around the Circle," June 11, 1936.

103. *Evening Tribune*, "How to Serve Barbecued Dishes," July 10, 1931.

104. Cheryl Alters Jamison and Bill Jamison, *Born to Grill: An American Celebration* (Boston: Harvard Common Press, 1998).

Chapter 2

1. J. Hammond Trumbull, "Words Derived from Indian Languages of North America," *Transactions of the American Philological Association* (Hartford, CT: American Philological Association, 1872, 1873).

2. *Western Star and Roma Advertiser*, April 30, 1887.

3. "The loyal citizens have set about inaugurating a grand rural gathering—a pic-nic—or, in good old Virginia parlance, a barbecue." *Manitowoc Herald*, "Col. Horace T. Sanders Addresses the Secesh," July 24, 1862.

4. Edward Ward, *Barbacue Feast: Or, The Three Pigs of Peckham, Broil'd Under an Apple-Tree* (n.p.: Gale ECCO, Print Editions, 2010; originally published in 1707).

5. Henry Louis Mencken, "The Beginnings of American," *The American Language: An Inquiry into the Development of English in the United States* (New York: Knopf, 1945), 178; Bennett Wood Green, *Word-Book of Virginia Folk-Speech* (Richmond, VA: W.E. Jones, 1899).

6. John Smith, *The Generall Historie of Virginia, New England and the Summer Isles*, vol. 1 (Glasgow: James MacLehoge and Sons, 1907).

7. Virginia's First People, "Culture—Language," http://virginiaindians.pwnet.org/culture/language.php; Joseph Ewan and Nesta Ewan, *John*

Banister and His Natural History of Virginia, 1678–1692 (Urbana: University of Illinois Press, 1970), 383.

8. William Byrd, *William Byrd's Histories of the Dividing Line Betwixt Virginia and North Carolina*, ed. William K. Boyd (Raleigh: North Carolina Historical Commission, 1929).

9. Henry Chandlee Forman, *Virginia Architecture in the Seventeenth Century* (Williamsburg: Virginia 350th Anniversary Celebration, 1957).

10. Francis Augustus MacNutt, *De Orbe Novo, Volume 1 (of 2) The Eight Decades of Peter Martyr D'Anghera*, May 28, 2004, gutenberg.org.

11. "The bridge, consisting of forked stakes connected by a few poles." Helen C. Rountree, "Watching a Struggling Colony," *Pocahontas's People: The Powhatan Indians of Virginia through Four Centuries* (Norman: University of Oklahoma Press, 1990), 40; Helen C. Rountree, "Towns and Their Inhabitants," *Pocahontas's People*, 63.

12. William Strachey, *The Historie of Travaile into Virginia Britannia*, ed. Richard Henry Major (n.p., 1849).

13. Online Etymology Dictionary, "Hurdle," http://www.etymonline.com.

14. Thomas Harriot, *A Briefe and True Report of the New Found Land of Virginia* (New York: Dodd, Mead & Company, 1903).

15. William C. Spengemann, "John Smith's True Relation," *A New World of Words: Redefining Early American Literature* (New Haven, CT: Yale University Press, 1994), 58–59.

16. Native Languages of the Americas, "Algonquian Words in English," http://www.native-languages.org/wordalg.htm.

17. David I. Bushnell Jr., "The Native Tribes of Virginia," *Virginia Magazine of History and Biography* (April 1, 1922).

18. William Strachey, *A Dictionary of Powhatan* (Southampton, PA: Evolution Pub., 1999).

19. Edmund S. Morgan, *American Slavery, American Freedom: The Ordeal of Colonial Virginia* (New York: W.W. Norton & Company, 2003).

20. Encyclopedia Britannica—Bible Encyclopedia, "Gonzalo Oviedo Y Valdes—1911," studylight.org.

21. Gentleman of Elvas and Richard Hakluyt, *Virginia Richly Valued* (London: printed by F. Kyngston for M. Lownes, 1609); Luys Biedma, Knight of Elvas and Buckingham Smith, *Narratives of the Career of Hernando De Soto in the Conquest of Florida as Told by a Knight of Elvas*, ed. Edward Gaylord Bourne (New York: A.S. Barnes and University Microfilms, 1969; originally published in 1904).

22. Kathleen Ann Myers and Nina M. Scott, "New World, New History and the Writing of America," *Fernández De Oviedo's Chronicle of America a New History for a New World* (Austin: University of Texas Press, 2007), 3.

23. Smith, *Generall Historie*, 18; Ian Custalow, *Powhatan Dictionary* (n.p.: Wingapo Foundation, 2012).

24. Gabriel Angulo, ed., *Colonial Spanish Sources for Indian Ethnohistory at the Newberry Library Sasquehannock River*, 247, https://www.newberry.org/sites/default/files/researchguide-attachments/ColonialSpanishSourcesforIndianEthnohistory.pdf; Encyclopedia Britannica, "Gonzalo Oviedo Y Valdes—1911," studylight.org.

25. Gabriel Calderón and John Reed Swanton, *A 17th Century Letter of Gabriel Díaz Vara Calderón, Bishop of Cuba, Describing the Indians and Indian Missions of Florida* (Washington, D.C.: Smithsonian Institution, 1936).

26. Tim Miller, *Barbecue: A History* (Lanham, MD: Rowman & Littlefield, 2014).

27. Edward B. Tylor, "Fire, Cooking, and Vessels," *Researches into the Early History of Mankind and the Development of Civilization* (London: John Murray, 1865), 261.

28. James A.H. Murray, ed., *A New English Dictionary on Historical Principles, Part 2*, vol. 1 (Oxford, NY: Clarendon Press, 1887), 665; Oxford English Dictionary, "History of the OED—Oxford English Dictionary," http://public.oed.com/history-of-the-oed.

29. Johann Jakob Von Tschudi and Thomasina Ross, *Travels in Peru: During the Years 1838–1842, on the Coast, in the Sierra, Across the Cordilleras and the Andes, into the Primeval Forests* (London: D. Bogue, 1847); William Dampier, *A New Voyage Round the World*, vol. 1 (London: Knapton, 1699).

30. Nicolaus Federmann, *Narration Du Premier Voyage De Nicolas Federmann Le Jeune, D'Ulm: Haguenau, 1557* (Paris: Bertrand, 1837).

31. Mari Sobek, "Barbacoa," *Celebrating Latino Folklore: An Encyclopedia of Cultural Traditions*, vol. 1 (Santa Barbara, CA: ABC-CLIO, 2012), 106.

32. Sven Lovén and L. Antonio Curet, *Origins of the Tainan Culture, West Indies* (Tuscaloosa: University of Alabama Press, 2010).

33. Andrew Warnes, "From Barbacoa to Barbecue: An Invented Entymology," *Savage Barbecue Race, Culture, and the Invention of America's First Food* (Athens: University of Georgia Press, 2008).

34. Walter Skeat, "The Language of Mexico; and Words of West Indian Origin," *Transactions of the Philological Society* (London: Paul, Trench, Trubner, 1891).

35. C.S. Rafinesque, "Comparative Taino Vocabulary of Hayti," *The American Nations, or, Outlines of Their General History, Ancient and Modern* (Philadelphia, PA: C.S. Rafinesque, 1836), 232.

36. Daniel Garrison Brinton, *The American Race a Linguistic Classification and Ethnographic Description of the Native Tribes of North and South America* (New York: N. Hodges, 1891), 241

37. Skeat, "The Language of Mexico," *Transactions*; Richard L. Nostrand, "The Spanish Borderlands," *North America: The Historical Geography of a Changing Continent*, ed. Thomas F. McIlwraith and Edward K. Muller (Lanham, MD: Rowman & Littlefield, 2001), 47.

38. Edward Burnett Tylor, *Anahuac* (London: Longmans, Green, Reader, and Dyer, 1877), 95.

39. Raymond Breton, *Dictionaire Français-Caraibe*, ed. Julius Platzmann (Leipzig: B.G. Teubner, 1900); Lovén and Curet, *Origins of the Tainan Culture*.

40. Daniel G. Brinton, *The Arawack Language of Guiana in Its Linguistic and Ethnological Relations* (Philadelphia, PA: McCalla & Stavely, 1871).

41. Dampier, *New Voyage Round the World*, vol. 1.

42. Jean De Léry and Janet Whatley, *History of a Voyage to the Land of Brazil* (Berkeley: University of California Press, 1990).

43. Charles De Rochefort and John Davies, "A Caribbian Vocabulary," *The History of the Caribby-Islands* (London: printed by J.M. [John Macocke?], 1666).

44. James Burney, *History of the Buccaneers of America* (London: printed by Luke Hansard & Sons, for Payne and Foss, Pall-Mall, 1816).

45. Adriaan Berkel, *The Voyages of Adriaan Van Berkel to Guiana Amerindian-Dutch Relationships in 17th-Century Guyana*, ed. Martijn Bel, Lodewijk Hulsman and Lodewijk Wagenaar (Havertown, PA: Sidestone Press, 2014).

46. Everard Ferdinand Thurn, *Among the Indians of Guiana, Being Sketches Chiefly Anthropologic from the Interior of British Guiana* (London: Kegan Paul Trench & Company, 1883), 14.

47. John Russell Bartlett, *Dictionary of Americanisms: A Glossary of Words and Phrases, Usually Regarded as Peculiar to the United States*, 2nd ed. (Boston: Little, Brown & Company, 1859).

48. *Newbern Spectator*, July 18, 1829.

49. Doug Worgul, "Made in America," *The Grand Barbecue: A Celebration of the History, Places, Personalities and Technique of Kansas City Barbecue* (Kansas City, MO: Kansas City Star Books, 2001); Barbecue'n on the Internet, "A Brief History of Barbecuing," http://www.barbecuen.com.

50. Wikipedia, "Barbacoa," https://en.wikipedia.org/wiki/Barbacoa; Aqui es Texcoco, "History of Barbacoa," http://www.aquiestexcoco.com/about-aqui-es-texcoco/history-of-barbacoa.

51. John Wesley, *The Works of John Wesley* (Grand Rapids, MI: Zondervan, 1958). The diary entry for January 1, 1737, reads, "a little barbecued bear's flesh, (that is, dried in the sun) we boiled it."

52. Lionel Wafer and Edward Davis, *A New Voyage and Description of the Isthmus of America*, 2nd ed. (London: printed for James Knapton, 1704).

53. James A. Delle, Mark W. Hauser and Douglas V. Armstrong, eds., *Out of Many, One People the Historical Archaeology of Colonial Jamaica* (Tuscaloosa: University of Alabama Press, 2011).

54. Annie Brassey, *In the Trades, the Tropics & the Roaring Forties* (London: Longmans, Green, & Company, 1886), 32.

55. Gentleman of Elvas and Richard Hakluyt, *The Discovery and Conquest of Terra Florida by Don Ferdinando De Soto and Six Hundred Spaniards His Followers*, ed. William B. Rye (London: printed for the Hakluyt Society, 1851).

56. Elvas and Hakluyt, *Virginia Richly Valued*.

57. Edmund Hickeringill, *Jamaica Viewed* (London: printed for Iohn Williams, at the Crown in St. Paul's Church-yard, 1661).

58. James Rodway and Thomas Watt, *Chronological History of the Discovery and Settlement of Guiana* (Georgetown, Demerara: "Royal Gazette" Office, 1888), 171.

59. John Penington, "An Examination of Beauchamp Plantagent's Description of the Province of New Albion," *Gentleman's Magazine, and Historical Chronicle*, vol. 16 (London: William Pickering; John Bowyer Nichols & Son, 1840), 163. In this work, the author argues that "Beauchamp Plantagent" is a penname.

60. Beauchamp Plantagenet, *A Description of the Province of New Albion* (London, 1648); Virginia Center for Digital History, University of Virginia, "First Hand Accounts of Virginia, Virtual Jamestown," http://www.virtualjamestown.org.

61. Dennis Montgomery, *1607: Jamestown and the New World* (Williamsburg, VA: Colonial Williamsburg Foundation), 2007; Joseph Stromberg, "Starving Settlers in Jamestown Colony Resorted to Cannibalism," Smithsonian, April 30, 2013, http://www.smithsonianmag.com/history/starving-settlers-in-jamestown-colony-resorted-to-cannibalism-46000815/?no-ist; Smith, *Generall Historie*.

62. Richard Ligon, *A True and Exact History of the Island of Barbadoes* (reprint, London: Parker, 1673; originally published in 1657).

63. Hakluyt, *Virginia Richly Valued*.

64. Amelia Simmons and Karen Hess, "Historical Notes on the Work and Its Author, Amelia Simmons, An American Orphan," *American Cookery* (Bedford, MA: Applewood Books, 1996), xi.

65. Anthony S. Parent, "The Landgrab," *Foul Means: The Formation of a Slave Society in Virginia, 1660–1740*, 1st ed. (Chapel Hill: University of North Carolina Press, 2003), 26; Carrie Gibson, "Pirates and Protestants," *Empire's Crossroads: A History of the Caribbean from Columbus to the Present Day* (n.p.: Atlantic Monthly Press, 2014); *English Historical Review* 16 (1901): 658.

66. Morgan, *American Slavery*.

67. April Lee Hatfield, *Atlantic Virginia: Intercolonial Relations in the Seventeenth Century* (Philadelphia: PENN/University of Pennsylvania Press, 2004), 91.

68. Robert Beverly, "*The History and Present State of Virginia*—Robert Beverley, Ca. 1673–1722," Documenting the American South, http://docsouth. unc.edu.

69. Trumbull, "Words Derived from Indian Languages," *Transactions*; Margaret Holmes Williamson, "Dual Sovereignty in Tidewater Virginia," *Powhatan Lords of Life and Death: Command and Consent in Seventeenth-Century Virginia* (Lincoln: University of Nebraska Press, 2003), 231.

70. Henry Louis Mencken, "The First Loan Words," *American Language*, 178.

71. Ibid.

72. OpenJurist, "346 F. 2d 356—Hesmer Foods Inc v. Campbell Soup Company," http://openjurist.org.

73. John Reed Swanton, *Early History of the Creek Indians and Their Neighbors* (Washington, D.C.: Government Printing Office, 1922), 187.

74. Fred Duke and Tony Cox, "Duke Families of Nansemond County Virginia, before 1750," Duke Families of Nansemond County Virginia, before 1750, 2002, http://genealogy.ztlcox.com/~xcc2all/ cfreddukefiles/c_fred_duke_files_before1750.htm; John Bennett Boddie, *Southside Virginia Families* (Baltimore, MD: Genealogical Pub., 1966), 335.

75. *Sons of the Revolution in State of Virginia Semi-Annual Magazine* 5–7 (1927): 53.

76. Aphra Behn, "The Widow Ranter," *The Works of Aphra Behn*, ed. Montague Summers (London: William Heinemann, 1915), 263.

77. John Clayton, "A Letter from the Revd Mr. John Clayton, to Dr. Grew, in Answer to Several Queries Relating to Virginia," *Philosophical Transactions (1683–1775)* 41 (1753): 143–62.

78. William Hilhouse, "Notices of the Indians Settled in the Interior of British Guiana," *Journal of the Royal Geographical Society* 2 (1832): 233, 239.

79. Duke of Richmond, "Part of a Letter from His Grace the Duke of Richmond to M. Folkes," *Philosophical Transactions of the Royal Society of London* 8 (1809; 1743): 685; *Riverside Independent Enterprise*, "Corona Turns Out in Honor of Fourth," July 5, 1919; *Ironwood Daily Globe*, "Eats and Votes," September 7, 1938; *The Robesonian*, "Bank Employees Study

Group Is Organized Here," September 12, 1947; *Council Bluffs Nonpreil*, "Barbecuted Bear and Beef for Cherokee," November 4, 1949.

80. John Lawson, *A New Voyage to Carolina* (London, 1709.) All quotes from Lawson in this chapter come from this source.

81. Robert F. Moss, "Barbecue in Colonial America," *Barbecue*, 11; Benjamin Lynde, *The Diaries of Benjamin Lynde and of Benjamin Lynde, Jr with an Appendix* (Boston: [Cambridge, Riverside Press], 1880), 33, 138.

82. John Lederer and William Talbot, *The Discoveries of John Lederer* (Charleston, SC: Walker, Evans & Cogswell Company, 1891; printed from the original 1672 edition, published by J.C. for S. Heyrick), 42.

83. Dampier, *New Voyage*, vol. 1.

84. Samuel Johnson, *A Dictionary of the English Language* (London: W. Strahan, 1755).

85. *Times Dispatch*, "Good Roads at Green Bay," February 4, 1907.

86. *Macon Citizen*, "Correspondence," September 21, 1900.

87. Rufas Jarman, "Dixie's Most Disputed Dish," *Saturday Evening Post*, July 3, 1954, 36–37 and 89–91.

88. *Chicago Tribune*, "Drops Jubilee Barbecue Plan," September 30, 1898.

89. *Daily Illinois State Register*, "Horrors of the Jubilee," October 9, 1898.

90. *Chicago Daily Tribune*, November 3, 1892.

91. *Evening Index*, "Bar B Q," August 7, 1902.

92. *Oil City Derrick*, "The Century Lunch Room," January 1, 1929.

93. *Arlington Heights Herald*, "A Nice Place for Nice People," July 13, 1934.

94. *Sedalia Democrat*, "Annual Free Barbecue," July 27, 1934.

95. *Seattle Daily Times*, "California Rambler," March 29, 1950.

96. *Macon Telegraph*, "Barbecue of 1942 Loses Main Attraction—Crowd," July 25 1942.

97. Stuart Berg Flexner, *Listening to America: An Illustrated History of Words and Phrases from Our Lively and Splendid Past* (New York: Simon and Schuster, 1982), 491.

98. Cab Calloway, "The Hepster's Dictionary," 1939, http://www.tcswing.com.

99. *Atkinson's Casket* 8, "Perpetual Youth" (August 1, 1833): 369.

CHAPTER 3

1. Keith Egloff and Deborah Woodward, *First People: The Early Indians of Virginia*, 2nd ed. (Charlottesville: University of Virginia Press in Association with the Virginia Department of Historic Resources, 2006).

2. Emory Dean Keoke and Kay Marie Porterfield, *American Indian Contributions to the World: 15,000 Years of Inventions and Innovations* (New York: Facts on File, 2001), 69; *Daily Courier*, "Mastodon Barbecue Intrigues Some," April 21, 1996. In the 1990s, archaeologists in Saltville, Virginia, discovered remains of the oldest-known barbecue pit in North America that's at least fourteen thousand years old.

3. Nicholas J. Saunders, *The Peoples of the Caribbean an Encyclopedia Archeology and Traditional Culture* (Santa Barbara, CA: ABC-CLIO, 2005), 271; David G. Brinton, "The Arawack Language of Guiana in Its Linguistic and Ethnological Relations," *Transactions of the American Philosophical Society* 14, no. 3 (1871): 439.

4. Smith, *Generall Historie*.

5. "The manner of their roasting is by thrusting sticks through pieces of meat, sticking them round the fire, and often turning them." Mark Catesby, *The Natural History of Carolina, Florida and the Bahama Islands* (London: printed for Charles Marsh, 1754).

6. Colonel Norwood, "A Voyage to Virginia," First Hand Accounts of Virginia, Virtual Jamestown, Virginia Center for Digital History, University of Virginia.

7. Beverly, *History and Present State*.

8. Albert Tootal, "How They Cook Their Food," *The Captivity of Hans Stade of Hesse, in A.D. 1547–1555, Among the Wild Tribes of Eastern Brazil: Translated by Albert Tootal, and Annotated by Richard F. Burton*, ed. Hans Staden (London: printed for the Hakluyt Society, 1874), 133.

9. John Seymour and Will Sutherland, *The Concise Guide to Self-Sufficiency* (New York: DK, 2007), 178.

10. Louis Hennepin, Louis Joliet and Jacques Marquette, *A New Discovery of a Vast Country in America* (London: printed for Henry Bonwicke, 1699), 88, 163.

11. Rochefort and Davies, *History of the Caribby-Islands*, 297–98.

12. De Lery and Whatley, *History of a Voyage*, 126.

13. MacNutt, *De Orbe Novo*.

14. Tootal, *Captivity of Hans Stade*.

15. *Build a Smokehouse*, "What Is Smoking?" (Pownal, VT: Storey Communications, 1981), 3.

16. Walter Skeat, "Notes on English Etymology; and on Words of Brazilian and Peruvian Origin," *Transactions of the Philological Society* 27 (1887): 94.

17. Alexandre Olivier Exquemelin, *The Buccaneers of America* (New York: Macmillan Company, 1911).

18. *Dunlap's Maryland Gazette*, January 27, 1778; George David Rappaport, "The Seeds of War," *Stability and Change in Revolutionary Pennsylvania: Banking, Politics, and Social Structure* (University Park: Pennsylvania State

University Press, 1996), 175. "Agricola" was the penname of the Irish-born Pennsylvania statesman George Bryan.

19. E.W. Mellor, "Jamaica: The Crown of Our West Indian Possessions," *Journal of the Manchester Geographical Society* 21 (1906): 123.

20. John Taylor, *Jamaica in 1687 the Taylor Manuscript at the National Library of Jamaica*, ed. David Buisseret (Kingston, JM: University of West Indies Press, 2010), 135.

21. Hans Sloane, *A Voyage to the Islands Madera, Barbados, Nieves, S. Christophers and Jamaica with the Natural History* (London: printed by B.M. for the author, 1707).

22. Dampier, *New Voyage Round the World*, vol. 3 (London: Knapton, 1699), 141.

23. Beverly, *History and Present State*.

24. Mary Randolph, "Historical Notes and Commentaries on Mary Randolph's The Virginia House-wife," *The Virginia Housewife*, ed. Karen Hess (Columbia: University of South Carolina Press, 1984).

25. Exquemelin, *The Buccaneers*.

26. Lawson, *New Voyage*.

27. William Bartram, "*Travels through North & South Carolina, Georgia, East & West Florida*," Documenting the American South.

28. John Bartram, *A Description of East-Florida with a Journal, Kept by John Bartram of Philadelphia, Botanist to His Majesty for the Floridas; Upon a Journey from St. Augustine up the River St. John's as Far as the Lakes*, 3rd ed. (London: sold by W. Nicoll, 1769), 19.

29. Lionel Wafer, *New Voyage and Description of the Isthmus of America*, ed. George Parker Winship (Cleveland, OH: Burrows Brothers Company, 1903); Lionel Wafer, "Chap. V," *A Compendium of Authentic and Entertaining Voyages*, 2nd ed. (London: printed for W. Strahan, 1766), 273.

30. Lederer and Talbot, *The Discoveries*.

31. John Wesley, *The Works of John Wesley* (Grand Rapids, MI: Zondervan, 1958).

32. Sandra K. Mathews, *American Indians in the Early West* (Santa Barbara, CA: ABC-CLIO, 2008), 12.

33. Beverly, *History and Present State*.

34. Bernard Romans, *Concise Natural History of East and West Florida* (New York, 1776).

35. *New York Weekly Journal*, August 7, 1749.

36. Smith, *Generall Historie*.

37. John Gabriel Stedman, *Stedman's Surinam: Life in an Eighteenth-Century Slave Society*, ed. Richard Price and Sally Price (Baltimore, MD: Johns Hopkins University Press, 1992), 47.

38. John C. Fitzpatrick, ed., *The Writings of George Washington from the Original Manuscript Sources 1745–1799*, vol. 2, *1757–1769* (Washington, D.C.: Government Printing Office, 1944), 270.

39. Andrew Frank, "The Daily Life of a Soldier," *American Revolution People and Perspectives* (Santa Barbara, CA: ABC-CLIO, 2008), 133.

40. Rodway and Watt, *History of the Discovery and Settlement of Guiana*.

41. Maria Nugent, "Maria Nugent, Lady Nugent's Journal of Her Residence in Jamaica from 1801 to 1805," *Travel Writing, 1700–1830, an Anthology*, ed. Elizabeth A. Bohls and Ian Duncan (Oxford, UK: Oxford University Press, 2005), 332.

42. Helen C. Rountree, "Uses of Fire by Early Virginia Indians," Encyclopedia Virginia, May 30, 2014, http://www.encyclopediavirginia.org.

43. Lawrence A. Clayton, *The De Soto Chronicles: The Expedition of Hernando De Soto to North America in 1539–1543* (Tuscaloosa: University of Alabama Press, 1995), 270.

44. Edward Gaylord Bourne, *Narratives of the Career of Hernando De Soto in the Conquest of Florida as Told by a Knight of Elvas*, vol. 2. (n.p., 1904), 86.

45. Lawson, *New Voyage*.

46. Morgan Library & Museum, "Histoire Naturelle Des Indes—The Drake Manuscript," http://www.themorgan.org/collection/Histoire-Naturelle-des-Indes.

47. Estelle Woods Wilcox, *Buckeye Cookery and Practical Housekeeping* (Marysville, OH: Buckeye Publishing Company, 1877).

48. Kurtz, *Interview with Will Hill*.

49. Lawson, *New Voyage*.

50. Bartram, *Travels through North & South Carolina*.

51. Helen C. Rountree, *The Powhatan Indians of Virginia: Their Traditional Culture* (Norman: University of Oklahoma Press, 1989), 54; James Smith, *An Account of the Remarkable Occurrences in the Life and Travels of Colonel James Smith* (Lexington, KY: John Bradford, 1799). "They [Indians] have no such thing as regular meals." Strachey wrote, "They [Indians] accustom themselves to no set Meals, but eat night and day."

52. United States Department of Agriculture, "Fresh Pork from Farm to Table," http://www.fsis.usda.gov.

53. Philip Henry Gosse and Richard Hill, *A Naturalist's Sojourn in Jamaica* (London: Longman, Brown, Green and Longmans, 1851), 395–97.

54. George Thornton Emmons and Frederica Laguna, *The Tlingit Indians* (Seattle: University of Washington Press, 1991), 140.

55. John E. Staller and Michael Carrasco, *Pre-Columbian Foodways Interdisciplinary Approaches to Food, Culture, and Markets in Ancient Mesoamerica* (New York: Springer, 2009), 450.

56. John Bradbury, *Bradbury's Travels in the Interior of America, 1809–1811*, ed. Reuben Gold Thwaites (Ohio: A.H. Clark, 1904).

57. John Clayton, "A Letter from the Rev. Mr. John Clayton…Ad 1687," *Philosophical Transactions of the Royal Society of London* 8 (1809): 328–36.

58. Thurn, *Among the Indians of Guiana.*

59. Jack S. Williams and Thomas L. Davis, "The Changing Patterns of Everyday Life," *Indians of the California Mission Frontier* (New York: PowerKids Press, 2004), 39.

60. Swanton, *Early History of the Creek Indians.*

61. Lawson, *New Voyage.*

62. Beverly, *History and Present State.*

63. Helen C. Rountree, *Powhatan Indians of Virginia.* Rountree reported this from Archer with the comment, "That must have been tough meat to start with!"

64. John Brickell, *The Natural History of North-Carolina* (Raleigh, NC: reprinted by Authority of the Trustees of the Public Libraries, 1911; originally published in 1732). Brickell provided additional details: "They commonly barbecu or dry their *Venison* on Mats or Hurdles in the Sun, first salting it with their Salt, which is made of Ashes of the Hickery Wood; this Venison so cured, they keep and make use of in time of scarcity, and bad Weather, which they tear to pieces with their Hands and Teeth (for want of Knives) and then put it into a Morter and pound it very fine, adding the Powder of the Hickery Nuts or Wall-nuts and other ingredients, whereof they make a savory Dish."

65. Berkel, *Voyages of Adriaan Van Berkel*, 88–89.

66. Jessica B. Harris, "Guyanese Pepperpot," *Beyond Gumbo: Creole Fusion Food from the Atlantic Rim* (New York: Simon & Schuster, 2003), 226.

67. Smith, *Generall Historie.*

68. Daniel E. Moerman, *Native American Medicinal Plants: An Ethnobotanical Dictionary* (Portland, OR: Timber Press, 2009), 13; Catesby, *Natural History of Carolina.* "In their houses they live in perpetual smoke."

69. Hennepin, *New Discovery of a Vast Country*, 205.

70. John Gill, "Chinooks, Clatsops and Coast Tribes Traits, Country, Habits, Etc.," *Gill's Dictionary of the Chinook Jargon, with Examples of Use in Conversation and Notes upon Tribes and Tongues*, 15th ed. (Portland, OR: J.K. Gill Company, 1909), 7.

71. Thomas Crosby, *Up and Down the North Pacific Coast by Canoe and Mission Ship* (Toronto, CA: Missionary Society of the Methodist Church, the Young People's Forward Movement Department, 1914), 224; Heather Anderson, *Breakfast: A History* (Lanham, MD: AltaMira Press, 2013), 19.

72. Smith, *Generall Historie.*

73. Strachey, *Historie of Travaile.*

74. Smith, *Generall Historie.*

75. Forman, *Virginia Architecture.*

76. Helen C. Rountree, "Towns and Their Inhabitants," *Powhatan Indians of Virginia*, 61–62; H.C. Rountree, "Uses of Fire by Early Virginia Indians," Encyclopedia Virginia, May 30, 2014.

77. Edmund Clarence Stedman and William Wood, "The Meek Wives of the New World," *A Library of American Literature from the Earliest Settlement to the Present Time*, vol. 1 (New York: C.L. Webster, 1894), 163.

78. Strachey, *Historie of Travaile.*

79. Karl Bernhard, *Travels through North America, during the Years 1825 and 1826* (Philadelphia, PA: Carey, Lea & Carey, sold in New York by G.&C. Carvill, 1828), 28.

80. Lettice Bryan, "Venison Hams," *Kentucky Housewife*, 91.

81. Strachey, *Historie of Travaile.*

82. James Smith, *An Account of the Remarkable Occurrences in the Life and Travels of Colonel James Smith* (Lexington, KY: John Bradford, 1799).

83. Helen C. Rountree, "Cooking in Early Virginia Indian Society," Encyclopedia Virginia, May 30, 2014.

Chapter 4

1. *New Albany Gazette*, "The Late War.—No. 1," April 15, 1836; Isaac Weld, *Travels through the States of North America, and the Provinces of Upper and Lower Canada, during the Years 1795, 1796, and 1797* (London: printed for John Stockdale, Piccadilly, 1799); *The Sun*, July 18, 1888; Mary Newton Stanard, *Colonial Virginia: Its People and Customs* (Philadelphia, PA: J.B. Lippincott Company, 1917).

2. *Harrisonburg Rockingham Register*, August 22, 1873.

3. *Petersburg Index and Appeal*, "Letter from Manchester," January 23, 1878.

4. *Weekly Messenger*, June 2, 1825.

5. Trumbull, "Words Derived from Indian Languages," 3; *Manitowoc Herald*, "Col. Horace T. Sanders Addresses the Secesh," July 24, 1862.

6. Paul Granald, "Paintings in Profile," *Southern Literary Messenger* (July 1841).

7. *Daily Index Appeal*, "The Culture of Sheep," July 21, 1883; *Hawaiian Gazette*, May 2, 1911.

8. *Titusville Herald*, "An Old Dominion Institution," May 25, 1876; *Connersville Watchman*, "Madison," October 15, 1836; Alexander R. Boteler, *My Ride to the Barbecue, or, Revolutionary Reminiscences of the Old Dominion* (New York: S.A. Rollo, 1860).

9. *New York Daily Times*, "Interesting Memoir of Gen. Washington," January 22, 1853.

10. Matthew Reeves and Matthew Greer, "Within View of the Mansion: Comparing and Contrasting Two Early 19th-Century Enslaved Households at James Madison's Montpelier," *Journal of Middle Atlantic Archeology* 28 (2012): 69–80.

11. Richard N. Côté, "Adam and Eve in Paradise," *Strength and Honor: The Life of Dolley Madison* (Mount Pleasant, SC: Corinthian Books, 2005), 332; "Old Aunt Ailsey Payne at Montpelier," article from an unidentified newspaper from around the year 1900; *Detroit Free Press*, "An Old Virginia Cook," June 5, 1886. Contains an interview with Aunt Ailsey.

12. Mary Cutts, *Mary Cutts Memoir*, "Memories of Montpelier—Reading 1: Daily Life at Montpelier," Cutts Collection, Library of Congress, via United States National Park Service, https://www.nps.gov.

13. J. Ross Baughman, *Harvest Time* (Edinburg, VA: Shenandoah History, 1994), 111–12; *Huron Reflector*, July 2, 1839; Daniel Blake Smith, *Inside the Great House: Planter Family Life in Eighteenth-Century Chesapeake Society* (Ithaca, NY: Cornell University Press, 1986).

14. *Huron Reflector*, "A Virginia Barbecue," July 2, 1839.

15. Edmund S. Morgan, *Virginians at Home: Family Life in the Eighteenth Century*, 2nd printing (Williamsburg, VA: Colonial Williamsburg, 1952), 83.

16. Henry C. Knight, *Letters from the South and West* (Boston: Richardson and Lord, 1824), 66.

17. Hamilton W. Pierson, "Barbecues; and a Barbecue Wedding Feast in the Southwest," *In the Brush; or, Old-Time Social, Political, and Religious Life in the Southwest* (New York: D. Appleton & Company, 1881), 95.

18. *Exclusively Yours*, July 27, 1973.

19. Annie Lash Jester, *Domestic Life in Virginia in the Seventeenth Century* (Williamsburg: Virginia 350th Anniversary Celebration, 1957).

20. Jennings C. Wise, *Ye Kingdome of Accawmacke or, The Eastern Shore of Virginia in the Seventeenth Century* (Richmond, VA: Bell Book and Stationery, 1911).

21. Jester, *Domestic Life*.

22. Wise, *Ye Kingdome of Accawmacke*.

23. Jester, *Domestic Life*.

24. Philip Alexander Bruce, *Institutional History of Virginia in the Seventeenth Century* (New York: G.P. Putnam's Sons, 1910).

25. Lake E. High, "Barbecue in the Beginning," *A History of South Carolina Barbecue* (Charleston, SC: The History Press, 2013).

26. Remy Melina, "What's the History of the Barbecue?," LiveScience, July 26, 2010, http://www.livescience.com/32724-whats-the-history-of-the-barbecue.html.

27. Vince Staten and Greg Johnson, *Real Barbecue: The Classic Barbecue Guide to the Best Joints Across the USA, with Recipes, Porklore, and More!* (Guilford, CT: Globe Pequot Press, 2007).

28. William Waller Hening, *The Statutes at Large: Being a Collection of All the Laws of Virginia, from the First Session of the Legislature in the Year 1619* (New York: Bartow, 1823).

29. Francis B. Simkins, "Historical News," *William and Mary Quarterly* 2 (1945): 210–12.

30. Philip Vickers Fithian, *Journal & Letters of Philip Vickers Fithian 1773–1774: A Plantation Tutor of the Old Dominion*, June 20, 2012, gutenberg.org.

31. Kevin J. Hayes, ed., *Jefferson in His Own Time: A Biographical Chronicle of His Life, Drawn from Recollections, Interviews, and Memoirs by Family, Friends, and Associates* (Iowa City: University of Iowa Press, 2012), 62–63.

32. John Edwards Caldwell, *A Tour through Part of Virginia, in the Summer of 1808* (New York: H.C. Southwick, Printer, 1809).

33. Charles Lanman, "A Virginia Barbecue," *Haw-ho-noo: Or, Records of a Tourist* (Philadelphia, PA: Lippincott, Grambo & Company, 1850), 94–97.

34. *The Times*, "Cooking in the South," October 13, 1895.

35. Martha McCulloch Williams, *Dishes & Beverages of the Old South* (New York: McBride, Nast & Company, 1913), 277, 290; Virginia G. Pedigo and Lewis Gravely Pedigo, "Early Settlers of the Territory," *History of Patrick and Henry Counties, Virginia* (Baltimore, MD: Regional Pub., 1977), 18.

36. *Alexandria Gazette*, "A Fish Fry in the Old Dominion," December 1, 1851.

37. Joseph Addison Waddell, *Annals of Augusta County, Virginia, from 1726 to 1871*, 2nd ed. (Staunton, VA: C. R. Caldwell, 1902), 385–86.

38. *The American Turf Register and Sporting Magazine*, "Shooting Extraordinary" (June 1830).

39. *Virginia Herald*, July 8, 1809; John Cook Wyllie and Randolph W. Church, eds., *Virginia Imprint Series*, no. 4 (1946).

40. Boteler, *My Ride to the Barbecue*.

41. *Gettysburg Compiler*, July 6, 1825; Historic Shepherdstown & Museum, "A Brief History of Shepherdstown," 2014, http://historicshepherdstown.com.

42. Boteler, *My Ride to the Barbecue*.

43. *Richmond Dispatch*, "Elks Have a Barbecue in Albemarle," August 16, 1902.

44. John M. Duncan, *Travels through Part of the United States and Canada in 1818 and 1819*, vol. 1 (New York: W.B. Gilley, 1823), 296–300.

45. *New Albany Gazette*, "The Late War.—No. 1," April 15, 1836.

46. *Huron Reflector*, "A Virginia Barbecue." "The attack"; Isaac D. Williams, *Sunshine and Shadow of Slave Life: Reminiscences* (New York: AMS Press, 1975; originally published in 1885). Beef barbecue.

47. Weld, *Travels through the States of North America*.

48. Strachey, *Dictionary of Powhatan*; John Smith, *Travels and Works of Captain John Smith: President of Virginia and Admiral of New England, 1580–1631*, ed. Edward Arber (Edinburgh, GB-SCT: John Grant, 1910).

49. *Times Dispatch*, "Land of Content," June 5, 1904.

50. Erin Seiling, "The Fish that Saved Jamestown," *Virginia Marine Resource Bulletin* (Summer 2007); Sandra L. Oliver, "Foodstuffs," *Food in Colonial and Federal America* (Westport, CT: Greenwood Press, 2005), 53.

51. John Page Williams, "State of Our Bay: Return of the Giant," chesapeakeboating.net.

52. *Evening News*, "The Political Barbecue," September 11 1905.

53. *Richmond Dispatch*, August 10, 1892.

54. Ibid., "Grand Barbecue," September 6, 1885.

55. Edmund Berkeley Jr., "Quoits, the Sport of Gentlemen," *Virginia Cavalcade Magazine* (1965).

56. *University of Virginia Alumni News*, April 1921.

57. *Huron Reflector*, "Virginia Barbecue."

58. *Daily Index Appeal*, "The Culture of Sheep"; Allan Bowie Magruder, "Opinions: Personal Traits," *John Marshall*, Standard Library ed. (Boston: Houghton, Mifflin, 1898), 267.

59. *Huron Reflector*, "Virginia Barbecue."

60. *Chicago Daily Tribune*, "To Please the Palate."; *Daily Astorian*, "A Virginia Barbecue," August 20, 1882.

61. *Huron Reflector*, "Virginia Barbecue."

62. *Alexandria Gazette*, "An 'Old Virginia' Barbecue," September 14, 1849.

63. William Shurtleff and Akiko Aoyagi, *History of Worcestershire Sauce (1837–2012), Extensively Annotated Bibliography and Sourcebook* (Lafayette, CA: Soyinfo Center, 2012).

64. *Richmond Enquirer*, "Worcester Sauce," November 28, 1844.

65. *Jackson Citizen Patriot*, "A Virginia Barbecue," December 12, 1884.

66. Jim Shahin, "Pitmasters Embrace New Barbecue Truth: Rested Meat Is Sublime," NPR, June 8, 2015, http://www.npr.org/sections/thesalt/2015/06/08/411778404/pitmasters-embrace-new-barbecue-truth-rested-meat-is-sublime.

67. *Daily Astorian*, "Virginia Barbecue."

68. *Free Lance Star*, "The Barbecue at Sandy Point," January 5, 1901.

69. Ferdinand M. Bayard and Ben C. McCary, *Travels of a Frenchman in Maryland and Virginia, with a Description of Philadelphia and Baltimore, in 1791: Or, Travels in the Interior of the United States, to Bath, Winchester, in the Valley of the Shenandoah, Etc., Etc., during the Summer of 1791* (Ann Arbor, MI: [Edwards Brothers], 1950).

70. Doug Worgul, *The Grand Barbecue: A Celebration of the History, Places, Personalities and Technique of Kansas City Barbecue* (Kansas City, MO: Kansas City Star Books, 2001).

71. Ralph Izard to Alice Izard, May 28, 1801, Cheves Collection, South Carolina Historical Society; Catherine Clinton, *The Plantation Mistress: Woman's World in the Old South* (New York: Pantheon Books, 1982).

72. Weld, *Travels through the States of North America*.

73. J.E. Norris, ed., *History of the Lower Shenandoah Valley, Counties of Frederick, Berkeley, Jefferson and Clarke…* (n.p.: A. Warner & Company Publishers, 1890), 163.

74. Benjamin Henry Latrobe, *The Journal of Latrobe Being the Notes and Sketches of an Architect, Naturalist and Traveler in the United States from 1796 to 1820* (New York: D. Appleton, 1905).

75. John Burk, *The History of Virginia: From Its First Settlement to the Present Day*, vol. 3 (Petersburg, VA: printed for the Author by Dickson [et] Pescud, 1805).

76. J. Lewis Peyton, *History of Augusta County, Virginia*, 2nd ed. (Staunton, VA: Samuel M. Yost & Son, 1882).

77. Moss, "Barbecue in Colonial America," *Barbecue*, 13.

78. Lucia Stanton, "Dinner Etiquette," Thomas Jefferson's Monticello, https://www.monticello.org/site/research-and-collections/dinner-etiquette.

79. François Jean Chastellux and George Grieve, *Travels in North-America, in the Years 1780-81-82* (New York: White, Gallaher, & White, 1828).

80. Ibid.

81. William Maclay, *Journal of William Maclay: United States Senator from Pennsylvania, 1789–1791*, ed. Edgar S. Maclay (New York: D.A. Appleton and Company, 1890), 138.

82. Stanton, "Dinner Etiquette."

83. "To Thomas Jefferson from William P. Farish, 11 July 1823," Founders Online, National Archives, http://founders.archives.gov/documents/Jefferson/98-01-02-3628. "[Chishance Lewis] moreover stated that he had your consent to have the Barbecue at your Spring.…I visited the Spring early in the morning & found your Cart engaged in bringing his provisions."

84. Kevin J. Hayes, "Once the Slave of Thomas Jefferson," *Jefferson in His Own Time*, 187–93.

85. John E. Semmes, *John H.B. Latrobe and His Times, 1803–1891* (Baltimore, MD: Norman, Remington, 1917).

86. Samuel L. Mitchill, *Dr. Mitchill's Letters from Washington, 1801–1813* (New York: Harper, 1879), 744.

87. *The Enquirer*, July 26, 1808.

88. Monticello Researchers, "Fourth of July," Thomas Jefferson Monticello, https://www.monticello.org/site/research-and-collections/fourth-july.

89. *Pee Dee Herald*, "A Virginia Barbecue," January 15, 1879.

90. *Jackson Citizen Patriot*, "Virginia Barbecue."

91. *Greensboro Daily News*, "Raleigh," August 15, 1915.

92. Augustus John Foster, "Virginia," *Jeffersonian America: Notes on the United States of America* (San Marino, CA: Huntington Library, 1954), 160–61.

93. *Richmond Whig*, "Fancy Balls—Fauquier Springs and Tournament—'Gander Pulling,'" August 29, 1845; *Newark Daily Advertiser*, "A Gander Pulling at Clarke Springs," June 18, 1846.

94. *General Advertiser*, "Description of a Gander Pulling," June 13, 1793; *New London Daily Chronicle*, August 9, 1850. A "Virginia 'Gander Pulling' is an Insult"; *Philadelphia Inquirer*, "Wild Scenes and Sports," August 20, 1847; *Alexandria Gazette*, August 2, 1873. Gander pulling in Virginia is "not approved of"; *Evening Star*, "Gander Pulling as an Amusement at a State Fair," October 17, 1873.

95. *New London Daily Chronicle*, August 9, 1850.

96. *Newark Daily Advertiser*, "A Gander Pulling at Clarke Springs," June 18, 1846.

97. John Stephen Farmer, *Slang and Its Analogues Past and Present*, ed. W.E. Henley (London: Poulter, 1891), 360.

98. *Grand Forks Daily Herald*, "Barbecue of Four Steers," January 27, 1907. "There were several manly games, among which was a 'gander pulling' contest."

99. *St. Albans Messenger*, July 20, 1877.

100. *Galveston Weekly News*, "Opinions of the State Press," May 28, 1877.

101. *Weekly Messenger*, June 2, 1825.

102. Virginius Dabney, *Richmond: The Story of a City*, rev. and expanded ed. (Charlottesville: University Press of Virginia, 1990), 69.

103. George Wythe Munford, *The Two Parsons; Cupid's Sports; The Dream; and the Jewels of Virginia* (Richmond, VA: J.D.K. Sleight, 1884).

104. Ibid.

105. Albert J. Beveridge, *The Life of John Marshall*, vol. 1 (Boston: Houghton Mifflin, 1916), 188.

106. Munford, *Two Parsons*.

107. *American Turf Register and Sporting Magazine*, "The Richmond 'Barbacue (or Quoit) Club'" (September 1, 1829): 41–42.

108. Samuel Phillips Day, *Down South or, an Englishman's Experience at the Seat of the American War* (London: Hurst and Blackett, 1862), 139–40.

109. Samuel Mordecai, *Richmond in By-Gone Days* (Richmond, VA: George M. West, 1856), 189.

110. R.T.W. Duke Jr., "Recollections," Albert and Shirley Small Special Collections Library, 1924, http://small.library.virginia.edu/collections/featured/duke-family-papers/recollections.

111. *Columbus Enquirer*, July 21, 1832.

Chapter 5

1. Megan E. Edwards, "Virginia Ham: The Local and Global of Colonial Foodways," *Local Foods Meet Global Foodways: Tasting History*, ed. Benjamin N. Lawrance and Carolyn De La Peña (New York: Routledge, 2012), 60–77.

2. James A.H. Murray, ed., *A New English Dictionary on Historical Principles: Founded Mainly on the Materials Collected by the Philological Society*, vol. 1, part 2 (Oxford, NY: Clarendon Press, 1887), 1,148.

3. Katharine E. Harbury, *Colonial Virginia's Cooking Dynasty* (Columbia: University of South Carolina Press, 2004).

4. Randolph, "Historical Notes and Commentaries," *Virginia Housewife*, 1984, xiii.

5. A.W., *A Book of Cookrye Very Necessary for All Such as Delight Therin. Gathered by A.W. and Now Newlye Enlarged with the Serving in of the Table. With the Proper Sauces to Each of Them Convenient* (London: printed by Edward Allde, 1591).

6. Ben Rogers, "Cooks," *Beef and Liberty* (London: Chatto & Windus, 2003), 24.

7. George Saintsbury, "Cookery of the Partridge," *The Partridge*, ed. Alfred E.T. Watson, 3rd ed. (London: Longmans, Green & Company, 1896), 256.

8. Gervase Markham and Michael R. Best, *The English Housewife*, reprinted ed. (Montreal/Ontario, CA: McGill-Queen's University Press, 2003).

9. Charles Dickens, "Learning to Cook," *All the Year Round: A Weekly Journal* 24, no. 577 (1879).

10. Medieval Cooking, "The Medieval Braai," http://www.3owls.org/sca/cook/medievalbraai.htm.

11. Kitchiner, *Cook's Oracle*, 319.

12. Randolph, *Virginia Housewife*.

13. Charles Campbell, *History of the Colony and Ancient Dominion of Virginia* (Philadelphia, PA: J.B. Lippincott & Company, 1860); Plantagenet, *Description of the Province*. First Hand Accounts of Virginia, Virtual Jamestown, Virginia Center for Digital History, University of Virginia.

14. Mechal Sobel, *The World They Made Together: Black and White Values in Eighteenth-Century Virginia* (Princeton, NJ: Princeton University Press, 1987); Henry Cabot Lodge, *A Short History of the English Colonies in America* (New York: Harper & Bros., 1881), 85–87.

15. Jonathan North, *England's Boy King: The Diary of Edward VI, 1547–1553* (Welwyn Garden City, GB-HRT: Ravenhall, 2005), 56.

16. Francis Osborne, *Advice to a Son* (London: David Nutt, 1896; originally published in 1656 and 1658).

17. *The Literary World*, no. 48, "The Royal Marriage" (London: G. Berger, February 22, 1840).

18. John Smith, *The True Travels, Adventures and Observations of Captaine Iohn Smith, in Europe, Asia, Africke, and America: Beginning about the Yeere 1593, and Continued to This Present 1629*, vol. 1 (Richmond, VA: Republished at the Franklin Press, 1819).

19. L. Daniel, Mouer et al., "Colonoware Pottery, Chesapeake Pipes, and 'Uncritical Assumptions,'" *"I, Too, Am America": Archaeological Studies of African-American Life*, ed. Theresa A. Singleton (Charlottesville: University Press of Virginia, 1999).

20. Frederick Jackson Turner, "The Significance of the Frontier in American History," *The Frontier in American History* (New York: Henry Holt and Company, 1921), 4.

21. Carville V. Earle, "Environment, Disease, and Mortality in Early Virginia," *The Chesapeake in the Seventeenth Century: Essays on Anglo-American Society*, ed. Thad W. Tate and Virginia Williamsburg (Chapel Hill: published for the Institute of Early American History and Culture by the University of North Carolina Press, 1979).

22. Ed Southern, *The Jamestown Adventure: Accounts of the Virginia Colony, 1605–1614* (Winston-Salem, NC: John F. Blair, 2004).

23. Elizabeth Hornsby, "Jamestown Unearthed: Archaeologists Dig Up First Named Smoking Pipe Since 2009," October 30, 2015, wydaily.com.

24. Smith, *True Travels*.

25. Fithian, *Journal & Letters*.

26. Ben C. McCary, "An Indian Dugout Canoe, Reworked by Early Settlers, Found in Powhatan Creek, James City County, Virginia," *Quarterly Bulletin of the Archaeological Society of Virginia* 19 (1964): 14–19.

27. Lyman Carrier, *Agriculture in Virginia, 1607–1699* (Williamsburg: Virginia 350th Anniversary Celebration, 1957).

28. Edward Arber, ed., *Travels and Works of Captain John Smith* (New York: Burt Franklin, 1910), 471.

29. Harriot, *Briefe and True Report*.

30. Virginia DeJohn Anderson, *Creatures of Empire: How Domestic Animals Transformed Early America* (Oxford, UK: Oxford University Press, 2004).

31. William Hugh Grove, "The Travel Journal of William Hugh Grove (1732)," Encyclopedia Virginia.

32. Ulrich Bonnell Phillips, "Some Virginia Masters," *Life and Labor in the Old South* (Columbia: University of South Carolina Press, 2007), 221.

33. Nicholas Cresswell, *The Journal of Nicholas Cresswell, 1774–1777*, reprint ed. (Bedford: Applewood Books, 2007; originally published in 1924).

34. David Hackett Fischer and James C. Kelly, *Bound Away: Virginia and the Westward Movement* (Charlottesville: University Press of Virginia, 2000).

35. Ernest Thompson Seton, *Woodcraft and Indian Lore: A Classic Guide from a Founding Father of the Boy Scouts of America with Over 500 Drawings by the Author* (New York: Skyhorse Pub., 2007).

36. L. Daniel Mouer, "Chesapeake Creoles: The Creation of Folk Culture in Colonial Virginia," *The Archeology of 17th-Century Virginia*, ed. Theodore R. Reinhart and Dennis J. Pogue (Richmond: Archeological Society of Virginia, 1993), 105–66.

37. William J. Hinke and Charles E. Kemper, eds., "Moravian Diaries of Travels through Virginia," *Virginia Magazine of History and Biography* (October 1, 1903).

38. Samuel Kercheval, *A History of the Valley of Virginia* (Winchester: Samuel H. Davis, 1833).

39. Danske Dandridge, *Historic Shepherdstown* (Charlottesville, VA: Michie, 1910).

40. Christopher Gist and William M. Darlington, *Christopher Gist's Journals with Historical, Geographical and Ethnological Notes and Biographies of His Contemporaries* (Pittsburg: J.R. Weldin & Company, 1893).

41. Rhys Isaac, "Political Enthusiasm and Continuing Revivalism," *The Transformation of Virginia, 1740–1790* (Chapel Hill: published for the Institute of Early American History and Culture, Williamsburg, Virginia, by University of North Carolina Press, 1982).

42. Fitzpatrick, *Writings of George Washington*, 236–37.

43. Don Higginbotham, *Daniel Morgan: Revolutionary Rifleman* (Chapel Hill: published for the Institute of Early American History and Culture at Williamsburg, Virginia, by the University of North Carolina Press, 1961).

44. Isaac, *Transformation of Virginia*.

45. Rountree, *Powhatan Indians of Virginia*.

46. Michelle L. Carr, "Talking Feet: The History of Clogging," *Tar Heel Junior Historian* (Fall 2009).

47. George E. Lankford, *Looking for Lost Lore Studies in Folklore, Ethnology, and Iconography* (Tuscaloosa: University of Alabama Press, 2008), 108.

48. Bayard and McCary, *Travels of a Frenchman in Maryland and Virginia*.

49. "They [Indians] are very kind and charitable to one another…for if any one of them have suffered loss by fire or otherwise, they make a general collection for him, everyone contributing to his loss in proportion to his abilities." Catesby, *Natural History of Carolina*.

50. Smith, *True Travels*.

51. William Stith, *The History of the First Discovery and Settlement of Virginia* (New York: reprinted for Joseph Sabin, 1865), 309.

52. David Peterson De Vries and Henry C. Murphy, *Voyages from Holland to America, A.D. 1632 to 1644* (New York: Billin and Brothers, Printers, 1853), 49–50.

53. Beauchamp Plantagenet, "A Description of the Province of New Albion," Personal Narratives from the Virtual Jamestown Project, 1575–1705, Virtual Jamestown, Virginia Center for Digital History, University of Virginia.

54. Norwood, "Voyage to Virginia."

55. Hugh Jones, "Chap. V," *The Present State of Virginia* (New York: reprinted for J. Sabin, 1865), 49.

56. Lord Adam Gordon, "Journal of an Officer Who Travelled in America and the West Indies in 1764 and 1765," *Travels in the American*

Colonies, ed. Newton D. Mereness (New York: Macmillan Company, 1916), 367–453.

57. Edmund S. Morgan, "Houses and Holidays," *Virginians at Home*, 83.

58. Côté, "Adam and Eve in Paradise," 332.

59. Joan Pong Linton, "Eros and Science: The Discourses of Magical Consumerism," *The Romance of the New World Gender and the Literary Formations of English Colonialism* (New York: Cambridge University Press, 1998), 99–100.

60. Ojibwa, "The First Anglo-Powhatan War," Native American Netroots, January 9, 2014, http://nativeamericannetroots.net/diary/1622.

61. *New York Herald*, "The Old Fashioned Barbecue in Virginia," April 29, 1858; Jack P. Greene, *Pursuits of Happiness: The Social Development of Early Modern British Colonies and the Formation of American Culture* (Chapel Hill: University of North Carolina Press, 1988), 16.

62. John Hammond, "LEAH and RACHEL, or, the Two Fruitfull Sisters Virginia, and Mary-Land," First Hand Accounts of Virginia, Virtual Jamestown, Virginia Center for Digital History, University of Virginia.

63. Jan Lewis, *The Pursuit of Happiness: Family and Values in Jefferson's Virginia* (New York: Cambridge University Press, 1985), 21–24.

64. Mouer, "Chesapeake Creoles."

65. William Dunlap, *Diary of William Dunlap (1766–1839)* (New York: New York Historical Society, 1930).

66. "Lady," *A Poetical Picture of America Being Observations Made, during a Residence of Several Years, at Alexandria, and Norfolk, in Virginia: Illustrative of the Manners and Customs of the Inhabitants: And Interspersed with Anecdotes, Arising from a General Intercourse with Society in that Country, from the Year 1799 to 1807* (London: printed for the author by W. Wilson, 1809).

67. Marshall Wingfield, *Franklin County, Virginia, a History* (Berryville, VA: Chesapeake Book, 1964).

68. Wilbur Fisk and Emil Rosenblatt, *Hard Marching Every Day: The Civil War Letters of Private Wilbur Fisk, 1861–1865* (Lawrence: University Press of Kansas, 1992), 27; William C. Davis, *A Taste for War: The Culinary History of the Blue and the Gray* (Mechanicsburg, PA: Stackpole Books, 2003), 50.

69. Norman Schools, "Colonial Falmouth," *Virginia Shade: An African-American History of Falmouth, Virginia* (Bloomington, IN: IUniverse, 2012), 4.

70. Frank E. Grizzard and D. Boyd Smith, *Jamestown Colony a Political, Social, and Cultural History* (Santa Barbara, CA: ABC-CLIO, 2007), 90.

71. *Virginia Herald*, "An Ordinance Respecting Hogs Running at Large within the Corporation of Fredericksburg," August 30, 1796.

72. Moncure Daniel Conway, *Autobiography, Memories and Experiences of Moncure Daniel Conway* (Boston: Houghton, Mifflin and Company, 1904), 15, 35.

73. *Asheville Daily Citizen*, "The Way the Earlier Virginia Presidents Bought Their Wines," January 6, 1887.

74. Edwards, "Virginia Ham."

75. William E. Burns, "Salt," *Science and Technology in Colonial America* (Westport, CT: Greenwood Press, 2005), 28. The author pointed out that in colonial times, salt was more important as a preservative than a seasoning. One of the first things produced in the Virginia colony was salt, which was made using evaporated seawater.

76. Edwards, "Virginia Ham."

77. Merril D. Smith, *History of American Cooking* (Santa Barbara, CA: ABC-CLIO, 2013), 127.

78. Charles T. Hodges, "Private Fortifications in Seventeenth Century Virginia: A Study of Six Representative Works," *The Archeology of Seventeenth-Century Virginia*, ed. Theodore R. Reinhart and Dennis J. Pogue (Richmond: Archeological Society of Virginia, 1993).

79. *Daughters of the American Revolution Magazine*, vol. 113 (Washington, D.C.: National Society of the Daughters of the American Revolution, 1979), 538; *Richmond Recorder*, "Stalled Beeves," April 6, 1803. "15000 weight of choice bacon, the hams salt-petred with particular care"; Smith, *History of American Cooking.*

80. William Bullock, *Virginia Impartially Examined and Left to Publick View*, 1649, 2010, lulu.com.

81. John Clayton, "A Letter from Mr. John Clayton Rector of Crofton at Wakefield in Yorkshire, to the Royal Society, May 12, 1688," 1888, First Hand Accounts of Virginia, Virtual Jamestown, Virginia Center for Digital History, University of Virginia.

82. Stanley Marianski, Adam Marianski and Robert Marianski, *Meat Smoking and Smokehouse Design*, 2nd ed. (Seminole, FL: Bookmagic, 2009).

83. Michael Olmert, "Smokehouses," *Colonial Williamsburg Journal* (Winter 2004–5).

84. Rountree, *Powhatan Indians of Virginia.*

85. Anderson, *Breakfast*, 19.

86. Brickell, *Natural History of North-Carolina.* "They commonly barbecu or dry their *Venison* on Mats or Hurdles in the Sun, first salting it with their Salt, which is made of Ashes of the Hickery Wood; this Venison so cured, they keep and make use of in time of scarcity, and bad Weather, which they tear to pieces with their Hands and Teeth (for want of Knives) and

then put it into a Morter and pound it very fine, adding the Powder of the Hickery Nuts or Wall-nuts and other ingredients, whereof they make a savory Dish."

87. Katharine E. Harbury, "Meats—One," *Colonial Virginia's Cooking Dynasty*, 75; A.F.M. Willich and James Mease, *The Domestic Encyclopaedia*, vol. 5 (Philadelphia, PA: published by W.Y. Birch and A. Small, 1803), 236–37. A firsthand account of how Native Americans used salt made of wood ash as a preservative.

88. Edwards, "Virginia Ham."

89. Morgan, *American Slavery*.

90. Arber, *Travels and Works*, 471. John Smith tells of two Indians enslaved by the colonists around the year 1609; J. McIver Weatherford, "The Trade in Indian Slaves," *Native Roots: How the Indians Enriched America* (New York: Crown, 1991), 139. Several Massachusetts Indians were enslaved by the English in 1614.

91. Thomas Jefferson, "Observations on M. Buffon's Character of the Indians of America, by Mr. Jefferson," *Edinburgh Magazine, or Literary Miscellany* (1787).

92. John C. Coombs, "Beyond the 'Origins Debate': Rethinking the Rise of Virginia Slavery," *Early Modern Virginia: Reconsidering the Old Dominion*, ed. Douglas Bradburn and John C. Coombs (Charlottesville: University of Virginia Press, 2011).

93. Linwood Custalow and Angela L. Daniel, *The True Story of Pocahontas the Other Side of History* (New York: Fulcrum Pub., 2007); C.S. Everett, "'They Shalbe Slaves for Their Lives': Indian Slavery in Colonial Virginia," *Indian Slavery in Colonial America*, ed. Alan Gallay (Lincoln: University of Nebraska Press, 2009). The author states that "rather than being merely incidental to African slavery, Indian slavery was ubiquitous, and probably a central component of Virginia's storied past"; J. McIver Weatherford, *Native Roots: How the Indians Enriched America* (New York: Crown, 1991); Alan Gallay, *The Indian Slave Trade: The Rise of the English Empire in the American South, 1670–1717* (New Haven: Yale University Press, 2002); Arica L. Coleman, *That the Blood Stay Pure: African-Americans, Native Americans, and the Predicament of Race and Identity in Virginia* (Bloomington: Indiana University Press, 2013); Margaret Ellen Newell, *Brethren by Nature: New England Indians, Colonists, and the Origins of American Slavery* (Ithaca, NY: Cornell University Press, 2015).

94. Arica L. Coleman, "Redefining Race and Identity: The Indian-Negro Confusion and the Changing State of Black-Indian Relations in the Nineteenth Century," *That the Blood Stay Pure*, 72.

95. Robbie Ethridge, "Economic Strategies, Native North American," *The Princeton Companion to Atlantic History*, ed. Joseph C. Miller (Princeton, NJ: Princeton University Press, 2015), 153.

96. James D. Rice, "Rethinking the 'American Paradox': Bacon's Rebellion, Indians, and the U.S. History Survey," *Why You Can't Teach United States History without American Indians*, ed. Susan Smith, Juliana Barr, Jean M. O'Brien, Nancy Shoemaker and Scott Manning Stevens (Chapel Hill: University of North Carolina Press, 2015).

97. Coleman, *That the Blood Stay Pure.*

98. This emerging research is being conducted by colleagues mentioned by Dr. James Rice in a lecture given in Stafford, Virginia, on April 27, 2015.

99. Morgan, *American Slavery*, 329; Coleman, "The Indian-Negro Confusion," *That the Blood Stay Pure.*

100. Karen Hess, *The Carolina Rice Kitchen: The African Connection* (Columbia: University of South Carolina Press, 1992).

101. Anne Firor Scott and Suzanne Lebsock, "Excerpts from Virginia Women: The First Two Hundred Years," the Colonial Williamsburg Official History & Citizenship Site, http://www.history.org/history/teaching/enewsletter/volume4/february%2006/virginiawomen.cfm.

102. Kathleen M. Brown, "Jamestown Interpretive Essays—Women in Early Jamestown," Virtual Jamestown. January 1, 1999; Edwards, "Virginia Ham"; Janie Mae Jones McKinley, *The Cultural Roots of the 1622 Indian Attack: Richard Pace and Chanco Save Jamestown* (Sylva, NC: Catch the Spirit of Appalachia, 2011).

103. Bernard W. Sheehan, "Dependence," *Savagism and Civility: Indians and Englishmen in Colonial Virginia* (New York: Cambridge University Press, 1980), 104.

104. Northampton County Records, vol. 1654–55, 135; Wise, *Ye Kingdome of Accawmacke.*

105. Alan Gallay, ed., *Indian Slavery in Colonial America* (Lincoln: University of Nebraska Press, 2009); Gallay, *Indian Slave Trade.*

106. Jack P. Greene, *Selling a New World: Two Colonial South Carolina Promotional Pamphlets* (Columbia: University of South Carolina Press, 1989), 43, 87.

107. Benjamin Franklin French, *Historical Collections of Louisiana*, vol. 2 (Philadelphia, PA: Wiley and Putnam, 1850).

108. Christina Snyder, *Slavery in Indian Country: The Changing Face of Captivity in Early America* (Cambridge, MA: Harvard University Press, 2010).

109. C.S. Everett, *Indian Slavery in Colonial America*, ed. Alan Gallay (Lincoln: University of Nebraska Press, 2009).

110. Ibid.

111. David L. Bushnell, "The Account of Lamhatty," *American Anthropologist* 10, no. 4 (1908): 568–74.

112. Arnold Johnson Lien, *Privileges and Immunities of Citizens of the United States* (New York: Columbia University, 1913), 243.

113. Greene, *Selling a New World*, 132.

114. *American Turf Register and Sporting Magazine*, "A Virginia Fish Fry" (August 1833).

115. James Adair, *The History of the American Indians* (London: E. & C. Dilly, 1775), 415; *Evening Star*, "Smoky Wood and 'Yarbs,'" June 12, 1955.

116. Martin D. Gallivan, *James River Chiefdoms: The Rise of Social Inequality in the Chesapeake* (Lincoln: University of Nebraska Press, 2003), 65–66.

117. William Bartram, *Travels through North and South Carolina, Georgia, East and West Florida* (London: reprinted for J. Johnson, 1792).

118. Rountree, *Powhatan Indians of Virginia*; *Alexandria Times*, "To the Military and Citizens of Alexandria & Its Vicinity," June 30, 1798. Advertising barbecued calf, lambs and shoats, the host informed readers that a "second breakfast or lunch of the cold victuals will be given to such as choose to partake gratis."

119. Boteler, *My Ride to the Barbecue*.

120. H.C. Rountree, "Uses of Fire by Early Virginia Indians," Encyclopedia Virginia, May 30, 2014, http://www.encyclopediavirginia.org/Fire_During_the_Pre-Colonial_Era_Uses_of.

121. Beverly, *History and Present State*.

122. J.H. Lefroy, *The Historye of the Bermudaes or Summer Islands* (London: Hakluyt Society, 1882), 277.

123. DeWitt, *Founding Foodies*, 160.

124. Randolph, *Virginia Housewife*, 1838.

125. Harbury, *Colonial Virginia's Cooking Dynasty*.

126. Edwards, "Virginia Ham."

127. Lawrence Butler, "Letters from Lawrence Butler, of Westmoreland County, Virginia, to Mrs. Anna F. Cradock, Cumley House, near Harborough, Leicestershire, England," *Virginia Magazine of History and Biography* 40 (1932): 362–70.

128. Randolph, "Historical Notes and Commentaries," *Virginia Housewife*, 1984, 283.

129. Raymond A. Sokolov, *Why We Eat What We Eat: How the Encounter between the New World and the Old Changed the Way Everyone on the Planet Eats* (New York: Summit Books, 1991), 22.

130. Louis Hughes, *Thirty Years a Slave from Bondage to Freedom: The Institution of Slavery as Seen on the Plantation and in the Home of the Planter* (Milwaukee, WI: South Side Printing Company, 1897), 46–51.

131. Wilbur Fisk Gordy, *Stories of Later American History* (New York: C. Scribner's Sons, 1917).

132. Karen Hess and Mrs. Samuel G. Stoney, "Hoppin' John and Other Bean Pilaus of the African Diaspora," *The Carolina Rice Kitchen: The African Connection* (Columbia: University of South Carolina Press, 1992), 109.

133. Lynne Olver, "FAQs: Mexican & Tex Mex Foods," Food Timeline, March 10, 2015, http://www.foodtimeline.org/foodmexican.html.

134. Kurt Michael Friese, Kraig Kraft and Gary Paul Nabhan, *Chasing Chiles: Hot Spots along the Pepper Trail* (White River Junction, VT: Chelsea Green Pub., 2011).

135. James B. Avirett, *The Old Plantation; How We Lived in Great House and Cabin Before the War* (New York: F. Tennyson Neely, 1901), 175.

136. *New York Herald*, "Georgia Smiles at Our Barbecue," October 8, 1884.

137. Charles Campbell, *History of the Colony and Ancient Dominion of Virginia* (Philadelphia, PA: J.B. Lippincott & Company, 1860).

138. Irvin S. Cobb, *Cobb's Bill-of-Fare* (New York: George H. Doran, 1913).

Chapter 6

1. *New York Daily Tribune*, "From Boston," August 14, 1856; *New York Daily Tribune*, "Freemont Barbecue Near Boston," August 29, 1856.

2. *Saint Paul Globe*, "To Give a Barbecue," August 14, 1897.

3. *Virginian Pilot*, December 25, 1900.

4. *Evening News*, "Yearly Convention of the Drunkards Is in Session," May 27, 1909.

5. *Alexandria Times*, "To the Military and Citizens of Alexandria & Its Vicinity," June 30, 1798. Virginia barbecue on restaurant menu in 1798; Moss, *Barbecue*. Mentions the first recorded North Carolina barbecue restaurant from 1899.

6. *Richmond Dispatch*, "An Old-Time Dinner," November 2, 1900.

7. *Alexandria Gazette*, September 5, 1900; *Free Lance Star*, June 14, 1900.

8. Dabney, *Richmond*.

9. Munford, *Two Parsons*.

10. *Plain Dealer*, "Cooking of an Ox Whole," September 27, 1896.

11. Ibid.; *Boston Herald*, "It Will Be a Royal Feast," August 27, 1894; *Boston Herald*, "Beverly Y.M.C.A. Has a Genuine Old Time Virginia Barbecue," September 26, 1895.

12. *Boston Herald*, "Fr. Cummins' Barbecue," August 14, 1897.

13. *Boston Journal*, "Another Big Barbecue," August 30, 1895.

14. Thomas Nelson Page, *The Negro: The Southerner's Problem* (New York: C. Scribner's Sons, 1904), 199–200.

15. *Richmond Whig*, "Cool and Refreshing," July 21, 1869.

16. *The Negro in Virginia*, "Capital" (Winston-Salem, NC: John F. Blair, 1994), 329.

17. Munford, "The Richmond L.I. Blues' Dinner," *Two Parsons*.

18. *Alexandria Gazette*, July 1, 1868.

19. Page, *The Negro*; *Alexandria Gazette*, "Honorable," September 26, 1866.

20. *Alexandria Gazette*, July 1, 1868.

21. *Daily Dispatch*, July 25, 1862.

22. *Richmond Whig*, "Meetings of Railroad Companies," December 19, 1873.

23. Ibid., September 22, 1865.

24. *Commercial Bulletin*, "Business News," October 26, 1865.

25. *Richmond Whig*, "Turtle Soup and Mint Julep," May 24, 1859.

26. *Richmond Dispatch*, "Death of John Dabney," June 8, 1900; *The Times*, Reunion at the old Pump-House," June 12, 1900.

27. Philip J. Schwarz, "John Dabney (ca. 1824–1900)," Encyclopedia Virginia.

28. *Richmond Dispatch*, April 25, 1885.

29. *The Times*, January 27, 1901; *Richmond Times Dispatch*, August 7, 1949.

30. *Richmond Times Dispatch*, "Lived Over Other Days," May 26, 1903.

31. *Richmond Dispatch*, August 4, 1886.

32. *Richmond Dispatch*, "A Street-Shooting," August 4, 1886.

33. *Daily Times*, January 25, 1887; *Richmond Times Dispatch*, June 21, 1941, 4.

34. *Times Dispatch*, December 10, 1903.

35. *Richmond Dispatch*, December 26, 1893.

36. *Richmond Times Dispatch*, "I Remember When…," January 16, 1949.

37. *Douglass' Monthly* (September 1861).

38. Herbert C. Covey and Dwight Eisnach, *How the Slaves Saw the Civil War: Recollections of the War through the WPA Slave Narratives* (Santa Barbara, CA: ABC-CLIO, 2014).

39. *Times Dispatch*, "Aged Voter Who Pays No Poll Tax," April 22, 1906.

40. "Grand barbecue of the Walker colored voters!! of Richmond and Henrico County," broadside 1869 (Richmond, VA: Committee of Arrangements, 1869), G73, Albert and Shirley Small Special Collections Library, University of Virginia; *Richmond Whig*, "State Ticket," July 2, 1869. Much of the text found on Moses Rison's flyer can also be found in this newspaper article.

41. *Negro in Virginia*, "Reconstruction," 255–56.

42. *Richmond Times Dispatch*, "News of Fifty Years Ago," July 5, 1919.

43. James Branch Cabell, *Branchiana: Being a Partial Account of the Branch Family in Virginia* (Richmond, VA: printed by Whittet & Shepperson, 1907), 63–69.

44. *Richmond Whig*, "Respect to the Dead," July 6, 1869.

45. *Daily Dispatch*, November 1, 1859.

46. Ibid., "Barbecue," April 11, 1853; October 29, 1853.

47. Ibid., "Vauxhall's Island," August 20, 1860.

48. Ibid., September 15, 1864; October 29, 1864.

49. *Richmond Whig*, May 31, 1872.

50. *Daily Dispatch*, "Manchester and Vicinity," August 5, 1881.

51. *Richmond Whig*, "State Ticket," July 2, 1869. The flyer distributed by Moses Rison lists the name as "Thos Griffin," but in the newspaper version of the flyer, it lists the name as "Thomas Griffin." Of course, "Thos" is an abbreviated version of Thomas.

52. *University of Virginia Alumni News*, "Barbecue Specialists Prepare for Big Centennial Event" (April 1921); *The Times*, "A Virginia Barbecue," September 17, 1901; *Richmond Times Dispatch*, "Albemarle Club Entertains with Drag, Barbecue," November 23, 1931.

53. *The Enquirer*, July 26, 1808.

54. Duke, "Recollections"; Green, *Word-Book of Virginia Folk-Speech*. Juba is the African name for a dance ("Juba-dance"); *Negro in Virginia*, "Writers' Program." "Juba" is short for Jupiter; Sobel, *World They Made Together*. Jefferson's body servant, named Jupiter, was nicknamed "Uncle Juba."

55. *Times Dispatch*, "Great Field Day in Greene County," September 21, 1905.

56. *The Enquirer*, July 26, 1808.

57. *Daily Dispatch*, "Manchester and Vicinity."

CHAPTER 7

1. James E. Winston, "Virginia and the Independence of Texas," *Southwestern Historical Quarterly* 19, no. 3 (1913): 277–83.

2. Anonymous, *History of Clay and Platte Counties, Missouri…* (St. Louis, MO: National Historical, 1885), 479–80.

3. Henry Ruffner, *Address to the People of West Virginia…* (Lexington, VA: printed by R.C. Noel, 1847).

4. John S. Skinner, "Lower Virginia," *American Farmer* (October 28, 1825).

5. Josiah Hazen Shinn, *Pioneers and Makers of Arkansas*, vol. 1. (Washington, D.C.: Genealogical and Historical Publishing Company), 1908.

6. Kelly, *Bound Away.*

7. Joe Gray Taylor, "High on the Hog: Eating in the Great Plantation," *Eating, Drinking, and Visiting in the South: An Informal History* (Baton Rouge: Louisiana State University Press, 2008), 55.

8. *Columbus Enquirer*, July 21, 1832.

9. High, "Barbecue in the Beginning."

10. Webster, *First Edition of an American Dictionary.*

11. Mary Virginia Terhune, *Marion Harland's Complete Cook Book: A Practical and Exhaustive Manual of Cookery and Housekeeping, Containing Thousands of Carefully Proved Recipes*, new ed., rev. and enlarged (Indianapolis, IN: Bobbs-Merrill Company, 1906).

12. Garrett, *Encyclopædia of Practical Cookery.*

13. John J. Mayer and I. Lehr Brisbin, *Wild Pigs in the United States: Their History, Comparative Morphology, and Current Status* (Athens: University of Georgia Press, 2008), 36.

14. Moss, *Barbecue.*

15. William Richardson and Emma B. Richardson, "Letters of William Richardson, 1765–1784," *South Carolina Historical and Genealogical Magazine* 47, no. 1 (January 1946): 1–20.

16. Moss, *Barbecue.*

17. Kelly, *Bound Away*, 137–40.

18. Izard to Izard, May 28, 1801, Cheves Collection; Clinton, *Plantation Mistress.*

19. William L. Saunders, *Colonial Records of North Carolina*, Gale Digital Collections, Making of Modern Law, 2012.

20. Works Progress Administration, *North Carolina: A Guide to the Old North State* (Chapel Hill: University of North Carolina Press), 281–82.

21. Dennis F. Daniels, "Samuel Stephens," NCpedia, http://ncpedia.org.

22. Works Progress Administration, *North Carolina*, 567.

23. Robert D. Mitchell, "The Colonial Origins or Anglo-America," *North America: The Historical Geography of a Changing Continent*, ed. Thomas F. McIlwraith and Edward K. Muller, 2nd ed. (Lanham, MD: Rowman & Littlefield, 2001), 98.

24. *Times Dispatch*, "Woodmen Banquet," July 7, 1905.

25. Barton, *Paternity of Abraham Lincoln*; Ida M. Tarbell, "The Origin of the Lincoln Family," *The Life of Abraham Lincoln: Drawn from Original Sources and Containing Many Speeches, Letters, and Telegrams Hitherto Unpublished and Illustrated with Many Reproductions from Original Paintings, Photographs, Etc.* (Whitefish, MT: Kessinger Pub., 2008).

26. Edythe Rucker Whitley, *Genealogical Records of Buckingham County, Virginia* (Baltimore, MD: Genealogical Pub., 1984), 121.

27. John E. Kleber, "Barbecue," *The Kentucky Encyclopedia* (Lexington: University Press of Kentucky, 1992), 50.

28. Martha McCulloch Williams, *Dishes & Beverages of the Old South* (New York: McBride, Nast & Company, 1913), 277. "It was a very cold spring with mint growing beside it, as is common with springs thereabout. Early settlers planted it thus hard by the water—they built their houses high, and water got warm in carrying it up hill. Lacking ice houses, to have cool juleps, they had to be mixed right at the well-head."

29. *The Times*, "Cooking in the South."

30. Ibid.; *Atlanta Constitution*, "In the Barbecue Country," August 26, 1889.

31. Eliza A. Bowen and Louise Frederick Hays, *The Story of Wilkes County, Georgia* (Baltimore, MD: Clearfield, 1997).

32. Robert Preston Brooks, *History of Georgia* (Boston, MA: Atkinson, Mentzer, 1913); *Calhoun Times*, "Gordon County," September 1, 2004.

33. E. Merton Coulter, *Old Petersburg and the Broad River Valley of Georgia: Their Rise and Decline* (Athens: University of Georgia Press, 1965), 9.

34. *Augusta Chronicle*, "The Barbecue," July 2, 1840.

35. *Southern Recorder*, "Anti-Van Buren Meeting," May 26, 1840.

36. *American Turf Register and Sporting Magazine*, "Rifle Shooting—Accuracy of Sight—Precision of Aim—A Georgia Barbacue, &c." (October 1831).

37. *Witchita Daily Eagle*, "All had 'COMPS,'" June 29, 1894.

38. *Morning Times*, "Georgia Barbecued Pig," July 13, 1896.

39. A.V. Goodpasture, "Why the First Settlers of Tennessee Were from Virginia," *Tennessee Historical Magazine* 5, no. 4 (January 1920).

40. Edward Albright, *Early History of Middle Tennessee* (Nashville, TN: Brandon Printing Company, 1909).

41. Gordy, *Stories of Later American History*; Kelly, *Bound Away*, 146–47.

42. Shinn, *Pioneers and Makers*, 123–24.

43. Norman Schools, "Hogtown," *Virginia Shade: An African-American History of Falmouth, Virginia* (Bloomington, IN: IUniverse, 2012), 4–6.

44. Frederick Law Olmsted, *A Journey through Texas, or, A Saddle-trip on the Southwestern Frontier: With a Statistical Appendix* (New York: Dix, Edwards & Company, 1857), 124; Kelly, *Bound Away*, 214.

45. *El Paso Herald*, July 18, 1914.

46. Ibid., January 29, 1913, 8.

47. Anonymous, *History of Clay and Platte Counties*.

48. *Denton Evening News*, "Attention Texas-Virginians," October 2, 1899.

49. *Free Lance Star*, "Yes, Virginia, There Is an Interesting Story to Be Told," December 23, 1995; "Virginia Military Dead Database Introduction," Library of Virginia, http://www.lva.virginia.gov/public/guides/vmd/vmdintro.htm; Winston, "Virginia and the Independence of Texas," *Southwestern Historical Quarterly*; "Virginia Military Dead Database Introduction," Library of Virginia.

50. Jan Onofrio, *Texas Biographical Dictionary*, 3rd ed. (St. Clair Shores, MI: Somerset Publishers, 2009).

51. Louis Wiltz Kemp, *The Signers of the Texas Declaration of Independence* (Salado, TX: Anson Jones Press, 2009).

52. Z.T. Fulmore, *The History and Geography of Texas, as Told in County Names* (Austin: Texas State Historical Association, 1915).

53. *Texas Biographical Dictionary* (St. Clair Shores, MI: Somerset, 2001).

54. H. Crampton Jones, *A Tribute to Zach T. White: Being an Address Delivered at the Hall of Honor Banquet, El Paso County Historical Society, November 24th, 1968* (El Paso, TX: El Paso County Historical Society, 1968.); Amber Bauer and Elizabeth Garate, "Zach T. White Brought Progress to El Paso," EPCC Libraries, 2001, http://epcc.libguides.com/content.php?pid=309255.

55. Randolph B. Marcy, "Pioneers of the West," *Thirty Years of Army Life on the Border* (New York: Harper & Brothers Publishers, 1866), 382.

56. Sweet and Knox, *On a Mexican Mustang*.

57. Workers of the Writers' Program, *The Ohio Guide* (New York: Oxford University Press, 1940).

58. *The National Cyclopaedia of American Biography*, vol. 2 (New York: J.T. White, 1921), 439–40.

59. G. Richard Peck, *Chillicothe, Ohio* (Charleston, SC: Arcadia Publishing, 1999).

60. Carl Frederick Wittke, ed., *The History of the State of Ohio* (Columbus: Ohio State Archaeological and Historical Society, 1941), 449.; Kelly, *Bound Away*, 140.

61. *New Albany Gazette*, "The Late War.—No. 1."

62. Kelly, *Bound Away*, 178.

63. *Springfield Republican*, "The Old-Fashioned Barbecue," September 3, 1906.

64. *Kansas City Journal*, "All Gave Thanks," December 1, 1899.

65. "Missouri Valley Special Collections," Missouri Valley Special Collections, http://www.kchistory.org; Union Historical Company, *The History of Jackson County, Missouri, Containing a History of the County, Its Cities, Towns, Etc., Biographical Sketches of Its Citizens, Jackson County in the Late War… History of Missouri, Map of Jackson County…* (Kansas City, MO: Union Historical Company, 1881).

66. *Kansas City Star*, October 11, 1931; January 1, 1946; January 1, 1946; May 26, 1946.

67. Trumbull, "Words Derived from Indian Languages," 3.

68. *City Gazette*, November 9, 1793.

69. *Washington Times*, "Fact and Legend about Famous Washington Trees," March 22, 1903.

70. Edward Clark and Frederick Law Olmsted, *Annual Report of the Architect of the United States Capitol, for the Fiscal Year Ending June 30, 1882* (Washington, D.C.: Government Printing Office, 1882).

71. Joseph West Moore, *Picturesque Washington…* (Providence, RI: J.A. & R.A. Reid, 1884), 82–83.

72. *Baltimore Patriot*, "Mr. Kincaid's Address," August 6, 1829. "[A]t the barbecue at the White House on the 4th of July."

73. Charles L. Perdue, *Weevils in the Wheat: Interviews with Virginia Ex-slaves* (Charlottesville: University Press of Virginia, 1992), 153.

74. Bernhard, *Travels through North America*, 63.

75. *Texas State Gazette*, "Slave Exodus," February 12, 1859.

76. Kelly, *Bound Away*, 230.

77. Harbury, *Colonial Virginia's Cooking Dynasty*.

78. "A Married Lady," *The Improved Housewife*, 2nd ed. (Hartford, CT, 1844), 44.

79. *Daily Raleigh Register*, "Southern Barbecues," November 20, 1850. "'A Bountiful Barbecue will be prepared.' Over a table groaning with roast beef, and other 'fixins,' including perhaps Turkey and Oyster Sauce."

80. Malinda Russell, *A Domestic Cook Book: Containing a Careful Selection of Useful Receipts for the Kitchen* (Paw Paw, MI: self-published, 1866).

81. James D. Davidson and Ralph E. Pyle, *Ranking Faiths: Religious Stratification in America* (Lanham, MD: Rowman & Littlefield Publishers, 2011), 46.

82. Walter Allen Watson and H.R. McIlwaine, "Notes on Southside Virginia," *Bulletin of the Virginia State Library* (September 1925).

83. *Richmond Whig*, "The Old Fashioned Barbecue," April 27, 1858.

84. *Titusville Herald*, "An Old Dominion Institution," May 25, 1876.

85. Duke, "Recollections."

86. *Staunton Spectator and Vindicator*, "Day of Barbecues," January 18, 1910.

87. *Times Dispatch*, "Big Barbecue as Labor Day Feature," July 5, 1907.

88. Allen C. Guelzo, "The Year that Trembled," *Fateful Lightning: A New History of the Civil War and Reconstruction* (Oxford, UK: Oxford University Press, 2012).

89. Workers of the Writers' Program of the Work Projects Administration, *Virginia, a Guide to the Old Dominion* (Oxford, UK: Oxford University Press, 1946).

90. *Commercial Bulletin*, "Local Intelligence," July 4, 1865.

91. *Richmond Dispatch*, "July the Fourth," July 6, 1886.

92. Ibid.

93. *Alexandria Gazette*, "Local News," February 11, 1875.

94. *Washington Post*, "A Virginia Barbecue," November 2, 1884.

95. *Cincinnati Daily Gazette*, "Local Political News," September 15, 1879.

96. *Richmond Times Dispatch*, "Three Gordonsville 'Waiter Carriers' Recall 'Fried Chicken Center of the World' Days," June 13, 1948; John T. Edge, *Fried Chicken: An American Story* (New York: G.P. Putnam's Sons, 2004); *Daily State Journal*, February 21, 1873; *St. Tammany Farmer*, "Miscellaneous," November 22, 1884; *Richmond Times Dispatch*, June 28, 1905; *Richmond Times Dispatch*, July 8, 1923; *Charlotte Observer*, July 2, 1934.

97. *University of Virginia Alumni News* (August 1920).

98. Duke, "Recollections."

99. Ibid.

100. Cora Brown and Rose Brown, *America Cooks: Practical Recipes from 48 States* (New York: W.W. Norton & Company, 1940), 827.

101. *Daily Courier*, March 29, 1951; *Tucson Daily Citizen*, June 8, 1951.

102. *Richmond Times Dispatch*, "Dining Out," June 9, 1978.

103. Ibid., "George Rogers Presides Over Brunswick Stew," August 29, 1952.

104. Schwarz, "John Dabney."

105. Thomas Jefferson, *Jefferson's Notes on the State of Virginia* (London: J. Stockdale, 1787), 175.

106. Lorena S. Walsh, Ann Smart Martin, Joanne Bowen, Jennifer A. Jones and Gregory J. Brown, "Provisioning Early American Towns. The Chesapeake: A Multidisciplinary Case Study Final Performance Report," Colonial Williamsburg Digital Library, September 20, 1997.

107. Virginia Historical Society, "Urbanization in Virginia," http://www.vahistorical.org/collections-and-resources/virginia-history-explorer/urbanization-virginia.

108. *Richmond Dispatch*, "The Day We Celebrate," July 4, 1891. The impact of railroads; Arinori Mori, *The Japanese in America*, ed. Charles Lanman (New York: University Pub., 1872), 182.

109. American Historical Association, *Annual Report of the American Historical Association* (Washington, D.C.: Government Printing Office, 1893), 124; James Edmonds Saunders, *Early Settlers of Alabama*, part 1 (New Orleans, LA: L. Graham & Son, Limited, Printers, 1899), 223; *Times Dispatch*, "Martin Given Warm Welcome," July 18, 1905.

110. J.D.B. De Bow, *De Bow's Review* 29 (November 1860): 613–14.

111. *Frank Leslie's Illustrated Newspaper*, "Changes in Campaign Methods," August 27, 1887.

112. *Breckenridge News*, "How to Interest the Virginia Voters," July 20, 1910.

113. Raymond A. Sokolov, "Introduction," *Fading Feast: A Compendium of Disappearing American Regional Foods* (New York: Farrar Straus Giroux, 1981), 7.

114. Virginia Writers' Project, *Virginia: A Guide to the Old Dominion* (New York: Oxford University Press, 1941), 590.

115. James D. Rice, *Nature & History in the Potomac Country: From Hunter-Gatherers to the Age of Jefferson* (Baltimore, MD: Johns Hopkins University Press, 2009).

116. Mouer, "Chesapeake Creoles."

CHAPTER 8

1. *Chicago Daily Tribune*, "To Please the Palate."

2. *Richmond Times Dispatch*, "Eating Moves Outdoors with Spicy Barbecue a Favorite."

3. *Huron Reflector*, "A Virginia Barbecue."

4. *New Albany Gazette*, "The Late War.—No. 1."

5. Hannah Wolley, *The Accomplished Ladies Delight* (London: Harris, 1675).

6. L.H. Bailey, Wilhelm Miller and M.G. Kains, "Sweet Herbs," *Cyclopedia of American Horticulture*, R–Z, vol. 4 (New York: Macmillan, 1909), 1,751–52; Keith W.F. Stavely and Kathleen Fitzgerald, *Northern Hospitality: Cooking by the Book in New England* (Amherst: University of Massachusetts Press, 2011), 116.

7. Mary Stuart Smith, comp., *Virginia Cookery-Book, Compiled by M.S. Smith* (New York: Harper & Brothers, 1885), 119.

8. Shurtleff and Aoyagi, *History of Worcestershire Sauce*; Giovanni Fenaroli, *Fenaroli's Handbook of Flavor Ingredients* (Cleveland, OH: Chemical Rubber, 1971), 802; Damon Lee Fowler, *Classical Southern Cooking* (Layton, UT: Gibbs Smith, 2008), 389.

9. *Good Housekeeping Magazine*, "What to Eat in December" (December 1, 1913).

10. Sarah Tyson Rorer, "Barbacue of Cold Beef," *Left Overs: How to Transform Them into Palatable and Wholesome Dishes, with Many New and Valuable Recipes* (Philadelphia, PA: Arnold & Company, 1898).

11. Marion Cabell Tyree, *Housekeeping in Old Virginia* (Louisville, KY: Favorite Recipes Press, 1965).

12. Mary Virginia Terhune (Marion Harland), "Barbecued Rabbit," *Common Sense in the Household: A Manual of Practical Housewifery* (New York: Scribner, Armstrong & Company, 1874); Forrest Crissey, *The Story of Foods* (Chicago, IL: Rand McNally, 1917). "Use of Paprika."

13. Harbury, *Colonial Virginia's Cooking Dynasty*, xiv.

14. Kleber, *Kentucky Encyclopedia*; J.M., "Kentucky," *New-England Magazine* 2, no. 3 (1832): 238, courtesy of Cornell University Library, Making of America Digital Collection; John Willigen, *Kentucky's Cookbook Heritage: Two Hundred Years of Southern Cuisine and Culture* (Lexington: University Press of Kentucky, 2014), 16; Indiana University, *Biographical Cyclopedia of Vanderburgh County, Indiana Embracing Biographies of Many of the Prominent Men and Families of the County* (Evansville, IN: Keller Printing and Publishing Company, 1897), 75.

15. Trumbull, "Words Derived from Indian Languages of North America," 19–32; Andrew Burnaby, *Travels through North America*, 3rd ed. (New York: A. Wessels Company. 1904; originally published in 1778).

16. Alexander Pope, *The Works of Alexander Pope Esq.*, ed. William Warburton (London: printed for J. and P. Knapton, H. Lintot, J. and R. Tonson and S. Draper, 1751), 81.

17. Tobias George Smollett Gentlemen, *Critical Review: Or Annals of Literature*, vol. 31 (London: Forgotten Books, 2013; originally published in 1771).

18. "A Member," *Memoir of the Schuylkill Fishing Company.*

19. Terhune, *Marion Harland's Complete Cook Book.*

20. *Evening Public Ledger*, "Mrs. Wilson Tells about the Good Things that Country Women Are Famous For," September 17, 1921.

21. Munford, "Dinner at Buchanan's Spring—The Barbecue Club," *Two Parsons.*

22. Ben Rogers, "Cooks," *Beef and Liberty*, 24.

23. Commonwealth of Virginia Tourism Website "Virginia Is for Lovers," "Germans in Virginia," http://www.virginia.org/GermansinVirginia.

24. Day, *Down South*, 139.

25. *Washington Times*, "Barbecued Hare in Virginia Style," January 14, 1906.

26. *Chicago Daily Tribune*, "To Please the Palate."

27. Tyree, *Housekeeping in Old Virginia*.

28. *Evening Star*, "Smoky Wood and 'Yarbs,'" June 12, 1955.

29. *National Tribune*, "Tribunets," October 10, 1895.

30. Bureau of American Ethnology, *Annual Report of the Bureau of American Ethnology to the Secretary of the Smithsonian Institution*, vol. 19 (Washington, D.C.: Government Printing Office, 1897), 422.

31. Laura S. Fitchett, *Beverages and Sauces of Colonial Virginia* (New York: Neale Publishing Company, 1906).

32. *Daily Republican*, "Hoover's Summer 'White House' in Virginia," September 6, 1929.

33. Ginter Park Women's Club, *Famous Recipes from Old Virginia*, 2nd ed. (Richmond, VA: [C.W. Saunders], 1941), 230.

34. *Richmond Times Dispatch*, "Barbecue Sauce," May 20, 1935.

35. Ginter Park Women's Club, *Famous Recipes*, 103.

36. *Woman's Auxiliary of Olivet Episcopal Church. Virginia Cookery, Past and Present: Including a Manuscript Cook Book of the Lee and Washington Families Published for the First Time* (Franconia, VA: Woman's Auxiliary of Olivet Episcopal Church, 1957).

37. Debbie Nunley and Karen Jane Elliott, *A Taste of Virginia History: A Guide to Historic Eateries and Their Recipes* (Winston-Salem, NC: John F. Blair, 2004), 157.

38. Christy Campbell, *Eat & Explore Virginia*, 1st ed. (n.p.: Great American Publishers, 2012), 132.

39. Patawomeck Indians of Virginia, *Patawomeck Indians Favorite Recipes 2012* (Kearney, NE: Morris Press Cookbooks, 2012).

40. Walker-Grant's Interested Supporters of Education, *Trojan Truffles* (n.p., 1985), 48.

41. Women's Society of Christian Service of Virginia, *Kitchens by the Sea* (Virginia Beach, VA: Virginia Beach Methodist Church, 1962).

42. Yesterday's Recipes, "Richmond Barbecue Sauce," http://www.yesterdaysrecipes.com/recipes/richmond-barbecue-sauce.

43. Elizabeth Austin Lowance, comp., *Tastefully Yours—Virginia: A Collection of Favorite Virginia Recipes* (Richmond: Virginia State Chamber of Commerce, 1976).

44. Junior League of Hampton Roads Inc., *Virginia Hospitality* (Newport News, VA: League, 1975).

45. Personal correspondence with the manufacturer.

46. Uncle June's Virginia Style BBQ Sauce, http://www.unclejunes.com.

47. *Richmond Times Dispatch*, "Virginia's Battle of the Bulge," March 8, 1947.

48. Ibid., "Barbecued Rabbit," November 27, 1931.

49. Horace Kephart, *The Book of Camping and Woodcraft: A Guidebook for Those Who Travel in the Wilderness* (New York: Outing Pub., 1906), 296.

50. *Harrisonburg Rockingham Register*, "A Political Reminiscence," November 13, 1891.

51. John Griffin and Bonnie Walker, *Barbecue Lover's Texas: Restaurants, Markets, Recipes & Traditions*, 1st ed. (Guilford, CT: Globe Pequot Press, 2014); Ernestine Sewell Linck, *Eats: A Folk History of Texas Foods* (Fort Worth: Texas Christian University Press, 1992), 138–40.

52. Ben Green Cooper, *Marietta Journal*, "Culinary Empire Grows," February 24, 1971.

53. Walsh, *Legends of Texas Barbecue Cookbook*, 121.

54. Walter Jetton and Arthur Whitman, *Walter Jetton's LBJ Barbecue Cook Book* (New York: Pocket Books, 1965).

55. Clayton, "Letter from the Rev. Mr. John Clayton."

56. Aaron Franklin and Jordan Mackay, "Meat," *Franklin Barbecue: A Meat-Smoking Manifesto* (New York: Ten Speed Press, 2015).

57. *Daily Index Appeal*, "The Culture of Sheep."

58. Dorothy Rowe, "Enjoy Eating," *Harrisonburg Daily News Record*, August 16, 2000; Martin Cizmar, "The Shirkey Secret," *Harrisonburg Daily News Record*, July 25, 2007.

59. *Free Lance Star*, "The Barbecue at Sandy Point," January 5, 1901.

60. John Shelton Reed and Dale Volberg Reed, *Holy Smoke: The Big Book of North Carolina Barbecue* (Chapel Hill: University of North Carolina Press, 2008), 113.

61. Andrew Sharbel, "A Taste of Virginia," *Loudoun Times-Mirror*, August 9, 2013.

INDEX

ABOUT THE AUTHOR

Born in Virginia, Joseph Ray Haynes has lived in the state his entire life. Through his father, his family tree reaches back to colonial times. Through his mother, he is a member of the Patawomeck Indian tribe of Virginia, and that part of his family tree, or course, reaches back in Virginia to precolonial times.

While in high school in the 1970s, Haynes received his earliest lessons on cooking Virginia-style barbecue working at a local restaurant. Over the years, Haynes continued to study the art of barbecuing under the tutelage of some of the finest barbecue cooks in the United States. During his travels, he has dined on delicious barbecue cooked by the finest pit masters all over the country. Since 2012, he is an award-winning competition barbecue cook. The world's largest organization of barbecue enthusiasts has certified him as a master barbecue judge. In 2012, he was the recipient of the Leadership in Barbecue Award given by the organizers of the BBQ Jamboree in Fredericksburg, Virginia. Although Haynes appreciates delicious American barbecue styles from all regions of the country, he has always found himself returning to the Virginia-style barbecue that he has enjoyed since his youth.

Often receiving invitations for interviews and lectures on the history of Virginia barbecue and Native American cookery, Haynes provides consultations to museums and other organizations in their efforts to host events that feature demonstrations and re-creations of historical Virginia barbecues. He also assists cooks and vendors in preparing authentic Virginia barbecue.

ABOUT THE AUTHOR

Haynes is the author of the Virginia Barbecue Proclamation, which unanimously passed as a House Joint Resolution in 2016 wherein it was "RESOLVED by the House of Delegates, the Senate concurring, that the General Assembly designate May through October, in 2016 and in each succeeding year, as Virginia Barbecue Season."

Visit us at
www.historypress.net
..
This title is also available as an e-book